OVER

For Eliza, Avery, and their cousins

Treat the earth well: It was not given to you by your parents,
it was loaned to you by your children.

—Native American proverb

Alex S. MacLean

OVER

The American Landscape at the Tipping Point

Introduction by Bill McKibben

Abrams, New York

Contents

CHAPTER 1

Atmosphere

The atmosphere is a finite blanket of gases that surrounds the earth. Aerial photography reveals the atmosphere's thinness and shows the interactions between the earth's surface and the air above. Because greenhouse gases such as carbon dioxide and methane account for less than .04 percent of the atmosphere, small increases resulting from human activity can make a decisive impact on it.

CHAPTER 2

Way of Life

Aerial images can tell important stories about our cultural standards—through perpetual development, conspicuous consumption, and the flamboyant display of possessions, and the discretionary, leisure-time use of energy and resources. The consequences of this behavior have been compounded by small "increments" that in themselves seem insignificant, but that collectively have enormous consequences.

CHAPTER 3

Automobile Dependency

In the last 100 years, this country has built a network of 4 million miles of roadways that, along with automobiles and inexpensive fuel, have allowed us to settle in a very diffuse way. This road network is currently dependent on the internal combustion engine, which is only 20 percent energy efficient. As more people drive longer distances, the U.S. road network is subject to congestion resulting from a lack of capacity, longer vehicle trips, serious accidents, and delays caused by ongoing road maintenance.

CHAPTER 4

Electricity Generation

Electric generation accounts for 40 percent of our carbon footprint in the United States. We can literally see how centralized thermoelectric power is less than 60 percent energy efficient, by the visible discharge of huge amounts of heat as waste into the environment. Other inefficiencies come in mining and transporting fossil fuels to power stations, and in transmitting electricity over transmission lines—where another 8 to 9 percent of electrical energy is lost.

Deserts

The southwestern United States is largely arid, and the availability of inexpensive land and energy and warm winters have caused a mass migration to the area. Developers have built large communities to accommodate this surge in population. However, they often fail to tailor their designs to local landscape and climate, creating communities that are water and energy intensive. Harsh desert environments call into question the long-term carrying capacity of the land, and climate change will have a direct bearing on the sustainability of desert settlements.

Water Use

Water is essential for human settlement, energy generation, agriculture, and industry. From the aerial perspective, water is best understood via human settlement patterns and activity. It's clear to see how the built environment has been engineered to accommodate and exploit water for our everyday habitation; however, as our climate changes, our water supply will become less predictable. It must therefore be viewed as a finite commodity.

Sea-Level Rise

Future sea-level rise is one of the most difficult aspects of climate change to viscerally comprehend. The consequences of the sea level rising three vertical feet will include the loss of thousands of square miles of coastal lands. Coastal development will be further compromised by stronger and more frequent storm surges. Across the board, sea-level rise will take a horrific and persistent economic and social toll.

Waste and Recycling

Waste is defined as "objects or materials for which no use or reuse is intended." Where there is human activity there is waste, yet waste is nonexistent in natural environments. The challenge waste presents is one of eliminating it before it is created or, where that is not possible, recycling it into other production processes. It takes time, space, and energy to process waste for disposal or for its safe release back into the environment.

Urbanism

The collision between population growth and measures to mitigate global warming will necessitate changes in where and how we build new housing. In the next 35 years the United States' population will go from 300 million to 400 million. It is estimated that 70 million housing units—more than half those on the ground today—will be built in this time period. Novel strategies will be needed to make housing units more efficient and environmentally friendly. To accomplish this, we will have to be less dependent on cars and live in denser, mixed-use environments.

Introduction
by Bill McKibben

Even here you can't quite see it. Carbon dioxide is colorless, invisible. But in these brilliant pictures you can see everything else, everything you need to know.

The first thing: The world is small. We almost never notice because we exist in the horizontal. I live in Vermont, which is one of the smallest states in the United States, which itself covers only 1.5 percent of the earth's surface. It's small—but it doesn't seem small. There's a trail, the Long Trail, that runs from stem to stern of Vermont in a relatively straight line—and it takes weeks to walk it. In a car the trail requires hours and hours. And to cross the entire United States, even in an airplane like Alex MacLean's, takes days.

But of course the horizontal is not the crucial dimension when we're worried about climate change. Vertical is what counts—the almost unbelievably narrow envelope of atmosphere and ocean in which everything that lives lives. If I walk out my front door and look up, it's about six miles to the useful end of that atmosphere. Six miles is nothing—I can run six miles in well under an hour. I can bike it in 20 minutes. And yet that's all there is—that's the entire ocean of atmosphere that exists to soak up all the effects of everything we do.

Let's talk about other invisible dimensions. Like time, for instance. Here is what global warming is: It's taking tens of millions of years' worth of biology, all of which decayed into coal and gas and oil, and burning it all inside of three centuries. That's what those big piles of coal that Alex has shot are, the small mountains beside the power plants and the huge strings of barges and train cars. It's time, nothing more and nothing less. It's time stacked up over eons and then unstacked over decades. Over years now. The Chinese are opening a new coal-fired power plant every single week at the moment. Every single week.

So why should it surprise us—at all—that we're warming the planet? All that carbon slowly accumulating in those pools and sandstones and veins, and then, in a flash, set free. It's like saving all your money in a bank for a lifetime and then blowing it in a weekend—we're on a bender. It seems normal to us, because the bender has lasted our lifetimes, but the party is clearly getting ready to end. And of course, as it does, we're getting a little surly. We can taste the hangover that's coming, and so we keep it at bay with a few more rounds. But it's only a matter of time.

Can I tell you about Alex and his airplane? It will provide a break from considering in such clinical detail what we're doing to the planet. Alex MacLean is boyish, funny. He took me up in his plane one day over the Adirondack Mountains that dominate the North Country, where I live. We flew over my house, and as we did so he started taking pictures. Now, I don't know anything about photography. I'd assumed that aerial photos were probably taken from some kind of a box that hung underneath the airplane, and that the pilot maybe pushed a button. Imagine my terror when it turned out that Alex opens the pilot's side window and lets go of the controls of the plane and leans way out, banks the plane over and holds his camera up to his eye and squeezes off frames.

Squeezes off *many* frames, long after it's become clear that we're almost certainly going to crash into the nearby mountainside and die for art. But then he puts down the camera and closes the window and takes the controls again and sudden death is averted. And after a while, you get calm enough to really take a look. At the height he's flying, the world is incredibly interesting. It's not so high—like a jet—that all's a blur. But it's high enough that patterns emerge. Many are natural; I remember looking at the wildly abstract cracks that fractured the frozen lakes high up in the mountains. The world is impossibly beautiful viewed from the microscopic to the telescopic.

But the patterns that count for this discussion, of course, aren't natural at all. The patterns that count here are the reflections of human desire scattered across the landscape. If there's a recurring shape in MacLean's work, for instance, it's the bulbous head of the suburban cul de sac—the endless erection, flamed by vague consumer longing, that symbolizes without even a hint of irony our very real rape of the landscapes we inhabit. The cul de sac in the desert, in the mountains, in the beachfront condo cluster. It's like those chalk drawings cut by paleoman into the English countryside, but this time for commerce, not art.

As the author James Howard Kunstler has pointed out in great detail, the American economy since World War II has been overwhelmingly devoted to producing a single commodity: more suburbs. By the 1990s, he writes, "the dirty secret of the American economy was that it was no longer about anything except the creation of suburban sprawl and the furnishing, accessorizing, and financing of

it." On the ground, from our normal vantage point, it just looks like a slowly spreading maze of "communities," each with its own guardhouse, its own network of curved boulevards. From MacLean's vantage point, however, the logic is clearer. For the first time in human history, settlement paid no attention to the dictates of the landscape. These new developments and subdivisions owed their existence not to the proximity of rivers or ports or rail networks or . . . anything. They were the pure and abstracted products of real estate—hence the square block of crowded suburb still surrounded by intact desert.

And of course they needed only one thing to bring them to life: a road. We had no doubt about their importance—we called them arteries, which was exactly the right analogy. They brought life to these increasingly distant limbs. Indeed, in some kind of mad-scientist trick, they managed to transform these suburbs and exurbs into the new heart of our society, slowly draining much of the life from the center cities that had been sited due to the now archaic logics of geography. Now the important nodes had nothing to do with watershed or seacoast—they were entirely human-made, the intersections of these concrete veins we'd spent the years since 1950 building. To map the loci of American growth all you needed was a map of the highways; wherever they crossed was fertile ground. Indeed, developers soon had the most sophisticated possible maps of traffic flow, and hence the knowledge necessary to spread shopping malls, muffler shops, doughnut stands, and "adult" bookstores to precisely the right places. Growth depended on growth, and in MacLean's photos you can see the process with the same elegance as rings on a tree stump.

But as the 21st century begins, it looks as if we may not have fully understood the arterial metaphor. We thought progress flowed down all those roads—trucks bearing commodities, cars bearing commuters. But it may turn out that they mainly carried oil, that they were in point of fact less arteries than pipelines. And the trouble with an oil-based geography, unlike the older water-based geography, or even the 19th-century rail-based geography, is that it might not last forever. That end has begun to happen. Partly because we're running short—MacLean's cameras can't capture what's beneath the ground, but if they could they'd show all those pools and oil fields dropping steadily. (And his Chinese or Indian counterpart could show us that, even as those levels drop, the demand grows; there are

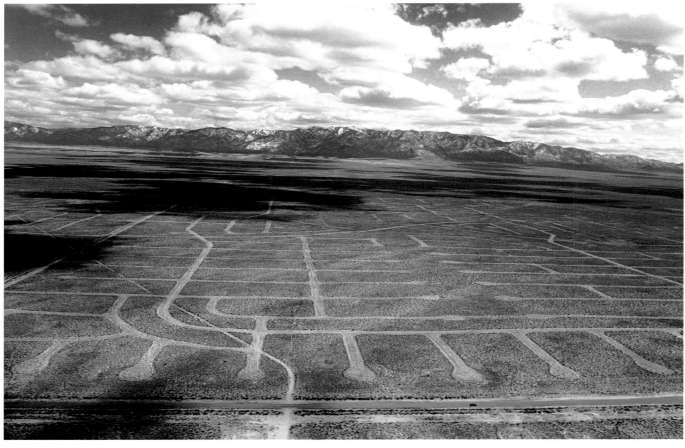

Northwest of Albuquerque, NM
Land speculation maps out an undeveloped suburban community.

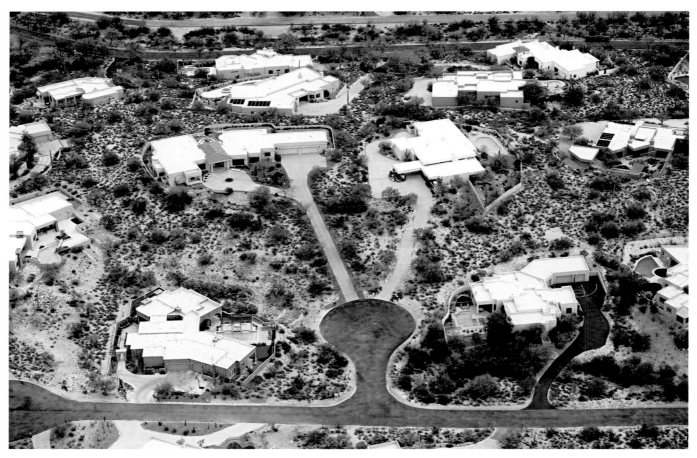

Tucson, AZ
Large xeriscaped desert homes with pools extend off of a cul-de-sac.

Asian equivalents of every scene in this book, and more every day. Our lesson has been well taught.) And partly because we simply can't keep burning oil, or natural gas, or coal. If we do, then the atmospheric changes will simply overwhelm us. Among other things, rising sea levels will quickly remind us of the ultimate primacy of the old geography.

To use another petrometaphor, let's "drill down" into the pictures that MacLean provides. One constant across the continent is the astonishing number of enormous new homes—homes that in an earlier age would have served as starter castles for entry-level monarchs. The average new house in America doubled in size between 1970 and 2005—*doubled. And that's as the average number of people *living* in each of the houses dropped by almost a full human.

And what's inside those homes? Are they great hives of convivial living? Here's how *The Wall Street Journal* recently described new trends in home construction: "Major builders and top architects are walling off space. They're touting one-person 'Internet alcoves,' locked-door 'away rooms,' and his-and-her offices on opposite ends of the house. The new floor plans offer so much seclusion that they're 'good for the dysfunctional family,' says Gopal Ahluwalia, director of research for the National Association of Home Builders."

According to the *Journal,* two years ago, when the housing bubble was at its highest, the industry built an "ultimate family home" for its annual Las Vegas trade show. It "hardly had a family room." Instead, the boy's bedroom came with its own 42-inch plasma TV screen, and the girl's bedroom had a secret mirrored door leading to a "hideaway karaoke room." In the words of Mike McGee, chief executive of Pardee Homes of Los Angeles, "We call this the ultimate home for families who don't want anything to do with one another."

"Don't want anything to do with one another," it turns out, includes sleeping together. In the spring of 2007, as many as a quarter of new higher-end homes were being built with dual master bedrooms, separate-but-equal suites for couples who don't really want all that much to do with each other, reported *The New York Times*: "'Couples today are writing their own script, rewriting how to have a marriage,' said Pamela J. Smock, a University of Michigan sociologist.

'The growing need for separate bedrooms also represents the speed-up of family life—women's roles have changed—and the need for extra space eases the strain on the relationship. If one of them snores, the other one won't be able to perform the next day.' [Indeed, one Florida builder attests to a growing demand for "snoring rooms."] . . . 'Women are buying more homes, and women are sensitive to that terminology of the "master suite," and they're opting for the term "owners' suite,"' said Barbara Slavkin, an interior designer in St. Louis. Dale Mulfinger, an architect in Minneapolis, said, 'How about "couples' realms"?'"

How about "incredibly sad"? Whatever you call them, there are a couple of bottom lines. One is environmental: Here's 500 square feet that needs to be heated and cooled and lit and plumbed and wired. Another is less quantifiable: What does it say about a society when its richest members are hunkered down in their own caves, staring off across the hallway at their mates?

What it says, I think, is that fossil fuel has done three interrelated things. The first is to make us rich—until we learned to burn coal in the early 18th century, the human standard of living had doubled once, maybe, in the previous two millennia. By contrast, we've seen our material wealth treble since about 1950.

The second is to wreck the climate—there's nothing humans have ever done that's as big as that. But ignore it for the moment.

Because the third, hidden effect is to make us the first people in the world who have no need of our neighbors. Take a look at those pictures again. They show endless detached homes, each fronting the same sterile strips of concrete. But there's no lateral connection—nothing to tie them together.

That's very new. For all of human history, until 75 years ago in America, you needed your neighbors to get through the day. Without them you couldn't get food on the table, a roof over your head, or much in the way of entertainment. We were (we are) socially evolved primates, not all that far away from our simian ancestors who spend all day grooming one another's fur. But cheap fossil fuel, which underwrote the landscape that MacLean displays, also underwrote a kind of pervasive individualism—a hyper-

individualism that in essence has made us a new species. Americans have half as many close friends as they did a generation ago and eat meals with friends and family half as often. In essence, we learn how to do one small thing, we use that skill to make money, and we use that money to make sure we don't need anyone around us. If you have a credit card and a working Internet connection, all the neighbors in your cul de sac could die tomorrow and it wouldn't much affect your daily life. In fact, you might not even notice—three-quarters of Americans don't have a relationship with their *next-door neighbor.*

The symbols of this new, pervasive hyper-individualism are the SUV (designed to make sure that if you're in an accident the other guy dies) and the big-box store. If you welcome Wal-Mart into your community, you are signing the death warrant for most of the local merchants, also known as your neighbors. Collectively your life will suffer— counties with Wal-Marts grow poorer than surrounding counties without them. But as an individual you will benefit, which is to say the stuff you buy will be cheaper, and hence there will be more of it.

So, has all this growth, and all this hyper-individuality, *worked*? Beyond its doleful effect on the planet's future, has it at least succeeded in making us happier in the short term?

The saddest pictures in MacLean's whole catalogue are not the coal plants; they're the pleasure domes. That golf cage on a New York City pier that looks from the air like nothing so much as a giant playpen. That Las Vegas vista— "New York, New York" the casino is called—with its half-size simulacra of a real and vivid place. That faux stern-wheeler, bolted to its pier for the convenience of slot-machine addicts. Can you sniff desperation from 2,500 feet?

As it turns out, the percentage of Americans who describe themselves as "very happy" peaked in the mid-1950s and has gone steadily downhill ever since. And the reason, as far as anyone can tell, has everything to do with the community that simultaneously declined. It turns out we don't want to be in our own isolation room. We *literally* don't want to live this way. If you can find an American, and there are tens of millions of them, who doesn't belong to some group, convince them to join up. Doesn't matter what—church choir, camera club, motorcycle gang. Their

mortality—the chance that they will die in the next year— drops in half. Half is a lot.

Let's return to all that invisible carbon dioxide for a moment. If you'd taken a picture from the very first airplane (which wouldn't have even required opening a window!), each cubic meter of air in the shot would have had somewhat less than 300 invisible parts per million carbon dioxide. That number is now 385 parts per million, and rising steadily.

While 85 parts per million doesn't sound like much, it's the biggest thing, by far, that we did in the twentieth century. It makes building an atom bomb look like nothing; in the long run the world wars will be a footnote.

Not to belabor it. You can start to see the effects from MacLean's altitude: the effects of stronger hurricanes, for instance—those FEMA trailers parked forever in some sunbaked lot, holding the evacuees from Katrina or Rita or Wilma.

But back it up a couple of hundred miles and you can *really* see it—the satellite shots of Arctic ice are the scariest pictures ever. Last fall we were losing ice at a rate equal to the size of California every day. The shots from space showed the Northwest Passage, open, for the first time ever.

What are we going to do? What can we do?

Those windmills are a good sign. Their spinning blades, the breeze made visible, are a marker for our time, a new aesthetic far lovelier than the power plants they replace. Those solar panels are a good sign—but notice how few there are. You can fly over the sun-drenched suburbs of Florida or Arizona or California or Nevada and see one solar panel for every hundred swimming pools or sand traps.

In the end, though, how we generate energy is going to be less important than how we use it. There's no way to build windmills and solar panels fast enough to keep our particular high-consumption hyper-individualism afloat. That's why these pictures are such a key reality check; they show us the world we've built.

Much of that world is a relic of cheap fossil fuel burned with no regard for its environmental effect. As that era ends, some of these landscapes are going to become

untenable. (In fact, in the last year we've learned that much of the most recent "development" was underwritten with money that wasn't real, a fact that now threatens to undermine our entire economic system.) Who wants a 4,000-square-foot house 75 miles away from their job? Who wants waterfront? No one with a working knowledge of energy and the environment and a life expectancy longer than about a decade.

In fact, every one of these systems is starting to crumble. Consider the industrial agriculture exemplified by the giant circles on the Great Plains landscape. Those circles are an artifact of cheap irrigation water, itself now growing scarce. They've fed the corporate food machine, which has managed to deliver great quantities of corn syrup that turned us into a nation of pudgy diabetics. But that food machine depends on cheap fossil fuel, just like everything else in these pictures. Now, in a kind of ironic death spiral, it's burning vast quantities of oil to produce ethanol—which is to say, corn-flavored gasoline. To keep the rest of the picture operating for a few more years.

I can't tell you how it's going to come out. I can tell you what I think these pictures will look like 50 years hence—if we're lucky. Forget homes clustered around golf courses; imagine instead homes clustered around community-supported agriculture farms, which are already spreading quickly. Forget huge individual palaces; imagine instead the rapid growth of cohousing, small semidetached homes that share a common dining room and recreation hall. Forget landscapes designed for cars; imagine instead parking lots crowded with bikes, like those you see at Danish train stations. Imagine trains!

It's not going to all work out easily everywhere; it's very hard to imagine a future with the Vegas Strip playing the same role in our culture that it does today. It's easier to imagine its fountains filled with blowing sand.

The key—and nothing has ever made this clearer than Alex MacLean's photos—is not new technology. It's a new sense of who we are and what we want. If our imagination can't escape from the privatized prison we've locked it into, then we have no chance. But there are signs, tantalizing ones: Farmers' markets are the fastest-growing part of our food economy, for instance. And farmers' markets are important not just because they make more ecological sense; they're important because the average shopper there has 10 times

more conversations than the average shopper at a supermarket. The walls we've built—the very literal walls visible on these pages, and the psychological ones they imply—start to crumble.

But we've put ourselves into the hardest possible corner. Like no other on earth, our landscape reflects the depth of our addiction to fossil fuel, the fossil fuel now wrecking our planet. We've built an environment that will mock our efforts to reform it. We will envy many other spots on earth that we now scorn before we're through. These pictures show the high tide of the ultimate material civilization, and now that tide is rushing out.

Alex MacLean's pictures are an irreplaceable document bearing testimony to the precise forces now undermining our only planet. May they help give us the insight to make the changes that we must.

Atmosphere

I first became aware that the atmosphere had mass as a boy in my parents' 1954 station wagon. As we were driving along, I mindlessly stuck my hand out the window and held it flat, only to have it slammed back toward me. As I tilted it up and down in the car's slipstream, the force of the air striking my hand made it go up and down. It was then I realized there was something in the clear air that I could not see. It had mass and power.

From the ground, our atmosphere appears infinite, extending from horizon to horizon and seemingly equally high as wide. In fact, not only is it finite, but it is much smaller than most people imagine; the majority of the atmosphere lies within five miles of the surface of the earth, beneath the cruising altitude of most commercial airplanes. The problem with our misconception about the size of the atmosphere is that it has lulled us into thinking that our atmosphere is an endless sink into which we can pour greenhouse gases without consequence. This is similar to how we once thought of the oceans as being an unlimited depository for waste. The truth is that 99.9 percent of the mass of our atmosphere lies within 30 miles of the earth, whose diameter is 7,926 miles. To get an idea of the proportions, picture cellophane wrapped around an orange.

The mass and density of the atmosphere falls off at an exponential rate; in other words, the atmosphere gets thinner as you get higher in altitude, but this does not happen at an even rate. The lowest or innermost part of our atmosphere, known as the troposphere, contains roughly 80 percent of the atmosphere's mass and is only five to nine miles thick. Its thickness varies with earth's latitude; it is wider at the equator than at the poles, because greater rotational forces at the equator throw it out farther into space than the forces do at the poles. This outward centrifugal force is countered by gravity, which is pulling and compressing our atmosphere toward the earth's surface.

Most of the sun's shortwave radiation passes through the air of the troposphere, heating the earth's surface. The troposphere itself is mostly heated from the ground up by longwave infrared radiation (heat) coming off the earth's surface. This heat is spread through the troposphere by unstable air, better known as weather. The troposphere is the region where greenhouse gases come into play. To keep temperatures relatively constant over time, the

heat coming in and the heat being radiated back out into space need to be about equal. The presence of heat-trapping gases that absorb longer-wave radiation throws this balance off, causing global warming and climate change.

My sense and understanding of the atmosphere changed dramatically after taking up flying and aerial photography, because the atmosphere is the medium through which I see and travel. When I fly, I have to make accommodations for both existing and forecasted weather conditions: wind, temperature, visibility, precipitation, and cloud cover. I also need to know the local barometric pressure to set my altimeter and get an accurate reading of my altitude. As an aerial photographer I am concerned with the variable light quality as I look through long distances of the atmosphere from different directions and altitudes.

And as a pilot I appreciate how quickly the atmosphere thins as you climb. At 10,000 feet, the density of the air decreases by 30 percent compared to the density at sea level, engine performance falls off noticeably, and I feel a shortness of breath. At 12,500 and 15,000 feet, the aerodynamics of the plane change, and I am required by law to use supplemental oxygen to stay in that airspace for more than a half hour. At higher elevations all planes require longer runways to land, since it takes more airspeed to keep afloat in thinner air.

I will often climb to higher altitudes on hot days to take advantage of the environmental lapse rate, since temperatures drop an average of two degrees Fahrenheit every 1,000 feet. This lapse rate, in part, is what defines the troposphere; it is also why mountains have snow lines. Another reason to climb to higher altitudes is to take advantage of the winds, which are usually stronger and rotate in direction as you climb. Flying higher provides greater fuel efficiency, because there is less drag flying through thinner air.

Gliding along over the Gulf of Mexico in the summer, I can literally see the power of the sun's energy as it lifts moisture off of the Gulf and transforms it into towering cumulus thunderheads. I am forced to put down toward the middle of the day to wait until the late afternoon, when these thunderstorms dissipate as the heat from the sun starts to let up. It's a lesson in just how volatile and powerful the atmosphere is.

Visibility markedly improves as you gain altitude. You can see the space that contains invisible air because of markers such as fog, clouds, haze layers, and airborne contaminates moving over the earth's face. Not all that long ago my concern was strictly with the pollutants that directly impact our environment and health. I can remember thinking, back in the early 1980s, that CO_2 emissions were not a pressing concern—just eliminate the carcinogenic gases, airborne particles like lead and mercury that are neurotoxins, and gases like sulfur dioxide and nitrogen oxides that cause acid rain. At that time, climate change wasn't really thought of as something happening in the here and now. But today the visible haze layers and pollutants that we see in the troposphere suggest that CO_2 and other greenhouse gases are close to earth. Carbon dioxide is invisible and does not immediately affect our health; it is a trace gas that makes up less than .04 percent of our atmosphere. Since there is relatively little carbon dioxide in the atmosphere, though, it does not take much to increase the percentage as measured in parts per million. As evidence, today carbon dioxide levels have increased by approximately 37.5 percent above preindustrial levels, to 385 parts per million.

Given the thinness and finiteness of our atmosphere, it's obvious that the demands of more and more people for more and more energy and resources will rapidly increase the proportions of heat-trapping gases in the troposphere, leading to global warming and climate change. We must closely examine the problem and build a cultural consciousness around the idea that when we waste energy and resources we are wasting not only money but also the precious atmosphere we all share.

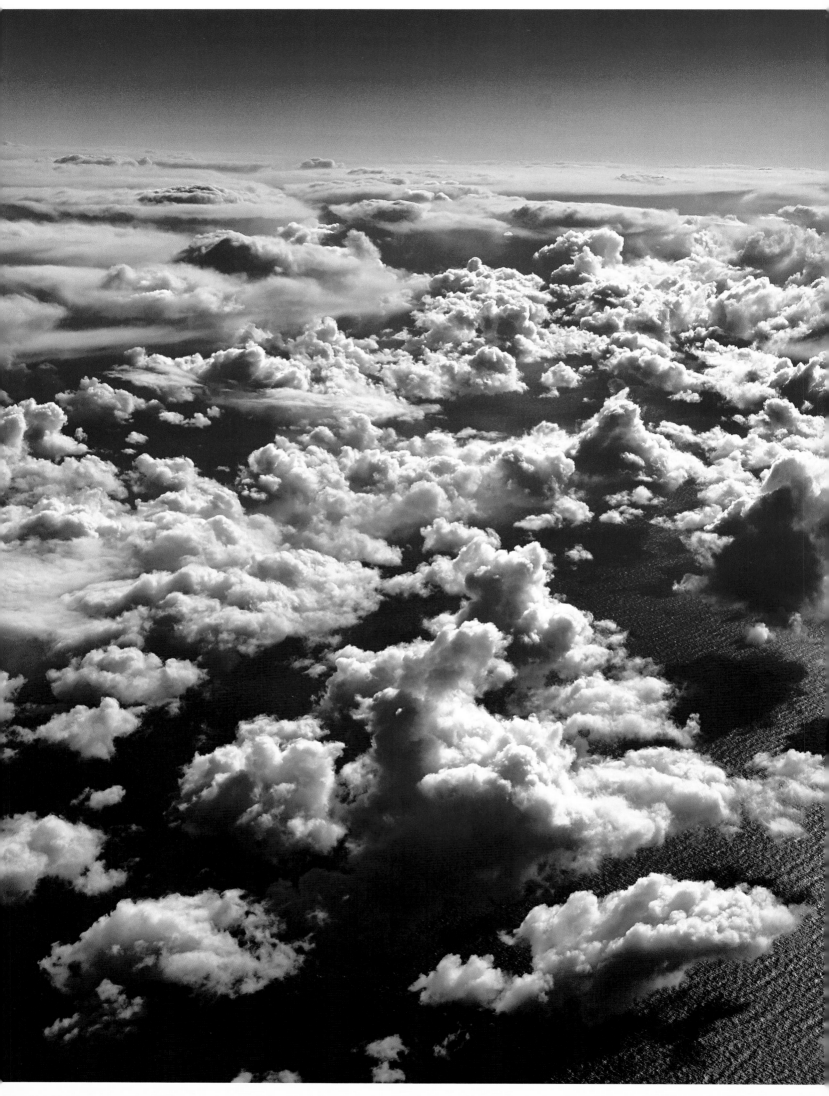

The North Atlantic
From 39,000 feet, clouds cast shadows on the North Atlantic. On the everyday commercial-jet
flight, passengers look down through the lowest level of the atmosphere, the troposphere. This layer
contains 80 percent of our atmosphere's mass.

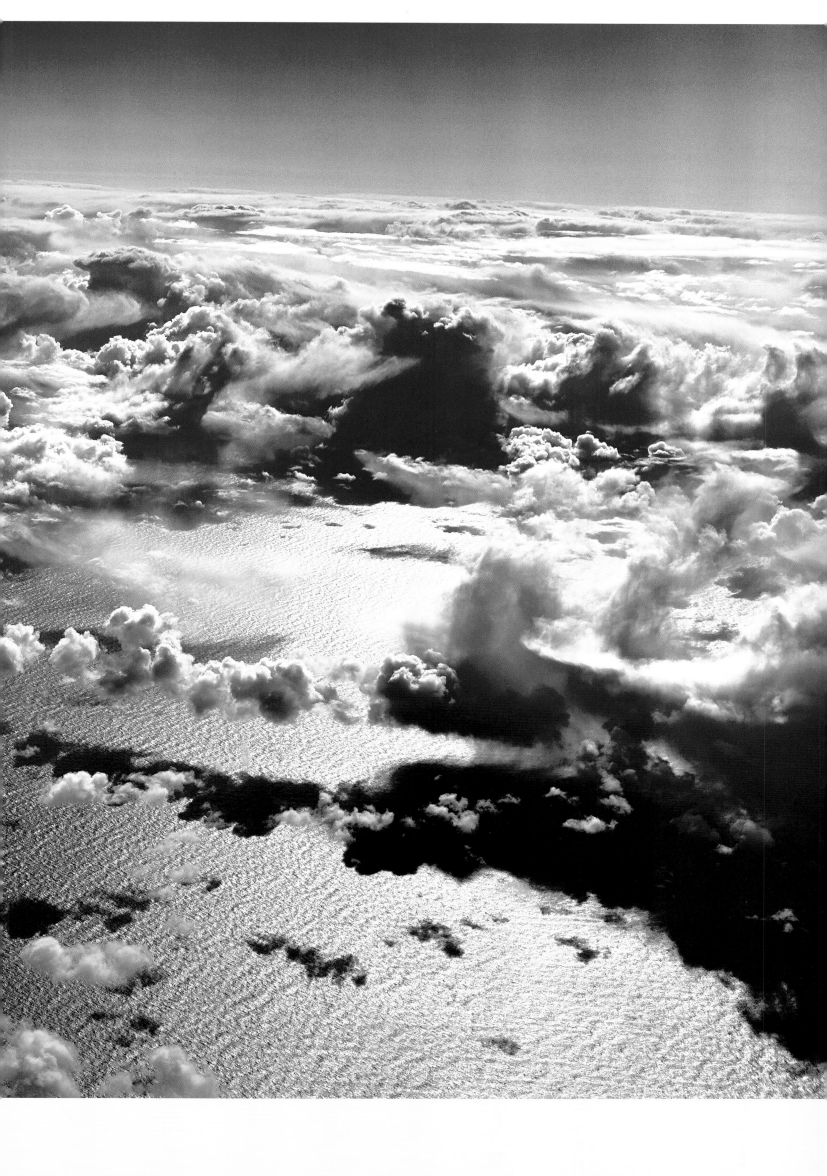

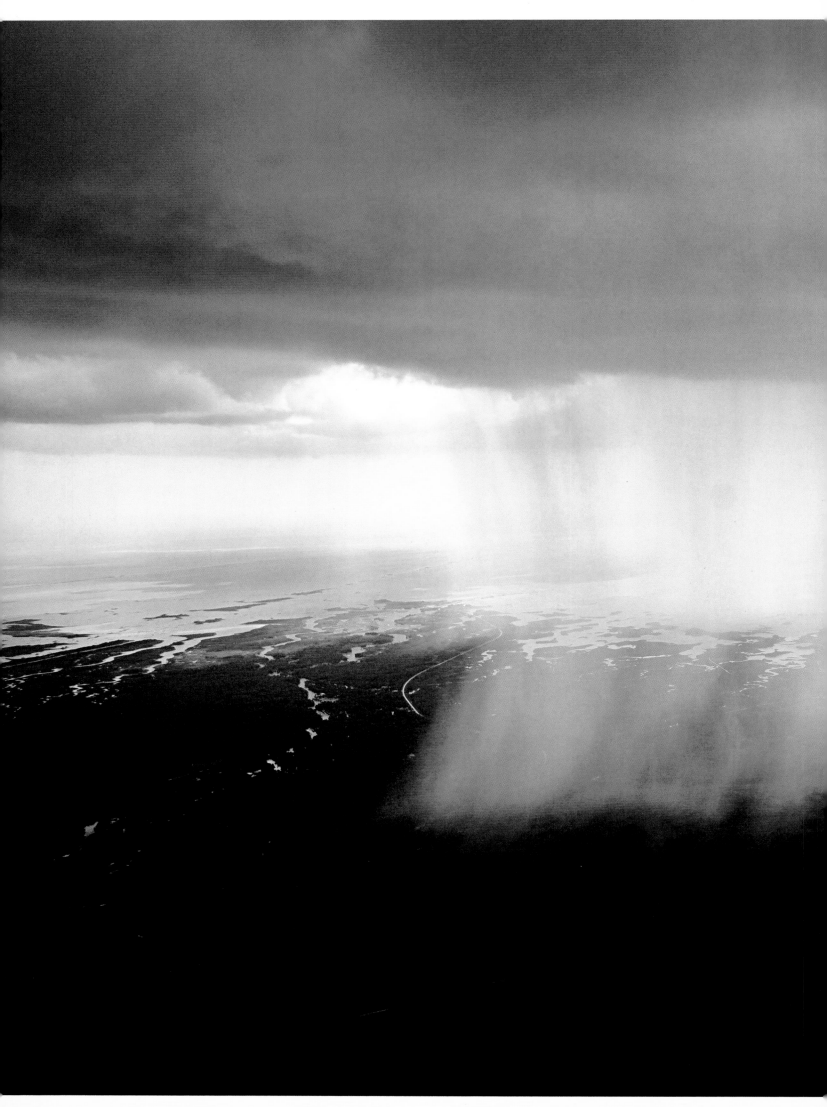

Withlacoochee Bay, Crystal River, FL
An isolated cloudburst over Gulf Coast wetlands illustrates the link between land and atmosphere.
Wetlands have large evaporative surfaces that are an important part of the water cycle. They
absorb rainwater runoff and filter out sediments, metals, and pollutants.

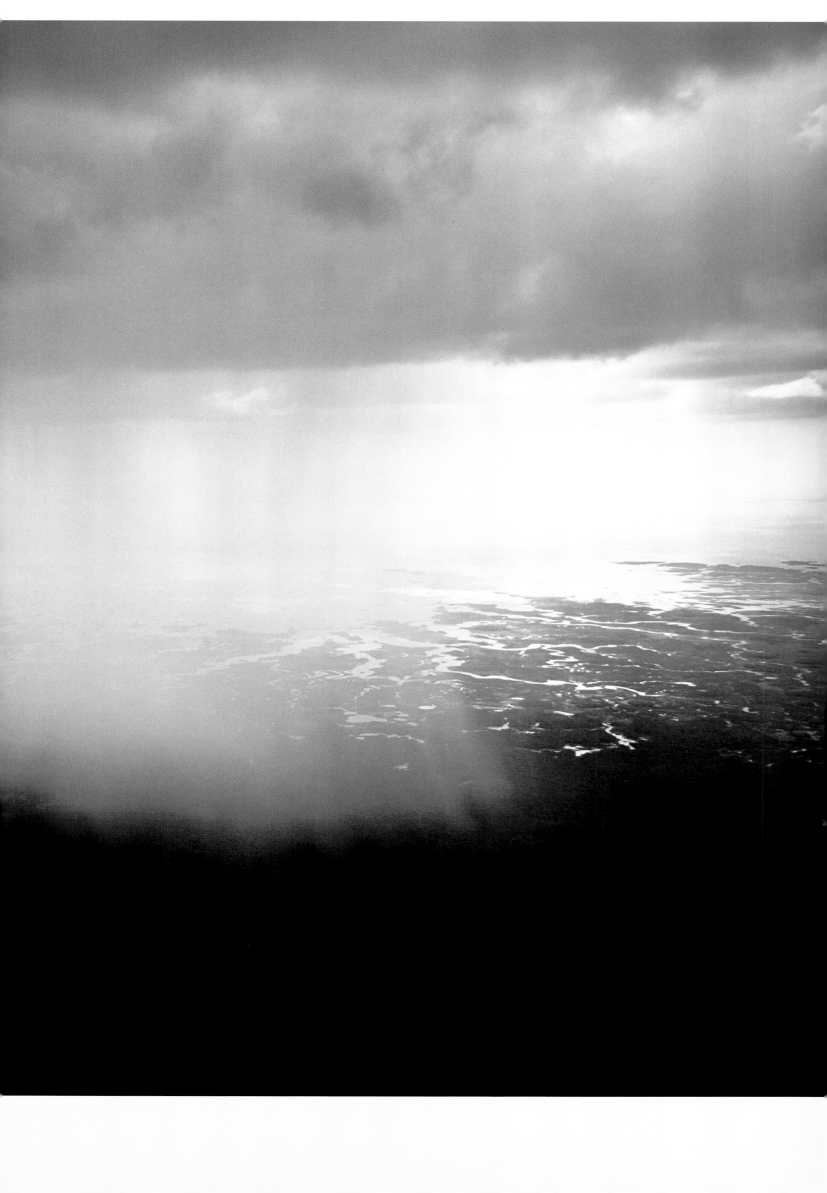

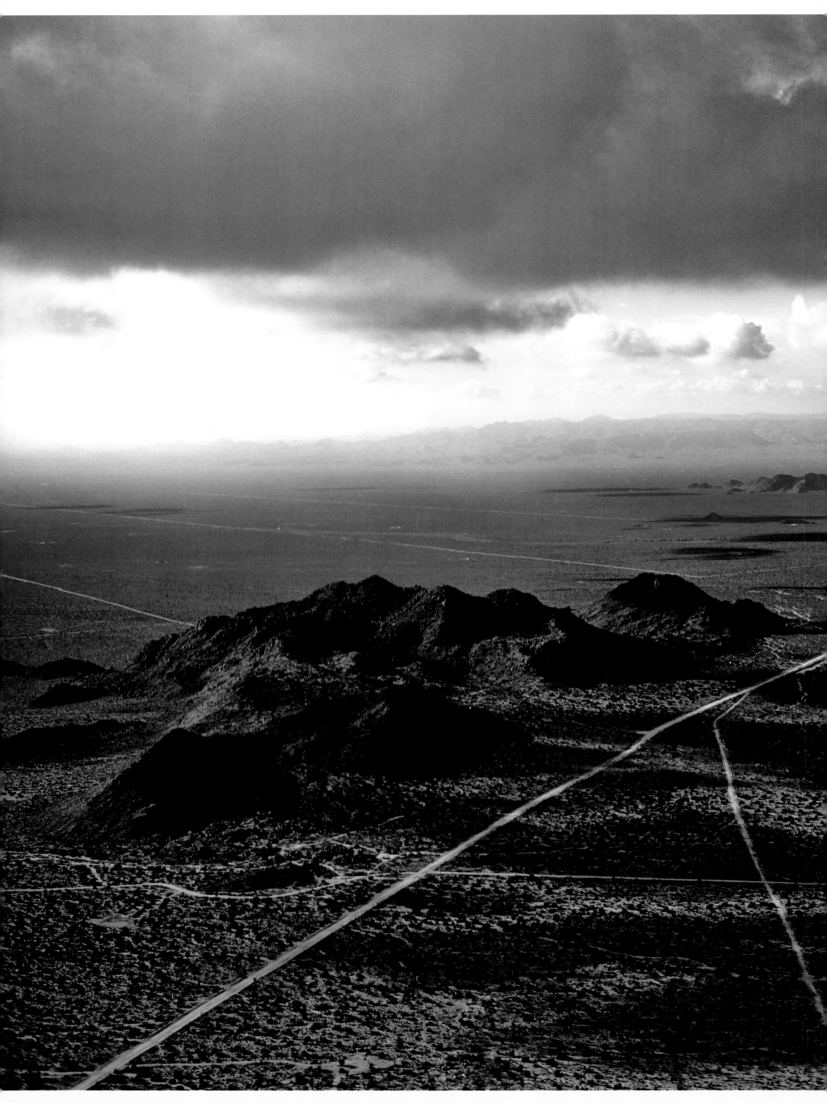

Signal, AZ
Scattered clouds cast shadows over northwestern Arizona scrub desert. Moisture passes over the dry land below, leaving the area's average rainfall at a meager 7.5 inches per year.

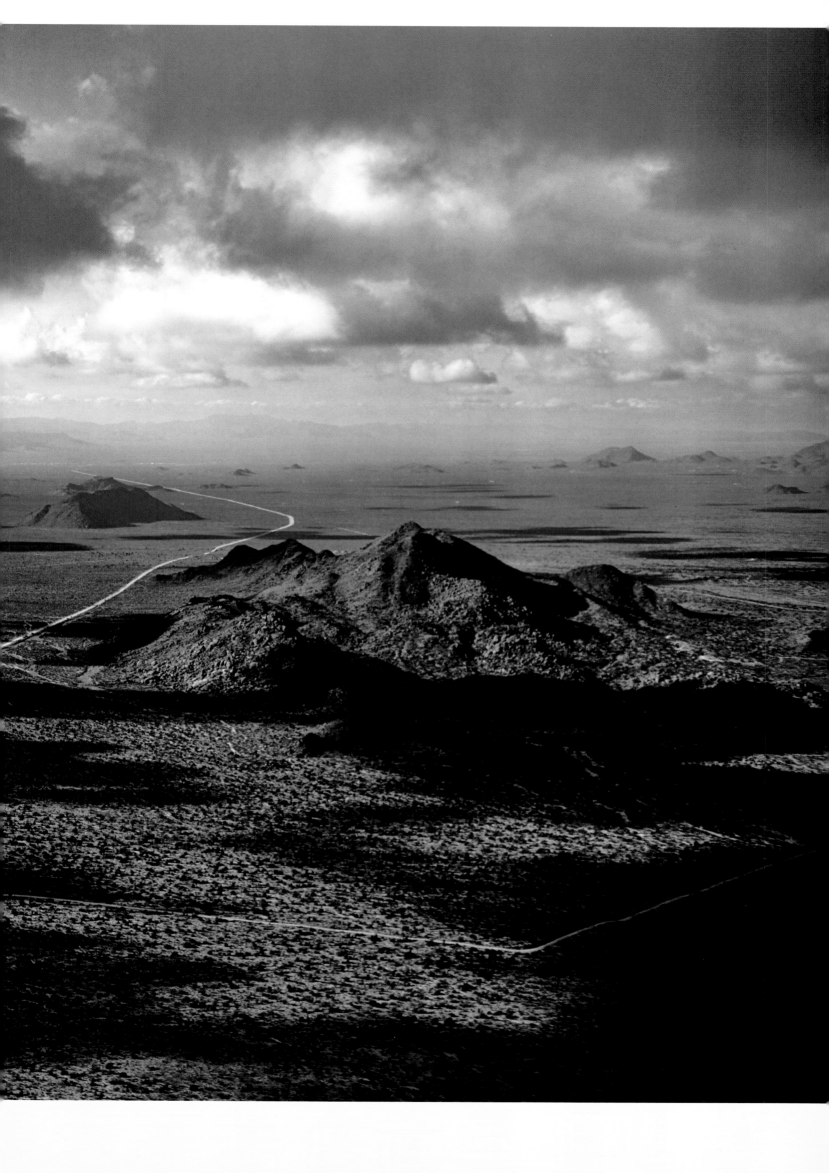

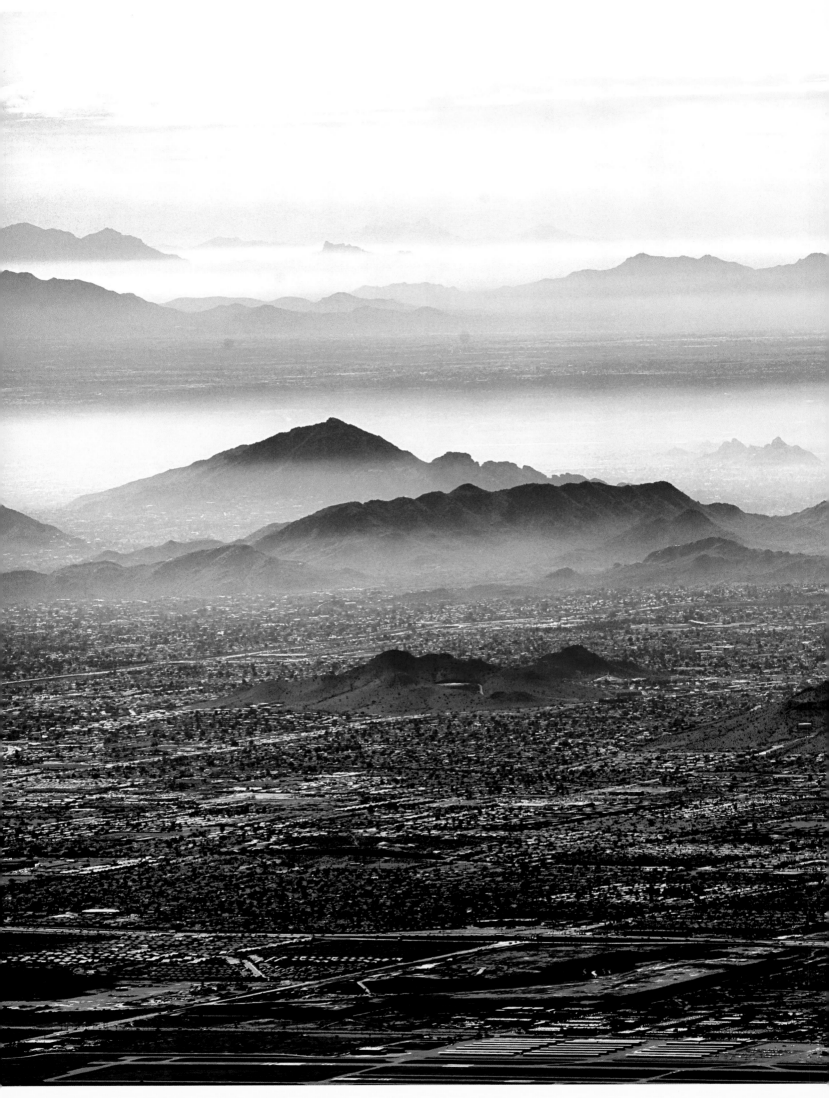

Phoenix, AZ
Smog settles between hills north of downtown Phoenix. In the Phoenix metropolitan area, the
natural inversion layer traps rising particulates and forms "brown cloud" as the ground heats
up during the day. Smog impacts inhabitants of urban populations that already suffer from
respiratory ailments, and continued suburban growth contributes to declining air quality.

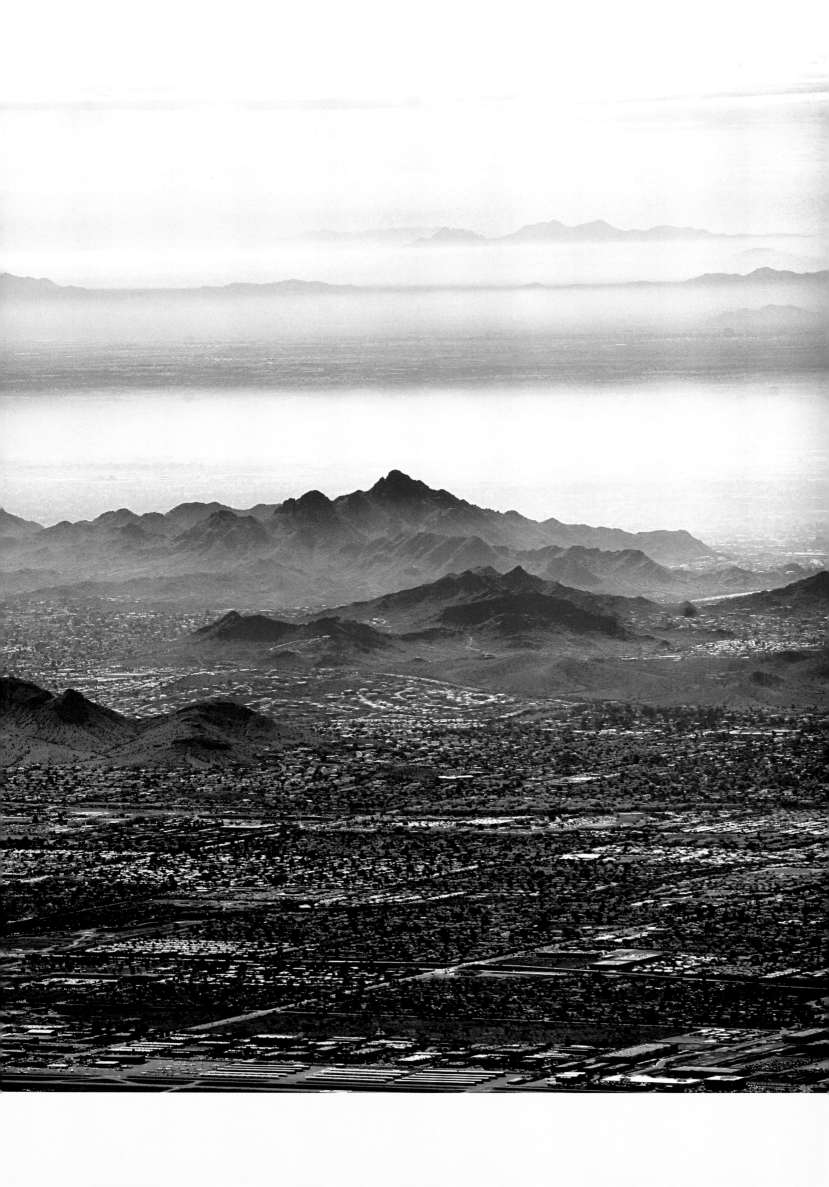

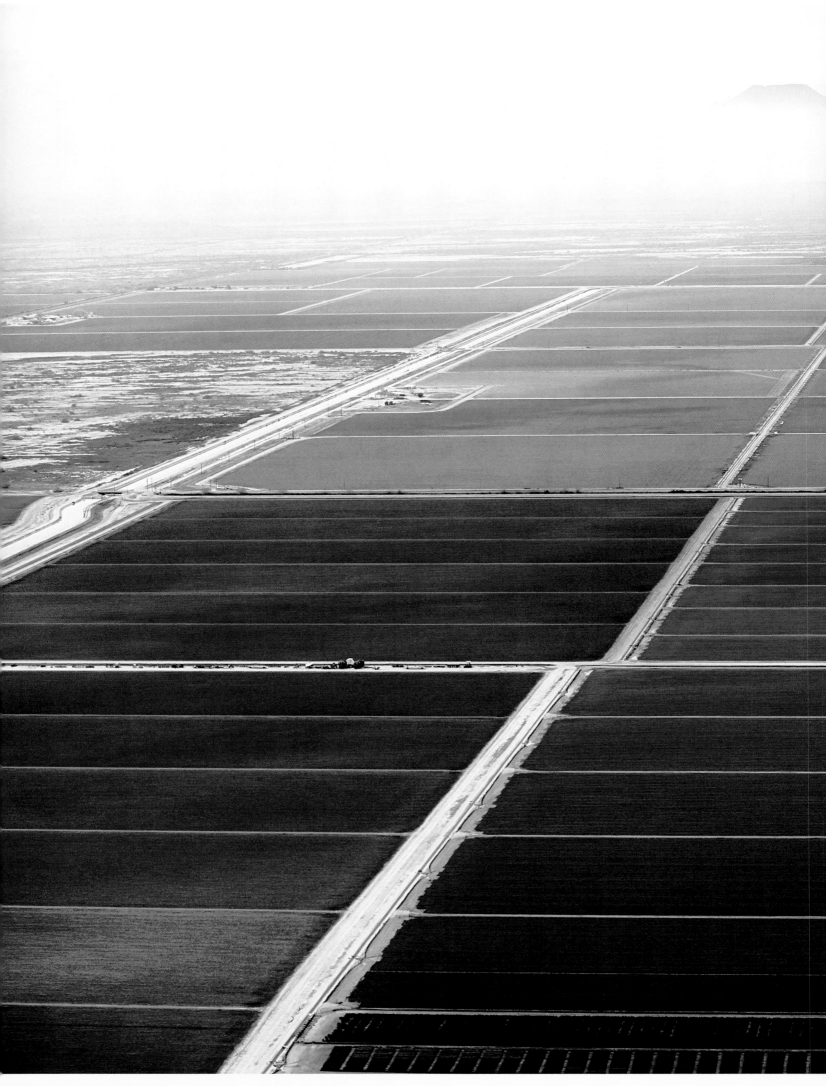

Arizona City area, AZ
Smog from downtown Phoenix hugs irrigated fields 30 miles south of the city. Smog's negative
effect on plant growth has been a major cause of crop losses around the world.

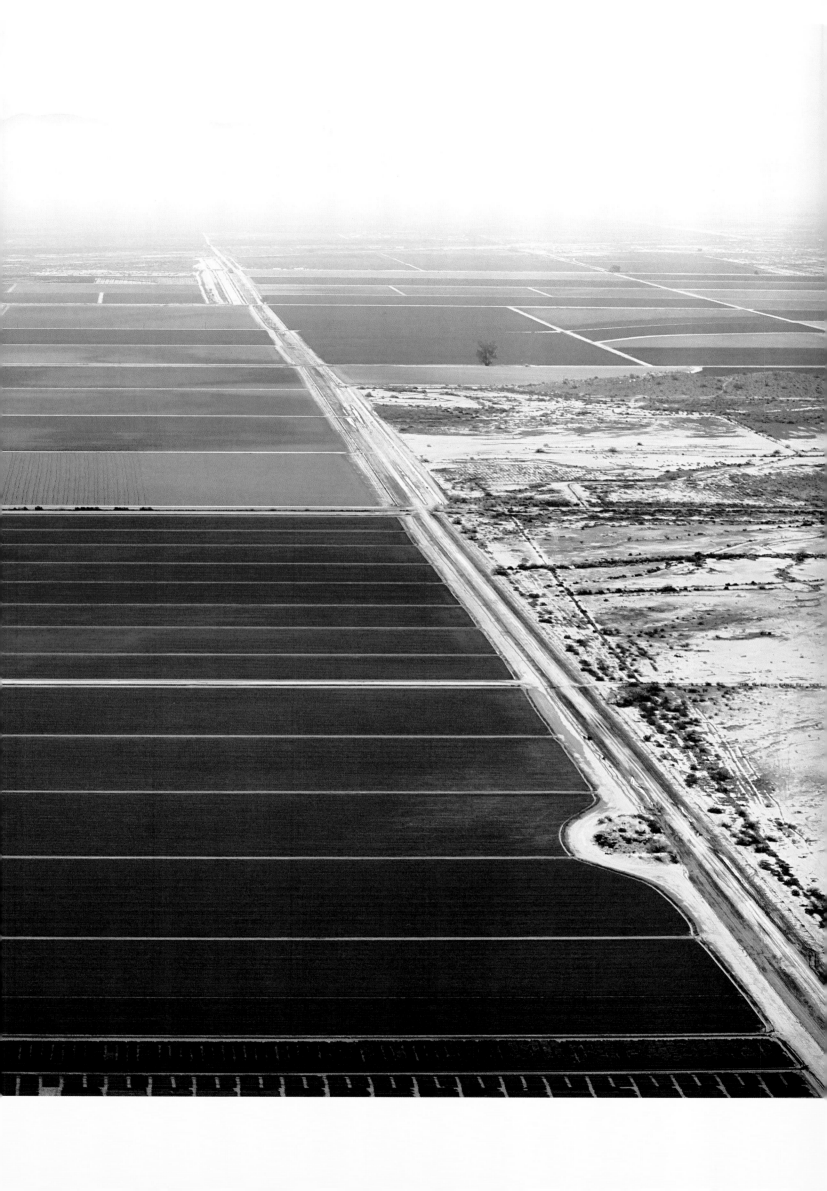

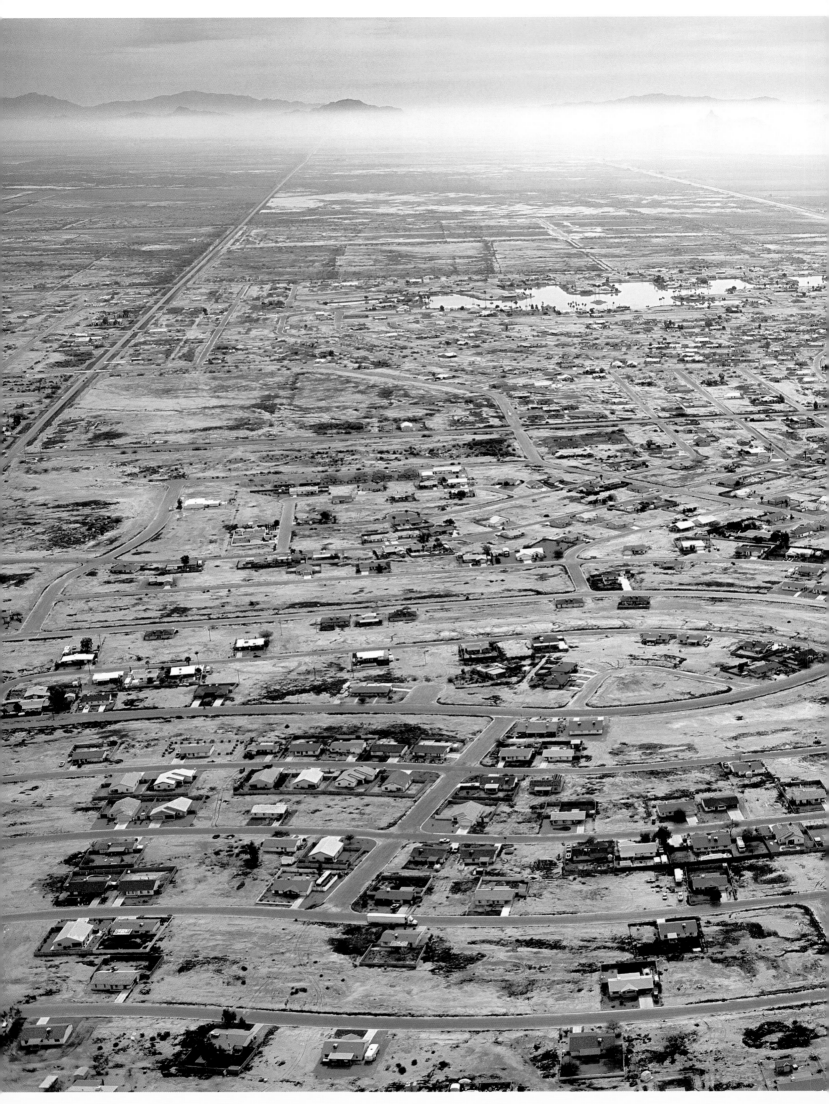

Arizona City, AZ
A thick layer of smog hangs over a sparsely settled area of Arizona City. Low-density suburban
development encourages more auto use, which is a major source of smog-creating pollutants
such as nitrogen dioxide, sulfur dioxide, carbon monoxide, and carbon dioxide.

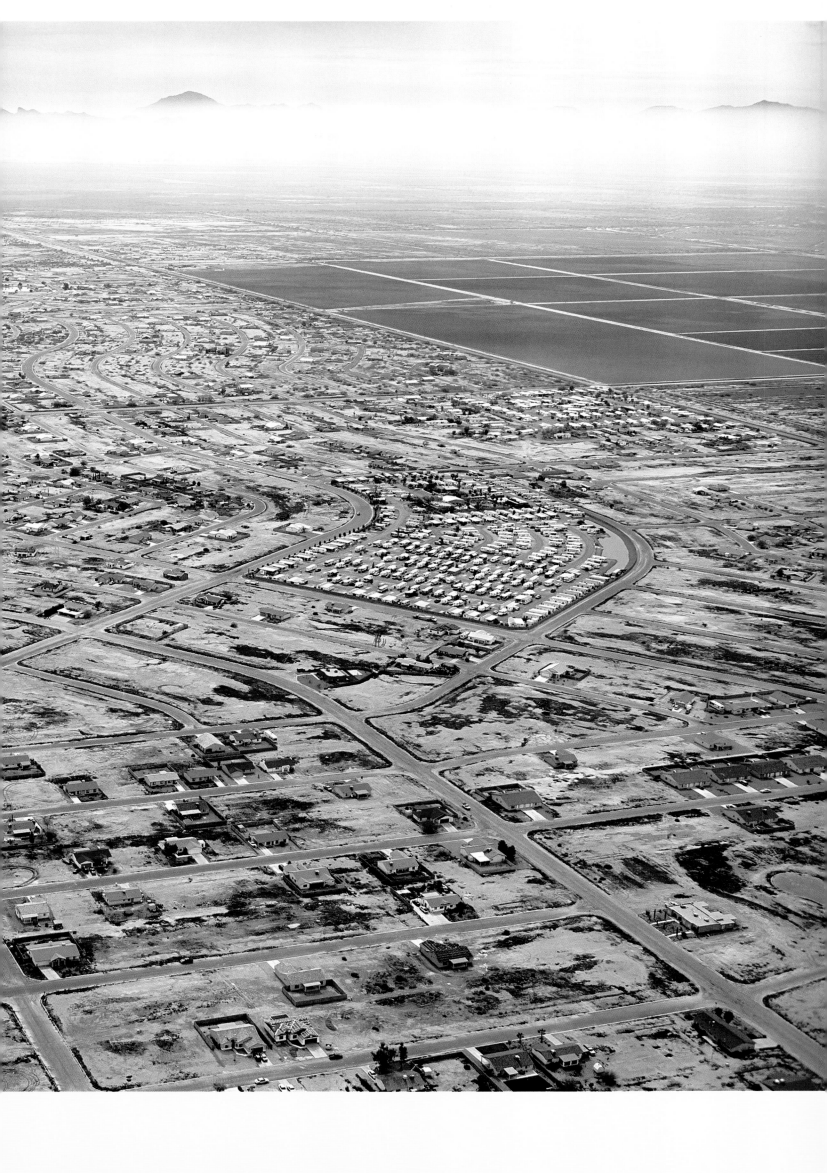

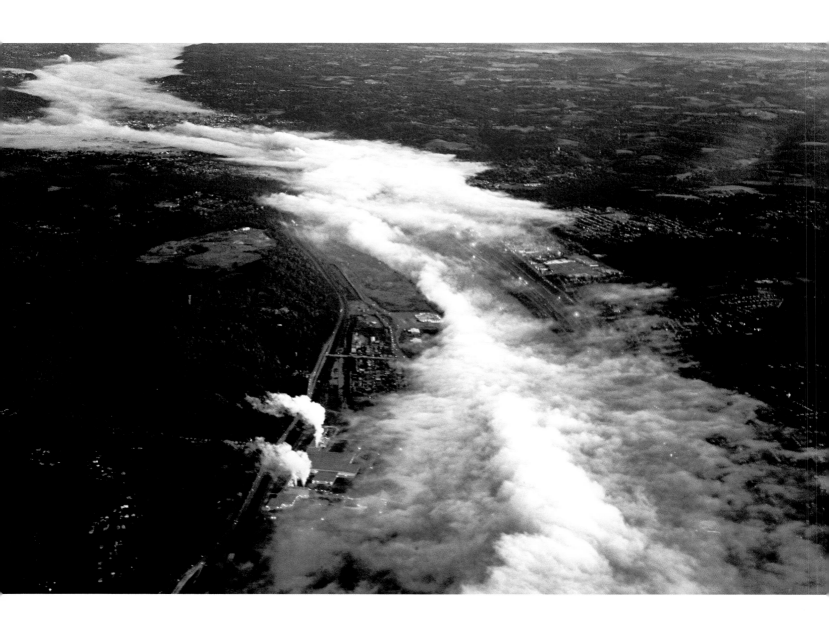

Aliquippa, PA
Twenty miles northwest of Pittsburgh, early morning fog follows the path of the Ohio River,
reflecting the link between earth and atmosphere.

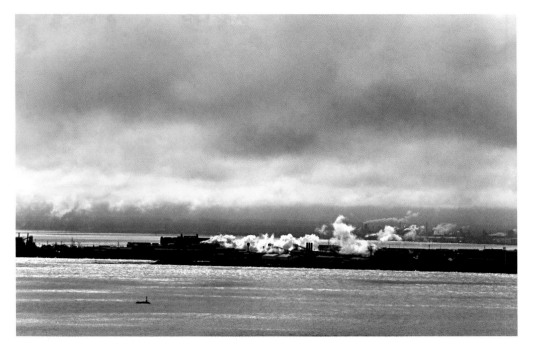

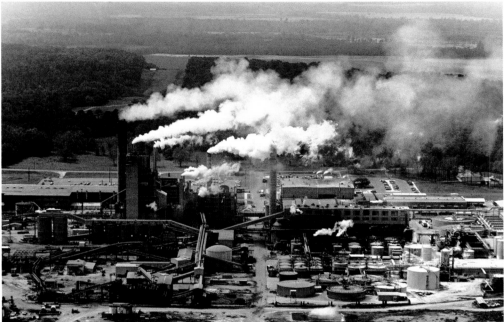

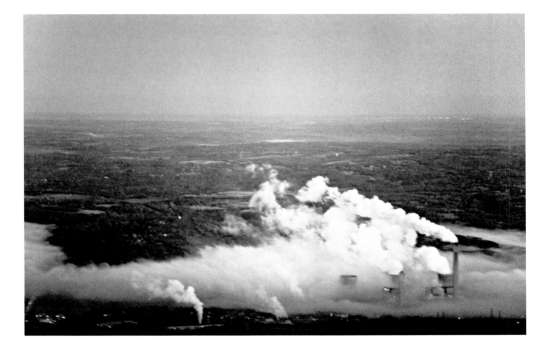

East Chicago, IN
Indiana Harbor, the largest steel producer in the country, employs blast furnaces to convert iron ore into steel. This process emits pollutants, blurring the line between the earth and sky.

Natchez, MS
Every year this Natchez paper mill releases more than 1 million pounds of toxic compounds into the air; they are then dispersed over the land through the atmosphere.

Shippingport, PA
Smoke from Beaver Valley Generating Station adds to the morning mist over the Ohio River.

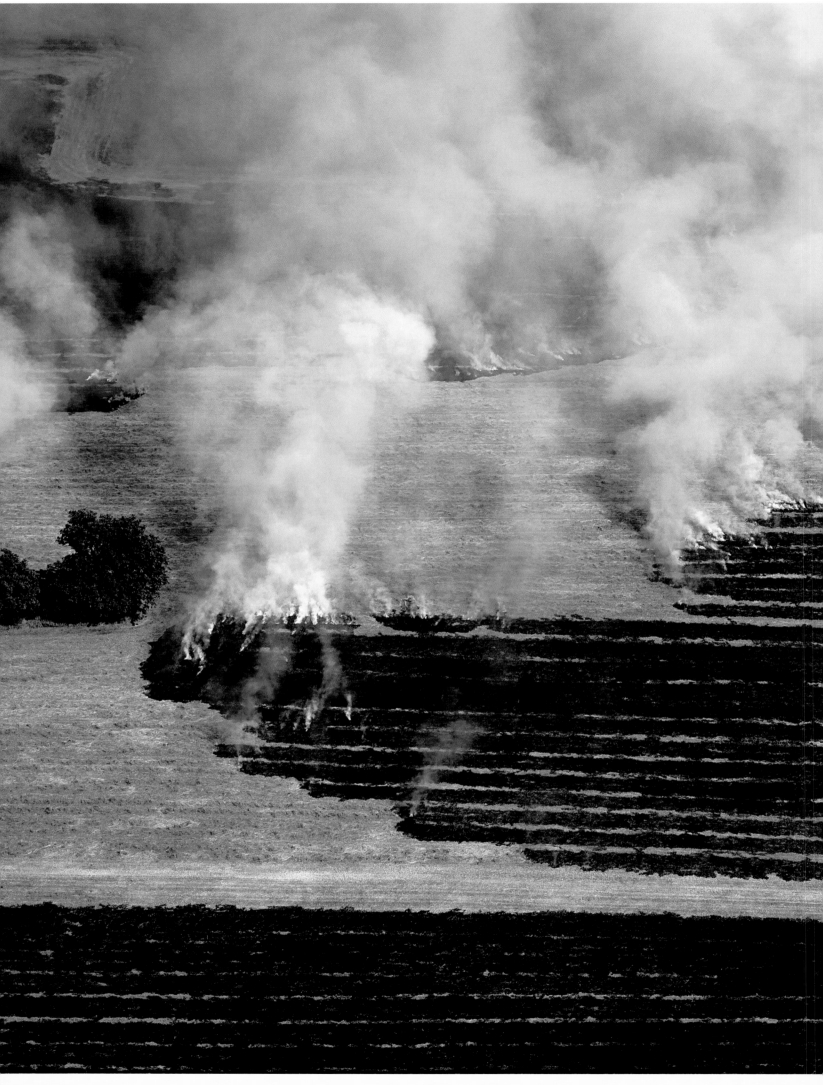

Middlebury, VT
Deliberate agricultural burning after harvest controls pests and disease but is a controversial
practice due to its impact on air quality.

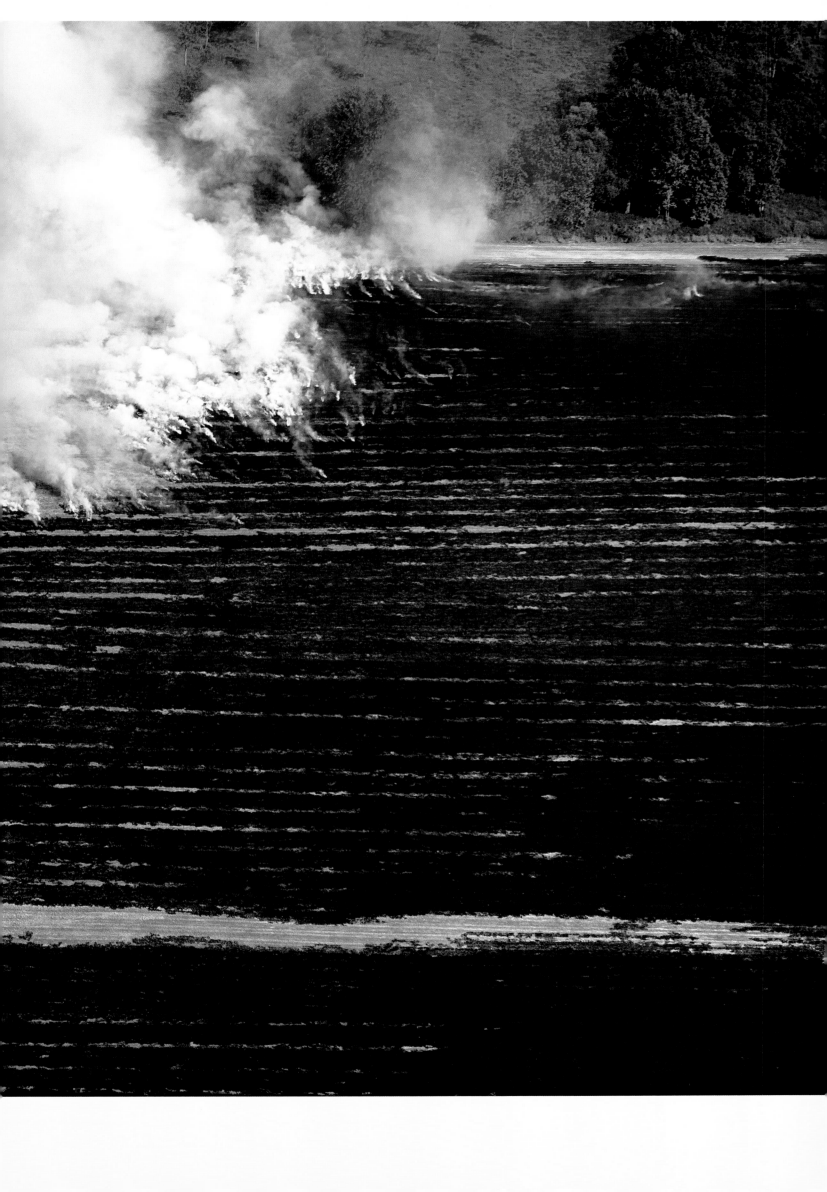

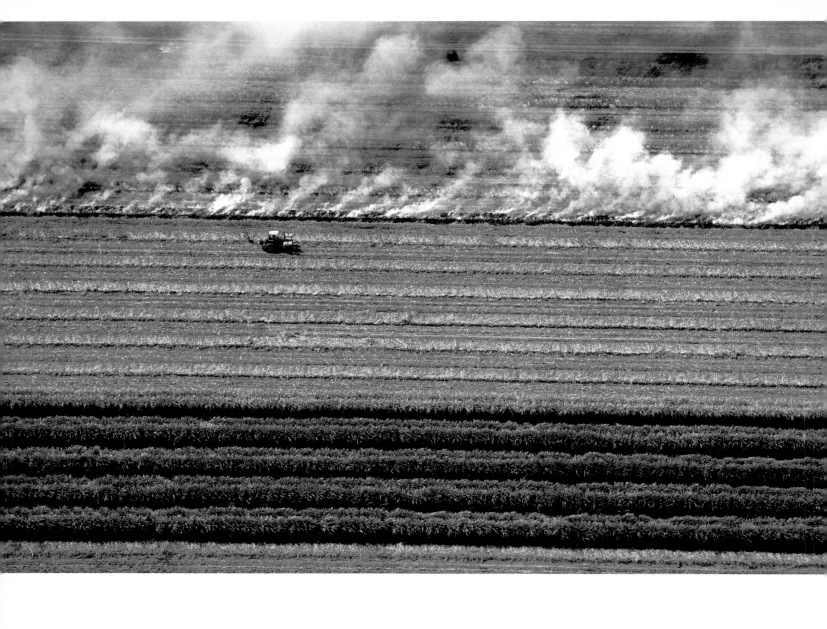

Plaquemine area, LA
Burning sugarcane reduces excess plant material before cane stalks are transported for refining.

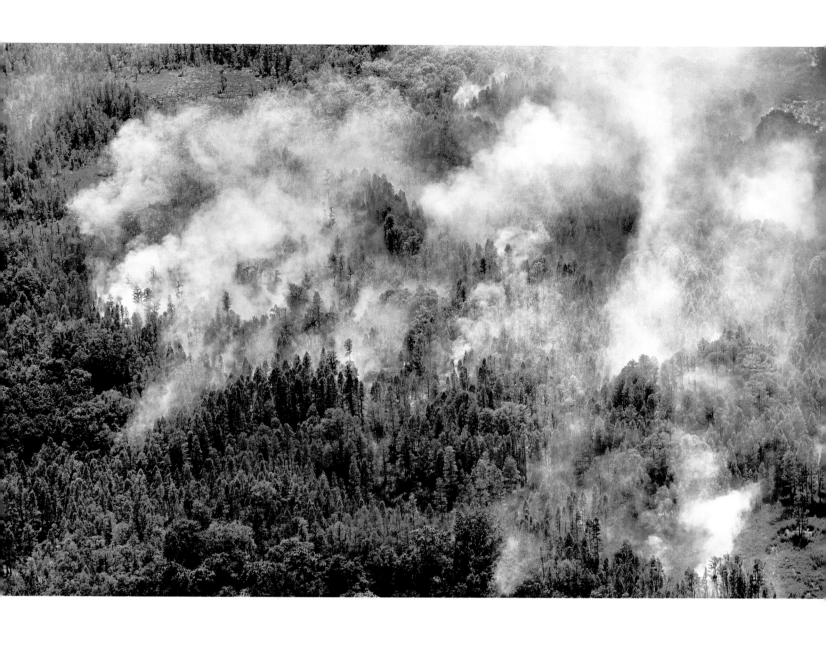

Big Cypress Swamp, Wesley Chapel, FL
Suffering from high temperatures and drought in the summer of 2007, northern Florida and Georgia
fell victim to hundreds of forest fires. As a result of higher temperatures from climate change,
forest fires will become increasingly frequent and difficult to manage.

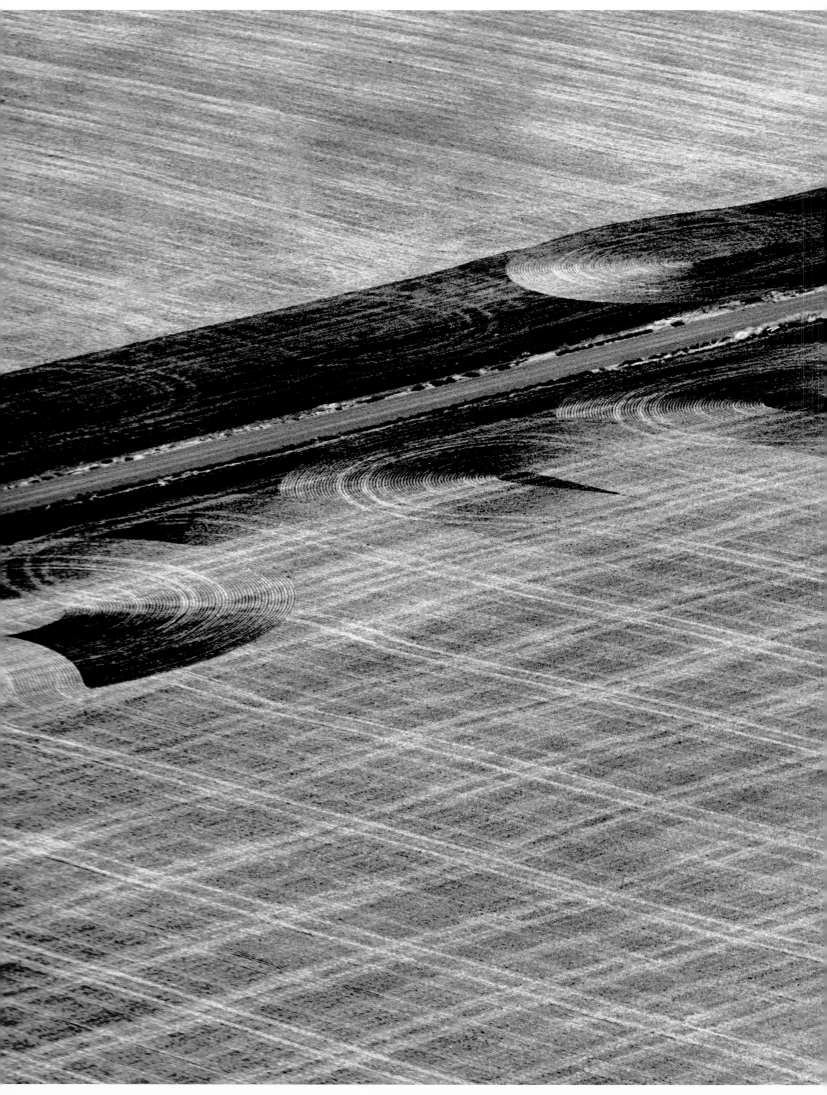

Eastern WA
A dust devil, a rotating updraft of wind, picks up soil on recently tilled agricultural land. The dust gives form to air currents that would otherwise be invisible.

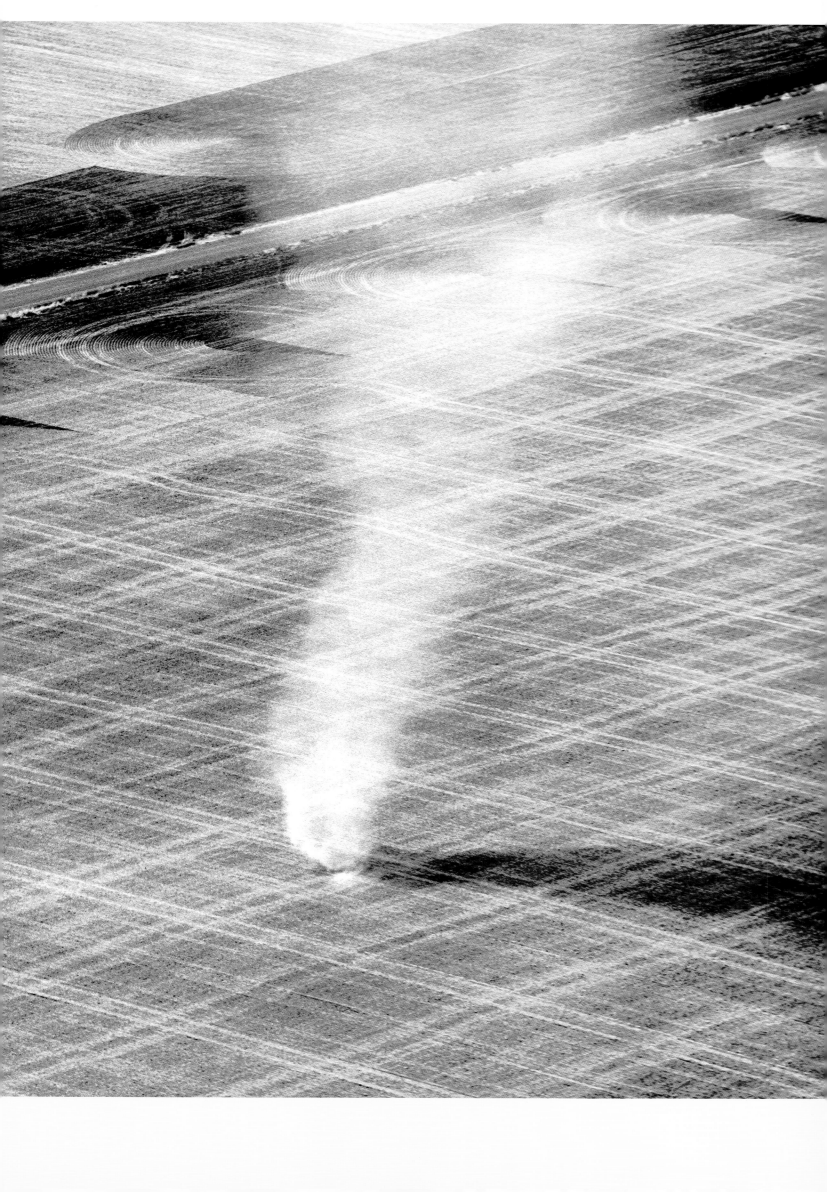

Way of Life

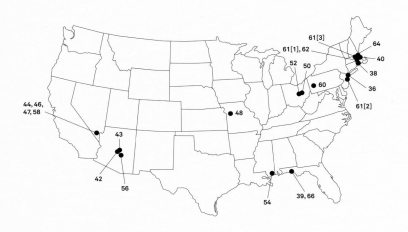

Aerial photography can be very useful for making quantitative measurements and objective observations, but I find it far more interesting to capture the more subjective aspects of our lives from the air. When shooting lifestyle images, I seek out odd occurrences in the physical landscape that serve as metaphors for shifts in societal values. These images tell important stories about our cultural standards—through perpetual development, conspicuous consumption, the flamboyant display of possessions, and the discretionary, leisure-time use of energy and resources.

These cultural symbols point to the huge economic discrepancies across our land. The uneven distribution of wealth is most readily seen in housing, which rapidly shifts from country estates to blighted urban housing projects and everything in between—suburban McMansions, bungalows, and trailer homes. Importantly, these pictures clearly indicate the direct correlation between wealth and the consumption of resources—which raises the question, should wealth grant a free ticket to fill a disproportional share of our finite atmosphere with CO_2? How do we allocate the world's atmosphere on an individual basis when it comes to the disposal of CO_2 and other heat-trapping gases? This is the same question being debated between rich and poor nations. What is a fair standard for rationing the emission of greenhouse gases—should it be determined on a per capita basis or by a country's wealth and size? From the air it is not hard to see that the poor are far greener than the rich.

Cultural landscapes are defined by how natural and built environments come together. But within the landscape, "increments," or seemingly small embellishments that add up, also assist in our understanding of the culture. From the air, the sum of the parts begins to emerge, and these increments become more meaningful. For example, residential lawns in the United States add up to an area equal to the state of Mississippi. Lawn mowers, leaf blowers, and other gas-powered lawn implements account for 5 percent of the country's air pollution. An estimated 1.5 percent of the gas they use is spilled when filling them, accounting for a total annual spill the size of the 1989 *Exxon Valdez* oil spill in Alaska. Similar statistics begin to emerge when we look at the everyday use of lighting, building materials, water resources, and transportation. Over time, seemingly negligible actions can have a tremendous impact, both positive and negative,

demonstrating how cultural increments are, in fact, anything but inconsequential.

If, as a nation, we are going to reduce our CO_2 emissions to 1990 levels by 2020, and by 80 percent below 1990 levels by 2050—as current legislation is calling for—we are going to have to make radical changes, not only to our lifestyles but to how we produce and consume commercial goods as a culture at large. While changing a culture might seem to be a very long process, there are four vehicles that speed that process up dramatically: advertising, technology, market forces, and government mandates.

The power of advertising to sway voters' opinions is the reason presidential campaigns spend hundreds of millions of dollars on TV commercials and other ad campaigns. Much of what we see on the ground is a product of advertising. The obsession with having a perfect suburban lawn, for example, is driven by advertising for lawn care products. No matter that the lawn is in the middle of the desert—it must be green and weed free. Millions of TV viewers are also told during commercial breaks that they need a special spray product to get rid of the weeds that grow in the cracks of their driveways. The success of this advertising campaign is based first on making homeowners aware that, every day, weeds are growing in their driveway, and then on convincing them that this is bad. Its success is also based on the fact that there are thousands of miles of cement and macadam driveways that can consume the contents of millions of convenient, disposable spray bottles—containing an unmentioned herbicide.

Technology is another important driver of change. We only have to look back 10 years to see the impact the Internet boom has had on society. Fundamental and previously unimaginable shifts have occurred in the ways we do business, communicate, and socialize. Many people think that new technologies being developed today in the clean and renewable arena will have an impact on society and landscape similar to that of the Internet age. In fact, we have already begun to witness this, with the rapid rollout of cell towers and wind farms.

Markets also change cultural patterns quickly. In this country there are no restrictions on consuming energy— just money and market forces. In fairness, our excessive consumption of energy and resources started long before we were even aware of the concept of a carbon footprint.

Energy markets are imperfect, as they do not account for or reflect the many hidden costs of burning fossil fuels, such as environmental damage from acid rain, rising health-care expenses due to air pollution–related illness, and the need for military protection of foreign sources of oil—not to mention the ultimate cost: climate change. Adding these external costs to the price of energy would force us to radically change our behaviors and, subsequently, the appearance of our cultural landscape.

Ultimately, we have to look to our government to promote and provide incentives or mandates for change in consumption. To date, the federal government has done little to promote shifts in consumption. Certain U.S. states individually have been more aggressive in adopting identifiable targets for change. More than 25 states have now voluntarily instituted, enforced, or enacted renewable portfolio standards, setting targets for renewable energy use. In addition, states such as California are leading the way with regulations such as "zero-emission" auto requirements, intended to protect and restore air, water, and land resources.

One of the greatest obstacles we face in changing our energy-consumptive culture is that we are individually invested and entrenched in the lifestyles we've become accustomed to. Going forward it will be difficult to shed energy-consuming possessions such as our second homes, powerboats, and oversize cars. It will also be a challenge to give up our discretionary use of energy. I personally find it hard to tell my daughter that she and her friends should not go waterskiing, something I used to do as a kid. For that matter, am I really supposed to give up flying around in a plane? Incremental changes effected through advertising, technology, markets, and government mandates are the real key to rapidly changing our way of life.

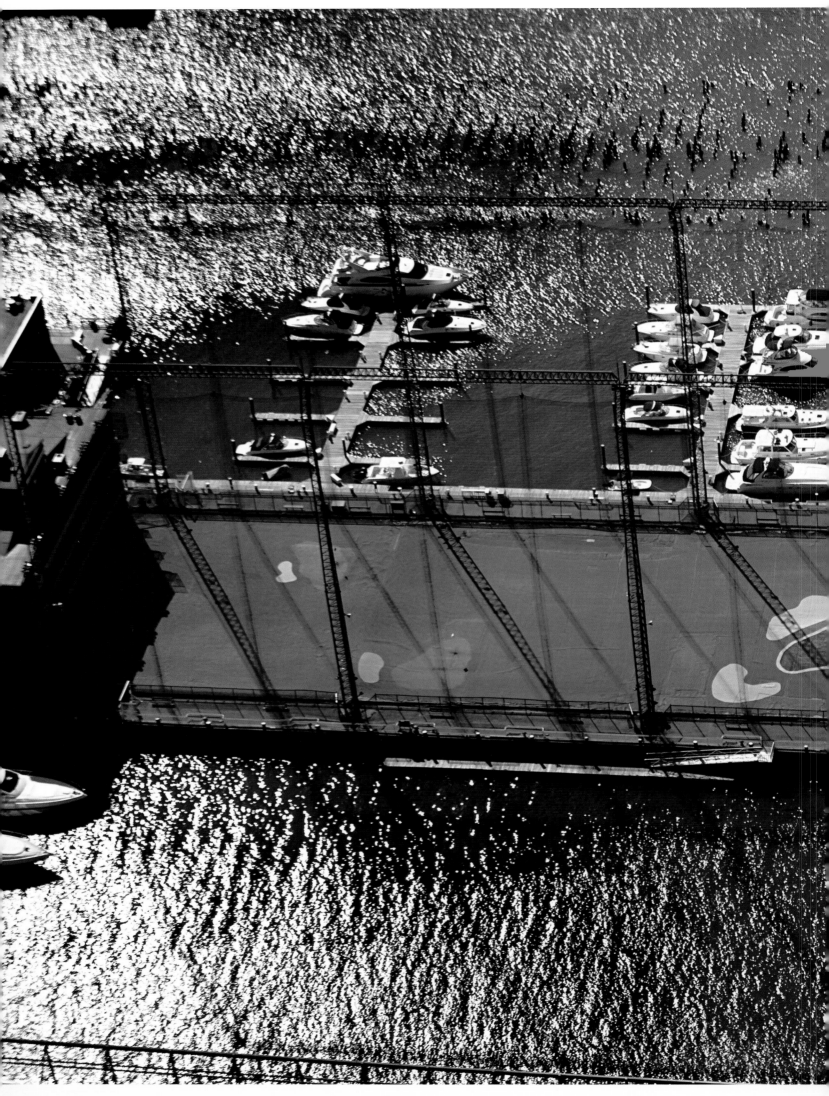

New York, NY
City golfers at the Chelsea Piers drive balls out onto the caged pier on the Hudson River. Once a
docking point for luxury ship liners in the early 20th century, the piers have been revitalized as
a center for leisure with spas, sports facilities, and maritime centers.

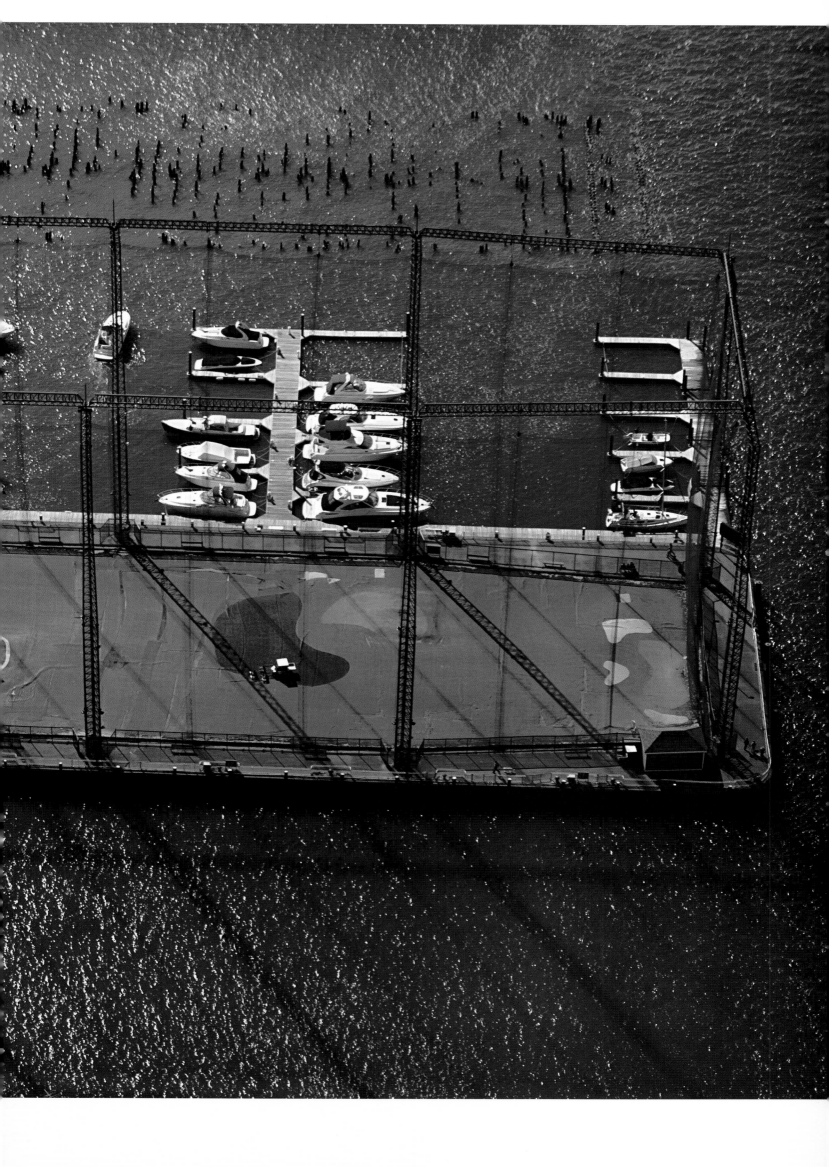

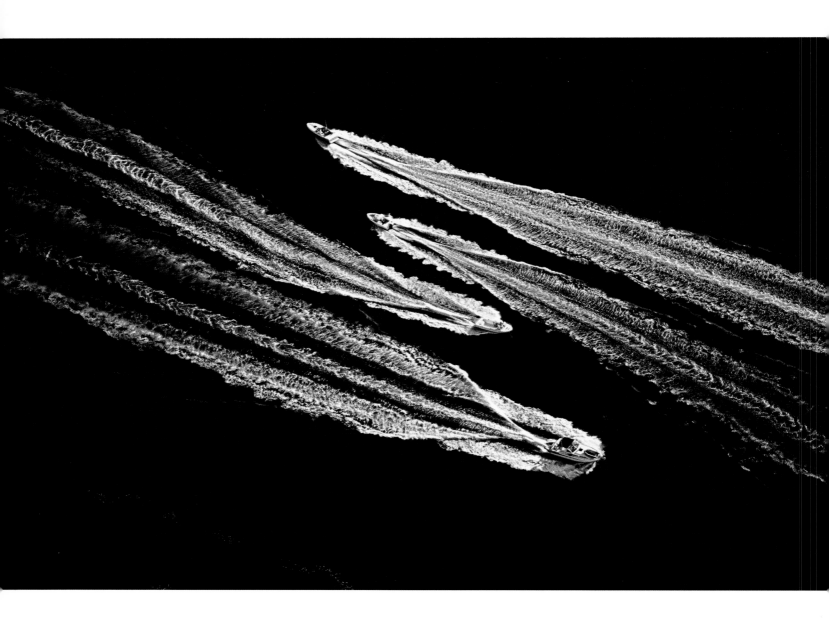

Narragansett Bay, RI
Powerboats pass each other in close formation at high speeds. In the United States, 10 million
boat engines, which historically have been high hydrocarbon and nitrous-oxide emitters, are
in operation.

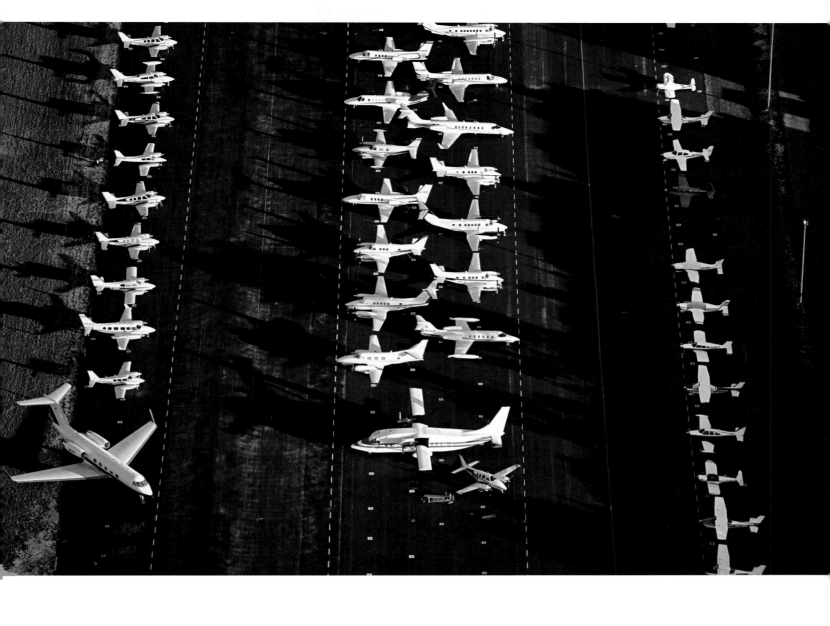

Destin, FL
America has a highly active fleet of private aircraft. As of 2006, there were more than 226,000 general aviation aircraft in operation in the country. These small private planes (piston and jet engines) consume 1.3 billion gallons of fuel per year.

Boston, MA
A sprinkler waters Astroturf, surrounded by grass, at Jordan Field. Watering the artificial turf lends
it a more controllable surface for field hockey matches. A fine mist evaporates from this large
sprinkler before it even reaches the ground, representing wasted water.

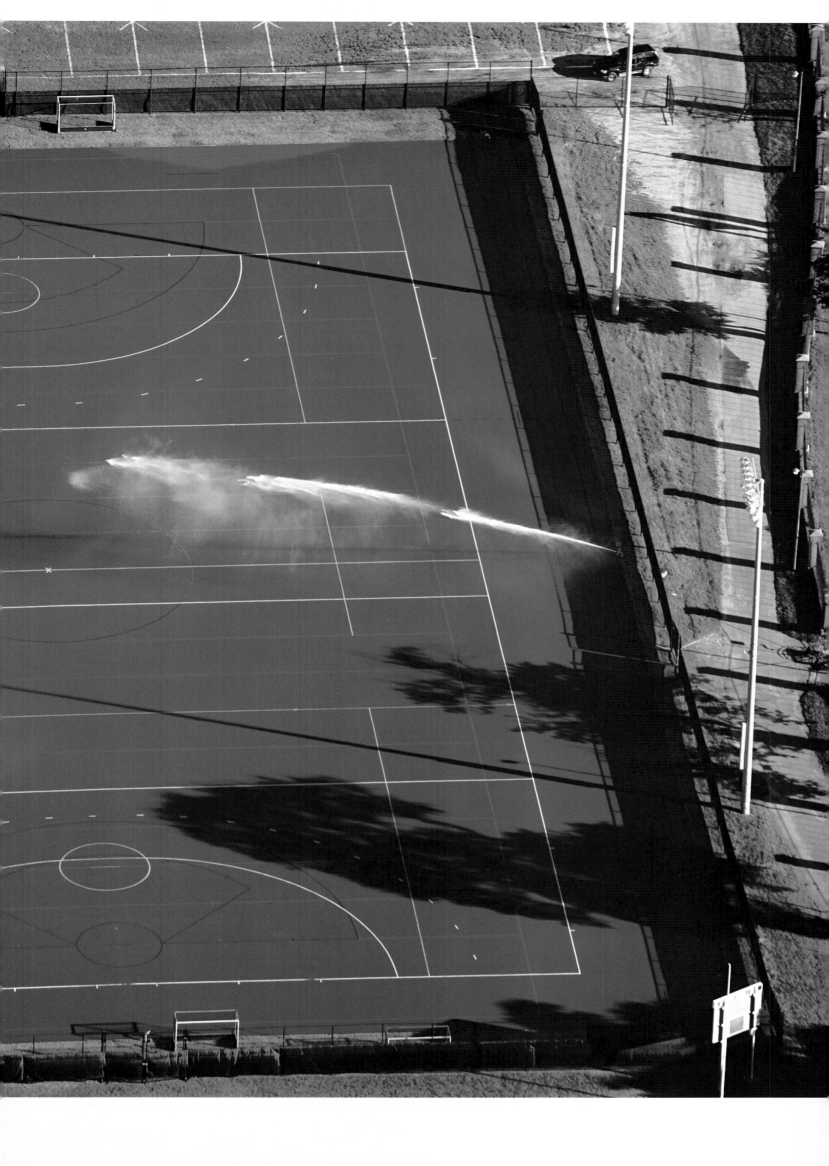

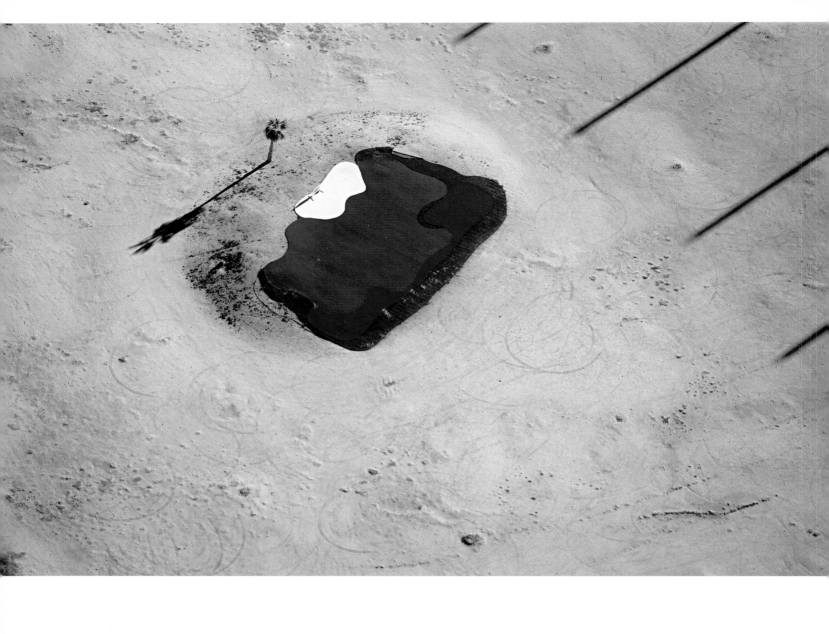

Scottsdale, AZ
In the middle of a desert landscape sits an isolated patch of an artificial golf course with a
simulated pond and sand trap. Artificial surfaces are used to save water and cut irrigation costs.

Anthem, AZ
A park is built in the middle of a new desert community to offer sanctuary from the dry climate.

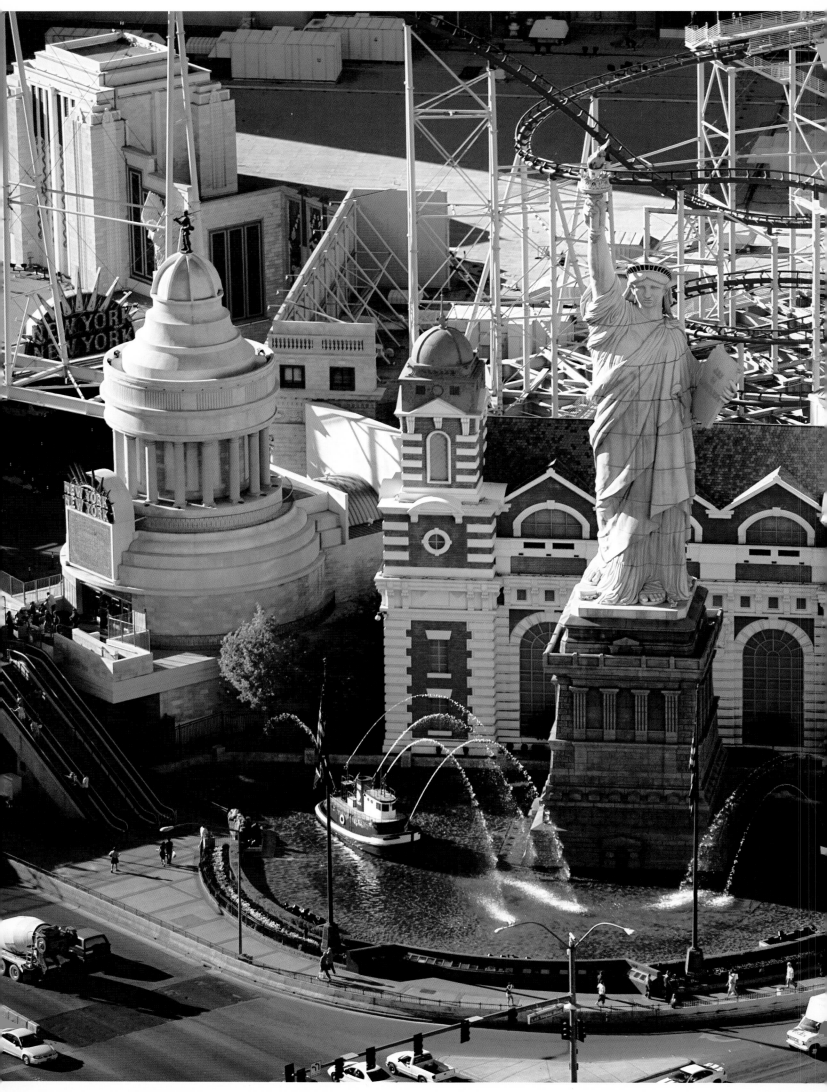

Las Vegas, NV
Visitors to Las Vegas can travel the world in several city blocks. Casinos with Parisian, Venetian, Egyptian, and (pictured) New York themes present an international facade. Scaffolding supports the faux New York buildings (top left) and the small pool (front) is meant to be New York Harbor. A roller coaster formerly known as the Manhattan Express (rear), climbs to heights of 144 feet.

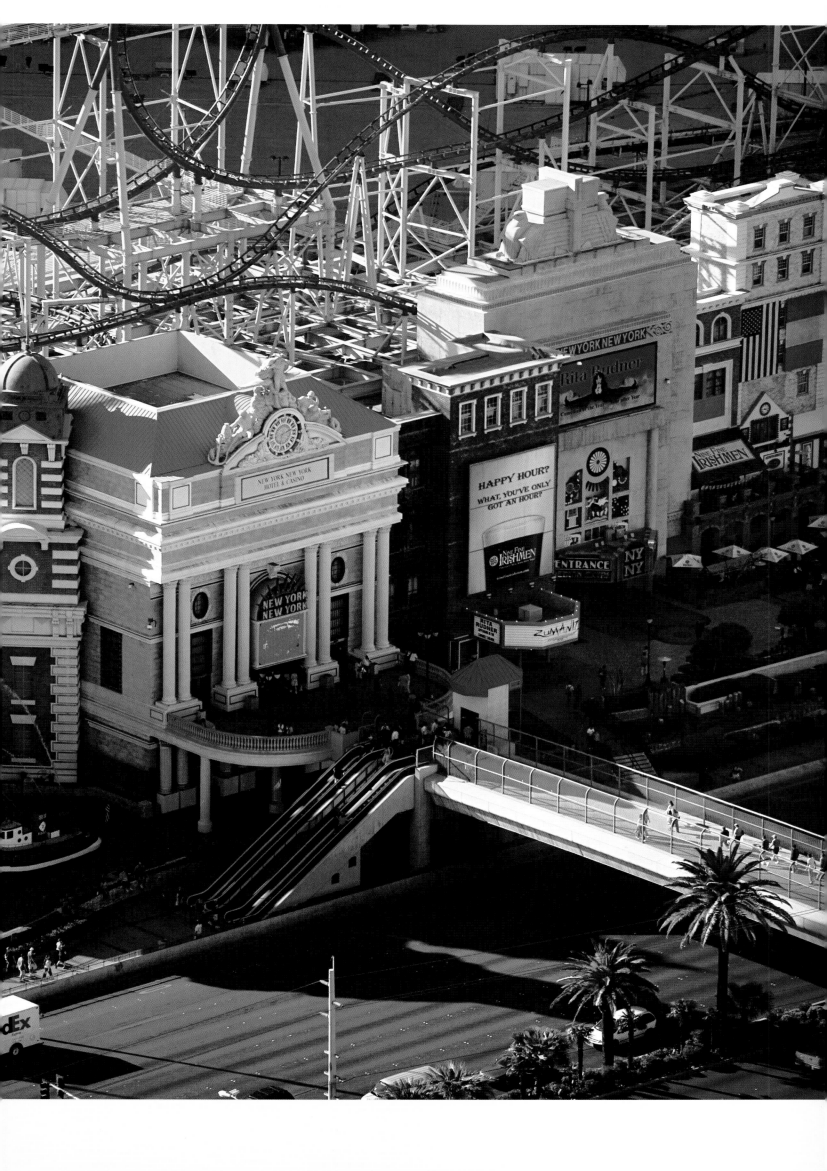

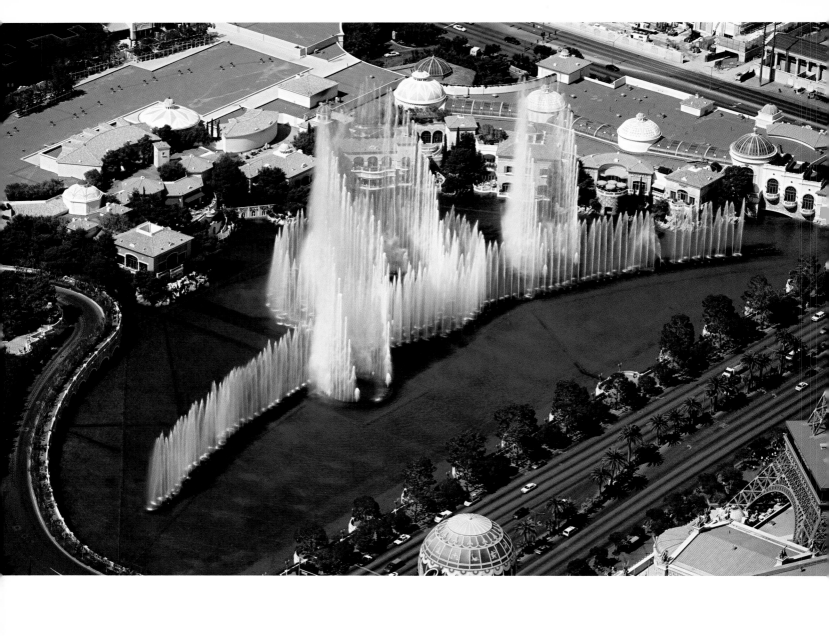

Las Vegas, NV
The 8-acre fountain at the Bellagio Hotel and Casino uses more than 1,200 nozzles to keep roughly 17,000 gallons of water in the air; some of these nozzles can shoot water vertically up to 250 feet. The project's estimated cost totaled over $40 million and it consumes roughly one third of the water that was used to irrigate the golf course that once covered the site.

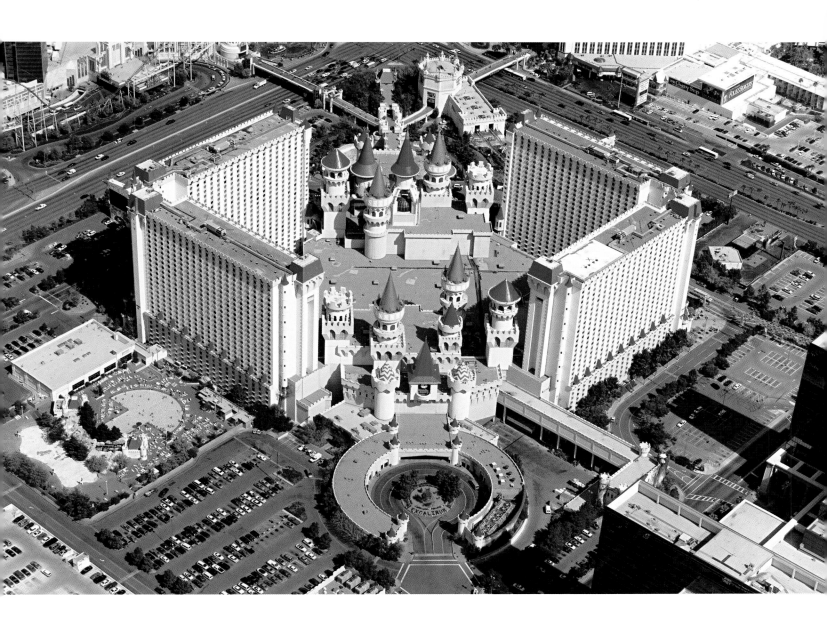

Las Vegas, NV
In an effort to attract more families to Sin City, Circus Circus Enterprises built the Excalibur Hotel and Casino. A medieval-themed hotel, its many attractions for children include a video arcade, a motion simulator, and a large family swimming pool. To date, it is the world's largest resort hotel, with 4,032 rooms.

Kansas City, MO
Roller coasters and amusement parks offer a momentary escape from everyday life.

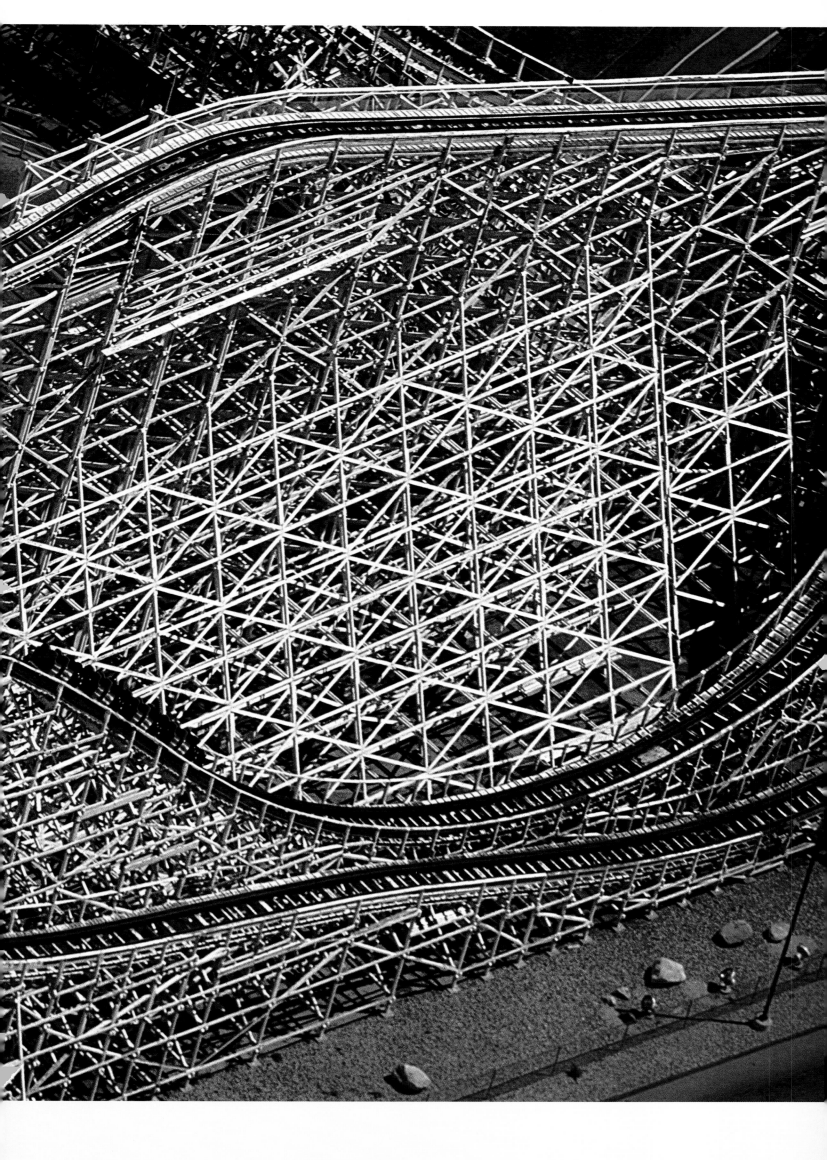

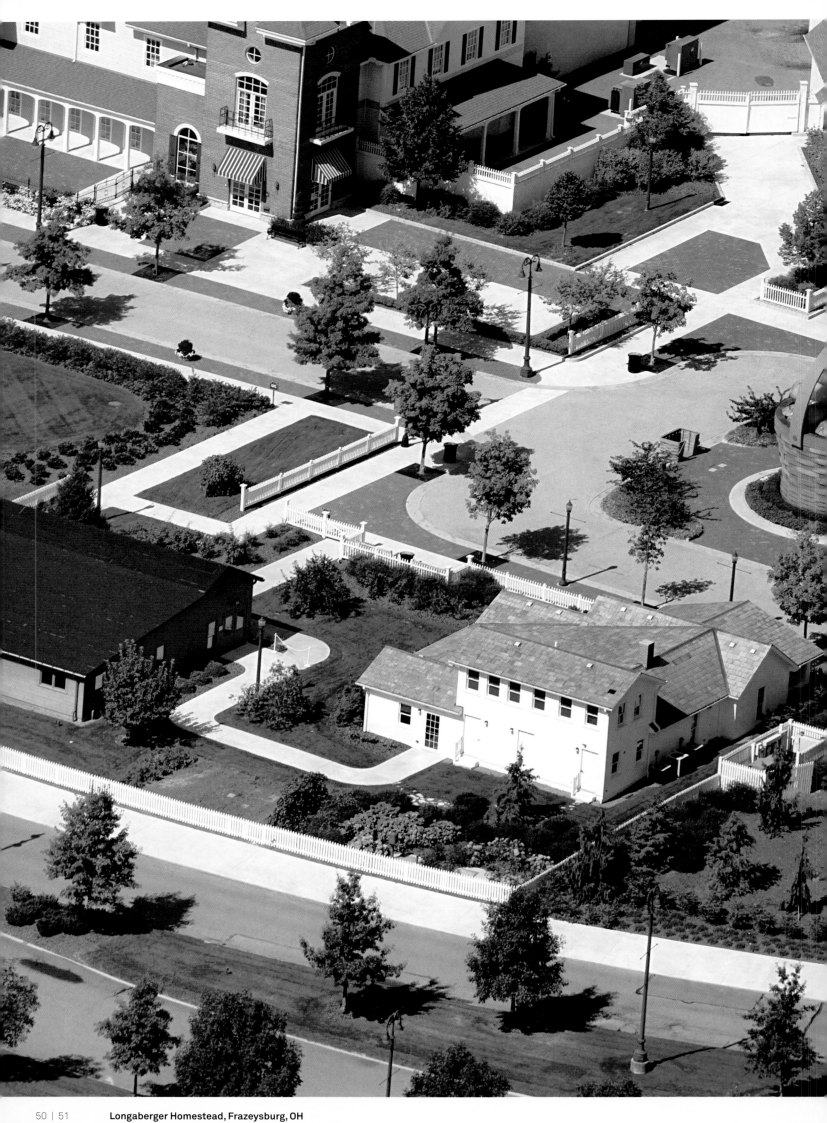

Longaberger Homestead, Frazeysburg, OH
Companies are sometimes able to cash in on the particular way they produce their goods,
marketing this as entertainment for visitors. Here, the Longaberger Homestead's mode of basket
production is tied to old, small-town America, and to family.

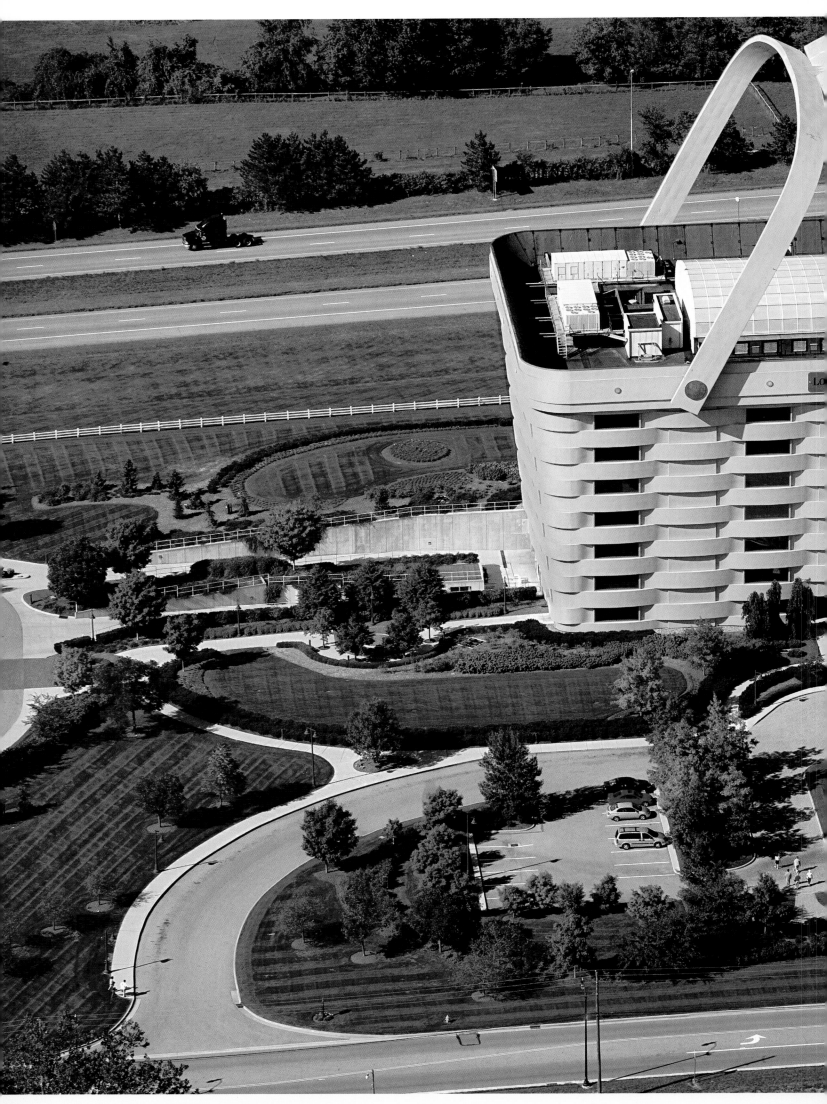

Longaberger Headquarters, Newark, OH
Using novelty architecture, the Longaberger Basket Company has created a spectacle out of their
headquarters, not only advertising their company but also creating a tourist attraction.

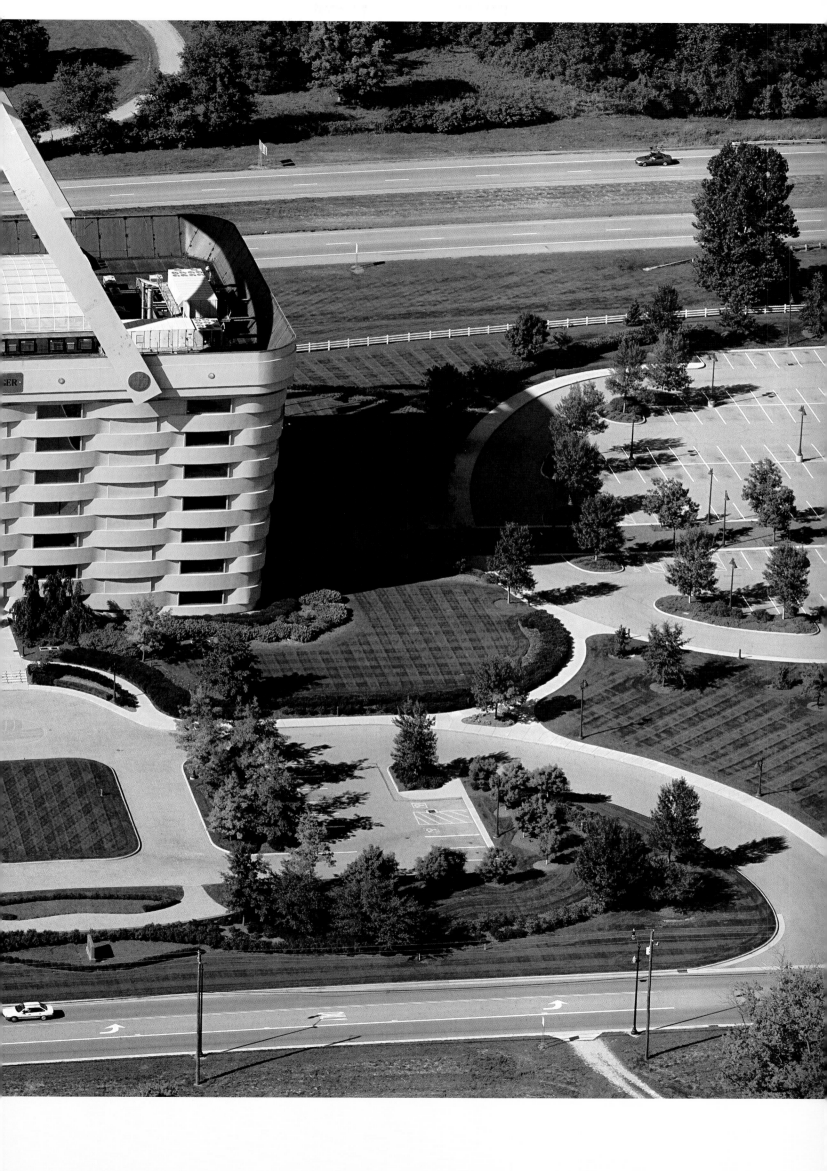

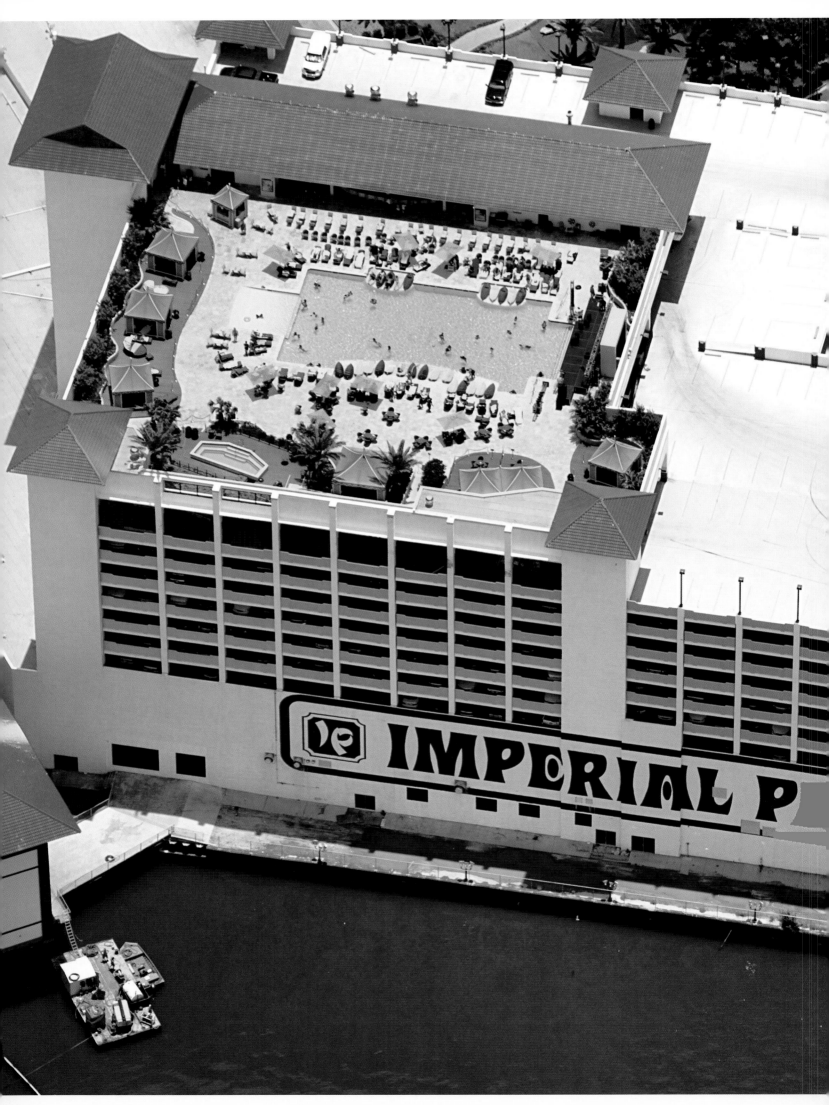

Biloxi, MS
Completely rebuilt after Hurricane Katrina, the Imperial Palace all-in-one casino, resort, and spa
features a parking garage complete with a swimming pool oasis and guest arrival information.

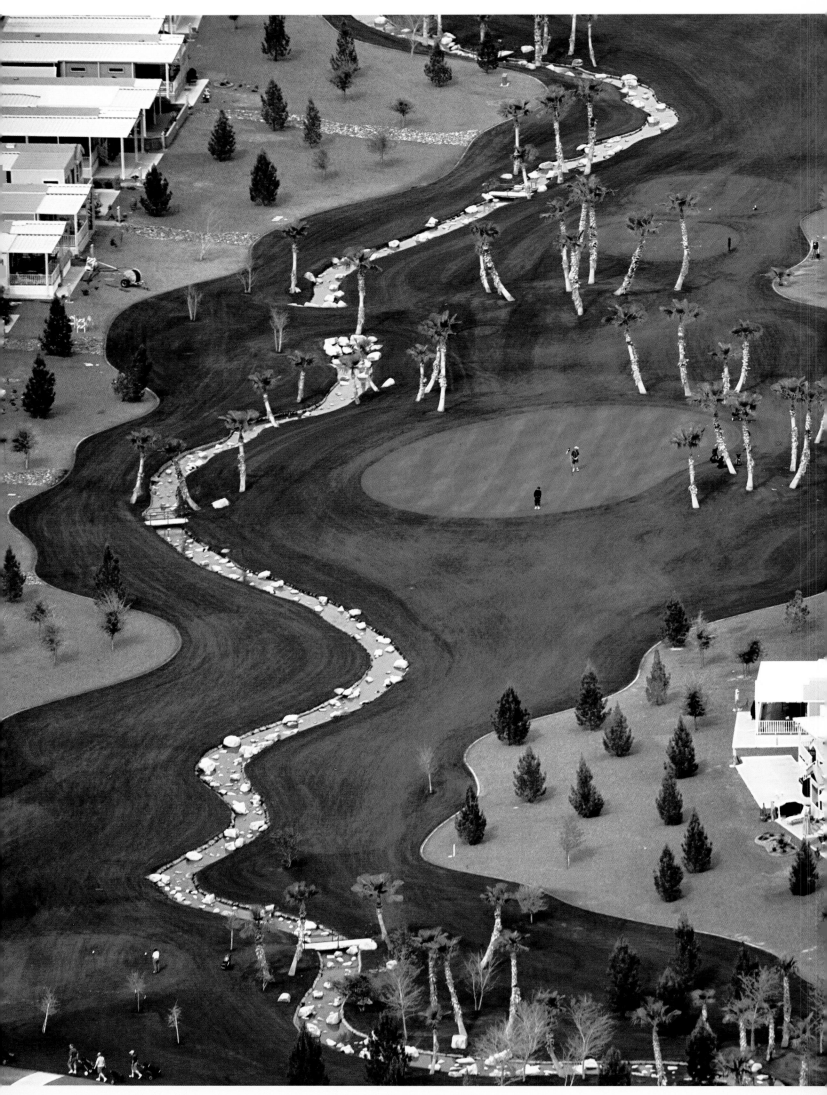

Casa Grande, AZ
Manufactured housing, irrigated golf courses, and palm trees create the illusion of paradise at the
Palm Creek Golf and RV Resort, which doubles as a retirement community and RV park. Using
desert land is inexpensive in the short term but costly in the long term because of the energy and
resources required to maintain the facade.

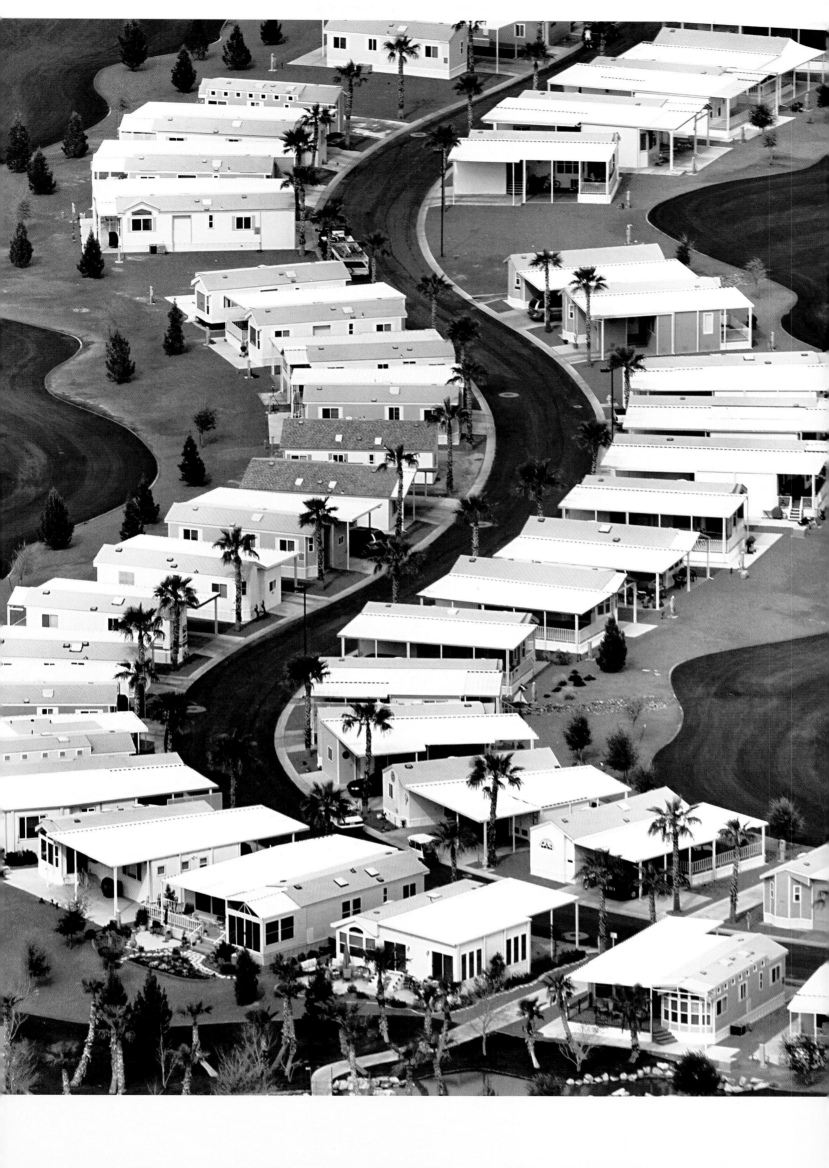

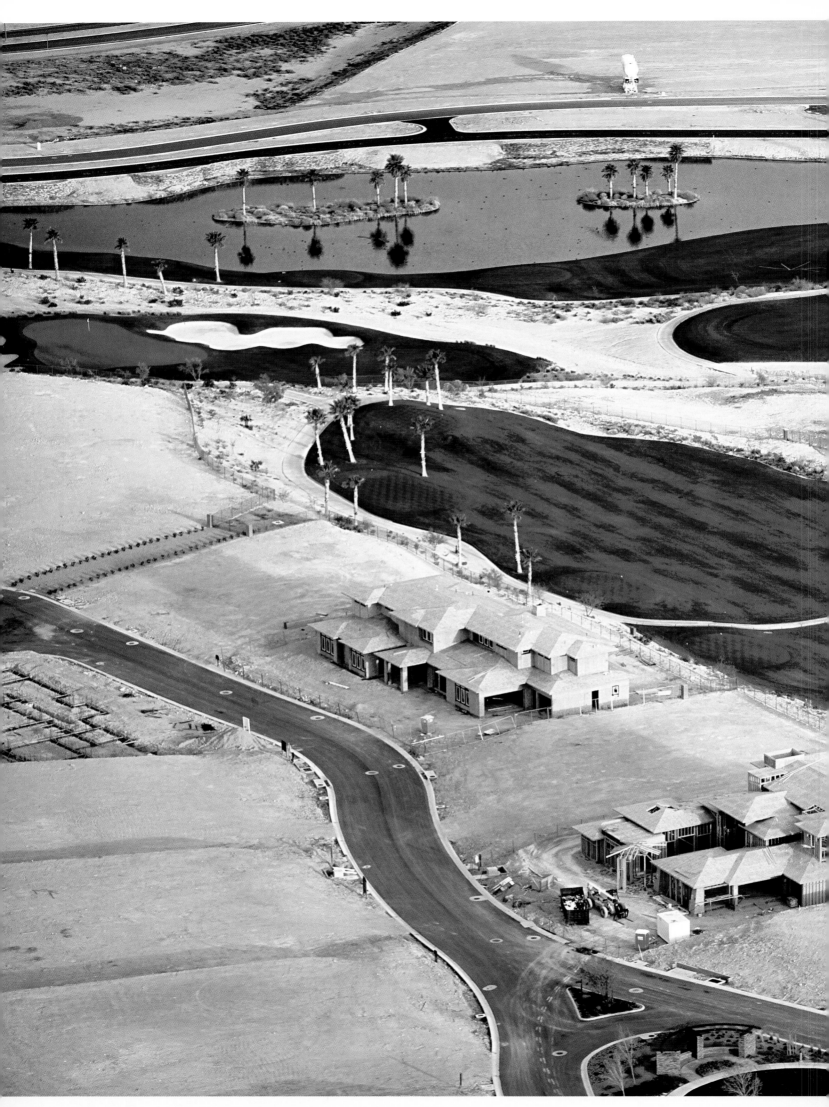

Las Vegas, NV
Though drought conditions are the norm in the Las Vegas area, golf courses and large-scale luxury housing developments continue to be built onto the arid landscape. This community in western Las Vegas gets most of its water from nearby Lake Mead, whose water levels have sunk to below half of their original volume.

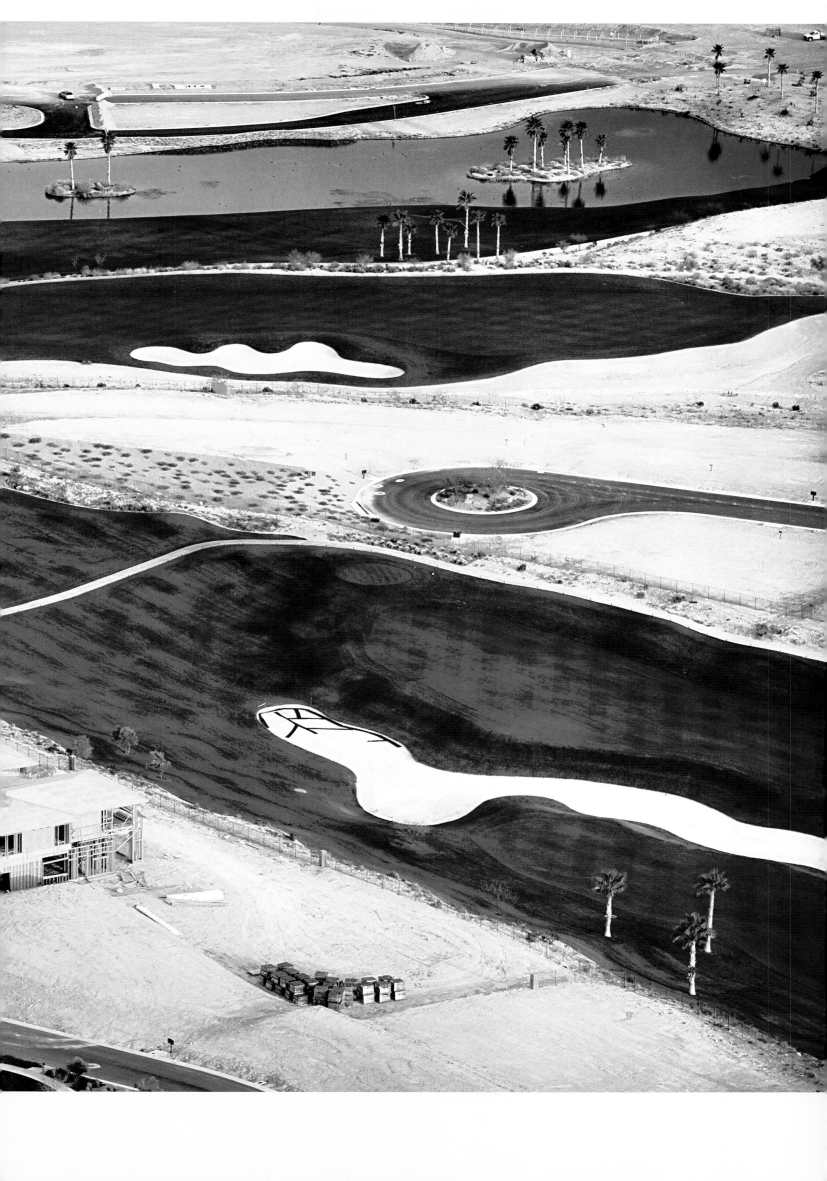

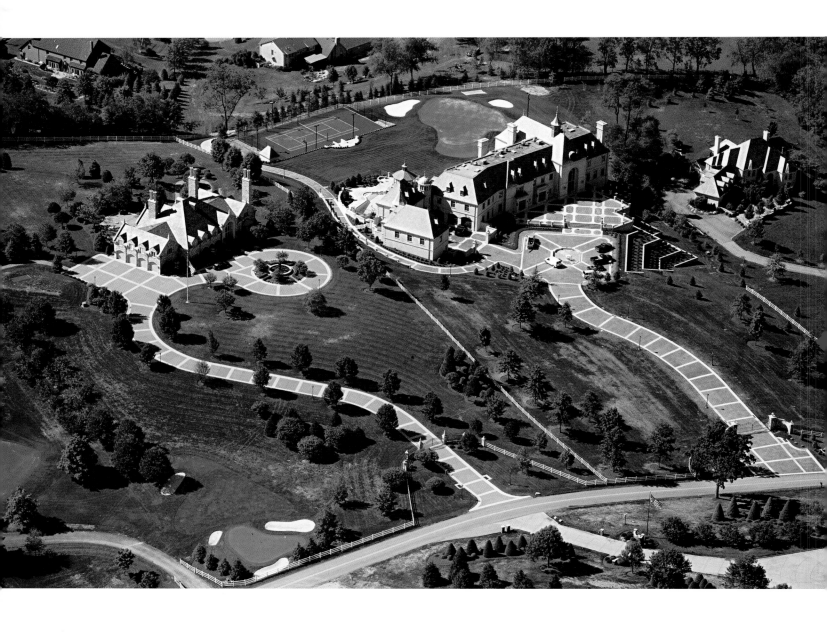

Pittsburgh, PA
Several mansions make their home in the western suburbs of Pittsburgh.

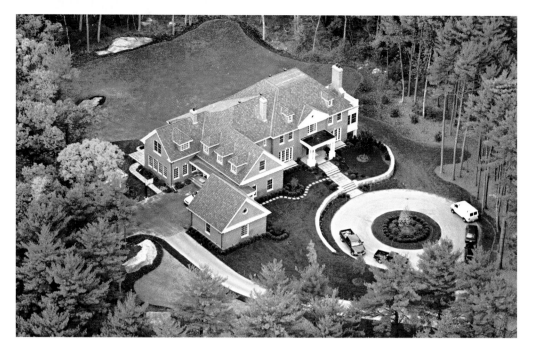

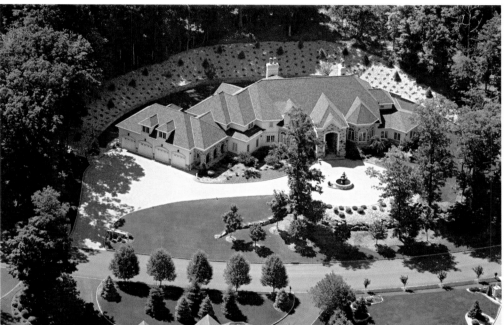

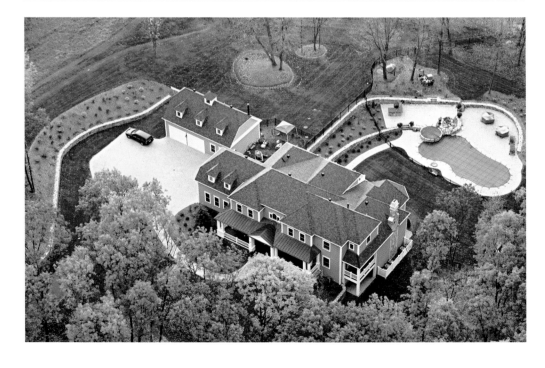

Hopkinton, MA
The cars lining this mansion's private driveway belong to workers putting the finishing touches on this home, which is being built on real estate speculation.

New Brunswick area, NJ
A contemporary mansion with a four-car garage is part of a larger development with similar homes.

Hudson, MA
A three-story single-family home requires large amounts of energy relative to its occupants. Lawn and pool maintenance add to the home's energy consumption.

Hopkinton, MA
This large single-family home, hidden in a densely forested area, was built on real estate speculation for an upscale market.

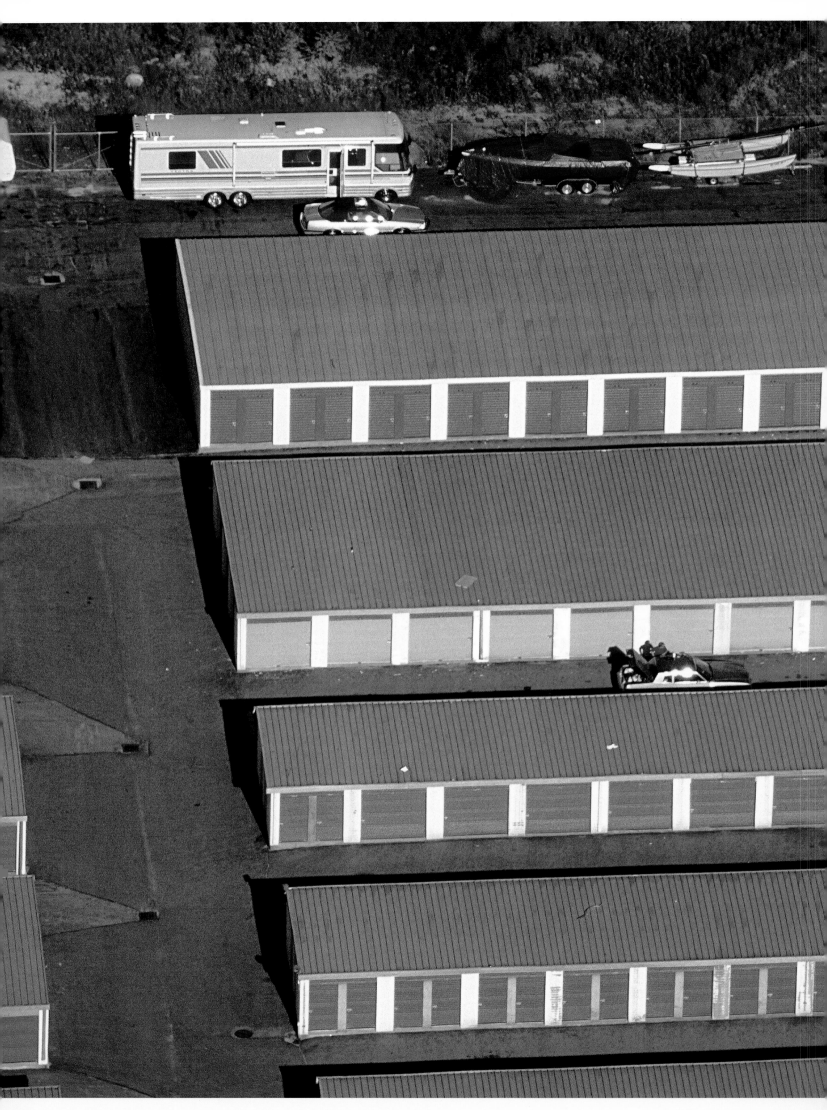

Dracut, MA
Self-storage facilities are small warehouses for individuals and small businesses. A result of overconsumption and overaccumulation, they take up more than 2.2 billion square feet in the United States and Canada. This facility was developed as a "placeholder," a way to generate extra revenue from the land in anticipation of growing real estate values.

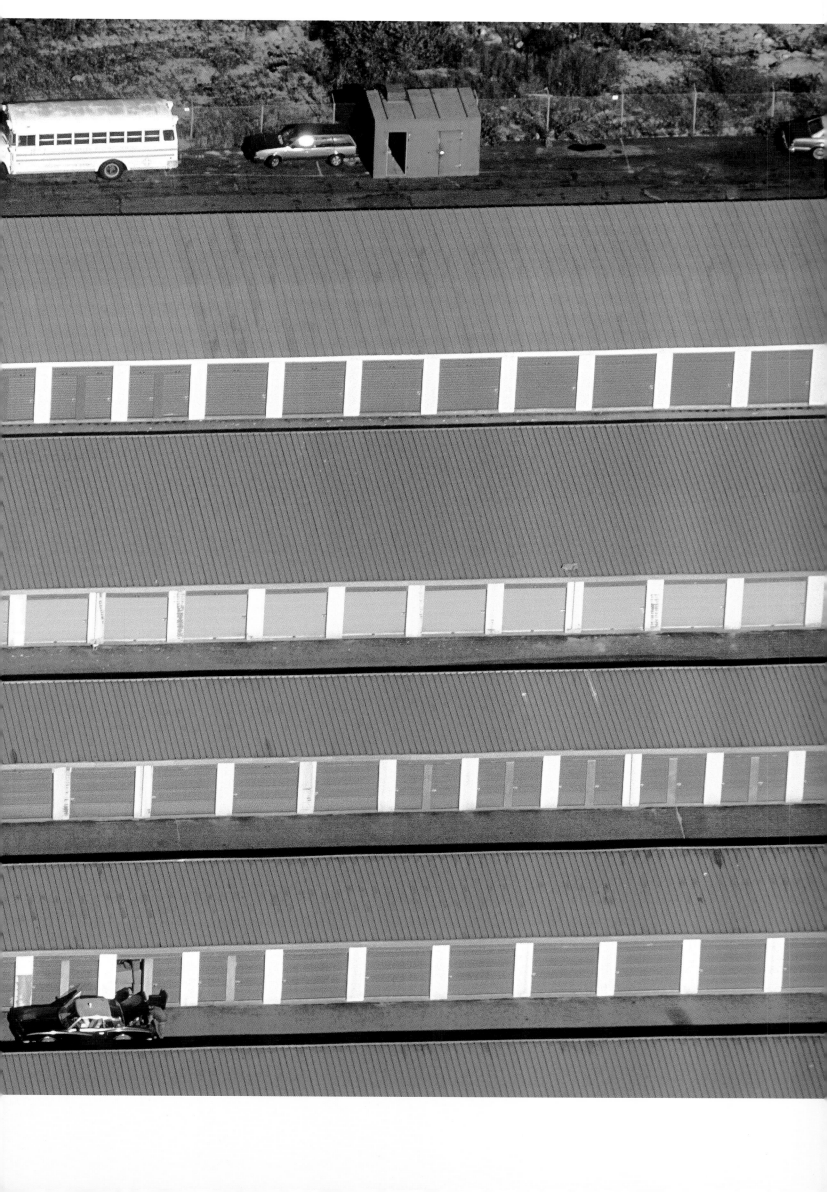

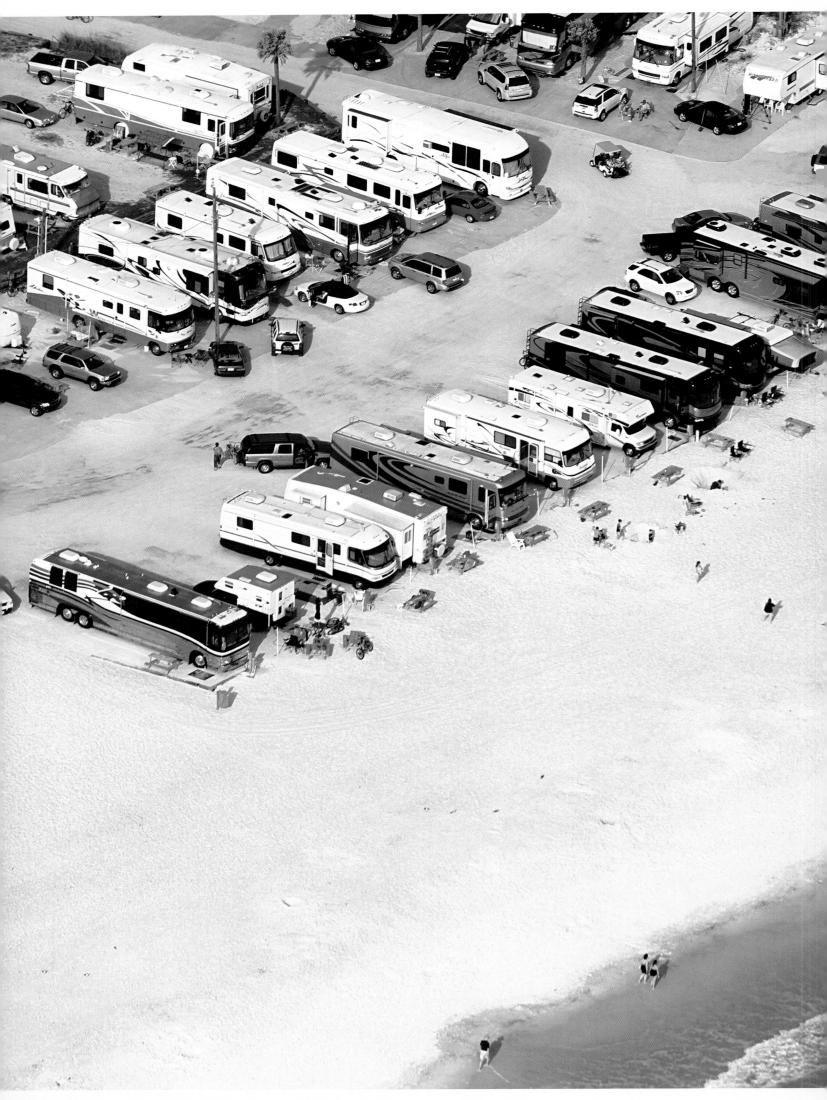

Destin, FL
Recreational vehicles, better known as RVs, sit parked along this Florida beach. In 2007, nearly 8 million U.S. households owned at least one RV. Typically the fuel economy of RVs is less than 10 miles per gallon.

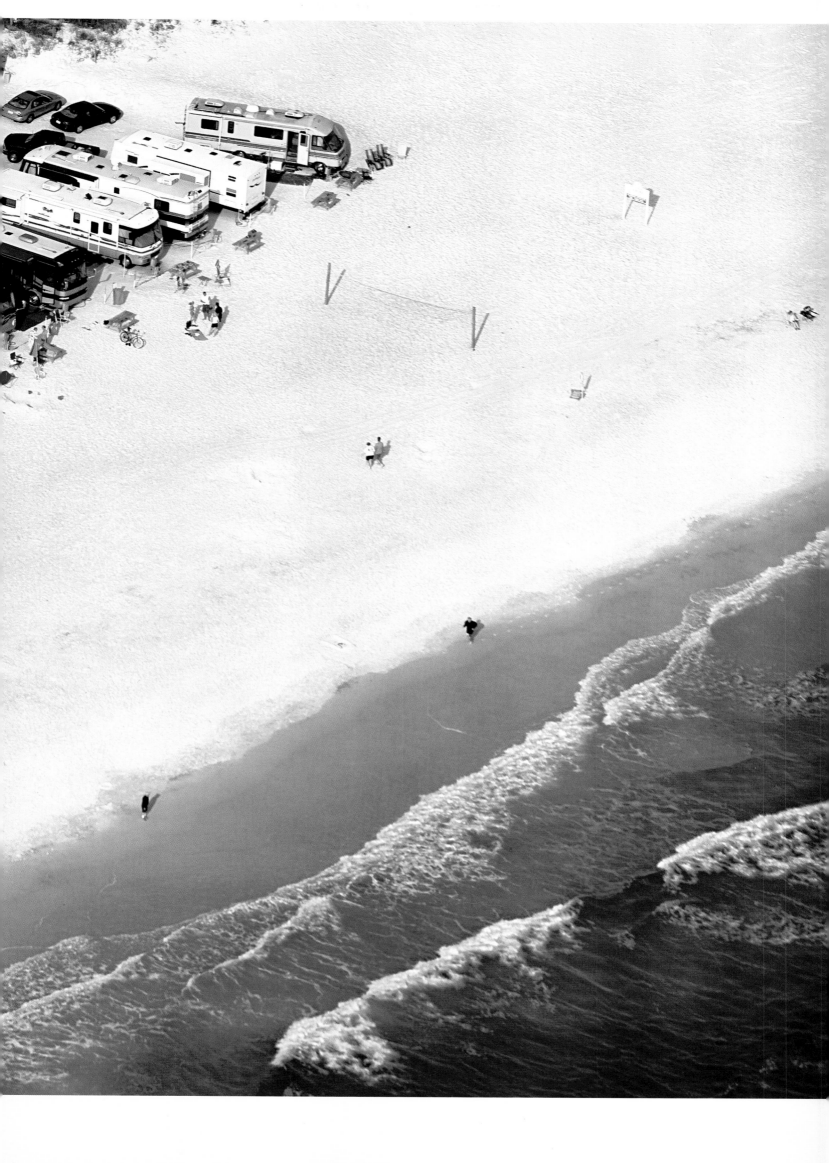

Automobile Dependency

As I fly over this vast country, one technique that allows me to see and comprehend the built environment is to break the landscape into two elements: "pathways" and "containments." This helps me compose and organize photographs within the viewfinder. Containments are the places where objects are held in place, such as buildings, parking lots, and reservoirs. Pathways are the visible trails by which objects are moved to and from containments, such as roads, canals, pipelines, rail lines, and power lines. Pathways linked to containments make up networks of infrastructure. I have been flying for nearly 35 years, and every flight holds surprises and new perspectives. One constant, however, is the continual expansion of the U.S. roadways. Our society is built on the concept of automobility, and our dependency on automobiles increases incessantly.

It is amazing how quickly and pervasively the automotive network came to define and dominate the American landscape. All built in less than 100 years, our public roadways now constitute more than 4 million miles, supported by nearly 2 million miles of oil and natural gas pipelines. It is a network composed of steel, concrete, and macadam. Americans represent roughly 5 percent of the world's population yet drive almost a third of the world's cars.

The network of roads and highways marks how land is organized and utilized. It defines hierarchies of space and the framework for development. Roads are the harbinger of growth. A new highway corridor bisecting agricultural lands on the edge of a metropolitan area signals the imminent transition to sprawling housing and commercial, retail, and industrial development. In turn, more roads will likely be built to serve the area's new residents.

This is a pattern of sprawl—automobile-dependent, low-density, single-use development—that has defined post–World War II growth around urban areas. It is a development pattern incompatible with public transportation, and as a result it discriminates against those who cannot drive: children, the elderly, and anyone who cannot afford a car.

Rush hour in metropolitan areas of sprawl tends to concentrate traffic from cul-de-sac and enclave communities onto arterial roads that clog during peak commuting times. The arterial roads move traffic up the

hierarchy to interstate highways that also tend to clog. Rush hour congestion arises for a number of reasons. First, there is simply not enough capacity. Interestingly, increasing the number of roadways doesn't lead to less traffic over time but actually tends to promote the opposite. Recent studies show that building or widening highways invites more traffic, a phenomenon called induced traffic. Shortly after a new lane or road is opened, public transit riders switch to commuting by car. Other motorists decide to take longer or more frequent trips, or they switch routes to take advantage of the new capacity. In addition, as the new or expanded roadway stimulates more development away from core cities and suburbs, motorists travel farther for their work and shopping centers. Often, induced traffic eats up 50 to 100 percent of a roadway's new capacity. After a few years, the "new" roadway has reached full capacity and created extra traffic on the local streets at both ends of the trip.

Second, rush hour congestion occurs because these once-new highways and roadways begin aging. The infrastructure is in constant need of repair; lane closures from construction projects, or road hazards as simple as potholes, often cause enough stricture to bring rush hour traffic to a crawl.

Third, roads are more congested than ever because people are traveling farther. The farther we travel, the more time we spend on the roads creating traffic. We can literally see the cause of these extended travel times by looking at low-density housing patterns and single-use developments, which require a separate trip to complete each daily task. In recent years we have seen more and more exurban housing developments built on cheap land, miles from any built commercial area. In exchange for the cheap land, the occupants of these remote developments spend more money on energy for longer car trips. These exurban developments also burden governments with the greater energy costs that come with providing public services like mail delivery and school busing over greater distances.

Fourth, there is often congestion at rush hour owing to the simple and sad fact that driving is inherently unsafe. Traffic frequently slams to a halt as a result of traffic accidents. Speaking casually over light background music, a radio reporter may report traffic slowdowns arising from fender benders, rubbernecking, and fatalities all in the same breath. Our acceptance of the fact that more than 42,000

people die on U.S. roadways each year is astounding. This pervasive nonchalance regarding auto-related deaths is the ultimate testimony to our automobile dependency.

Flying over this country has made me aware of the larger picture emerging from seemingly small-scale patterns. When, in one part of a metropolitan area, I see the idling of rush hour traffic, I know that the same thing is going on throughout the metropolitan region—and throughout thousands of cities across the United States. It is hard to imagine where all the gas to support this is coming from— then I remember flying over the huge ports and refineries along the Gulf Coast. Seeing the traffic patterns, I realize it is no wonder that these refineries are as expansive as they are. And seeing the scope and size of the oil facilities along the Gulf, I realize it is also no surprise that world gas futures spike with the threat of a hurricane. And given suburban sprawl and our level of auto dependency, it is no further surprise that the United States' balance of payments is directly linked to the price of a barrel of oil, or that our foreign policy is immorally tied to oil.

The minimal efforts our country has made to reduce automobile fuel consumption and CO_2 emissions have been primarily through improving fuel efficiency when traveling from point A to point B. Fuel efficiency alone is not going to fix our increasing dependency problem. A more sustainable solution is to move points A and B closer together. Admittedly, this is far more difficult to achieve, both for political and cultural reasons, and for the obvious reason that points A and B are literally set in concrete. From the aerial perspective, when we bring points A and B closer together, what we see begins to resemble a village, town, or city. A solution of this type would lead to denser, mixed-use communities in which public transportation, biking, and walking could be realistic means of getting around. The end result? Fewer roadways, fewer auto miles traveled—and greatly decreased auto dependency.

Spinnerstown, PA

Parking lots at this small rural church are larger than the building itself, which has a seating
capacity of more than 330. Juxtaposing the containments, the church and parking lots, illustrates
the amount of space that cars require in relation to their drivers. Today the church's congregation,
which was once primarily local German farmers, commutes from increasingly long distances.

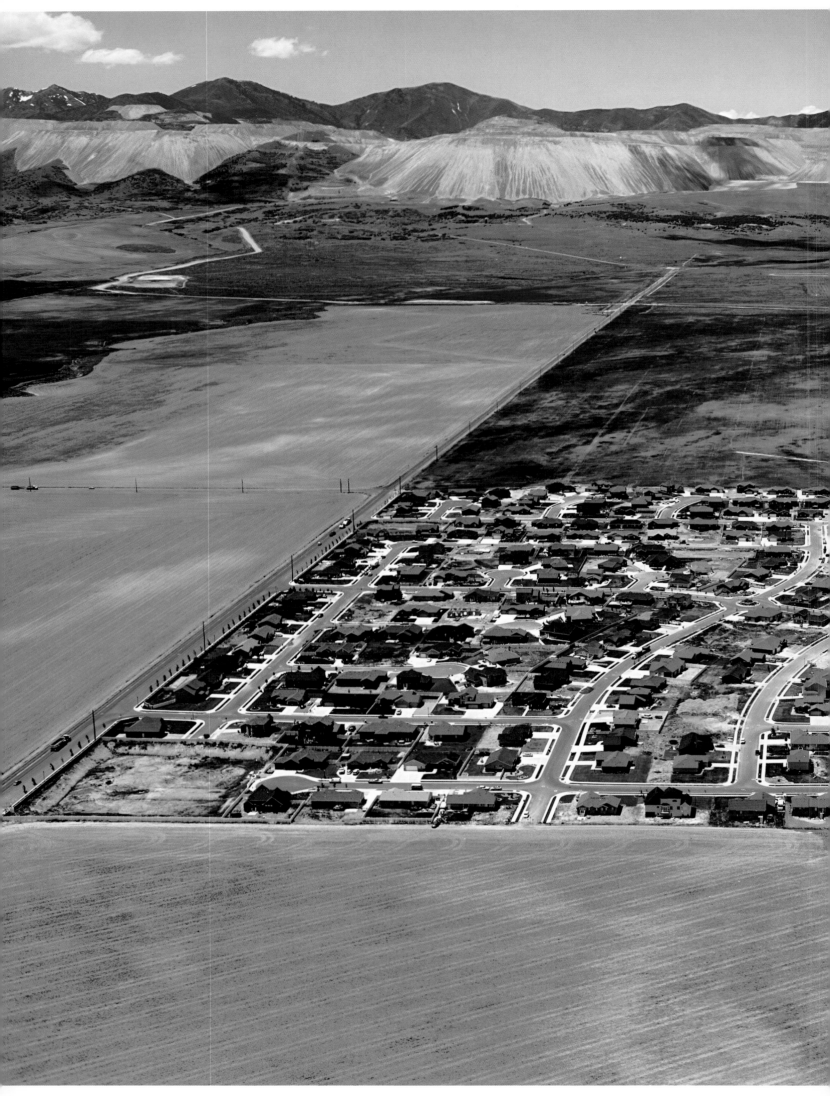

South Jordan, UT
Isolated exurban communities built on cheap agricultural land depend on cars for nearly every
activity. To access urban centers, residents often have to commute long distances. Because the
land is virtually undeveloped, all aspects of modern infrastructure (water, sewer, electric, and roads)
must be extended.

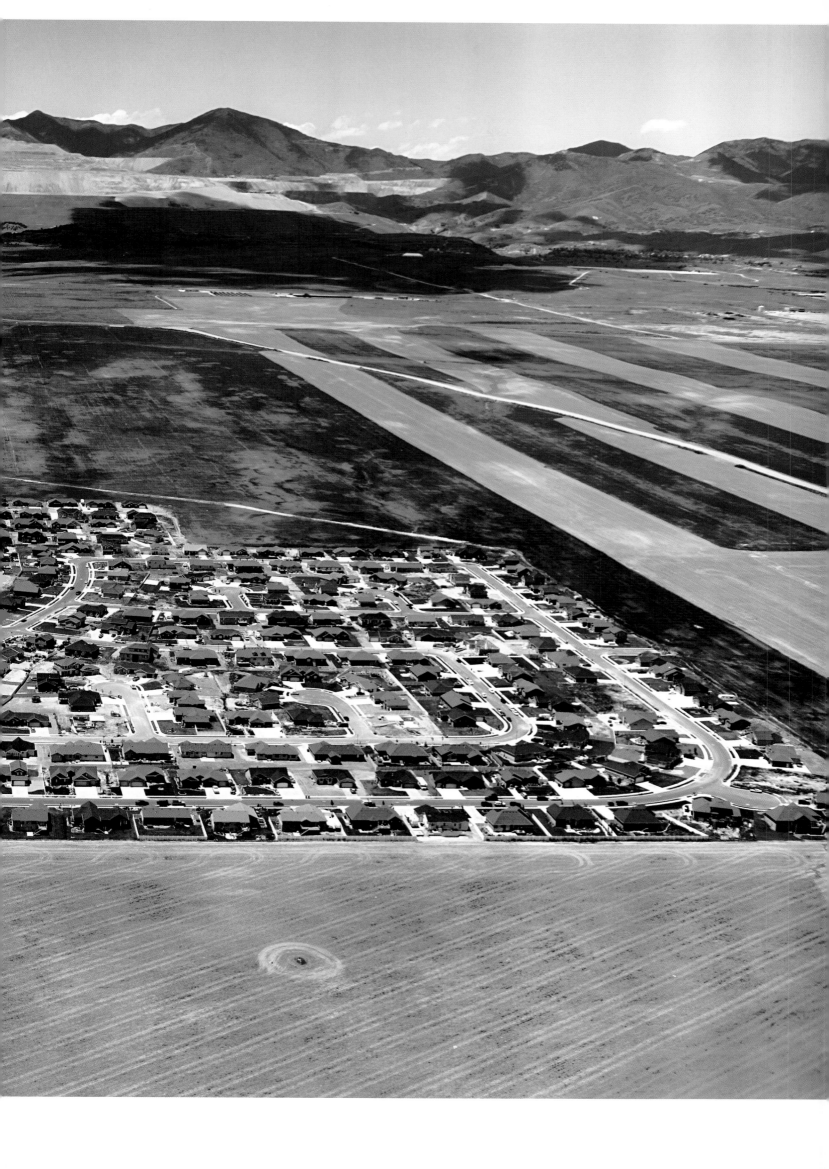

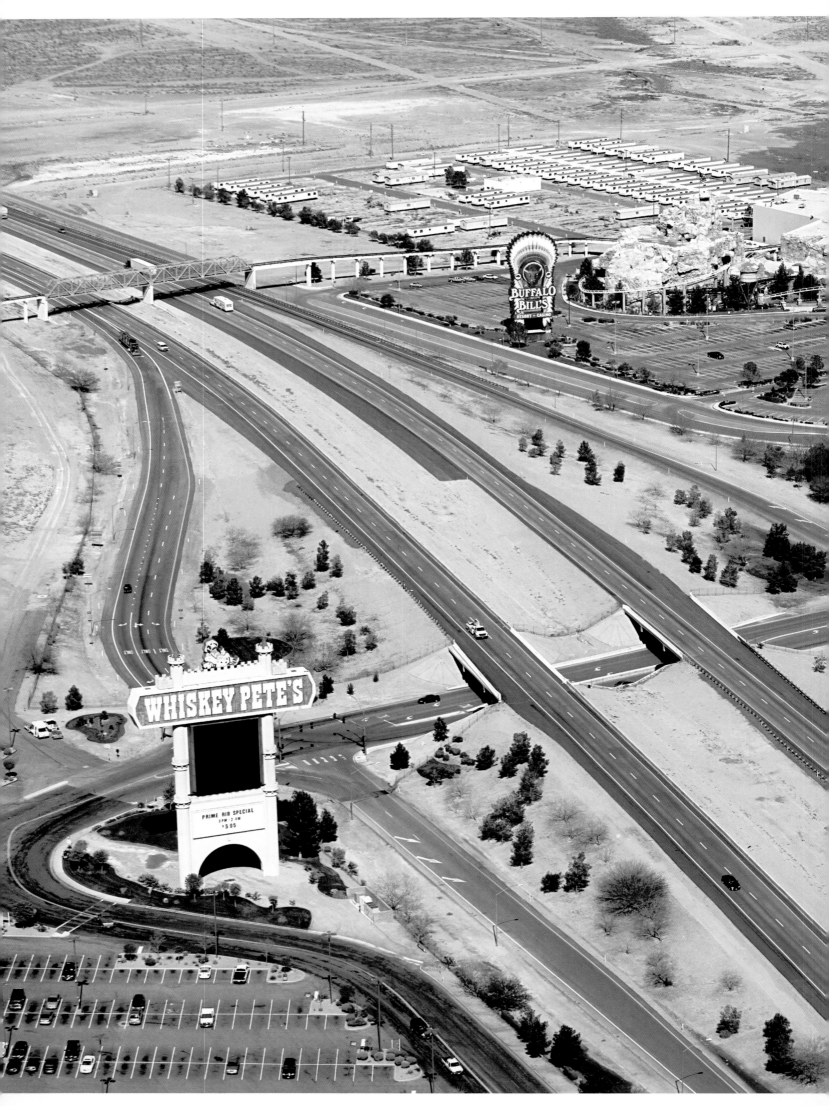

Primm, NV

Primm is a small commercial desert community in Clark County, Nevada, located 40 miles from Las Vegas. It is the first settlement after crossing the Nevada state line from California on Interstate 15. It owes its economic success—despite its highly isolated location—to the interstate, which draws thousands across the California border to take advantage of Nevada's relaxed gambling laws.

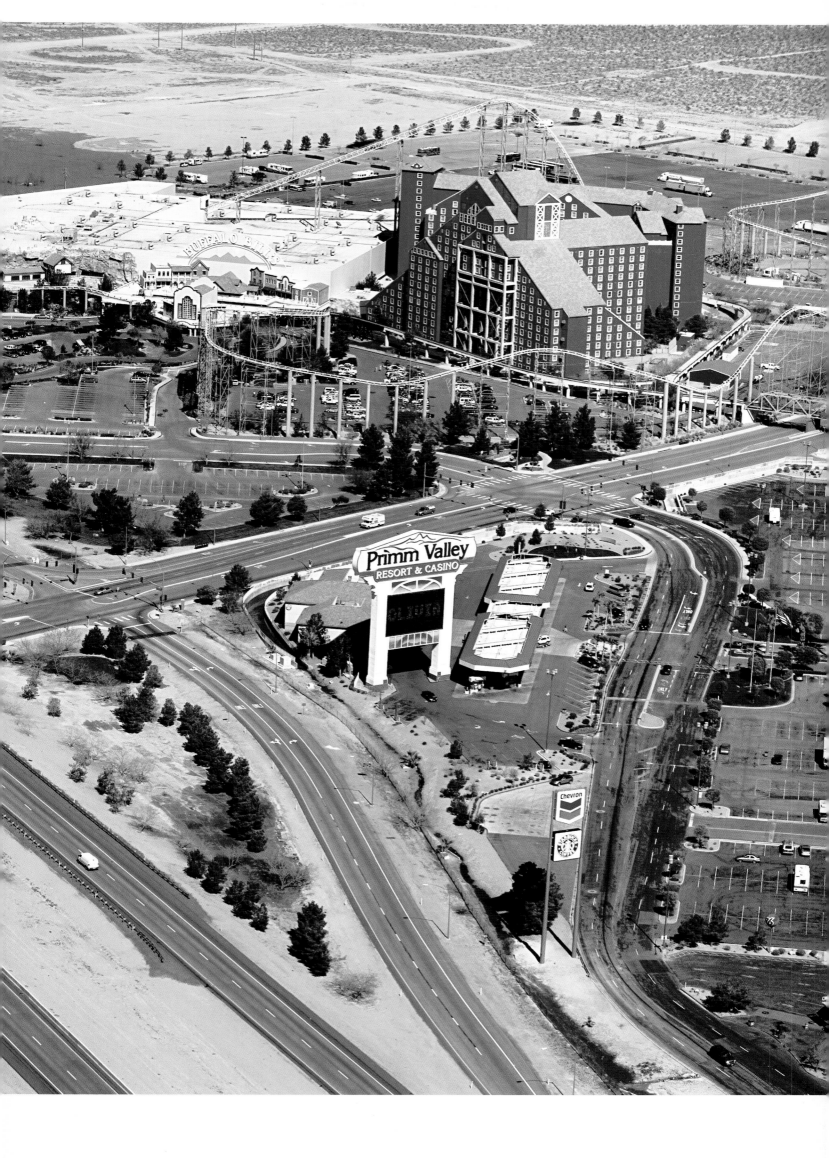

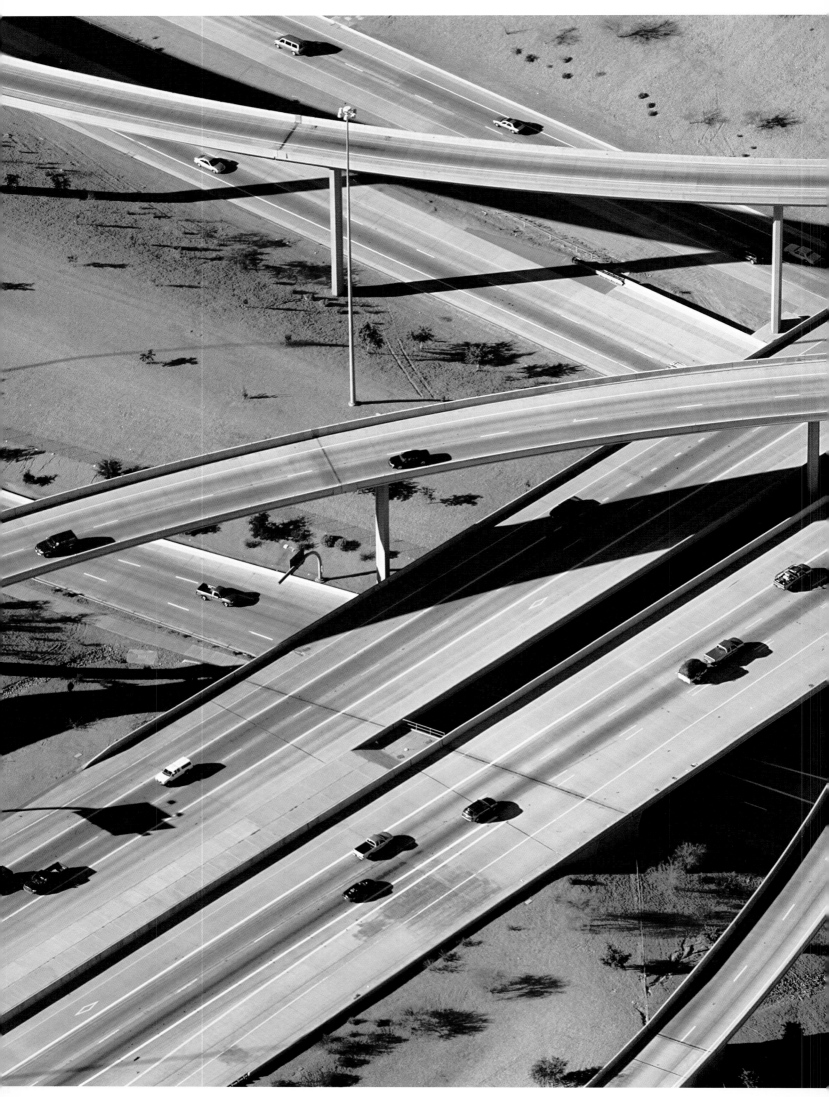

Phoenix, AZ
Massive highway interchanges connect urban centers and suburban ring roads. Little to no public
transportation exists, leaving exurban dwellers with no alternative to the car.

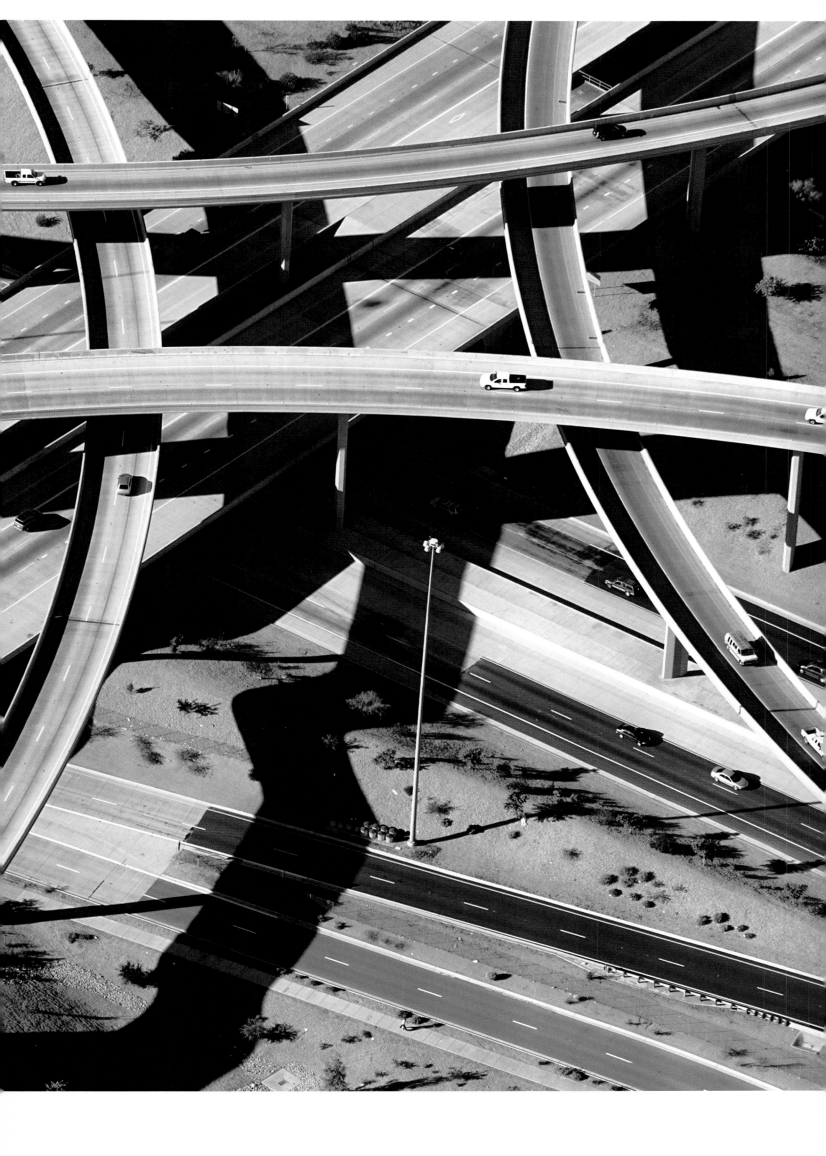

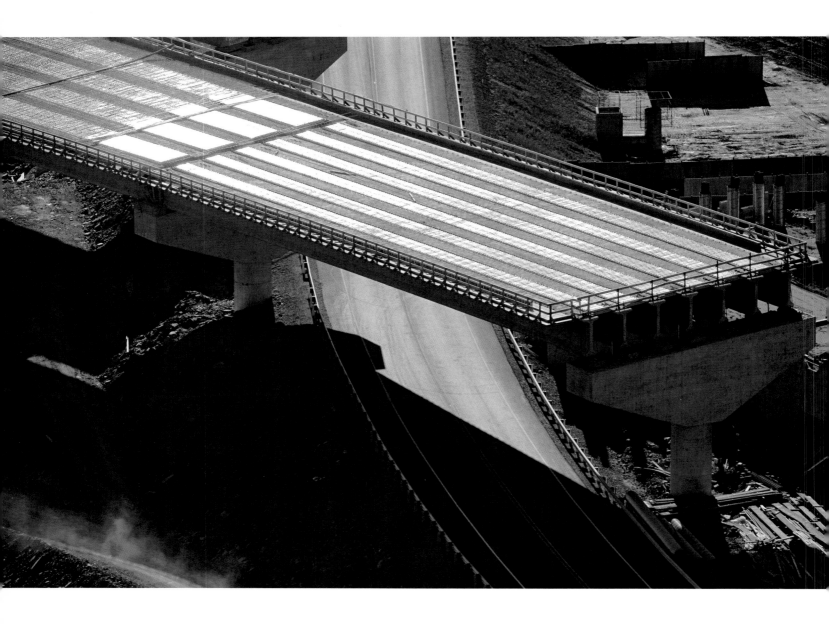

Lawrenceville, PA
A highway bridge under construction spans an existing road as part of the Appalachian Highway project. This plan aims to develop an over-3,000-mile-long road system that will connect the region to outside markets. The area's mountainous terrain has left communities up and down Appalachia relatively isolated and economically anemic.

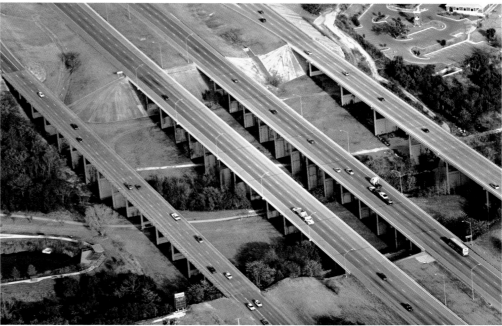

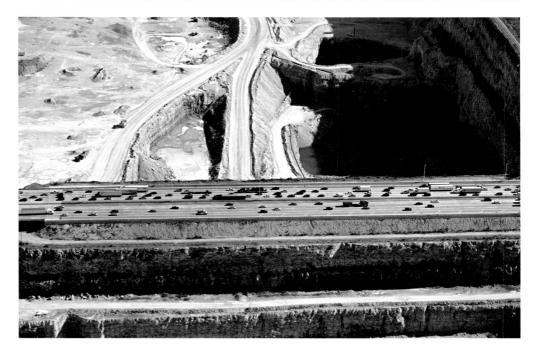

Huntsville, AL
Multiple feeder lanes between two interchanges
connect major interstate routes.

Austin, TX
Four parallel highways cross a small valley.

Thornton, IL
A highway passes over Thornton Quarry, the
largest limestone quarry in the world.

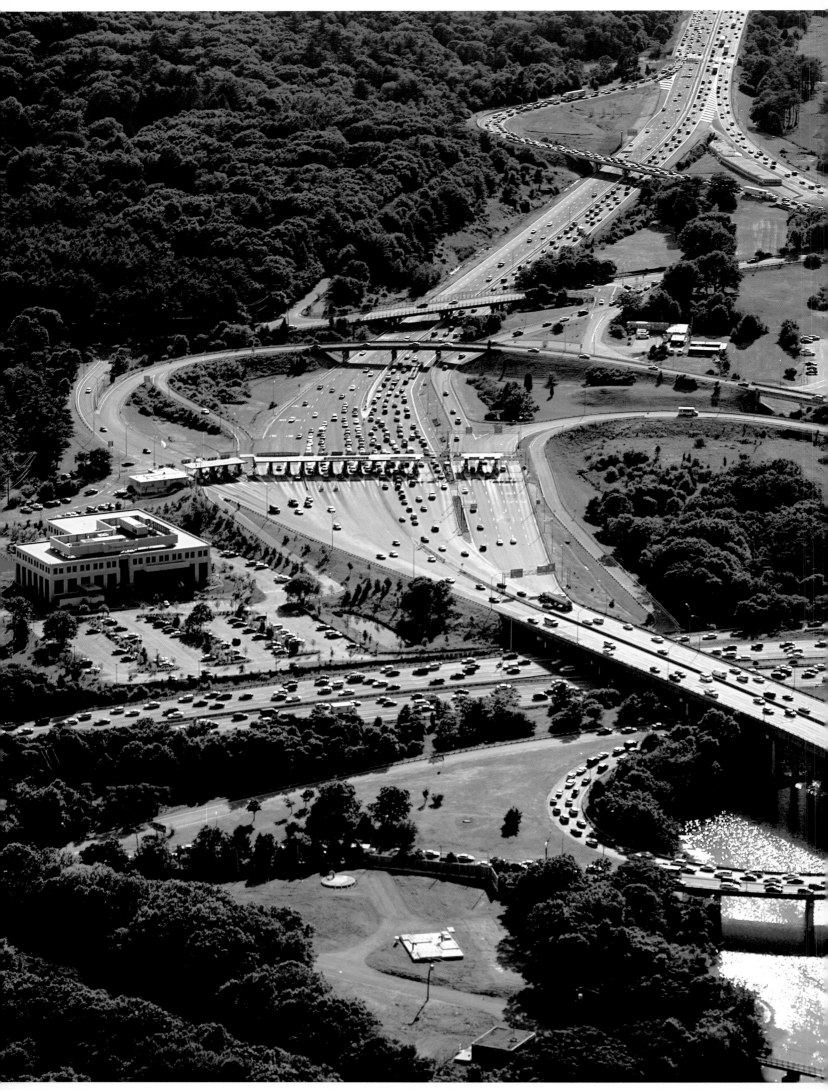

Weston, MA
Rush hour traffic stagnates behind the toll plaza on the Mass Pike, a major east-west toll road. This interchange with the circumferential highway Route 128 lies 10 miles outside of Boston and is a main junction for commuters. Despite numerous lane widenings, traffic is still bottlenecked at rush hour. The average commute in Massachusetts is 27 minutes.

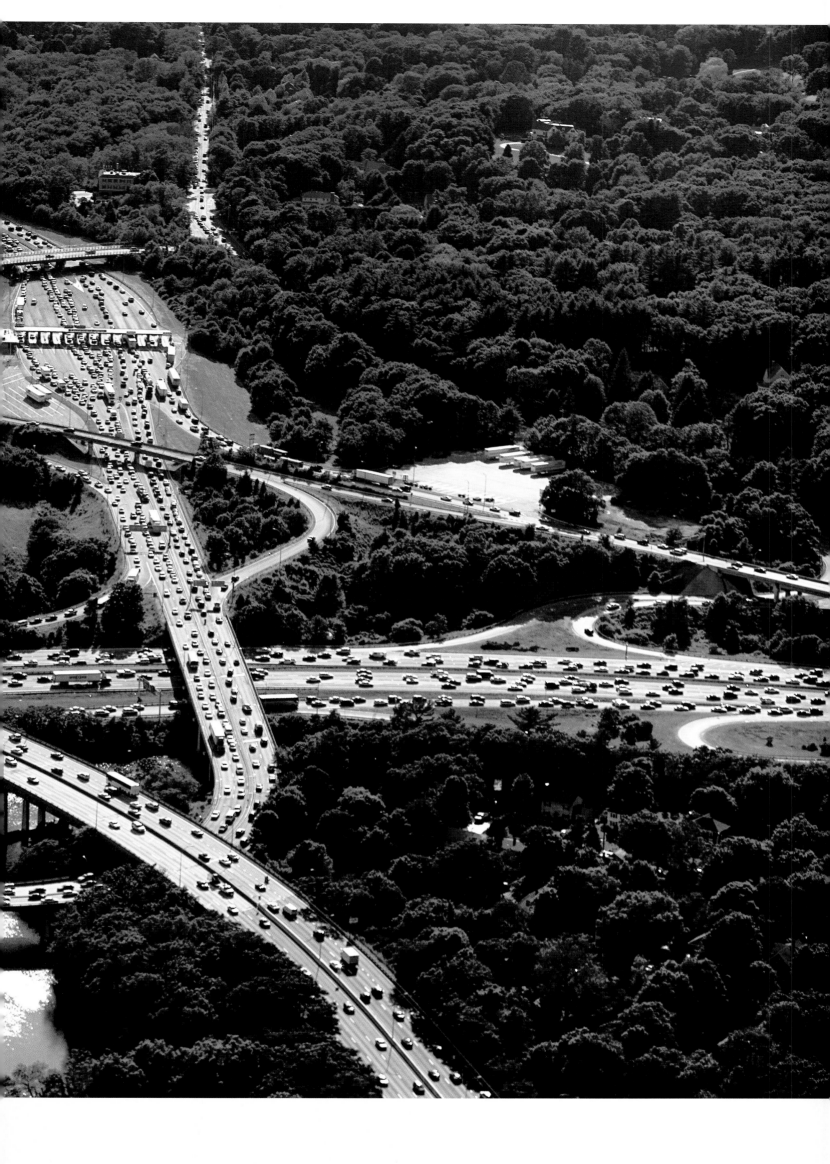

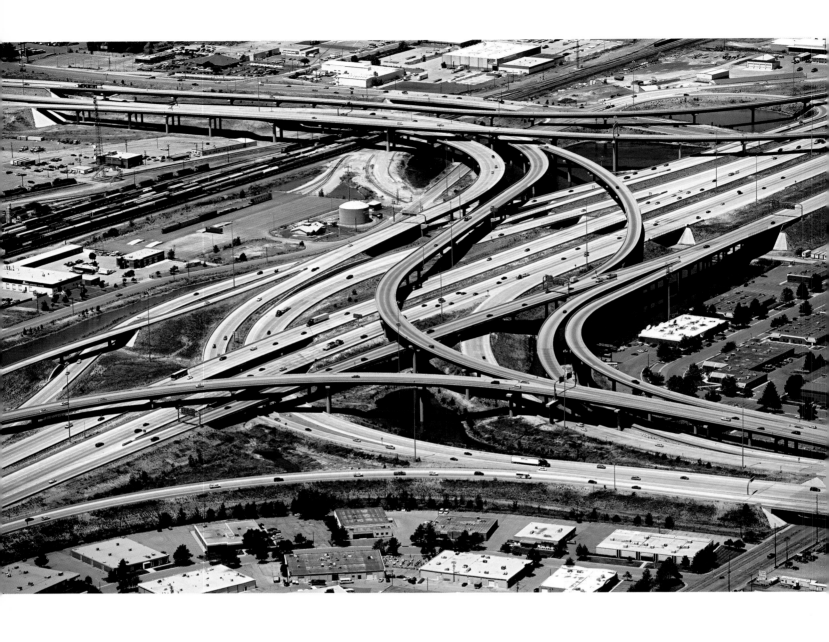

Salt Lake City, UT
The intersection of Interstate 15 and Interstate 80 extends three-quarters of a mile. The production
of cement, a component of concrete, accounts for 5 percent of the world's CO_2 emissions.

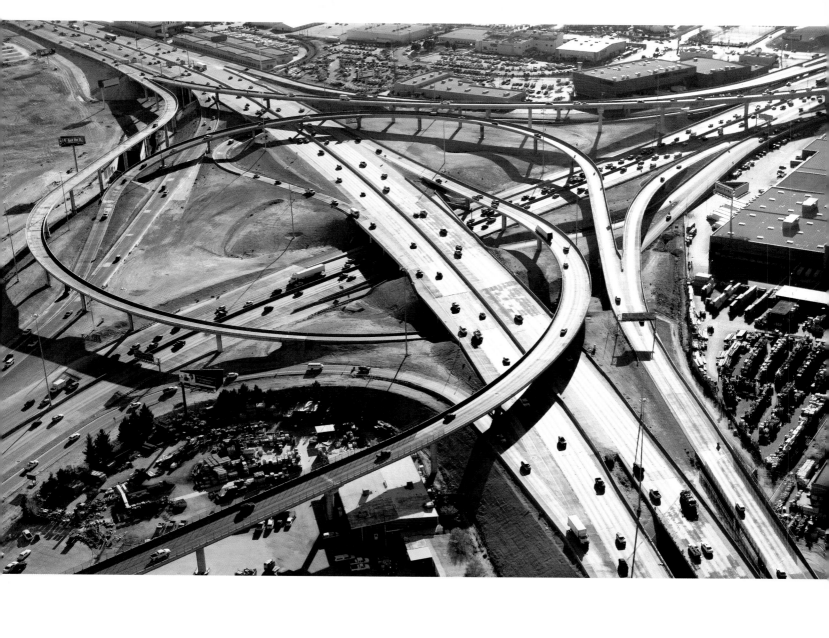

Las Vegas, NV
The Spaghetti Bowl is where U.S. 95 and 93 intersect with Interstate 15. Several multimillion-dollar lane-widening projects are scheduled for this stretch of highway, which, despite its size, is subject to heavy traffic every day.

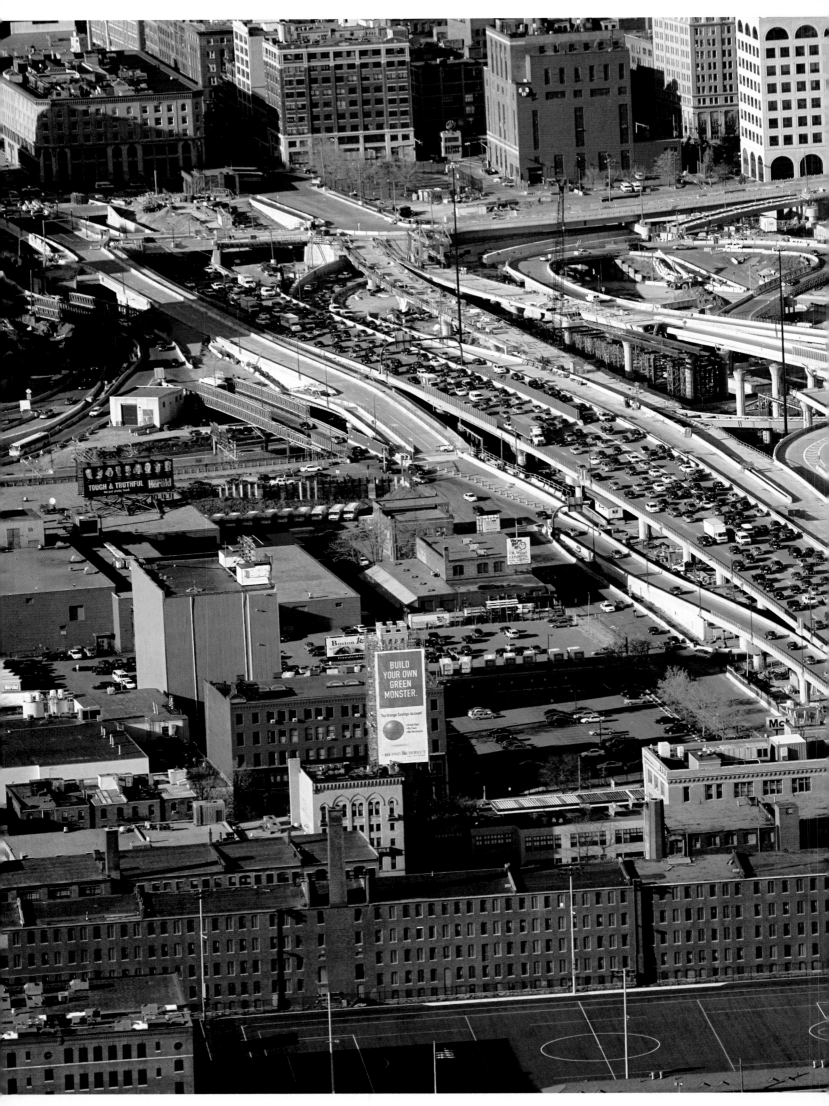

Boston, MA
East Coast cities typically have more treacherous, crowded highway systems than their newer West Coast counterparts. Rush hour traffic on Interstate 93 pours in and out of Boston's divided Tip O'Neil Tunnel. This tunnel was part of the $17 billion "Big Dig" project, built in part to depress the elevated Central Artery that cut the downtown off from the city's waterfront.

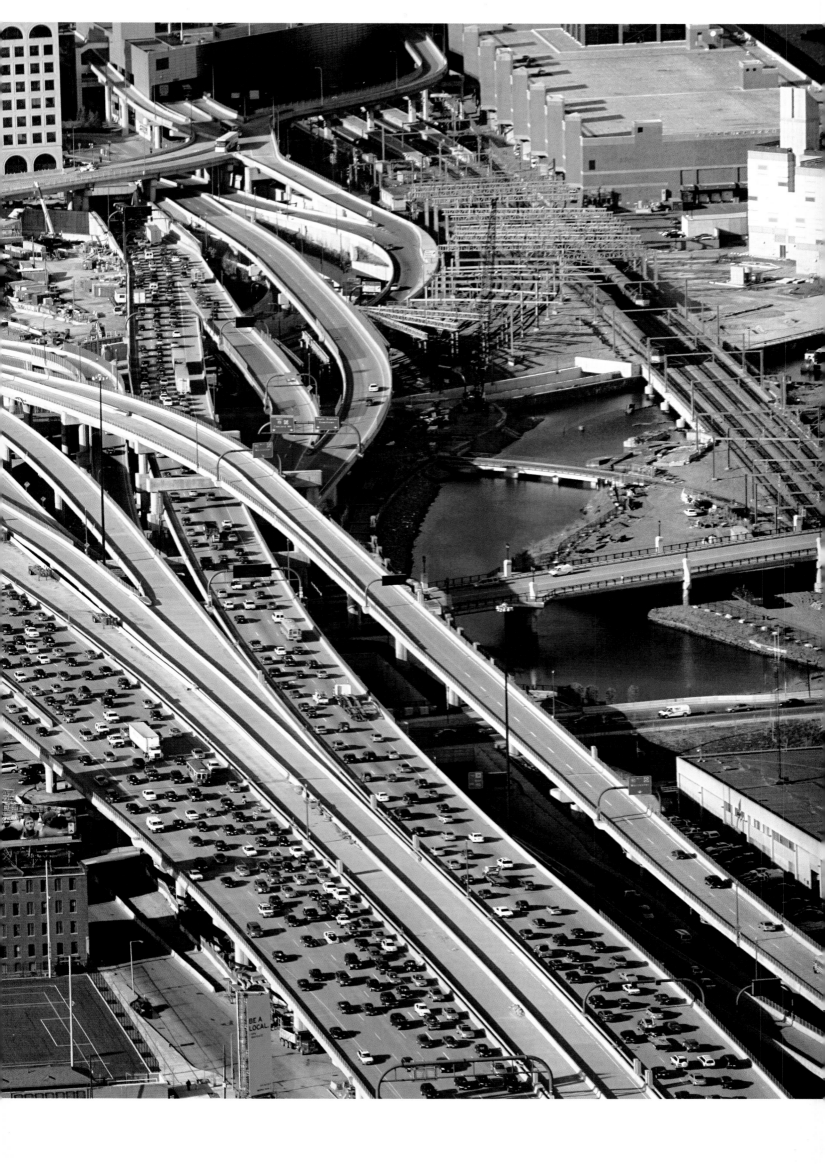

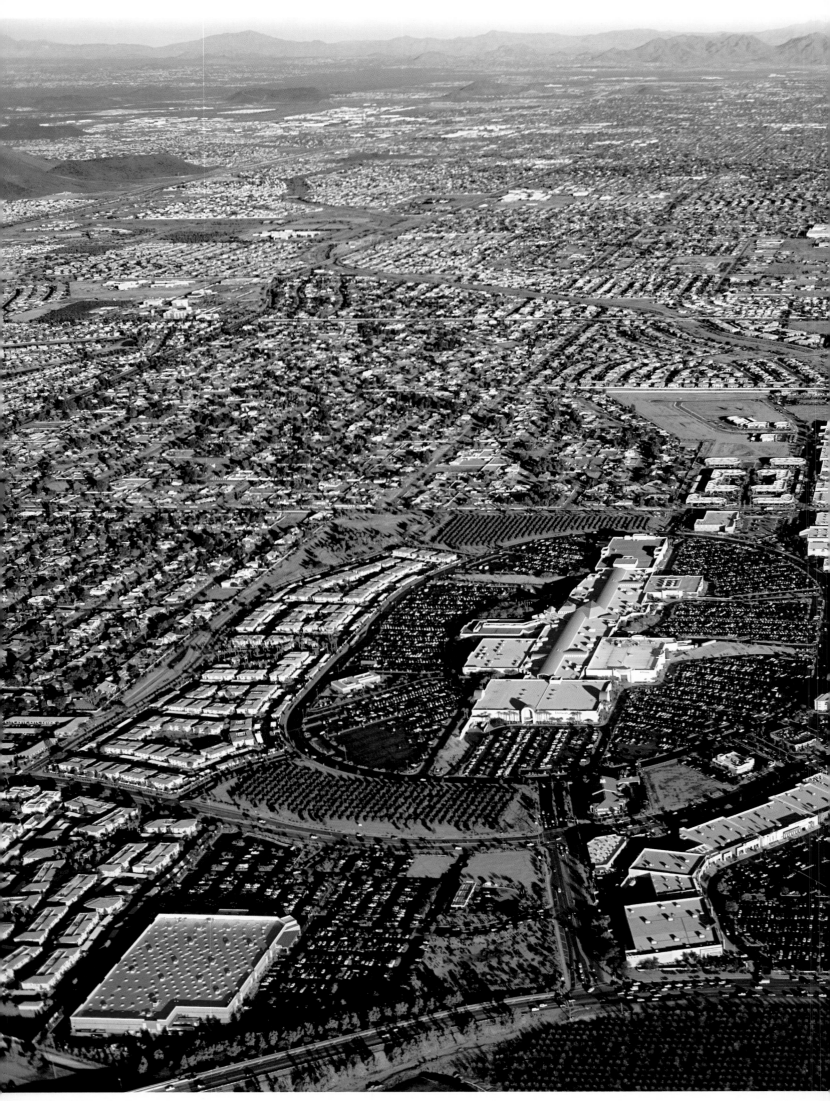

Glendale, AZ
Arrowhead Town Center is a regional shopping mall in the West Phoenix area. Post—World War II suburbs typically lack the traditional pedestrian-based town center; instead, a car is necessary to access the area's commercial center and to move within it.

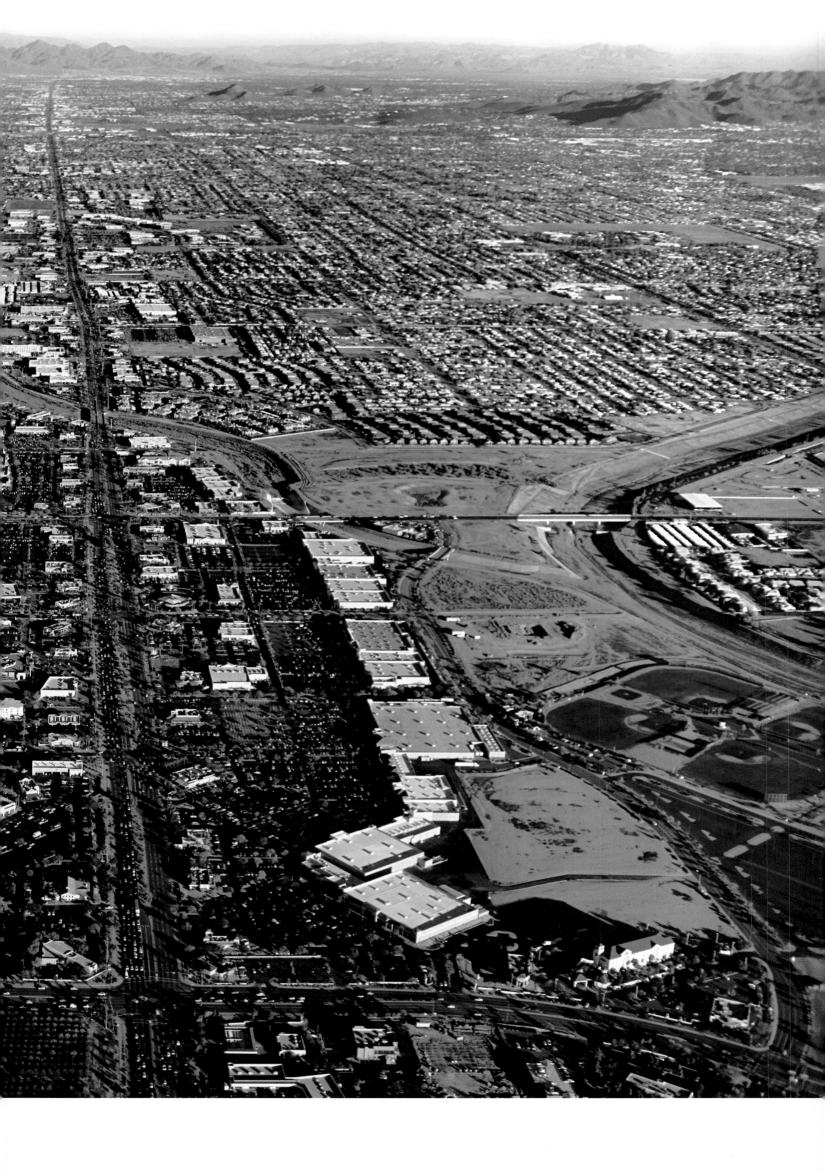

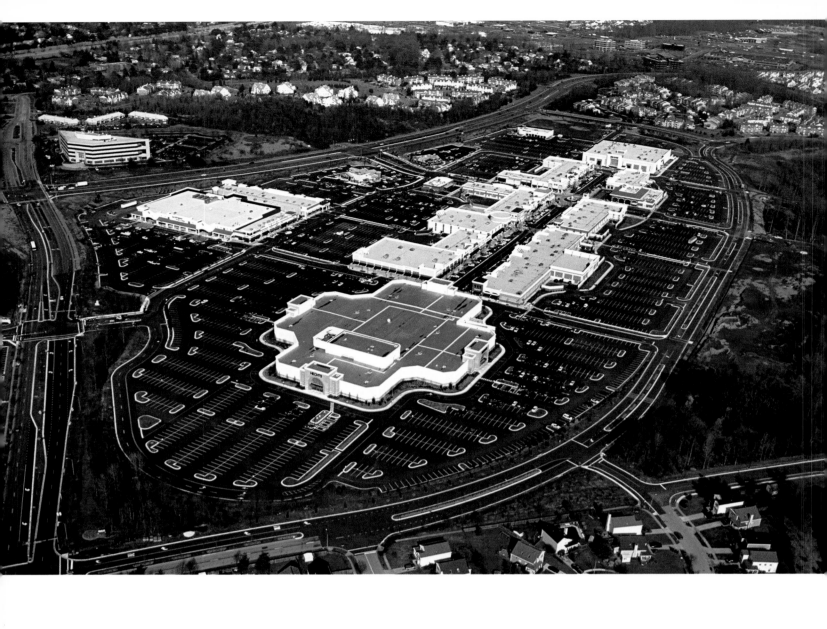

Bowie, MD

Bowie Town Center is a regional mall with a faux–Main Street lined with chain stores, meant to be reminiscent of an old town center. Today's regional malls are situated in such a way that accessing them other than by vehicle is almost impossible.

Plano, TX
The Prestonwood Baptist Church has a congregation of nearly 27,000. On Sundays, the church's massive parking lot fills with cars from the surrounding suburbs. For the rest of the week, the lot sits largely vacant.

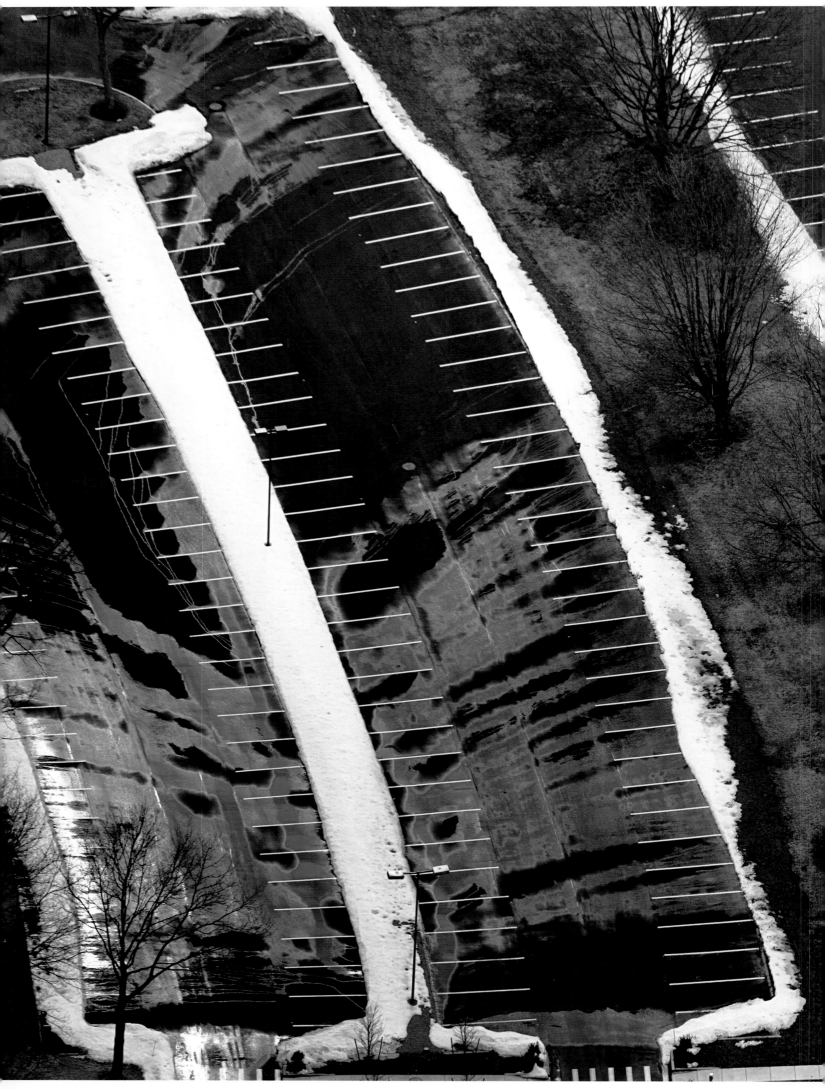

Waltham, MA

Parking lots paved with impermeable materials quickly send runoff with surface contaminants into streams and sewers, and prevent rainfall infiltration and ground water recharge. In the summer they become heat islands, greatly increasing the surrounding temperatures.

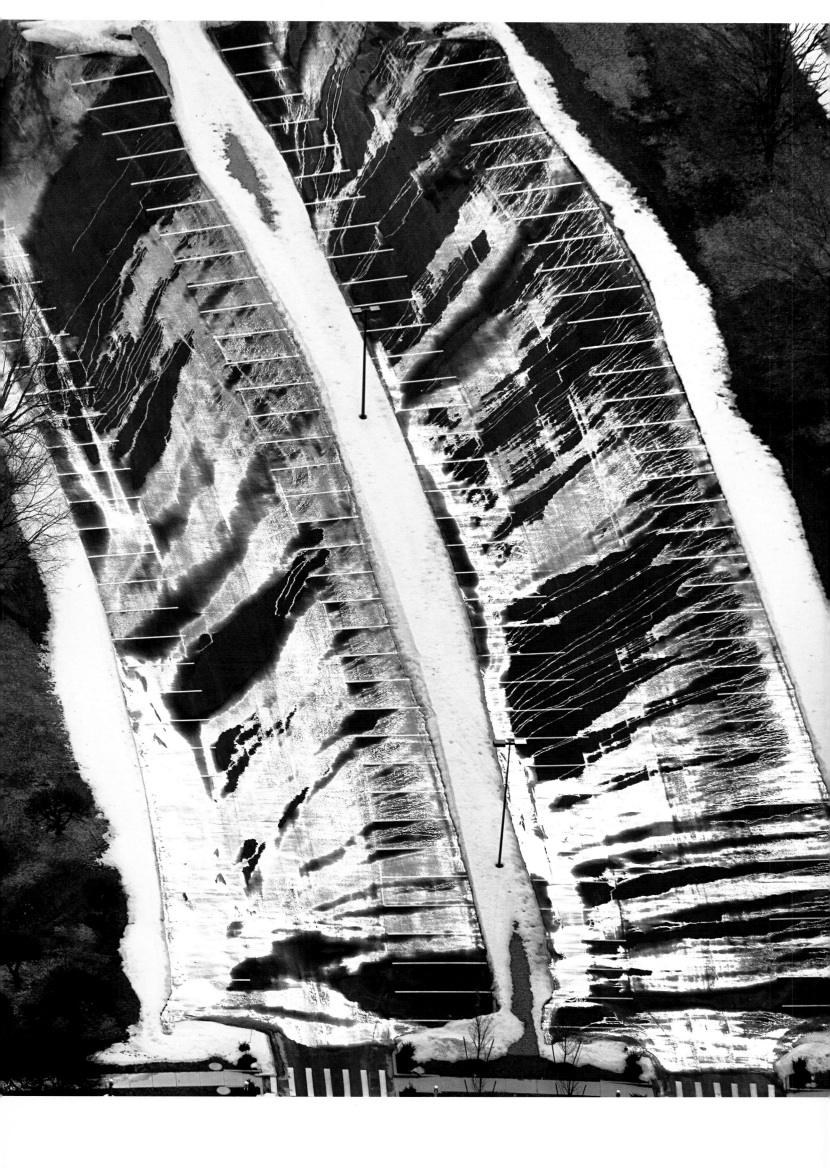

Portland, OR
Imported cars, primarily from Asia, are off-loaded in Portland. U.S. carmakers face stiff competition
from imports with better fuel economy.

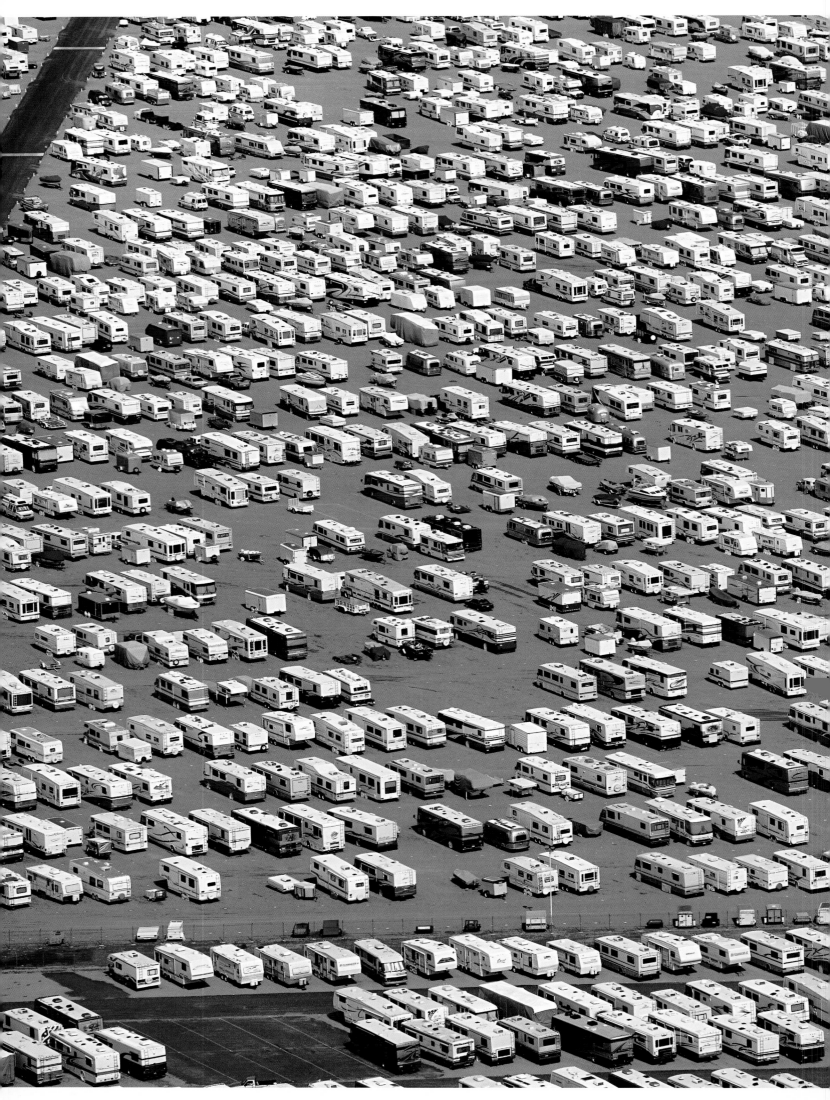

Sun City, AZ
Sun City found it had so many RVs that, in 1983, it had to apportion a half-mile-long-by-quarter-mile-wide parking lot to accommodate its residents' vehicles.

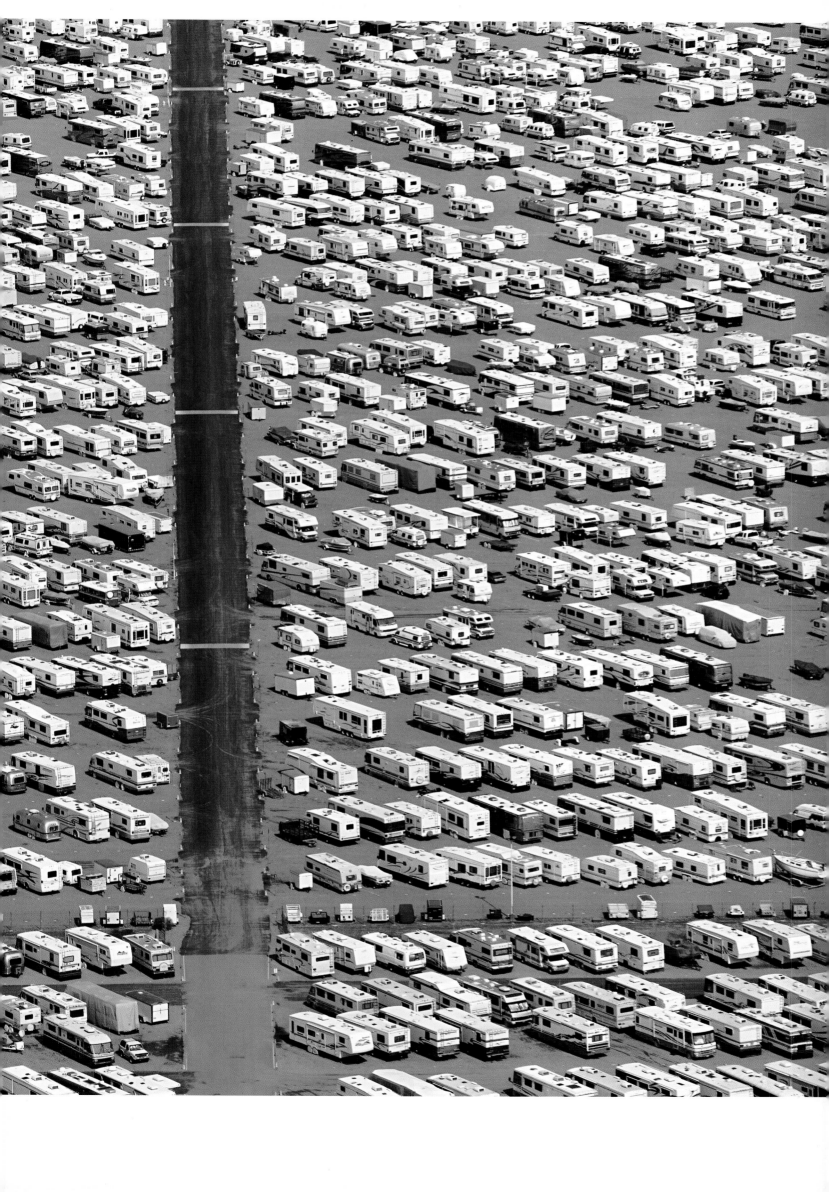

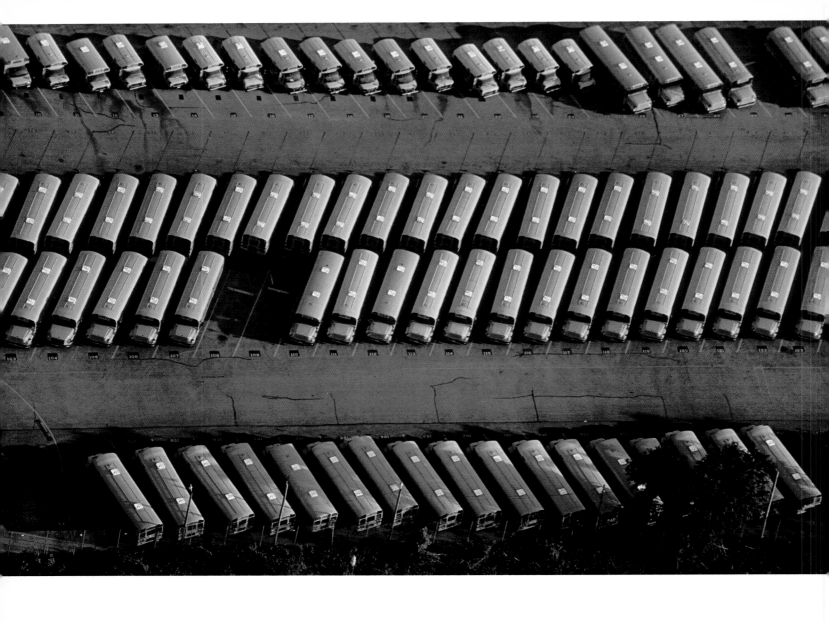

Kansas City, MO
One yellow school bus takes about 50 cars off the road, saving on individuals driving to and from
school, but the buses' diesel fumes remain heavy pollutants.

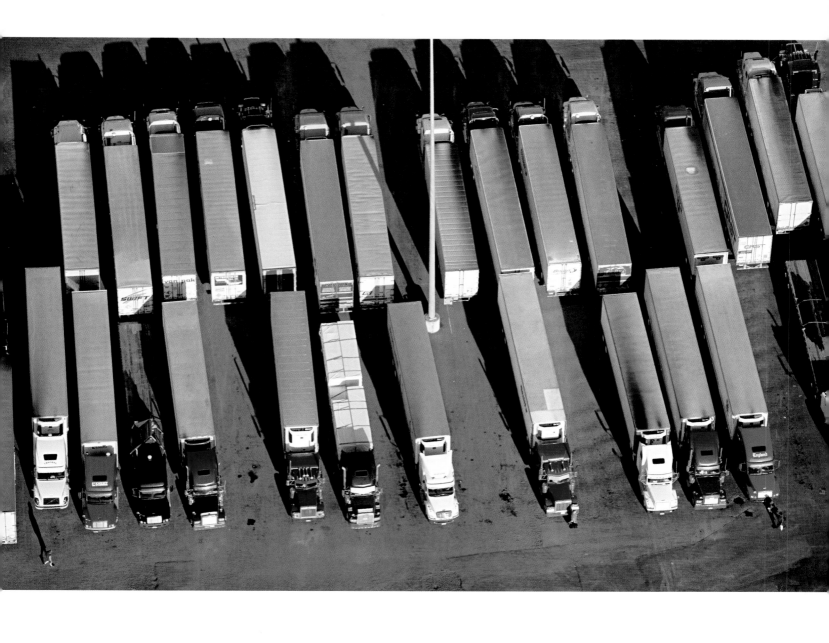

Aurora, OR

Every year, trucks transport 1.1 trillion tons of goods across the United States, each using an average of more than 4,000 gallons of fuel and emitting an estimated 10 million tons of CO_2, 50,000 tons of nitrogen oxides, and 2,000 tons of particulate matter. From idling at stops alone, long-haul trucks burn 20 million barrels of diesel fuel per year.

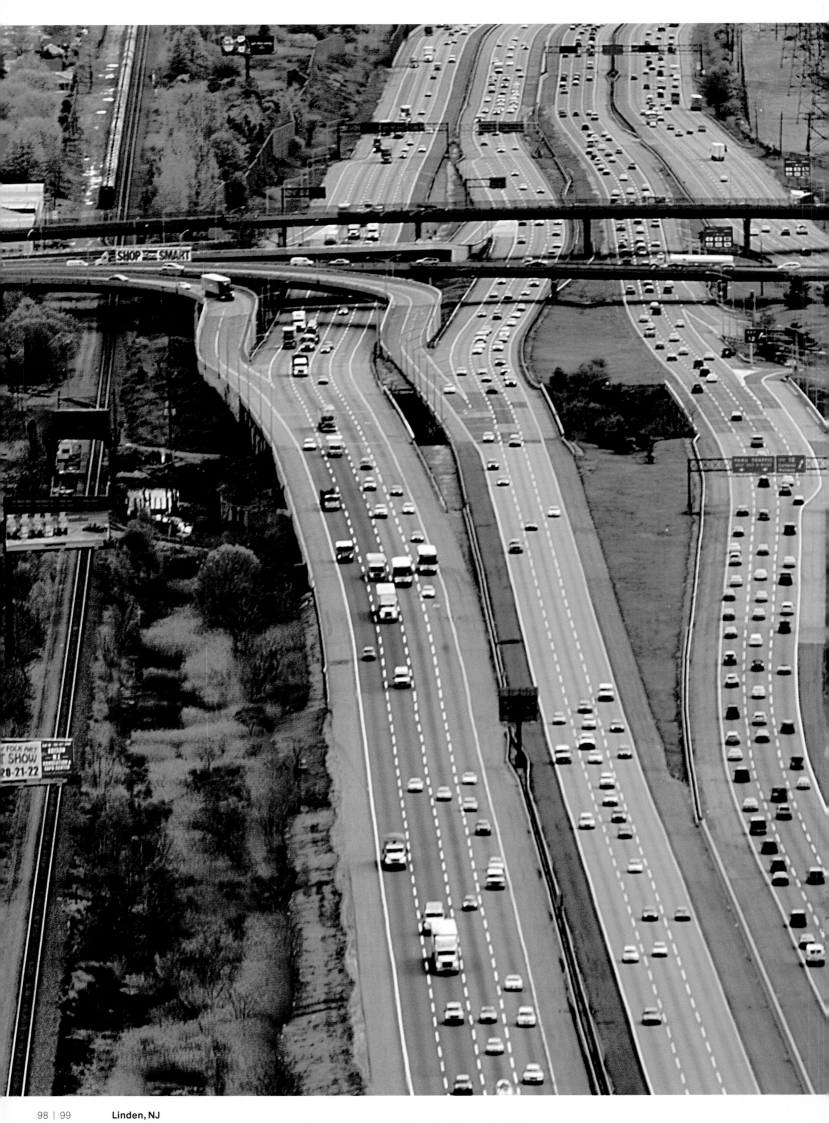

Linden, NJ
Cars pass intermediary gasoline storage tanks on the New Jersey Turnpike. This section of the
turnpike has 14 lanes that carry roughly 200,000 cars each day.

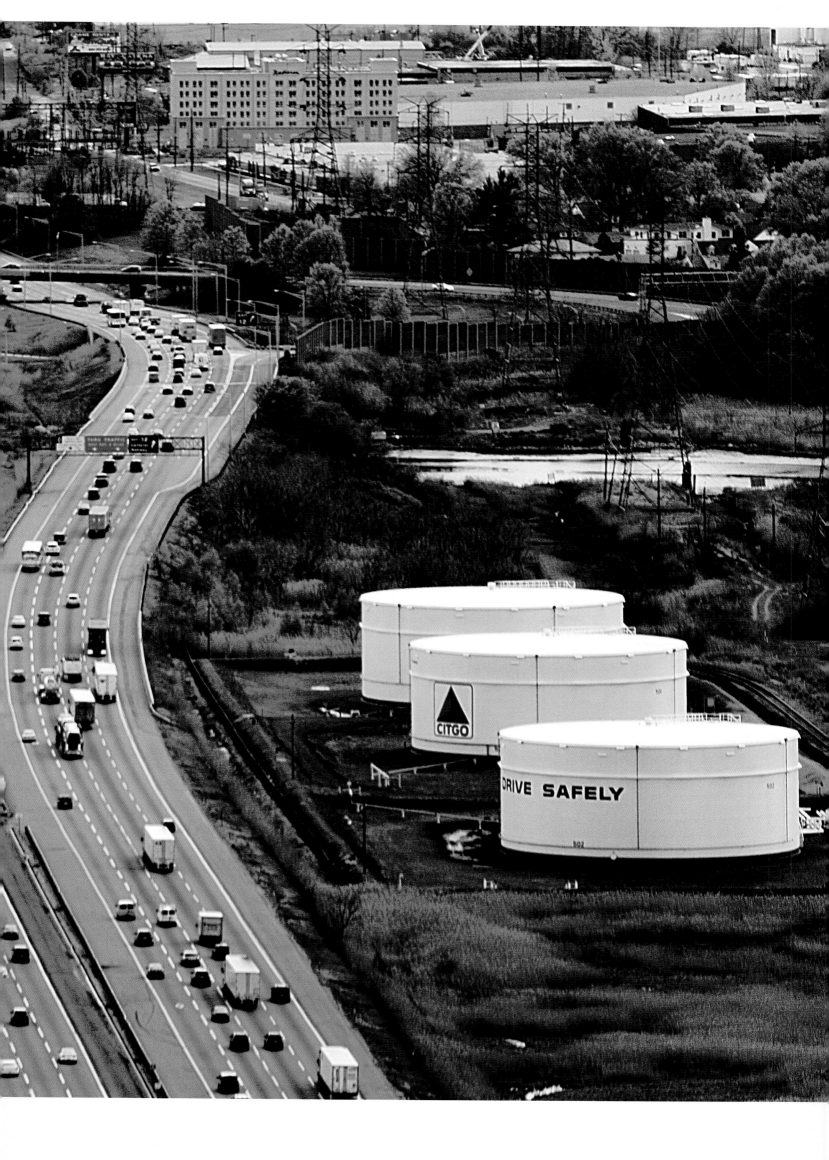

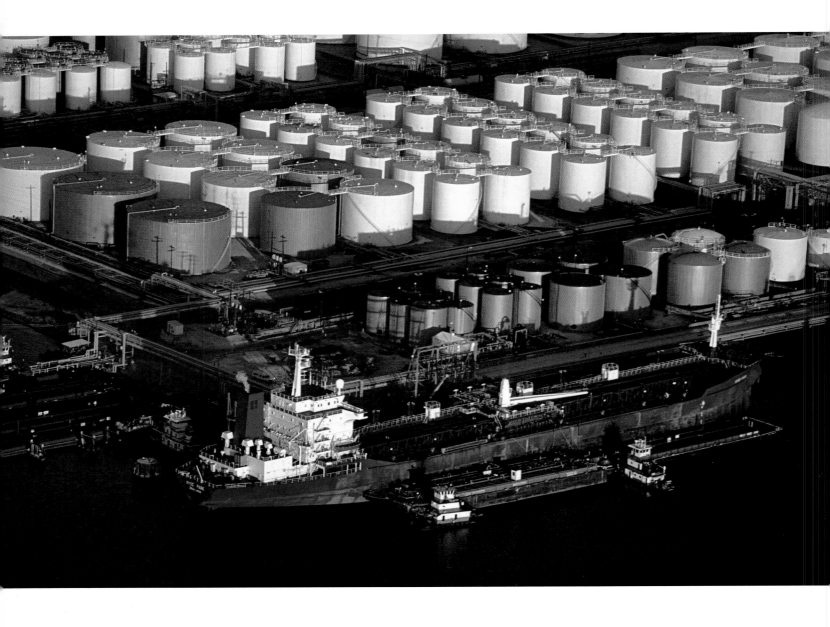

Houston, TX
America's transportation infrastructure includes an unseen network of ships, tanks, pipelines, and trucks that ultimately move fuel to end users at the pump. The Houston Ship Channel on the Gulf Coast is a central hub for receiving imported oil.

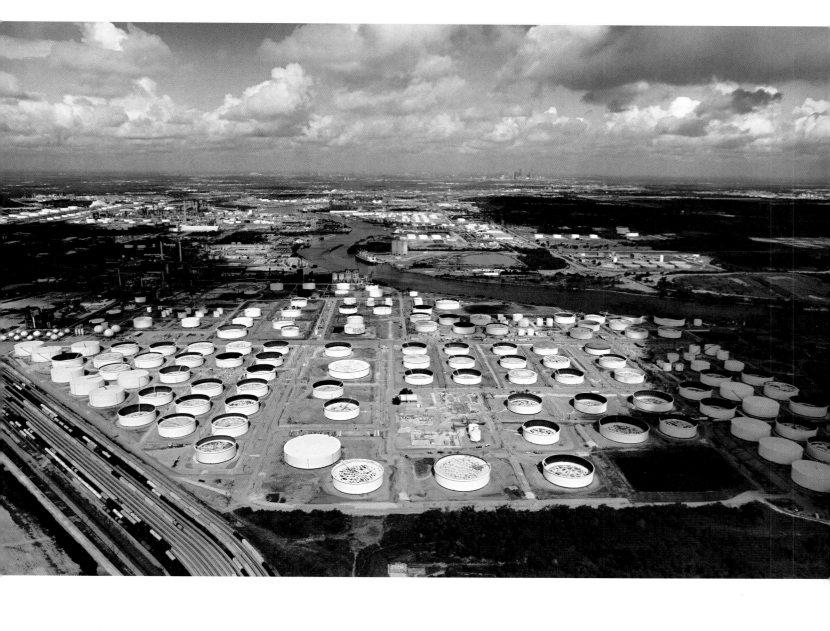

Houston, TX
Miles of refinery and petroleum infrastructure stretch out along the Houston Ship Channel.
Houston's downtown appears faintly on the horizon.

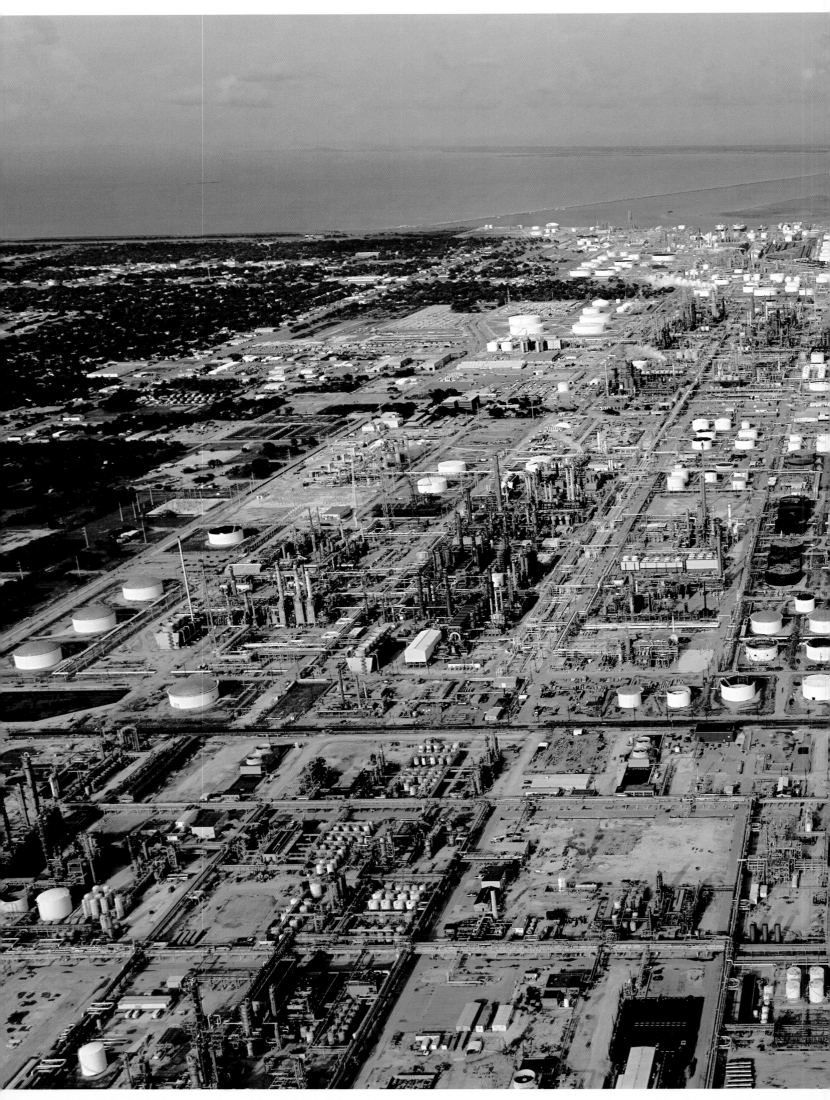

Texas City, TX
Southeast Texas is a central hub for receiving and processing imported oil along the Gulf Coast
and is home to many of the country's largest refineries. BP's Texas City refinery (one of several seen
here) occupies 1,200 acres and is capable of refining 10 million gallons of gasoline each day. It
produces 2.5 percent of all gasoline sold in the United States.

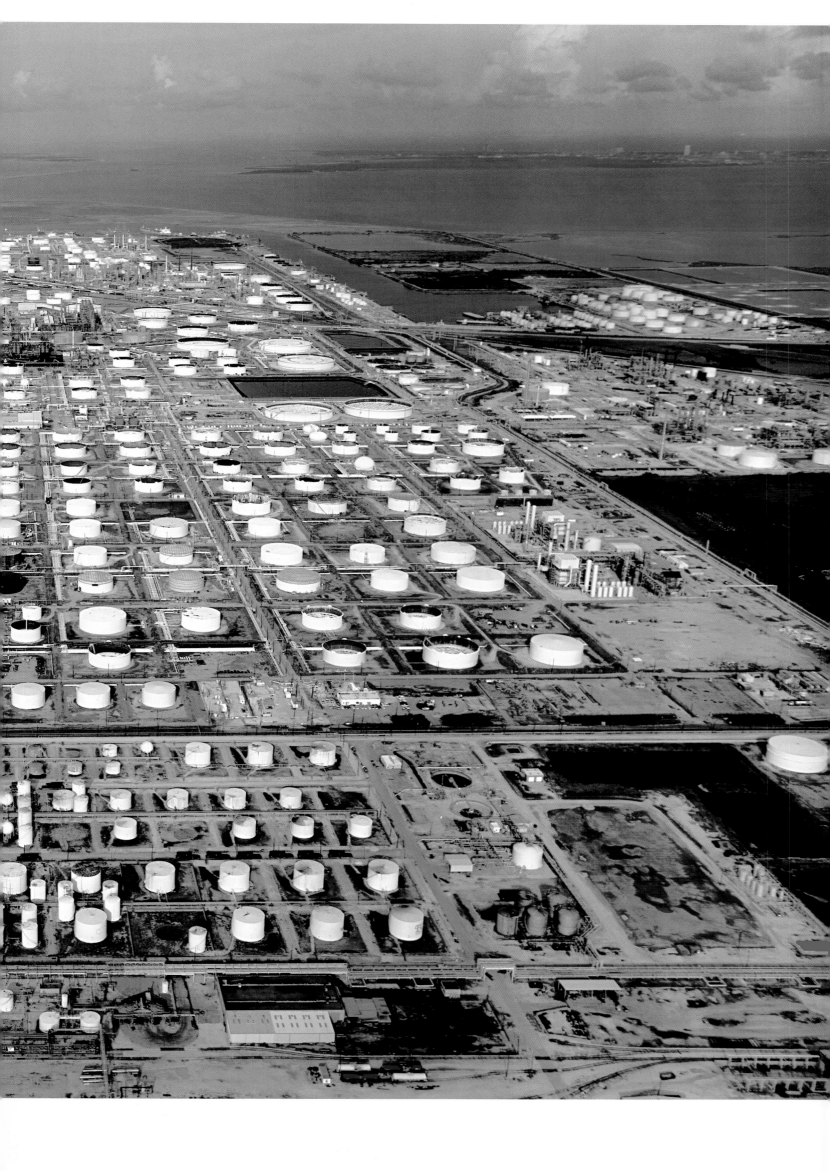

Electricity Generation

From my plane, I can detect fossil fuel power plants long before I see them. The telltale sign is a yellow-brown haze layer drifting downwind from the plant, often as far as 80 miles away. These centralized electric plants are massive in scale, and on clear days I can see their tall smokestacks and cooling towers far off on the horizon. These structures are obstructions to pilots and are clearly marked as hazards on my aeronautical maps. High-voltage transmission lines radiate outward from the plants for hundreds of miles.

About half of the electricity generated in the United States comes from 600-plus coal-fired power plants; these are responsible for 82 percent of the total CO_2 emitted through U.S. electric power generation. While the plants themselves are gigantic, I am often more impressed with the huge stockpiles of coal adjacent to their burners and the logistics for cooling steam and bringing the coal to the site. Extracting, processing, and transporting this coal represents a large expenditure of energy and resources; some coal comes by sea, but two-thirds of all coal arrives at its destination by train. This accounts for more than 40 percent of U.S. railroad freight traffic in terms of tonnage. From the air, I see trains that stretch for more than a mile loop around a plant's perimeter; for a large plant, a mile-long train loaded with coal represents only a 15-hour fuel supply.

Nuclear power plants stand out as a result of their unique concrete containment buildings for housing nuclear reactors and their iconic cooling towers with a condensation cloud rising above them. From the air these plants, which boast zero emissions, look clean, but being aware of their fuel's long radioactive half-life, problems with on-site storage of their spent fuel rods, groundwater contamination, and their potential vulnerability to terrorism and various mishaps, I perceive them as menacing.

About 20 percent of our electricity in the United States is generated from nuclear reactors. Most generating plants use steam turbines to produce power. Water is heated to create high-pressure steam, which expands inside turbines, driving the generators that produce electricity. After leaving the turbines, the steam must be cooled. Because nearly all such cooling in the United States relies on water as the heat sinks, steam-generated electricity is extremely water intensive. One-pass cooling systems

draw water from a nearby source and pass it through a heat exchanger before returning it to the source. This thermal pollution often kills off vital microorganisms that serve as the base of the marine food chain. Closed-circuit systems use evaporation to cool the steam through blowers, cooling towers, or cooling ponds; because of the significant evaporation loss they remove more water from the source than one-pass systems do.

Natural gas plants, situated adjacent to gas pipelines, are smaller and rely on gas turbines rather than steam turbines. As a result, they are quick starting and can be turned on only during peak usage periods; thus they are often referred to as "peaker plants." These plants release half the amount of CO_2 as coal-burning plants for each unit of electricity generated.

The process of thermoelectric generation is highly inefficient. A typical power plant uses less than 40 percent of the heat produced to generate electricity, while the rest escapes into the atmosphere or is absorbed by the water used for cooling. About 7 percent of the electricity produced is used just to operate the plant's pumps, blowers, crushers, and conveyor belts. There is also the energy needed to extract and process fuel from the ground and move it through pipelines, onto boats, or onto long-haul trains. Another 8 to 9 percent of the electricity produced is lost to resistance during its transmission; this happens as it moves from the plant along high-voltage lines strung on pylons, runs through visible corridors to substations, and then along overhead or underground wires to end users.

Nearly 40 percent of U.S. energy consumption goes toward producing electricity. The United States uses more electricity per person than any other nation, except Canada. As citizens, we are all too often unaware of the size and scale of our electric grid system—which is not that surprising, since we are often hundreds or thousands of miles removed from the actual source of power.

Because electric power generation also accounts for nearly 40 percent of our carbon footprint, it is essential that we find more efficient ways to produce and distribute this much needed form of energy. One step is to move toward cogeneration, a process by which otherwise wasted heat is captured for useful heating or cooling. Another step is to increase our reliance on sustainable and zero-emission energy sources, such as tidal, geothermal, hydro-, solar, and wind power. These sources offer the additional benefit of eliminating the need to mine fuel and transport it over thousands of miles to a generating plant; in fact, solar and wind generation can even be integrated into a building's design—doing away with the need to move electricity over long-distance power lines from a plant to our homes.

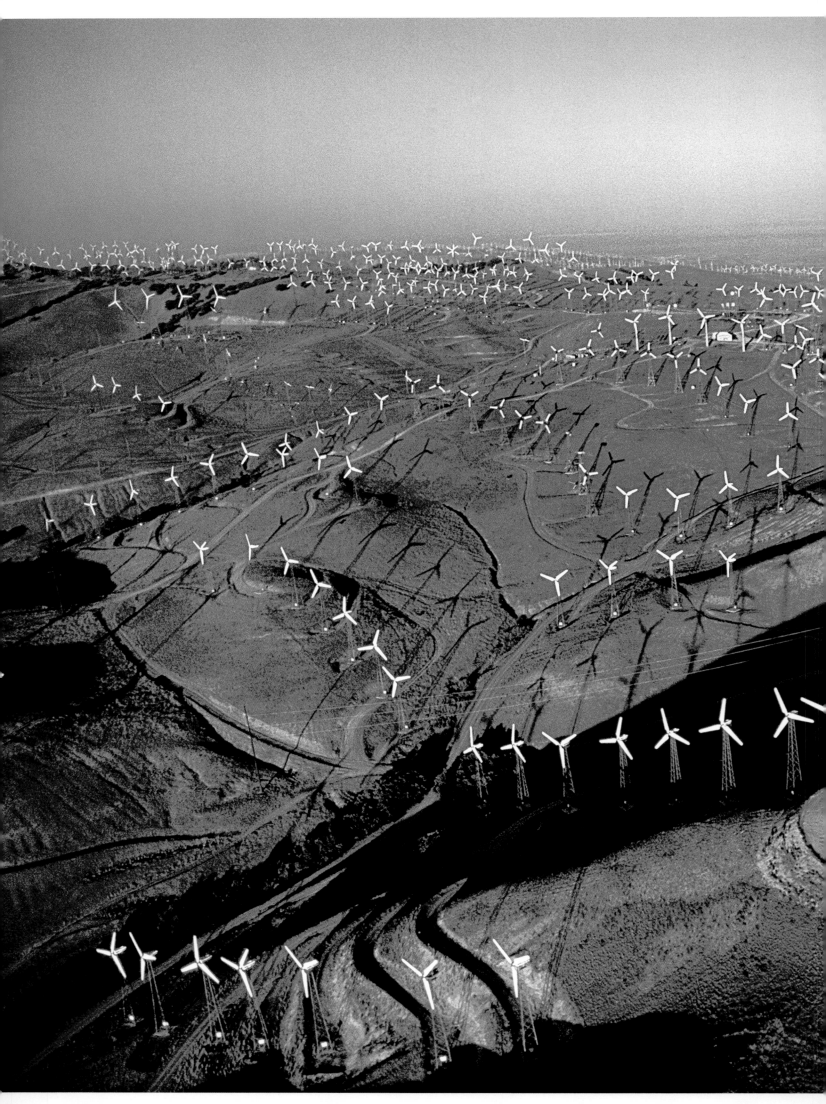

Tehachapi, CA
Five thousand wind turbines stretch out over the Tehachapi hills. Wind power represents only about
3 percent of installed electric generating capacity. The U.S. wind industry grew by 45 percent in
2007. Wind generators require no water for steam or cooling, no outside fuel for operation, and
produce no greenhouse gases.

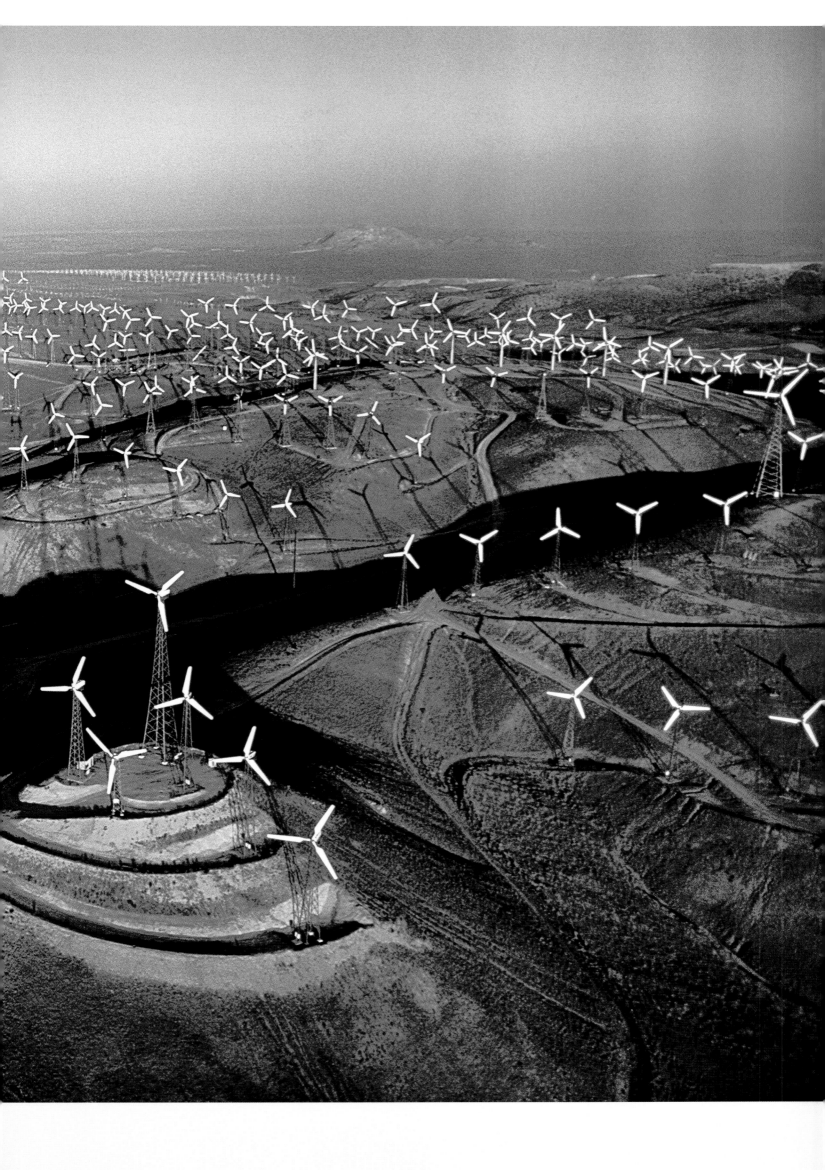

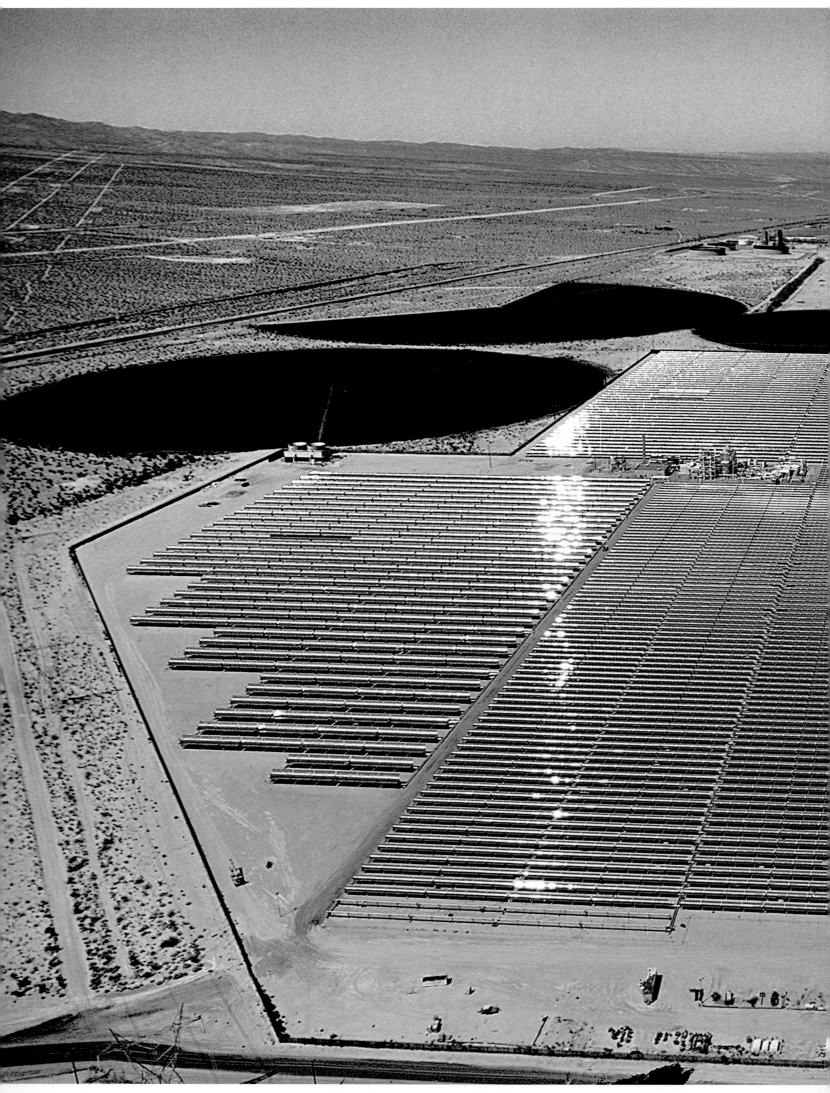

Daggett, CA
These two solar-electricity generating systems, along with seven other similar facilities in the
Mojave Desert, produce enough electricity for 500,000 people. These "trough" systems use large
parabolic mirrors to focus the sun's energy (at 30 to 60 times its actual intensity) to heat oil, which
is then used to drive a steam turbine for electricity.

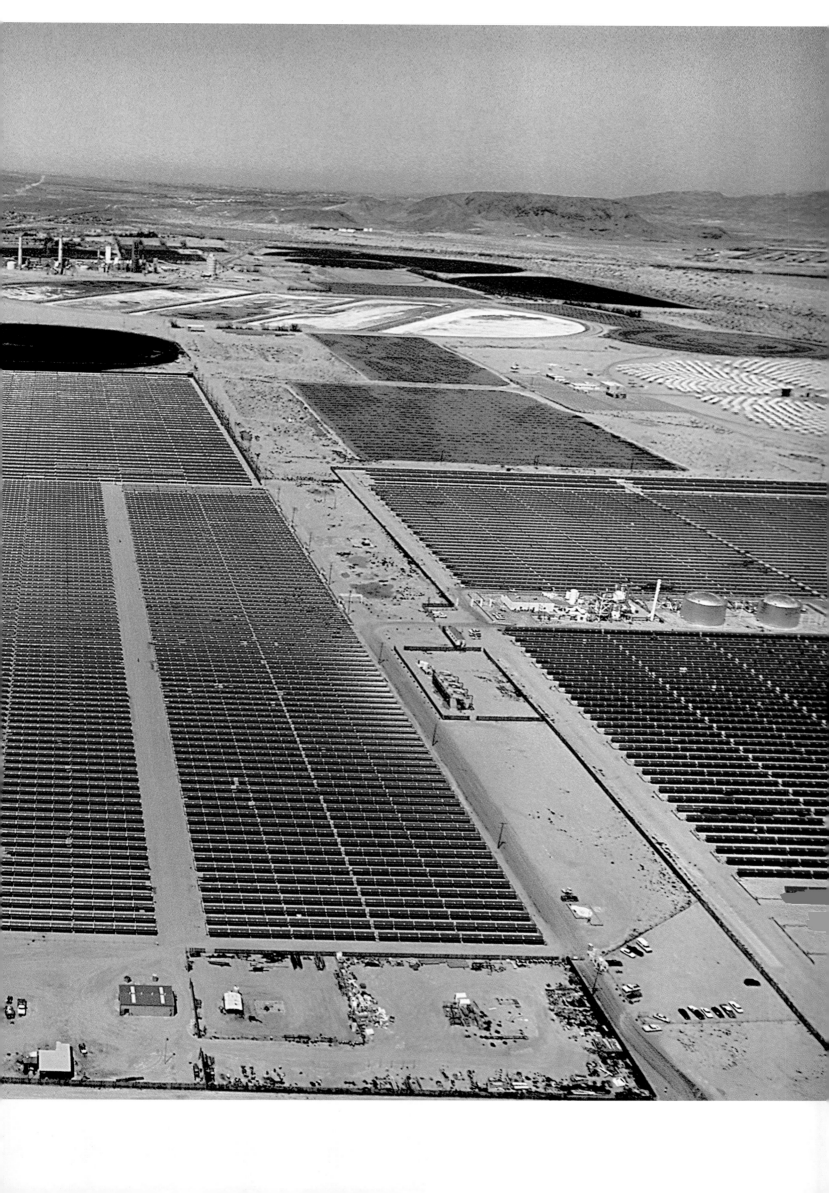

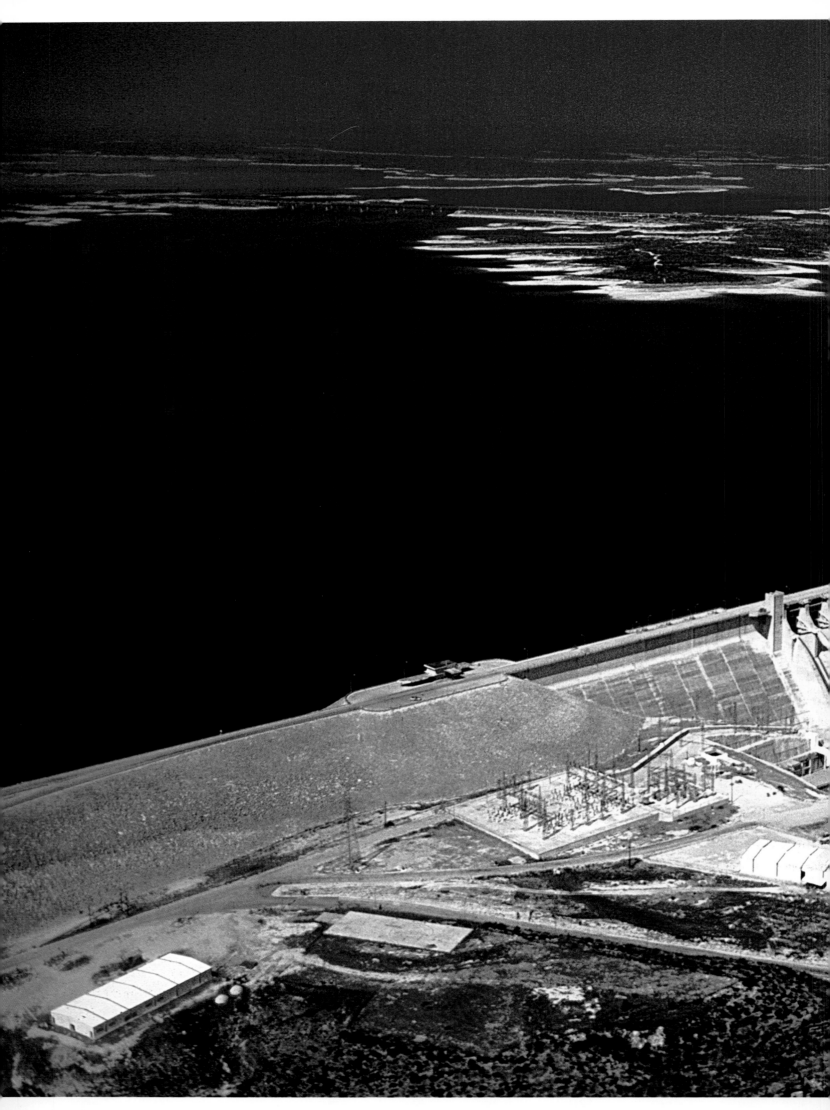

Del Rio, TX
Built mainly for flood control, the Amistad Dam is the largest dam on this section of the Rio Grande River. The U.S. and Mexico each manage their own hydroelectric generating facilities at the Amistad. The U.S. facility generates 161,000 megawatt hours a year, providing power for approximately 15,000 homes.

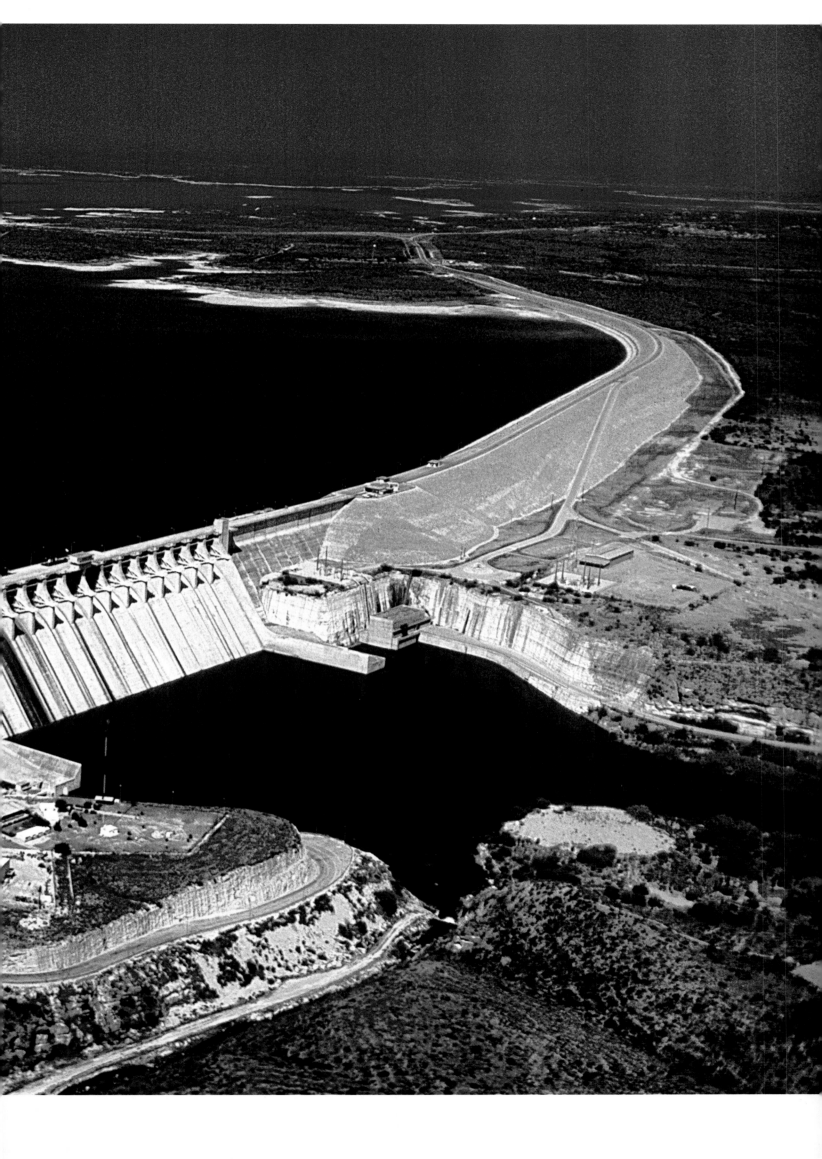

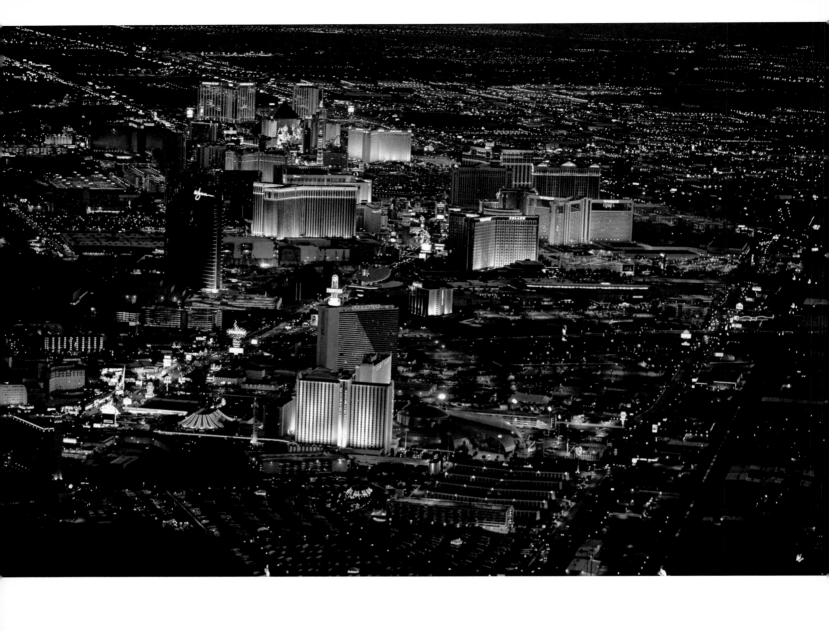

Las Vegas, NV
The last U.S. census named Las Vegas America's fastest-growing city. Between 1990 and 2000, Sin City expanded by 3 percent in the downtown area and by over 12 percent in the outlying suburban areas. At night, the entire Las Vegas Valley glows.

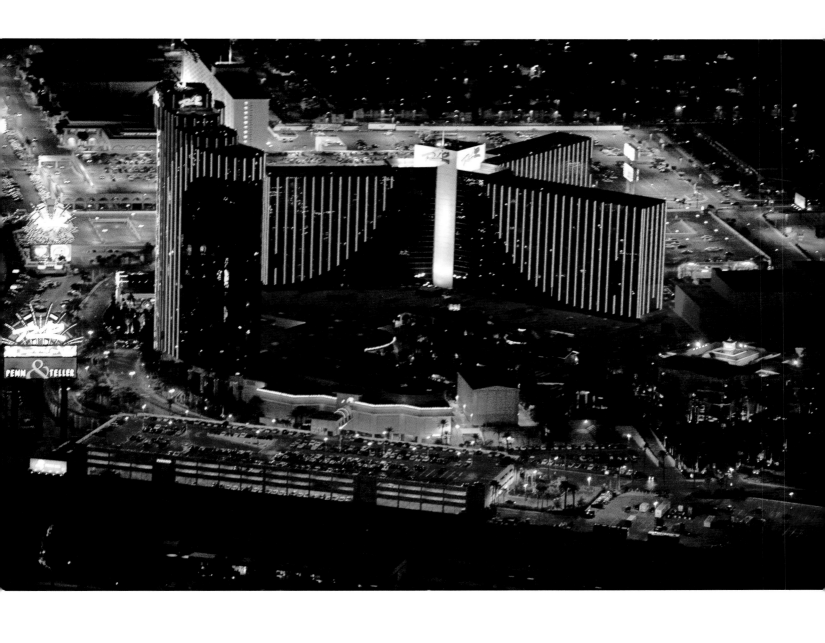

Las Vegas, NV
Bright lights are a staple of Las Vegas's booming tourist business. In 2001 alone, the amount of electricity used to light hotel facades on the Vegas Strip could have powered 23,500 homes.

Homestead, FL
High-tension wires leaving Turkey Point's nuclear power plant cross coastal wetlands. America's electricity grid employs 157,000 miles of high-voltage electric transmission lines.

Eastpoint, FL
A highway bridge and high-tension lines cross Apalachicola Bay. Demand for power in the United States has increased by 25 percent since 1990, while construction of new power lines has decreased by 30 percent over the same time period. Overstressed grids are less efficient, and U.S.-wide grid power losses amounted to nearly 10 percent in 2001.

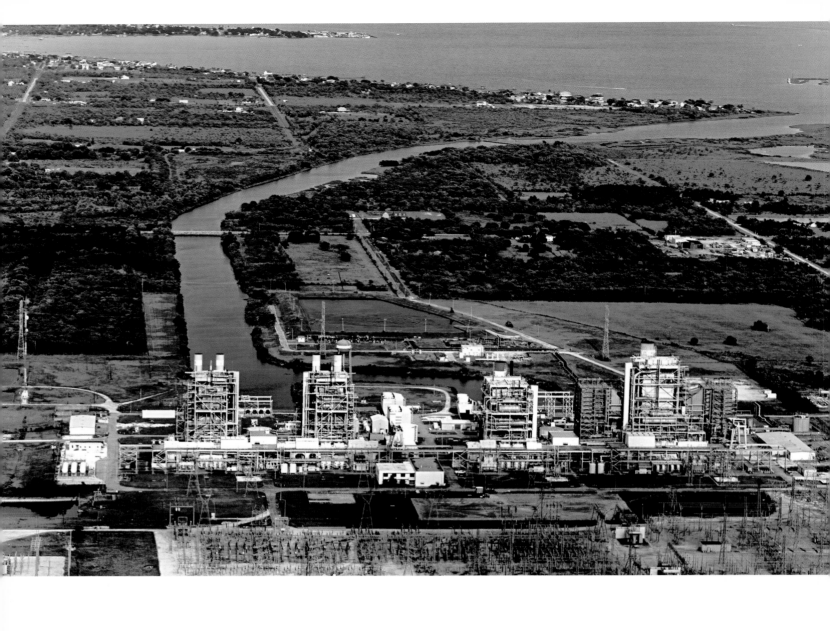

Bacliff, TX

P. H. Robinson is a small natural-gas power plant in South Houston. It is an example of a peaker plant, whose generators are turned on during peak usage times. Per unit of electricity generated, natural gas power plants release half the amount of carbon as coal power plants.

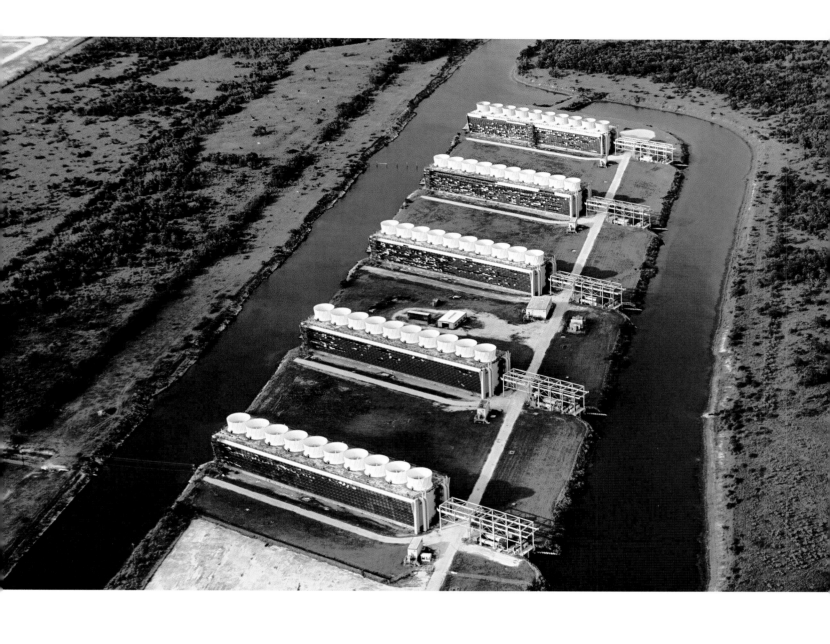

Bacliff, TX

The P. H. Robinson natural gas power plant uses water from Galveston Bay for its one-pass cooling system. Here, fans and evaporators within the cooling units bring down the temperature of the water before it is returned to the bay.

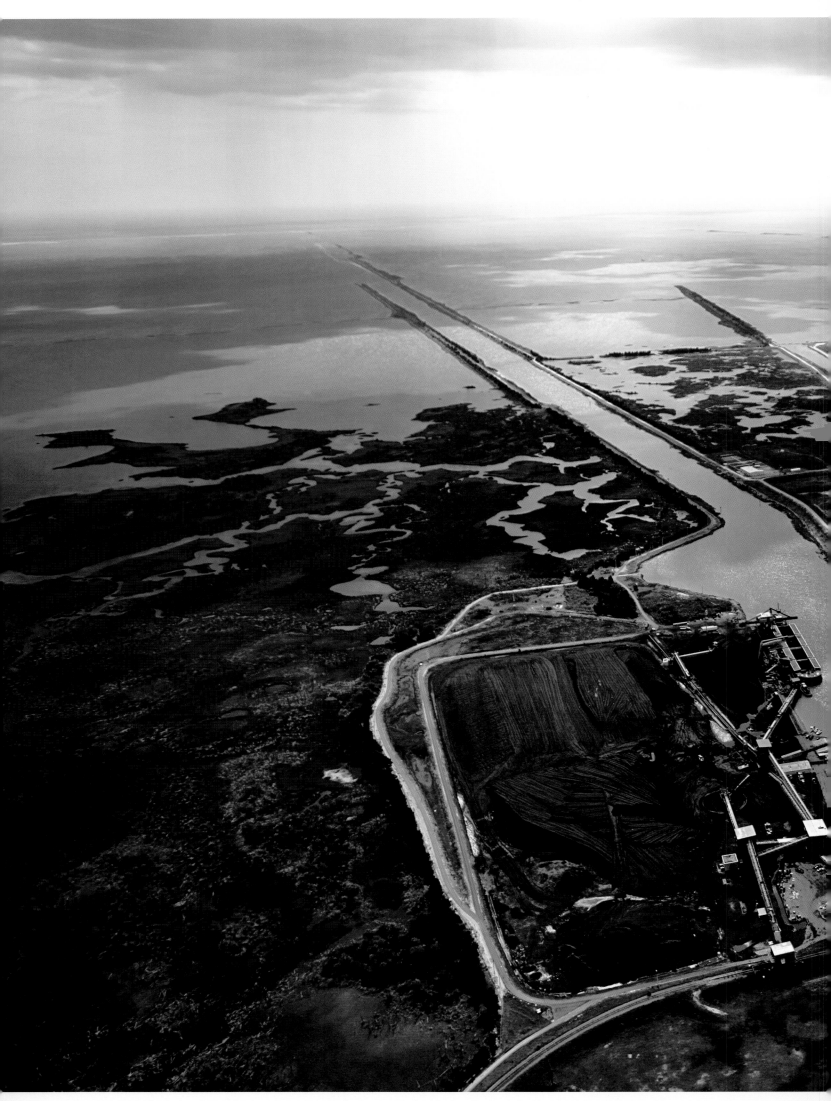

Crystal River, FL
The Crystal River Three Generating Station produces 6.6 megawatt hours per year and uses a one-pass cooling system. The left channel brings in water from the Gulf and the right channel returns it. Cooling units on the right channel bank help reduce the water's temperature upon exit. The excess heat and the energy to run the cooling system represent wasted energy.

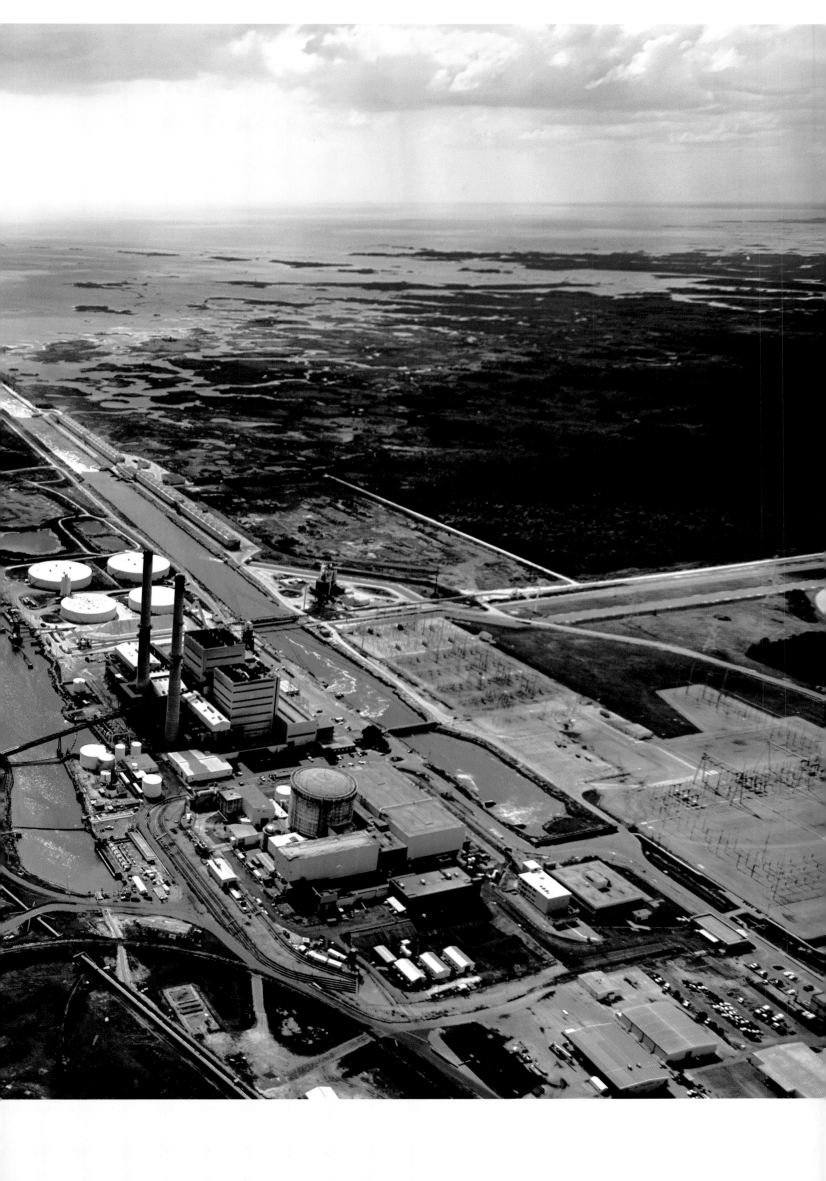

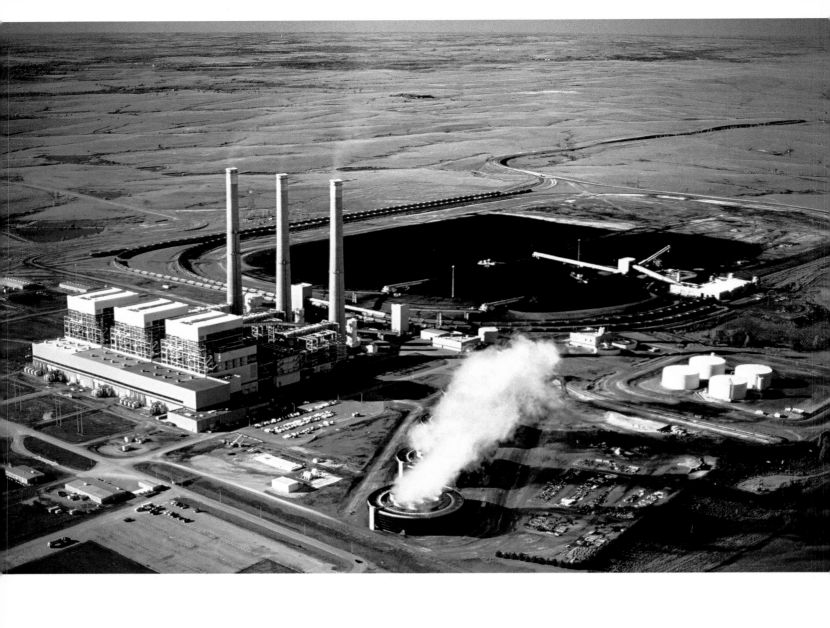

St. Marys, KS
Jeffrey Energy Center produces nearly 14 million megawatt hours per year and over 16 million tons
of CO_2 yearly. Among generating facilities, it is America's fifth-largest emitter of mercury, releasing
more than 1,000 pounds per year.

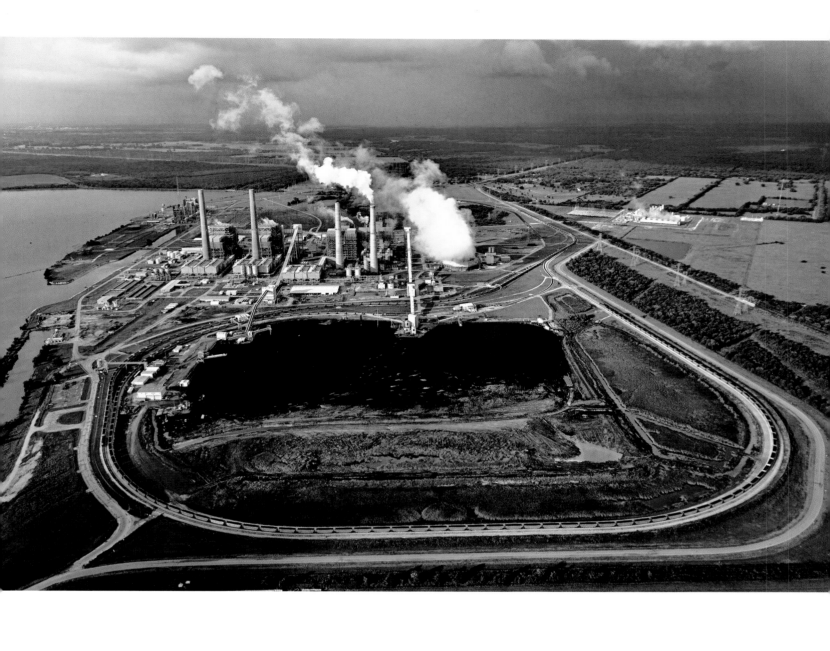

Sugar Land, TX

W. A. Parish is a coal-fired facility whose four generators produce nearly 19 million megawatt-hours per year. Encircling the plant's stockpile of coal (center) is a mile-long train that brings in low-sulfur coal from Wyoming. Each day, the plant consumes 36,000 tons of coal, which amounts to three mile-long trainloads.

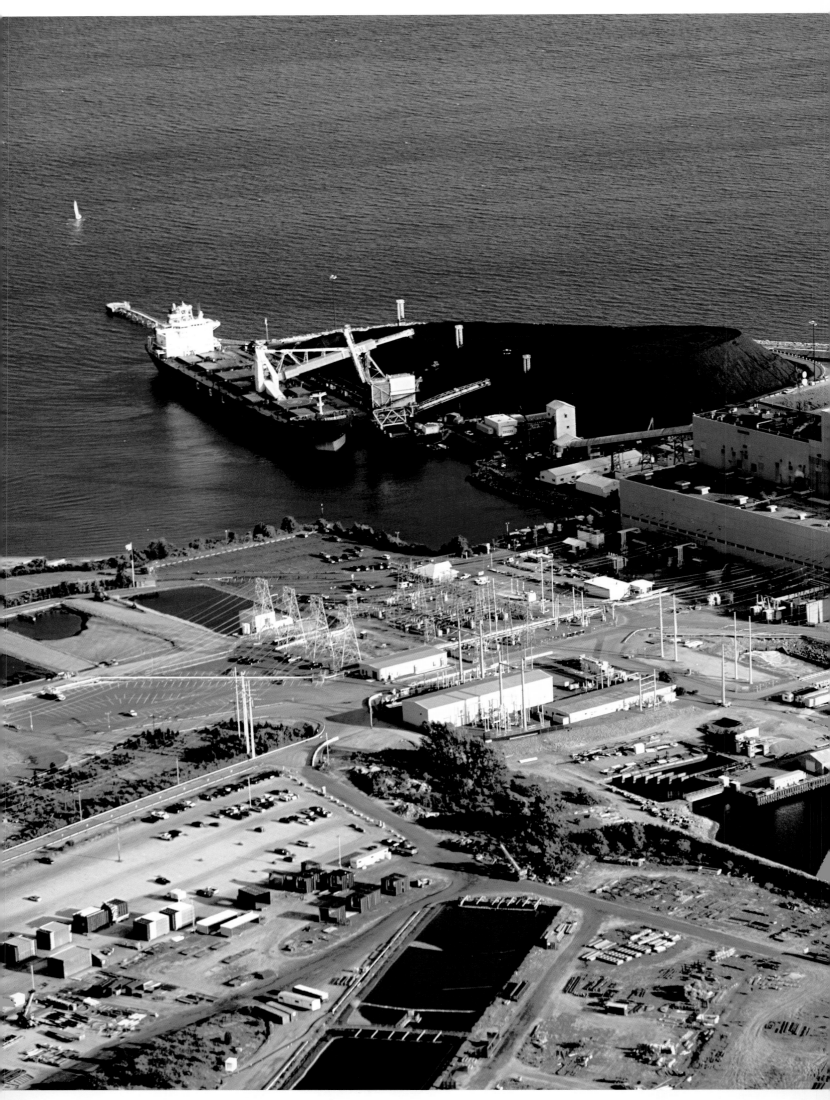

Somerset, MA
PG&E's Brayton Point Generating Station withdraws nearly 1 billion gallons of water daily from
Mount Hope Bay to cool steam in its condensers. Water is let out into the bay at temperatures of up
to 95 degrees Fahrenheit, killing microorganisms and disrupting fish habitats. Currently, nearly
$500 million is being spent to retrofit the facility with two 350-foot closed-circuit cooling towers.

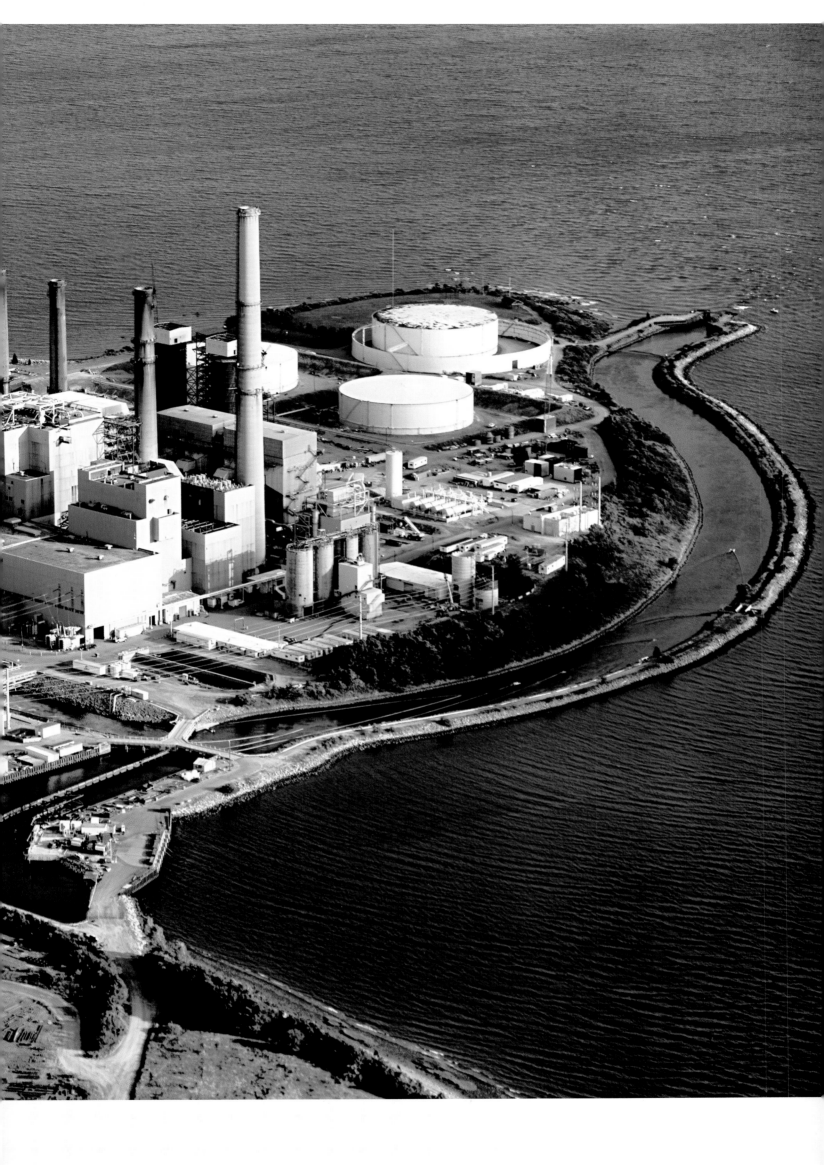

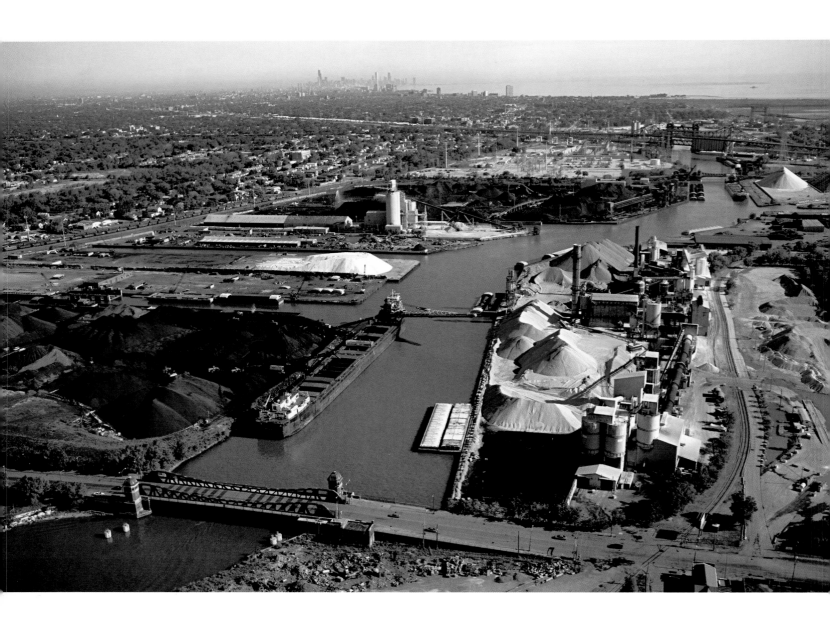

Chicago, IL
A large lake freighter unloads coal for shipment by rail. Coal-fired power plants are responsible for
nearly 80 percent of the electricity industry's CO_2 emissions.

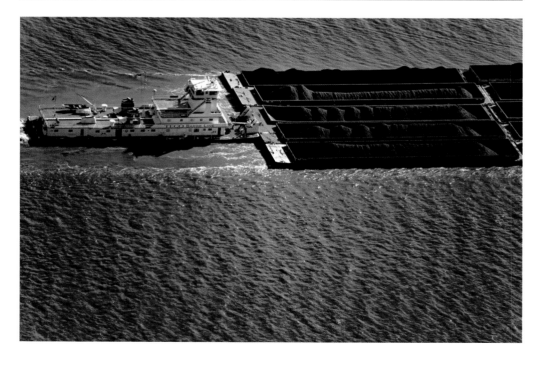

Belle Chasse, LA
Eleven percent of U.S. coal is delivered by barge, representing more than 100 million tons of coal. Most of this activity is concentrated here, on the Mississippi River, and on the Ohio River.

Mobile, AL
A tug boat and fuel barge alongside a coal freighter.

Belle Chasse, LA
In the United States, barge transportation is over 150 percent more fuel efficient than rail transport and over 700 percent more fuel efficient than trucking.

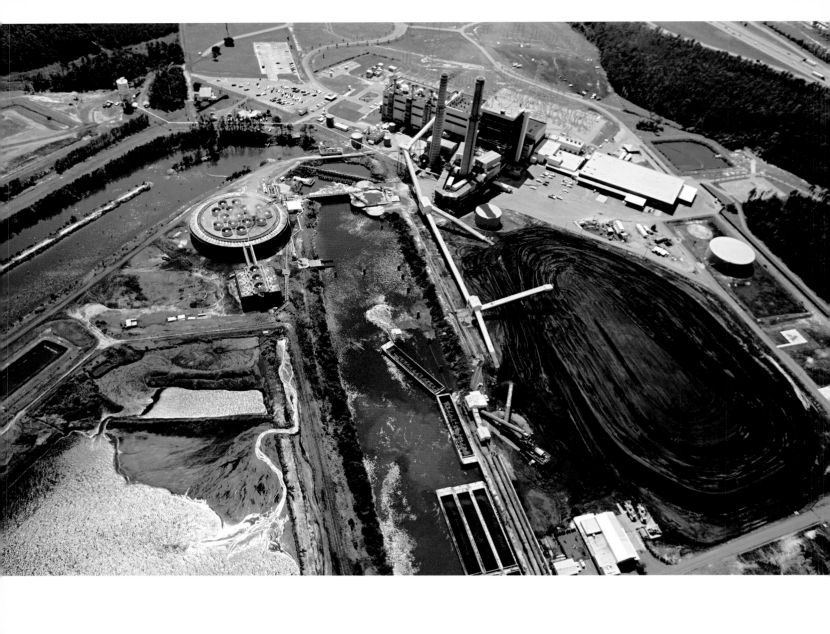

Gulfport, MS
Ash piles up in a pond (bottom left) at the Mississippi Power Company's Plant Watson facility, where
it will eventually be scooped up and recycled through to the construction industry for roads. During
Hurricane Katrina, nearly all of the plant's electrical controls and water pumps were damaged; the
plant became fully operational again in 2006.

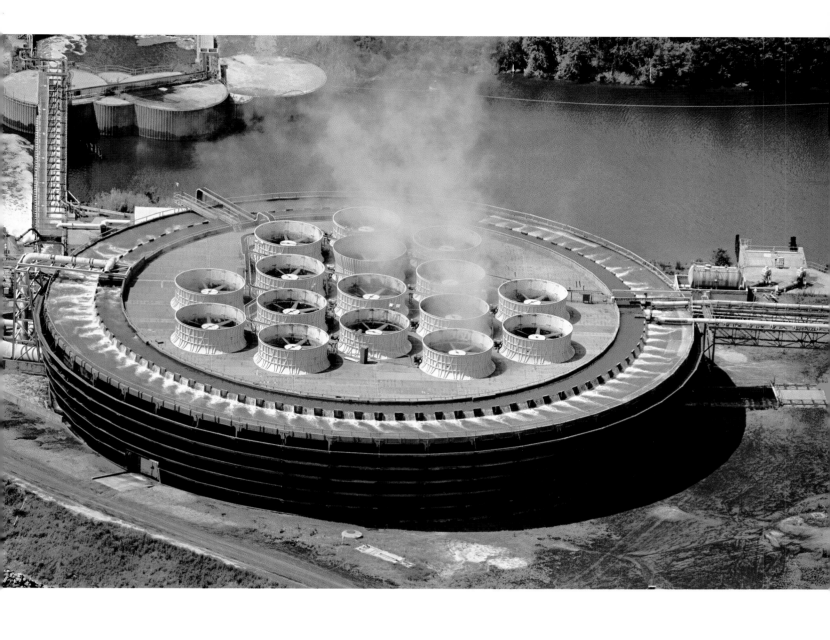

Gulfport, MS

When coal or natural gas is burned for energy, less than a third of the energy contained within these raw resources reaches the consumer as useful electricity. At Plant Watson (seen here), much of the facility's gross output, or the total amount of energy generated within its boilers, leaves the facility as steam and warm water from its circular cooling unit.

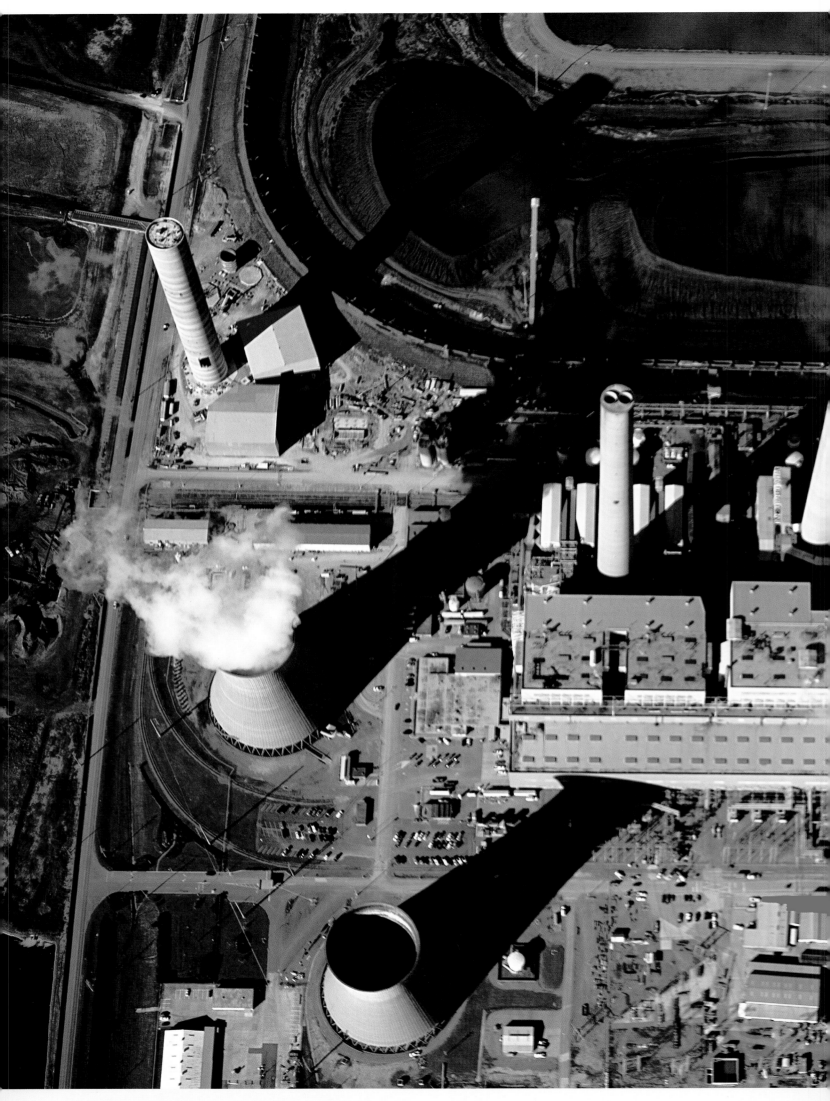

Euharlee, GA
Plant Bowen is the third-largest generator of electricity in the United States, producing more than 22 million megawatt hours per year and emitting 20.5 million tons of CO_2 and 900 pounds of mercury each year. Its four 400-foot-tall-by-300-foot-wide cooling towers are able to cool 300,000 gallons of water every minute. Its 1,000-foot-tall smokestacks cast long, ominous shadows.

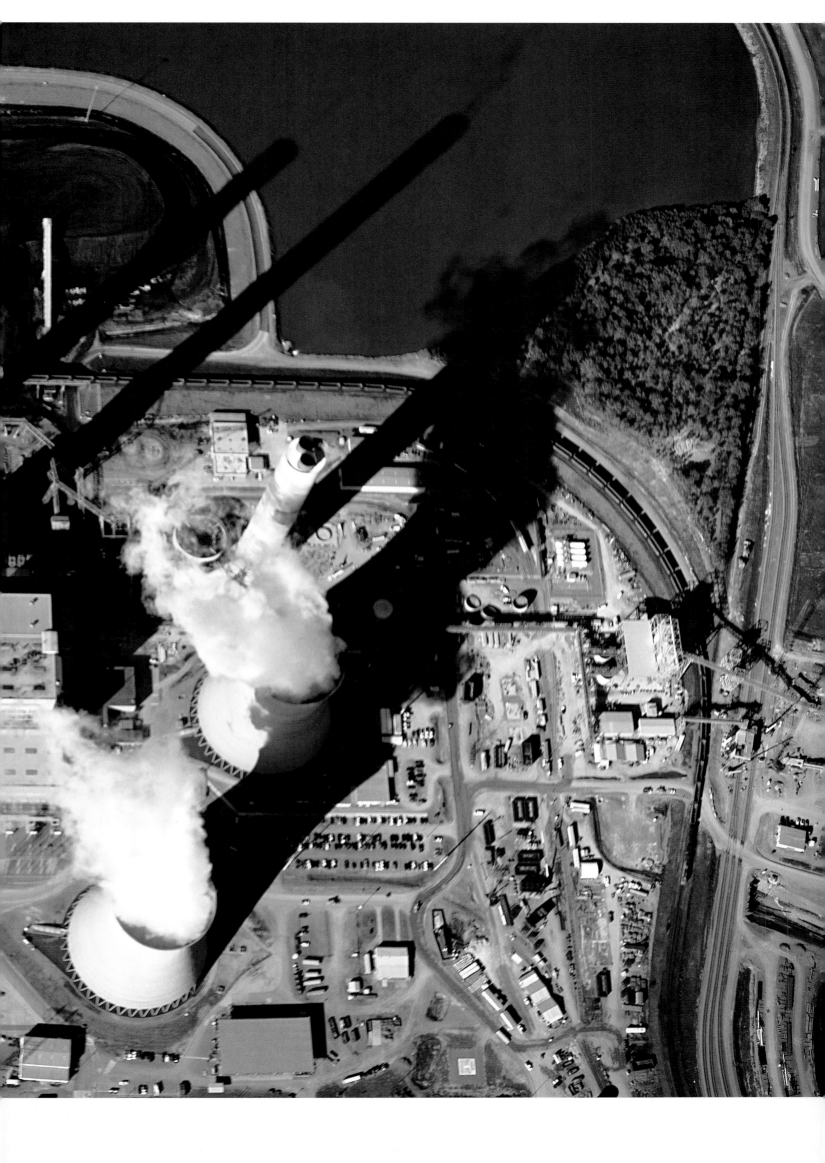

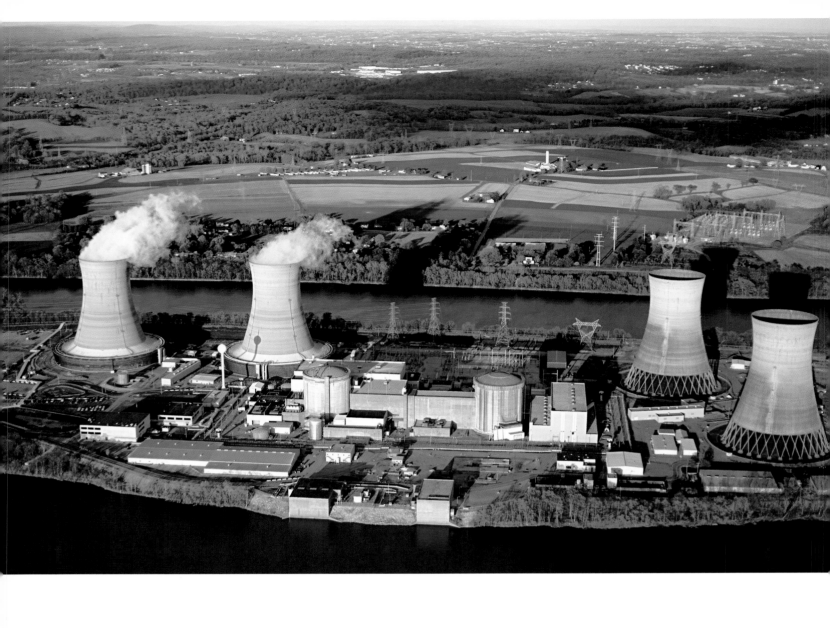

Harrisburg, PA
Three Mile Island, the site of America's worst nuclear accident to date, currently continues to operate one of its two reactors (left), as shown by the condensation leaving its cooling towers. The damaged reactor (right) took 12 years and cost nearly $1 billion to clean up.

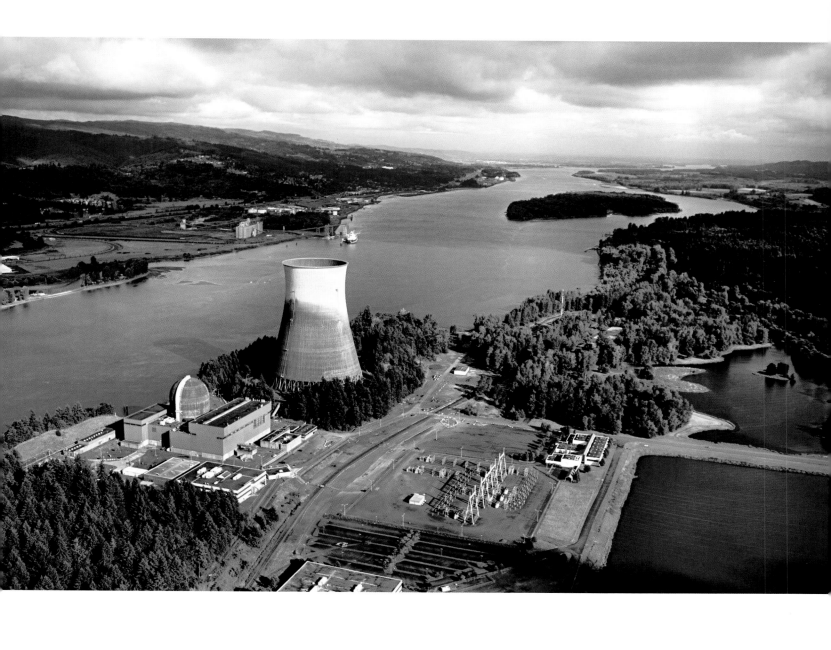

Rainier, OR

Trojan Nuclear Power Plant, seen here one year before the demolition of its 499-foot-tall cooling tower, was decommissioned only 16 years after it came into operation. Plagued by safety concerns and heavy popular opposition from the start, it remains the only nuclear reactor built in Oregon. In 1995 it cost $300 million to decommission, a job that itself took more than 17 years.

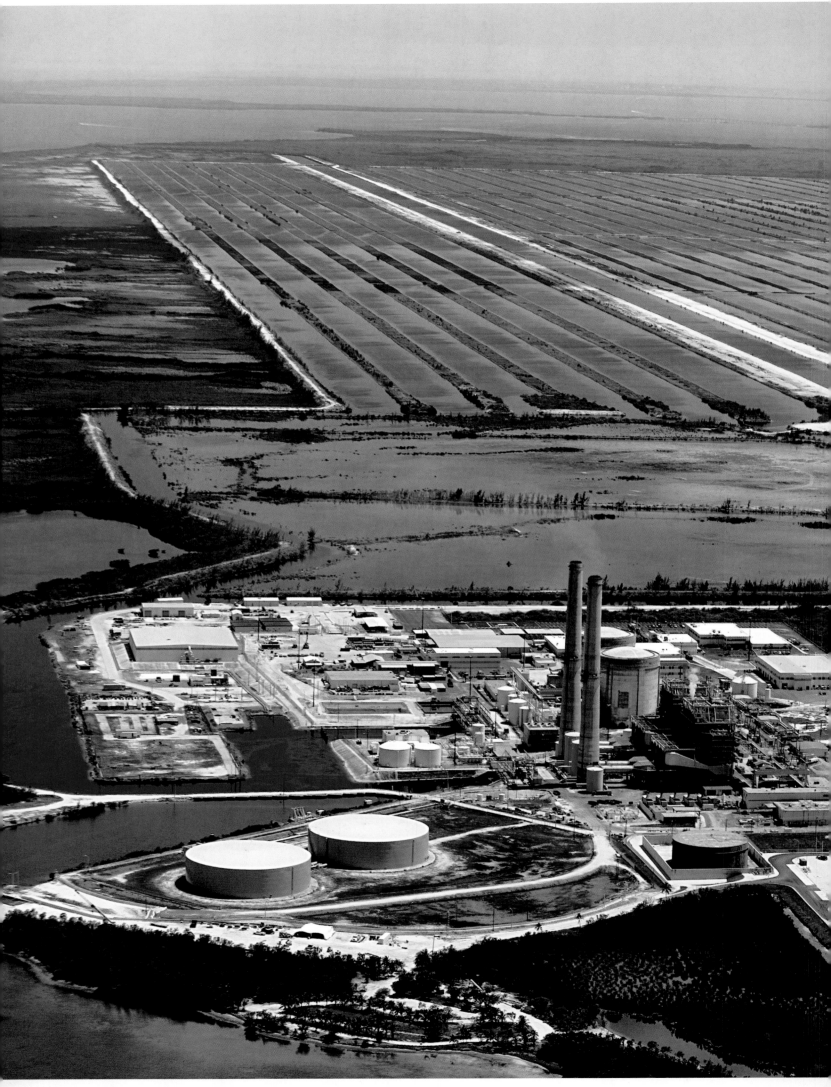

Homestead, FL
Turkey Point's nuclear reactors and oil- and natural gas-fired electric generators provide electricity
to 450,000 homes. It has a closed cooling system of 36 interconnected canals to cool the steam-
powered turbines.

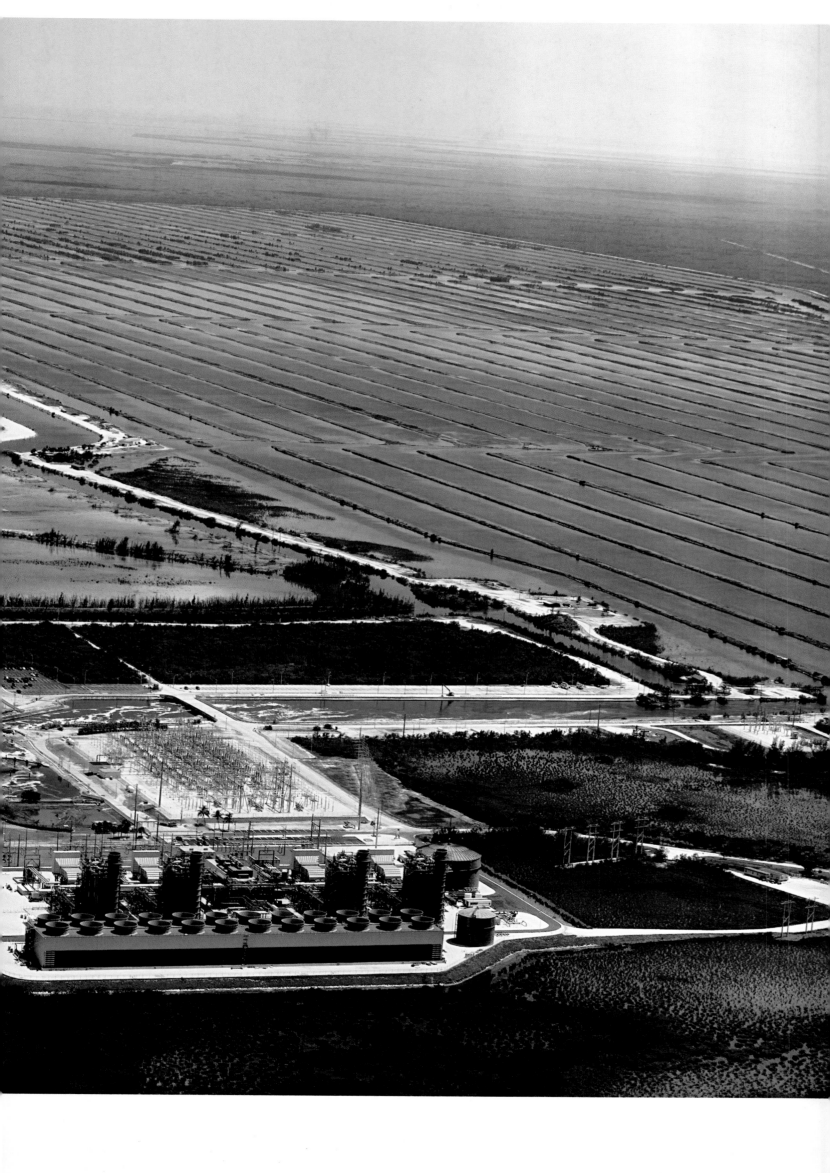

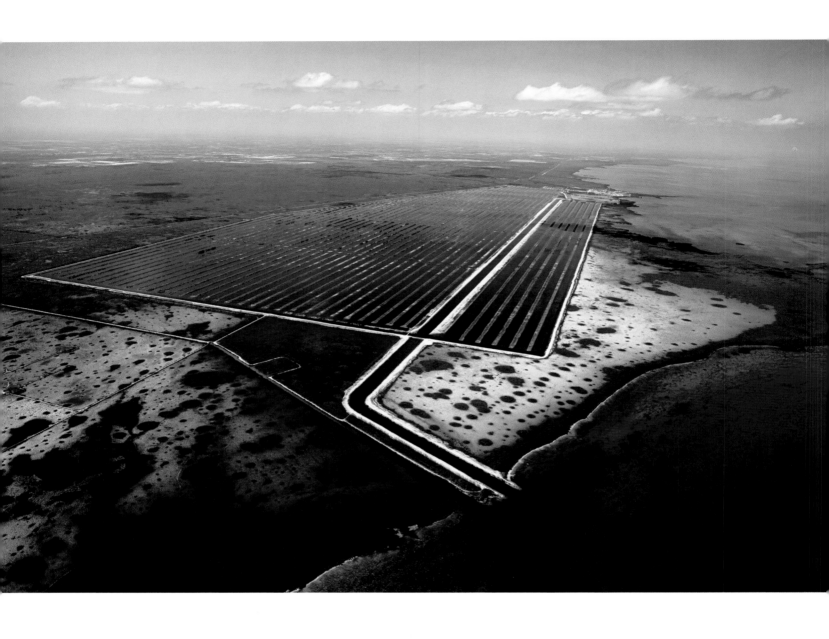

Homestead, FL

Turkey Point's canals act like a giant radiator to cool the water that travels 168 miles in 40 hours before it is circulated back to the condenser for reuse.

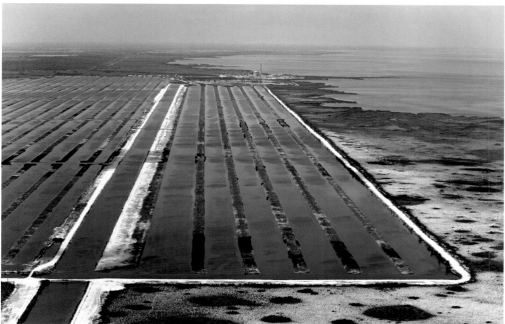

Homestead, FL
Turkey Point cooling canals. Closed-circuit, or indirect, cooling systems do not release heated water into the surrounding environment.

Homestead, FL
Turkey Point cooling canals. Nuclear generators give off most of their fuel's energy as wasted heat.

Homestead, FL
Turkey Point's cooling canals were dug in coastal wetlands.

Deserts

When you fly across the United States the land becomes arid as you pass west of the 100th meridian, a line of longitude extending from the North to the South Pole. Running through the United States along the eastern border of the Texas Panhandle and continuing north through the middle of the Dakotas, the 100th meridian is said to be the dividing line between the eastern and western halves of the United States. One of the most underappreciated differences between these two expanses is that, compared to the East, the West is largely arid, and, owing to a lack of water, there are miles of deserts and vast pockets devoid of people.

It is in this half of the country, especially in the Southwest, that I often find myself unexpectedly flying out over the middle of nowhere on the way to my next destination. The thoughts in the back of my mind at such times are similar to when I am flying above the ocean, out of sight of land; I am uneasy knowing that if I had to do a forced landing I would be in serious trouble. Looking out from the cockpit I wonder which direction I would walk to find civilization. It's a realization of how harsh and unforgiving these arid environments are, especially on a sizzling hot day. At these moments I attempt to reassure myself by remembering that I have filed a flight plan, that I have an emergency locator beacon onboard, and that I have an extra jug of water in the back of the plane.

At first it seems implausible that these same unforgiving lands are home to thriving cities such as Phoenix, Las Vegas, and Boise, sprawling with growth rates as high as any in the country. Water diversions, inexpensive hydropower, cheap land, and mild winter climates fuel the growth in these regions. As you fly into them, the desert surface, etched with dry-stream channels and scrub vegetation, changes to a more subtropical look, with irrigated agriculture fields, manicured golf courses, green lawns, and housing developments with palm trees. You can see the rapid growth evidenced in the extensive new construction of roads, endless strips of retail stores, and housing developments in various stages of completion, all being built on irrigated agricultural land or expanding out into the desert.

Suburban development on the arid landscape calls into question the natural carrying capacity of the land. So much of the new development, the materials, and the resources seem foreign and have been imported to the desolate

landscape. Perhaps even more foreign is the culture that has been established as more and more people have migrated onto these lands for jobs and inexpensive housing. The new residents do not seem to adapt to this environment but rather to impose what is familiar to them onto the landscape. There is little to suggest a local vernacular; rather, building materials have a transnational look, and structures' glazing and orientation have no connection to the sun's track across the sky—no thought has been given to reducing the heat load. Likewise, there are surprisingly few rooftop solar collectors for a place that uses so much energy—especially in the summer, when air-conditioning is essential. It is clearly an energy-intensive environment; there are few sidewalks, so most transactions have to be conducted by car. There are few signs of water other than what is diverted to the area by canals, irrigation ditches, and retention ponds. If these sources of water should dry up or be overspent, the rapid economic growth, along with the sprawling population, would likely wither very quickly. Better design, and buildings oriented to the local climate, could provide improved comfort, regional orientation, and, most importantly, conservation of energy.

Desert and arid developments are worth looking at in an environmental context, for they illustrate the vulnerability of large populations to climate change, calling into question population growth as a means of achieving economic growth. It is said that the water for cities will never run out, because cities can always take water from agriculture (which consumes 80 percent of the Southwest's usable water). San Diego is one of the first cities in the United States to pay farmers more for their water than they would have earned for their crops—validating the expression "water flows toward money." While it might be true that cities can depend on agriculture for water security, there are still predictions that Lake Mead and Lake Powell, two major diversion points on the Colorado River, will run dry by 2021 if demand does not let up.

In 1896 William Ellsworth Smythe wrote a book titled *The Conquest of Arid America*. The title alone speaks of the attitude and spirit of settling on these lands, a conquest that was under way when the federal government became involved in funding land reclamation in 1902. The use of the term *reclamation* stemmed from the belief that irrigation projects would "reclaim" arid lands for human settlements envisioned as small farms. The Reclamation Service began

building water infrastructure projects—including water diversions, dams, reservoirs, canals, and ditches—and hydroelectric plants for cheap energy. The agency was formally established as the U.S. Bureau of Reclamation in 1923 and undertook many large public-works projects during the Depression, such as the building of Hoover Dam. The Bureau also aided the resettlement of small farmers migrating from the Great Plains to escape the extended drought that caused the Dust Bowl of the 1930s. These farmers were settled farther west, to lands that were inhabitable thanks to the Bureau's irrigation projects.

The Dust Bowl reminds us that the earth has natural cycles, including long-term drought. The prolonged dry conditions caused the largest migration in American history, with 2.5 million Americans leaving the Great Plains. Centuries earlier, in the Southwest, drought also caused the collapse of the Anasazi civilization centered at Chaco Canyon. Which raises the question, how would the 35 million people now living in the arid Southwest survive a severe drought of similar magnitude? Climate change and rising temperatures will make this scenario more likely.

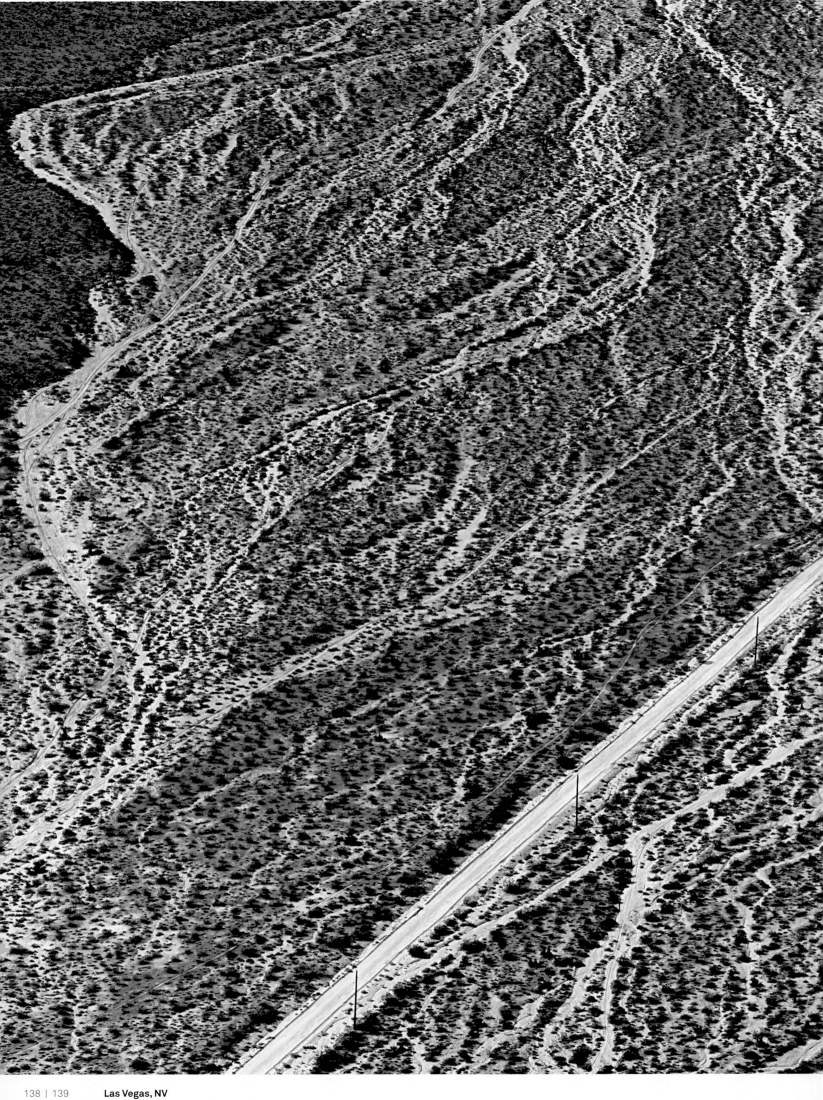

Las Vegas, NV
An isolated stretch of road and utility line passes through shrub desert etched by creeks
and washes.

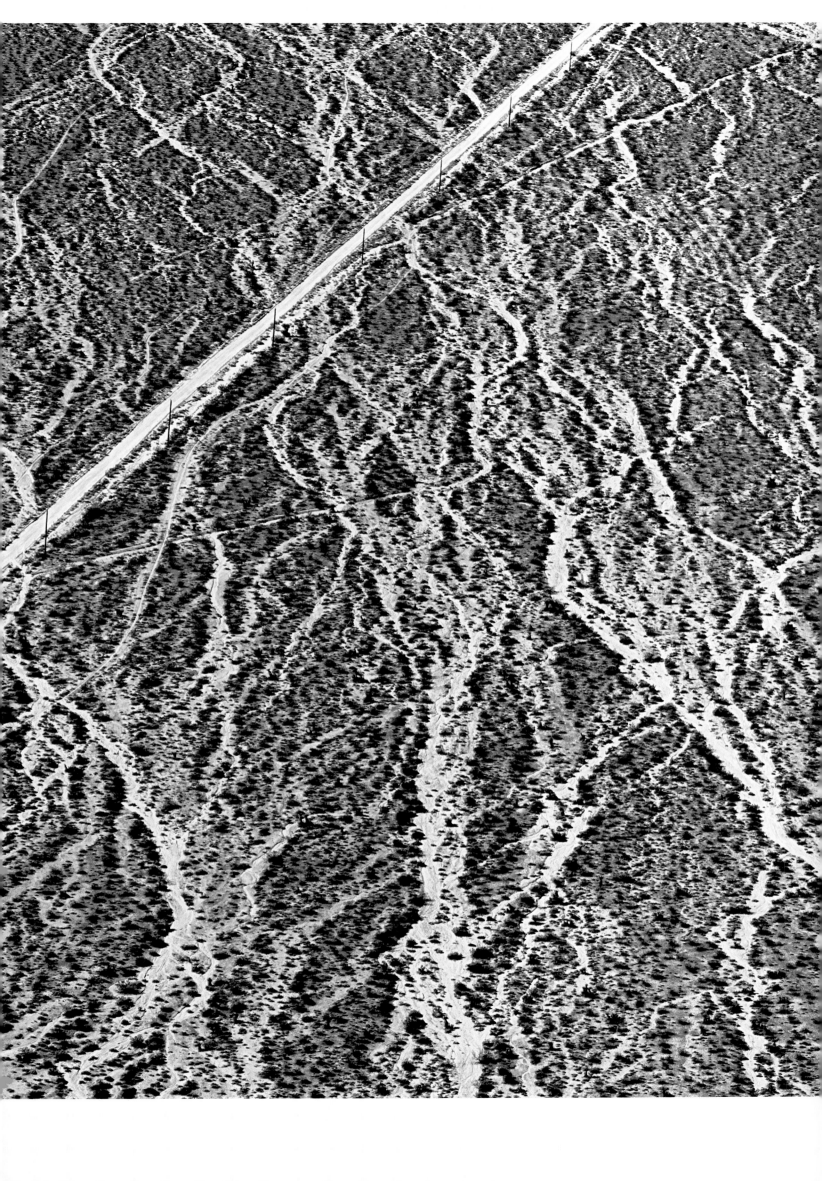

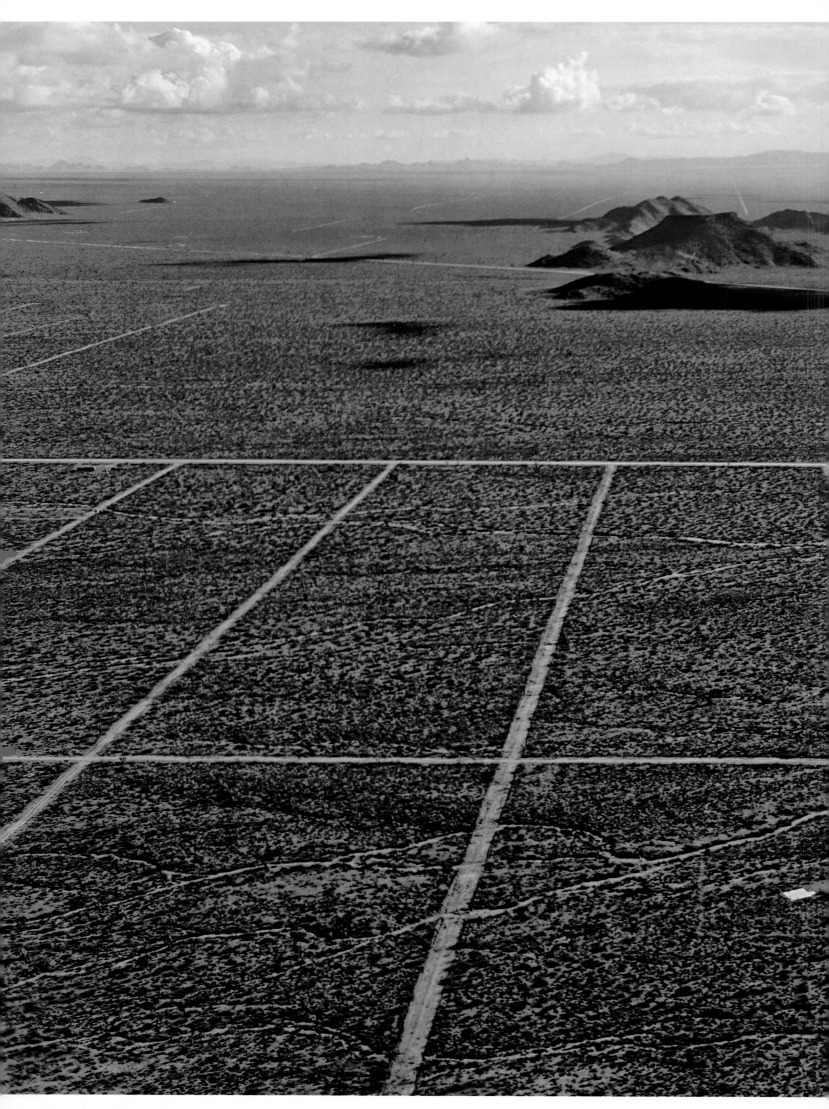

Signal, AZ

A land-development company has drawn out a grid of roads onto the desert to sell 20-acre lots for speculation. Future homeowners here will have to drill 600-foot wells for water and generate their own electricity.

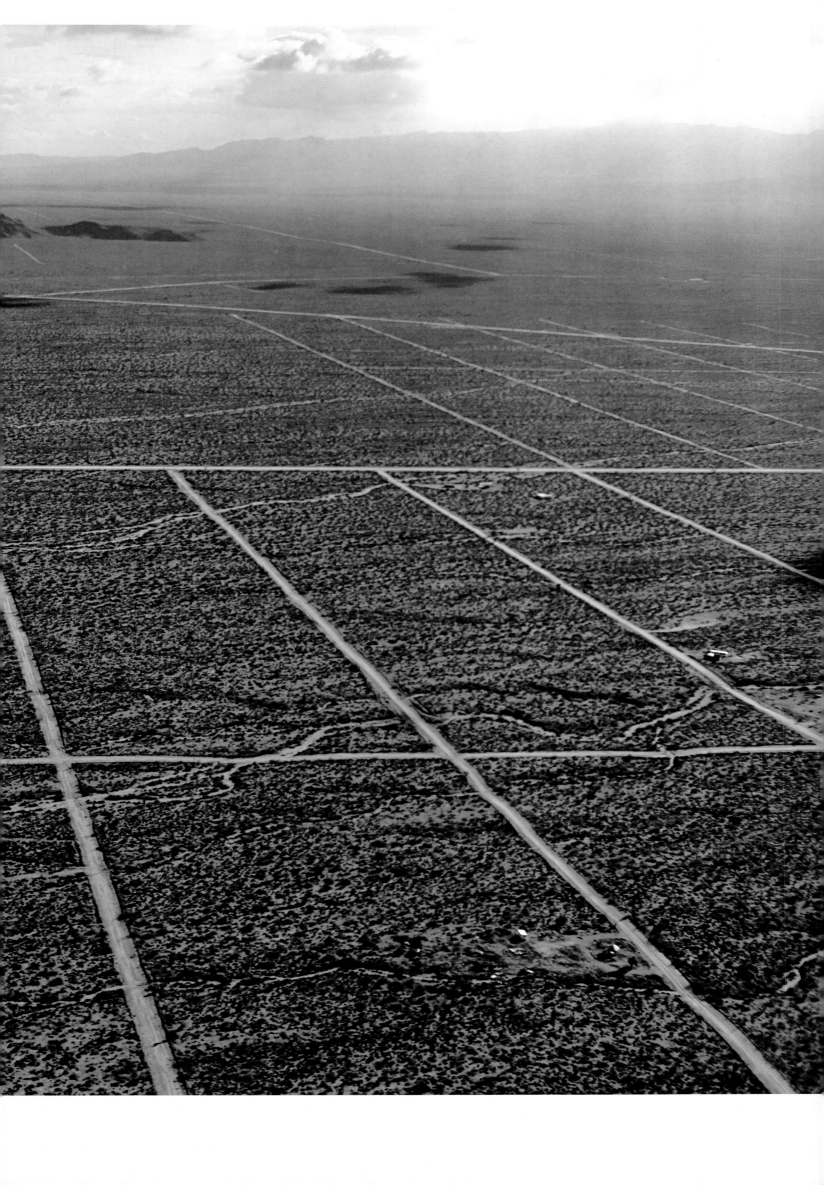

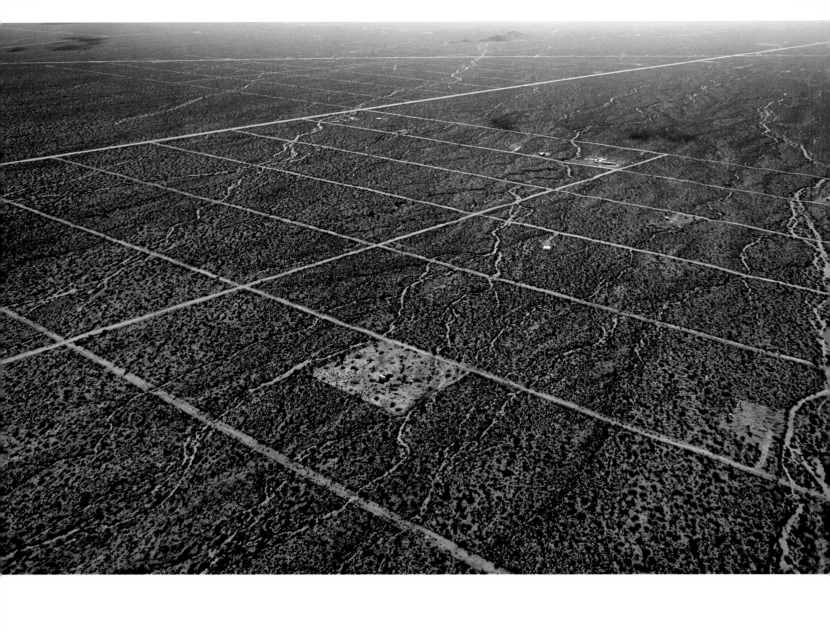

Signal, AZ
The footprint of a single lot stands out on the grid of another speculative land-development project
in undeveloped desert. Because desert plant life is fragile, development will leave a long-lasting
mark on the desert floor.

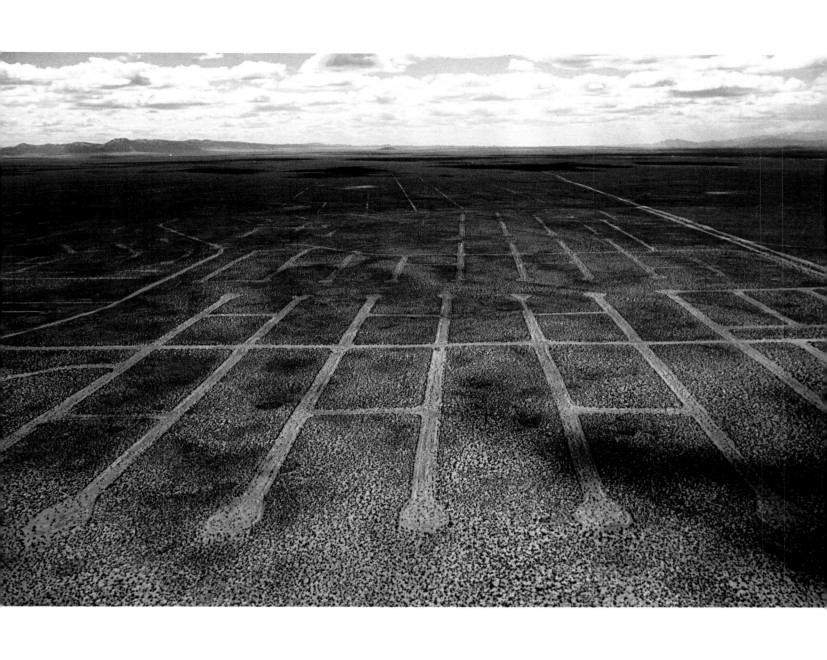

Northwest of Albuquerque, NM
Cul-de-sac land speculation maps out an undeveloped suburban community.

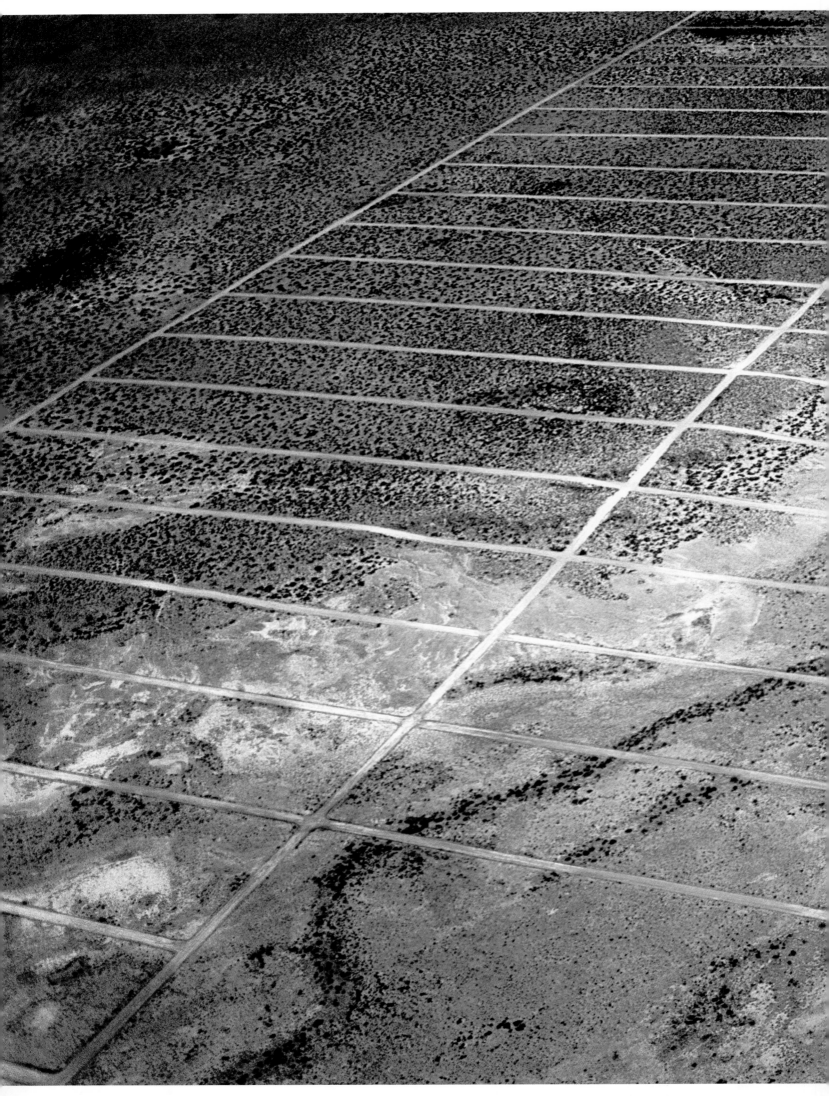

Deming, NM
Graded roads laid out in 1950 created a grid for property, speculation, and the sale of quarter-acre lots for "ranchettes." Nearly 60 years later, roads from the failed project are still clearly stamped on the landscape.

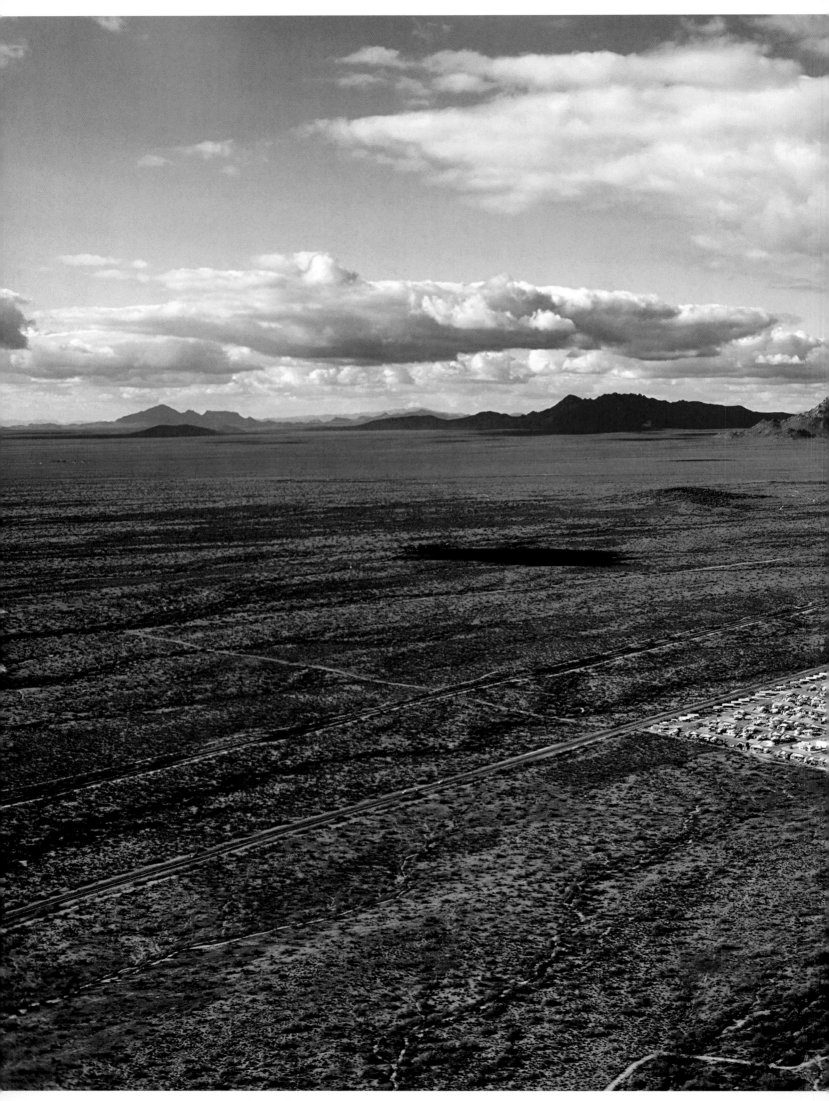

Congress, AZ
A quarter-square-mile mixed mobile home and permanent housing development sits in the middle of the desert. This development consolidates all necessary public services into its small community. The nearest commercial settlement is five miles away. The nearest city, Phoenix, is 60 miles away.

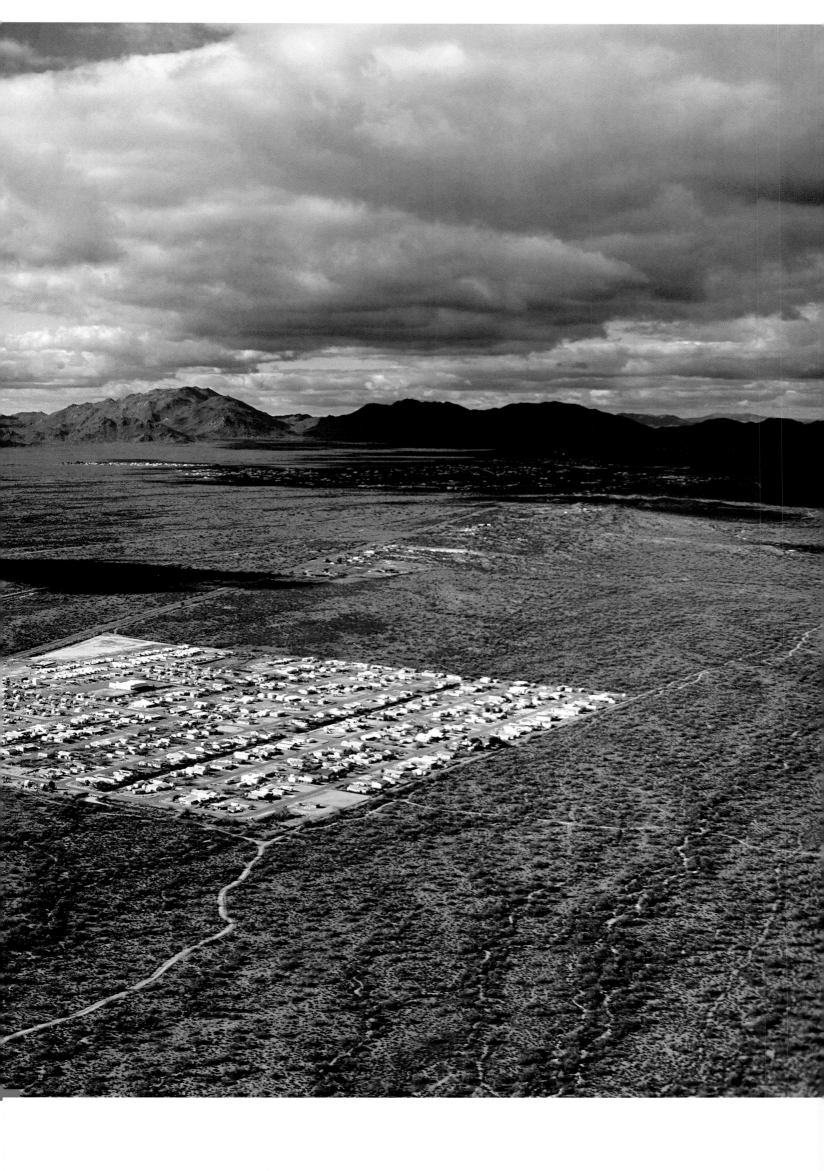

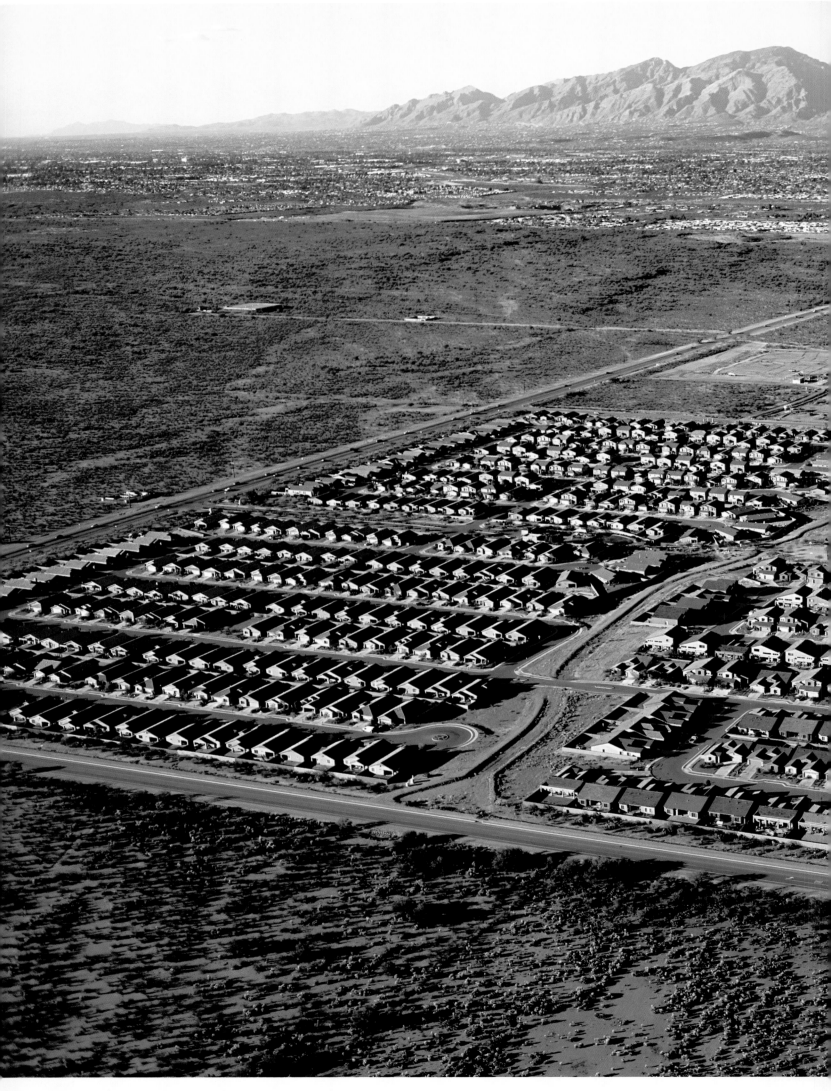

Civano, AZ
Sierra Morado, part of the Civano community, is a master plan development that includes strict
standards for energy efficiency in its homes and pedestrian-friendly streets. However, similar to
much rapid-growth development throughout the West, homes in this subdivision, built by a national
home builder, lack an indigenous, local style.

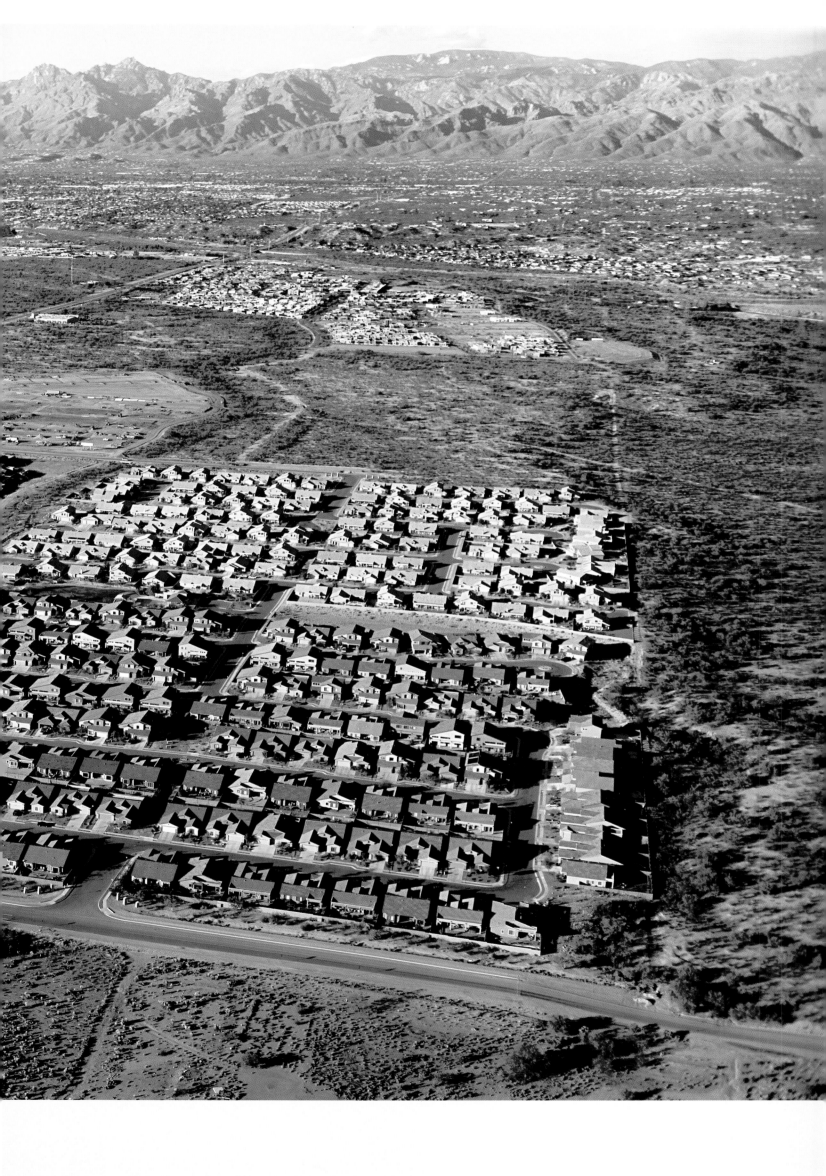

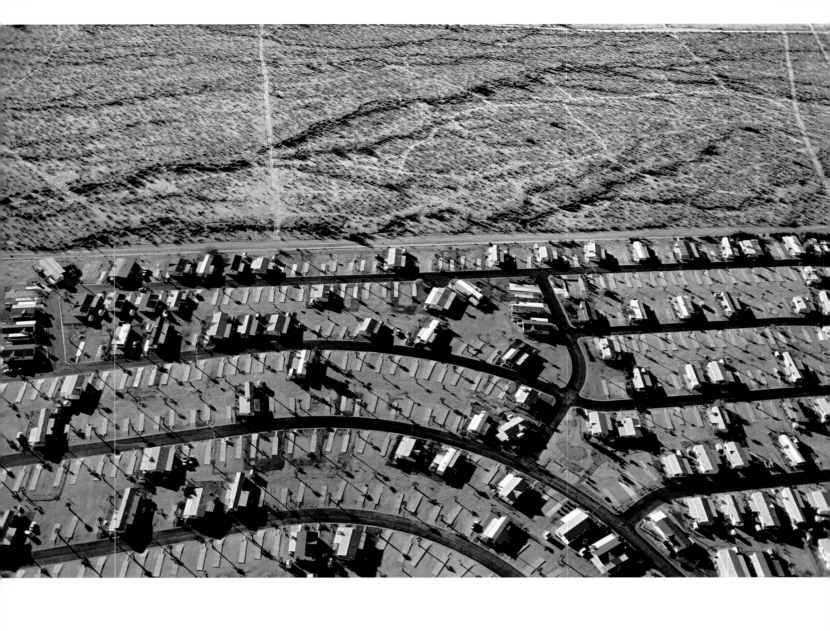

Buckeye, AZ
Buckeye's population has tripled in the last six years from roughly 10,000 to roughly 30,000
residents, making it the second-fastest-growing city in America. The Bona Vista mobile-home park,
seen here, has yet to be fully filled in with manufactured homes.

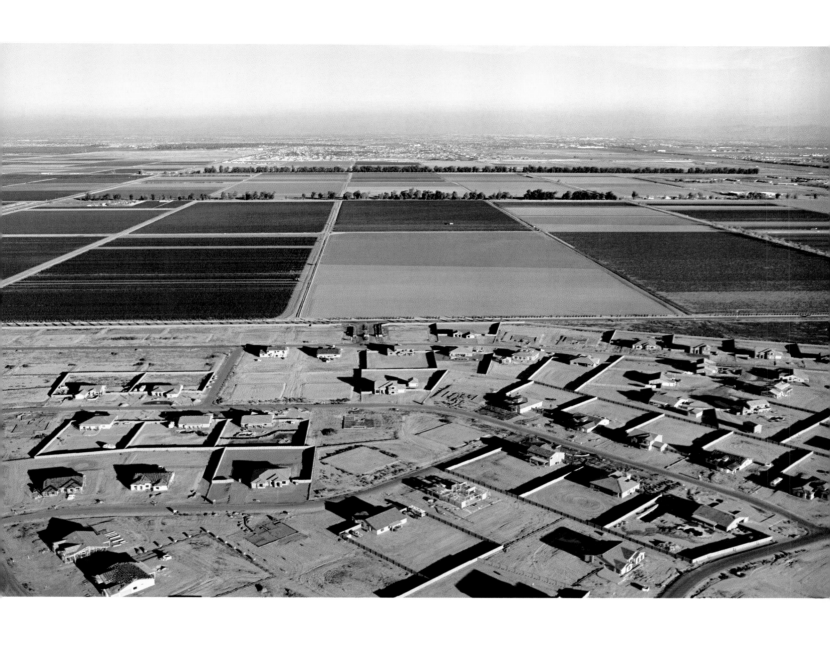

Goodyear, AZ

A new development spreads out over irrigated desert farmland. The community gets water from a combination of groundwater and water diverted from the Colorado River. Neighboring farms grow vegetables for export to other parts of the country.

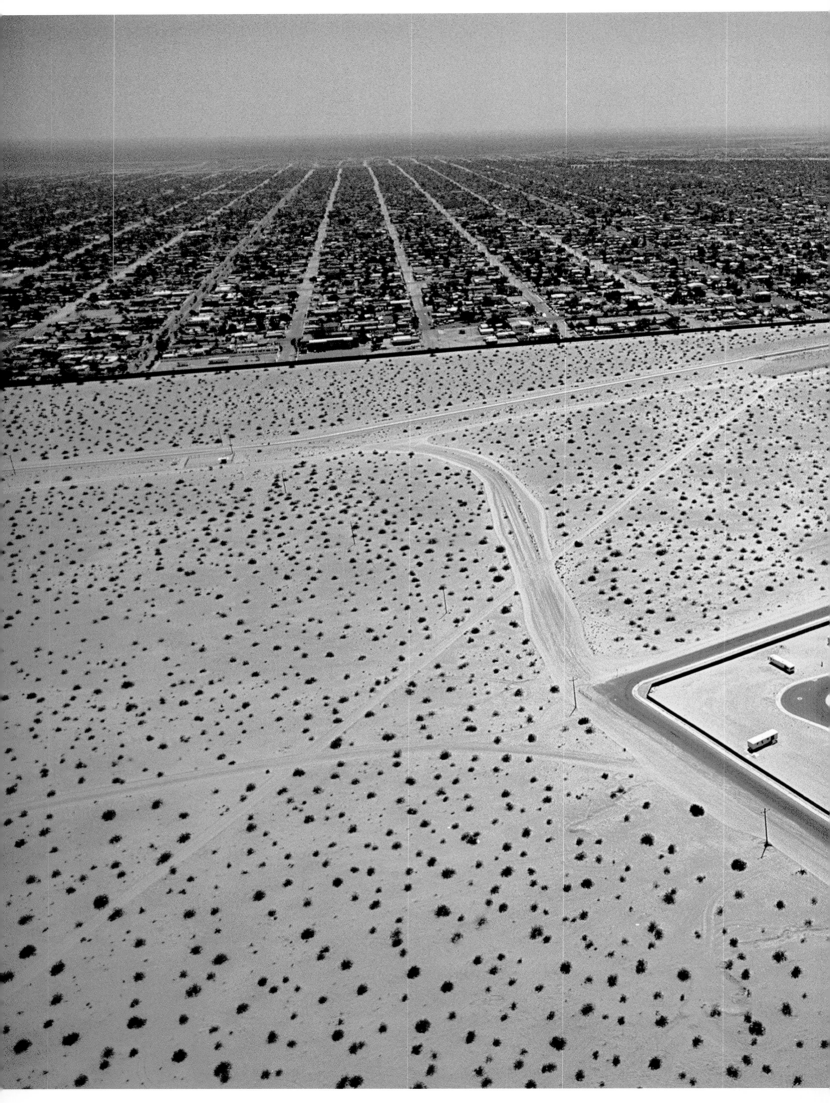

San Luis, AZ
A sparsely settled American trailer park sits in stark contrast to the dense Mexican border town
San Luis Rio Colorado. Hardships from climate change will affect food pricing and labor markets,
directly influencing Mexican-U.S. migration.

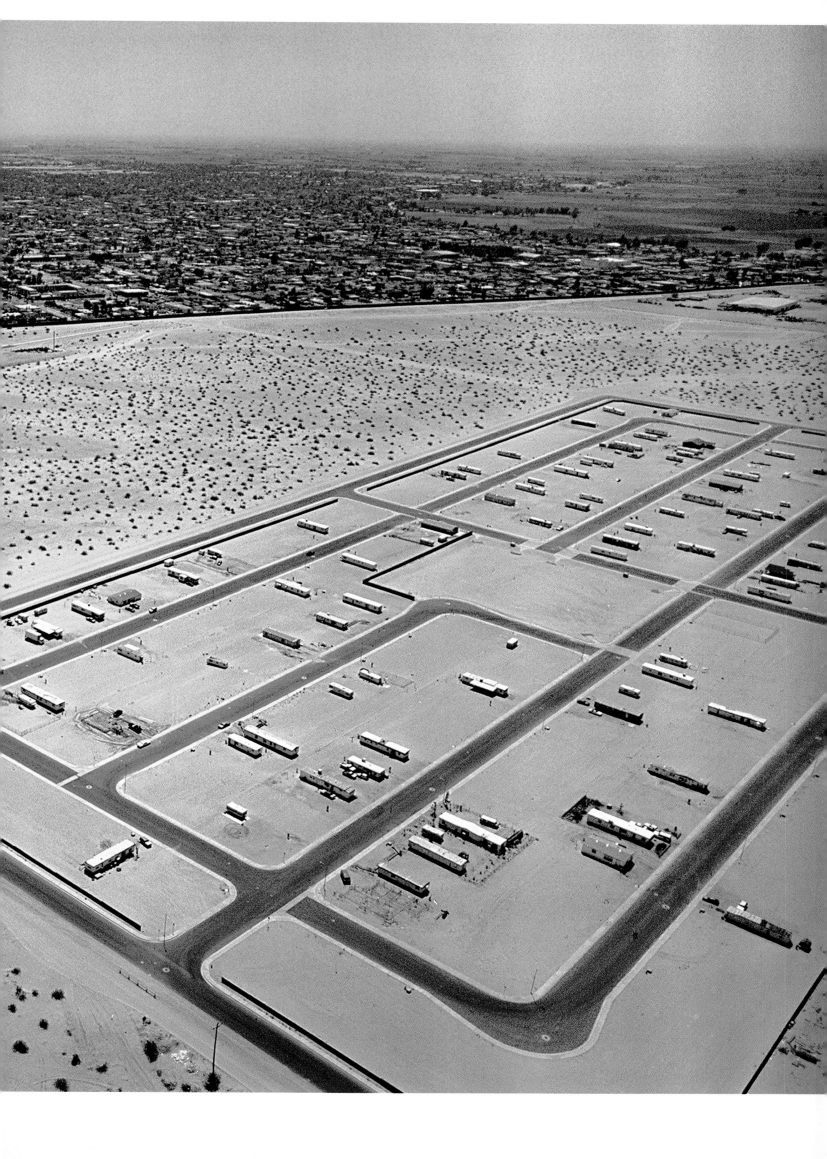

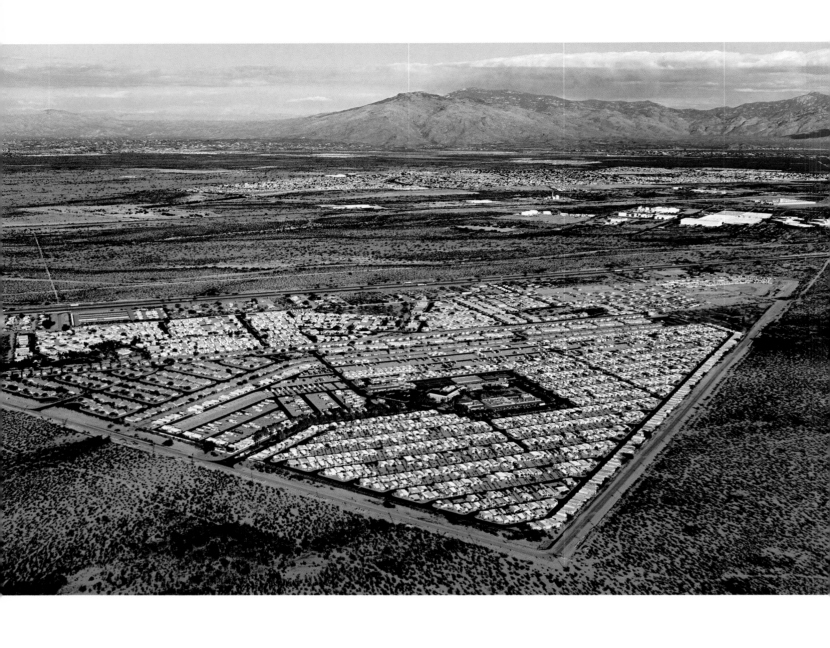

Tucson, AZ

Trails West, located 10 miles south of downtown Tucson, is a 55-and-over mobile-home community with planned activities and a clubhouse for residents. Built by an outside developer responsible for many similar communities across the country, it is designed to be an insular refuge for retirees.

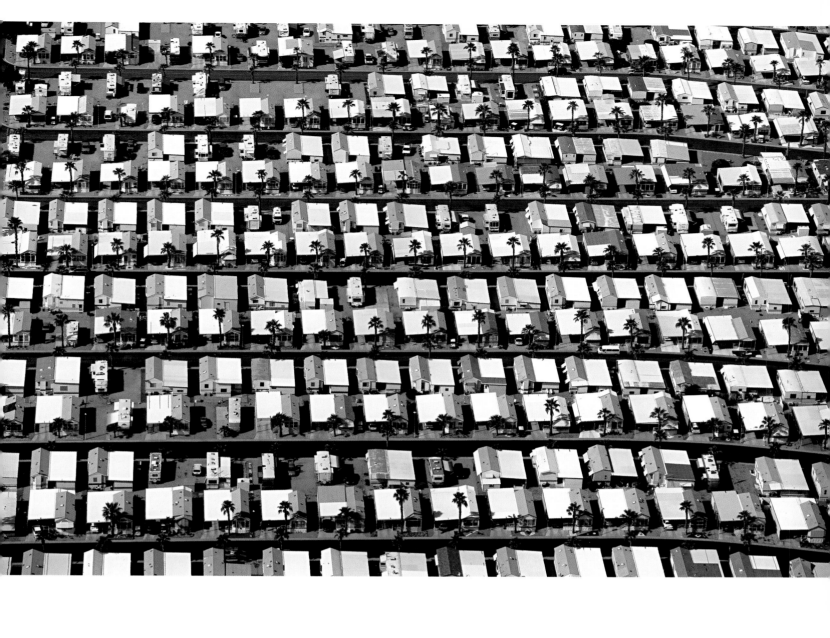

Surprise, AZ

More than 22 million Americans live in mobile homes. Despite the name, many are virtually permanent, because they have structural additions such as decks or carports or are older and fail to meet the contemporary building codes established in most areas. Often, they are the only way that a family can afford a home of their own.

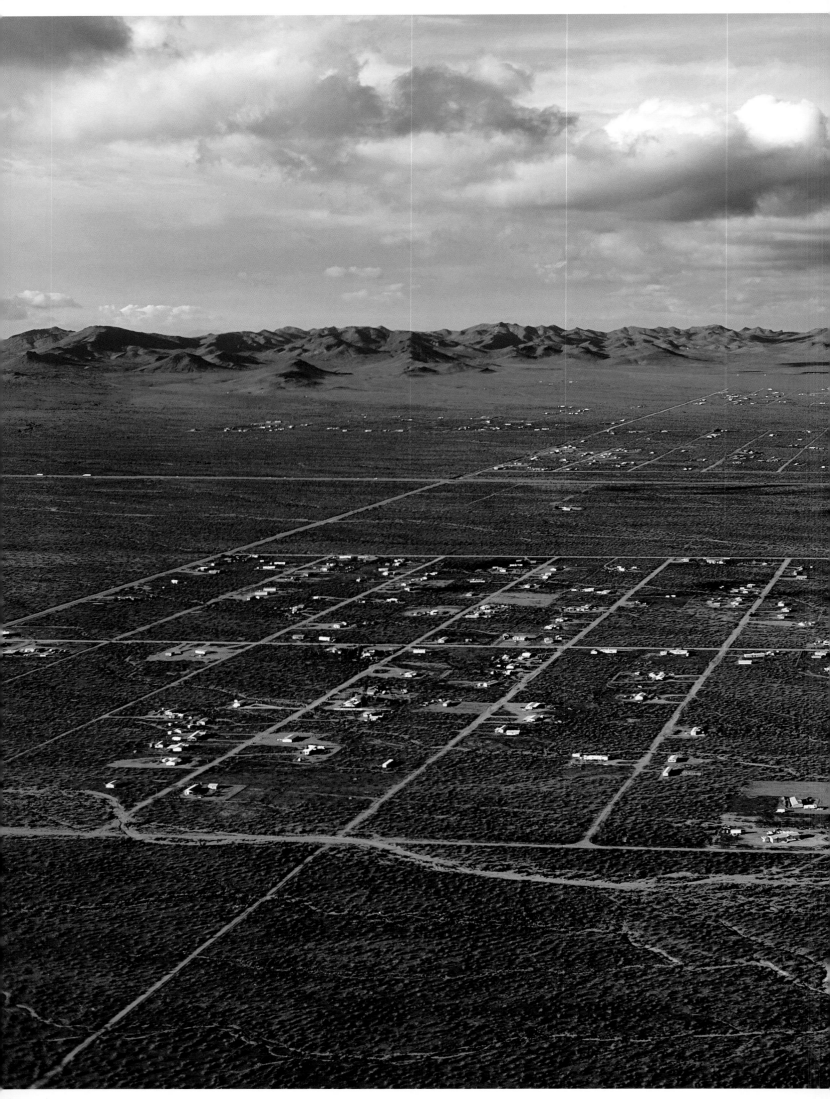

Golden Valley, AZ
This community in northwest Arizona is divided into square-mile grids, which are then subdivided
into smaller blocks and lots for development. Many residents commute to Nevada's casinos in
Laughlin and Las Vegas, respectively 20 and 60 miles away, for work.

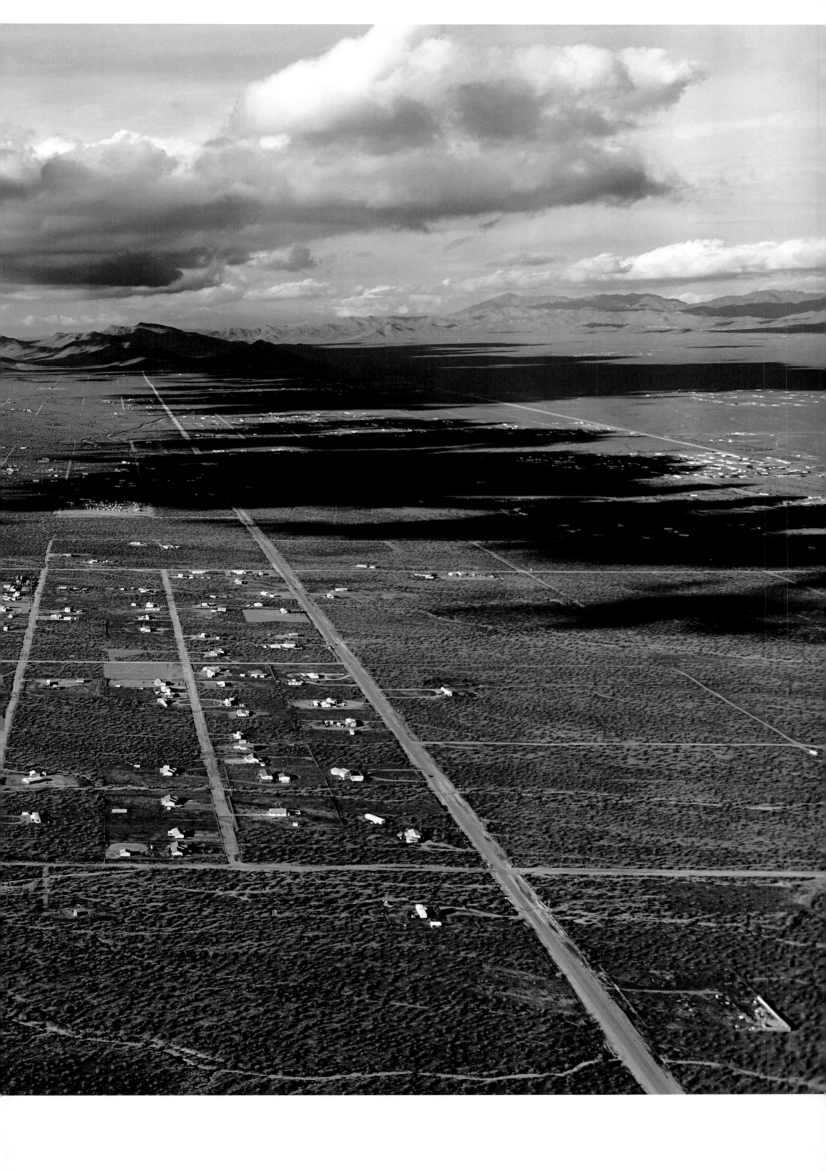

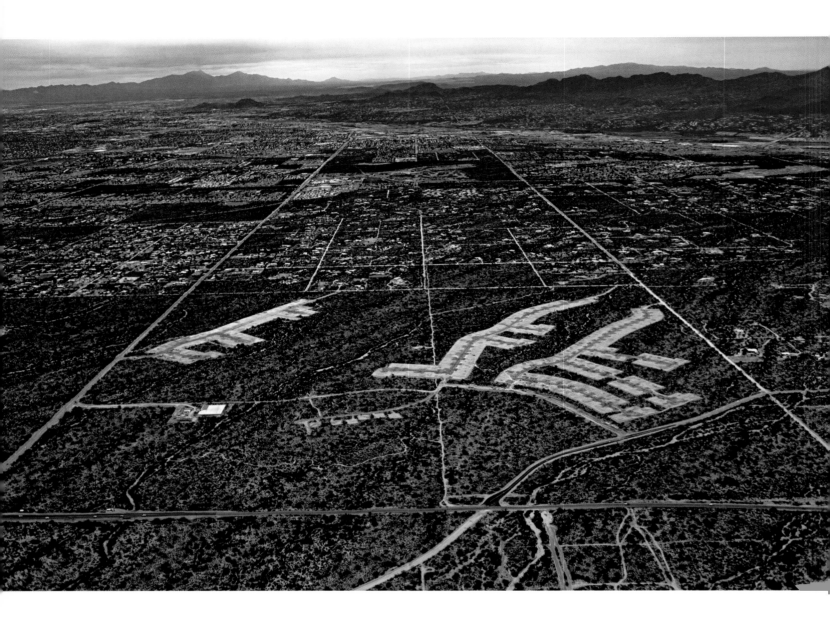

Tortolita, AZ

This new housing subdivision is rotated within the surveyed grid to better align with the topography and natural drainage system. The small dry streams running through the grid plans are known as washes and flood during rains.

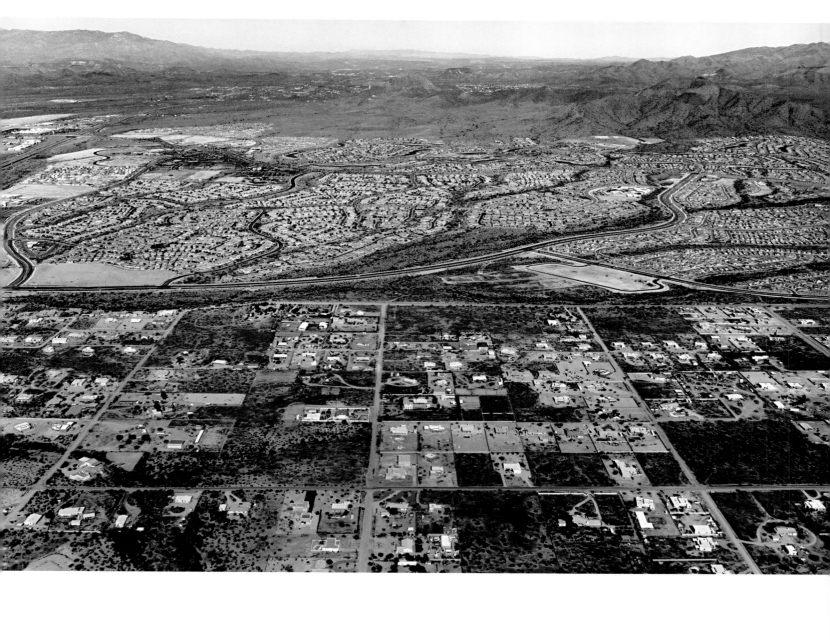

Phoenix, AZ
In the foreground, the standard grid of quarter-mile sections is stamped onto the Phoenix landscape. In the background is Anthem, a master planned suburban community in an as yet unincorporated area 34 miles north of downtown Phoenix. Since Anthem opened in 1998, its population has grown to 40,000.

Phoenix, AZ
A detail from the previous page shows how the grid is divided into smaller lots for individual homes.
Most of these homes use dry landscaping, known as xeriscaping, instead of using lawns and
nonnative plants, which often require large amounts of water. Arizonans use up to 70 percent of
municipal water for outdoor use.

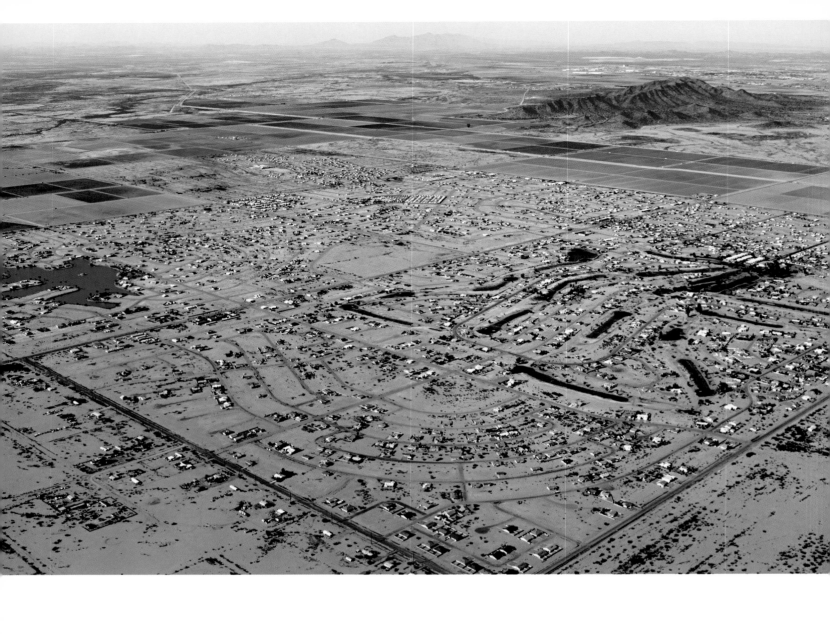

Arizona City, AZ
In Arizona City, developments fill in around the city's sparse 18-hole golf course. Originally, the golf
course was built in relative isolation to attract homebuyers in search of inexpensive property.
Reclaimed water from the municipal sewage plant irrigates the course.

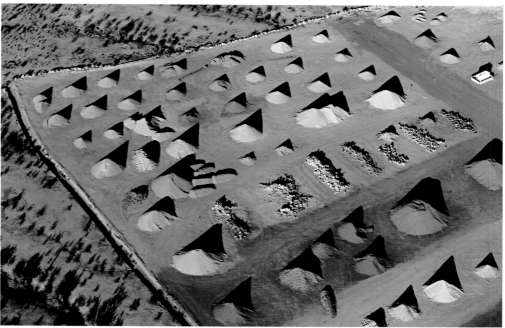

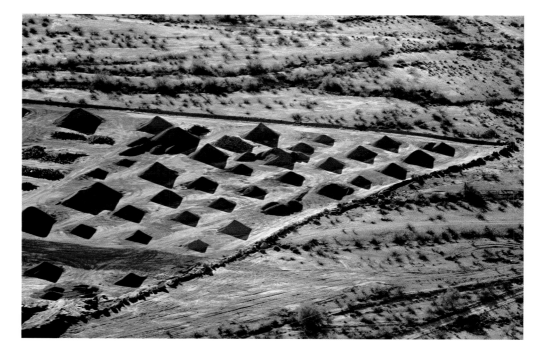

Arizona City, AZ
Retirees populate the Arizona City community.
Thus far, lots have been slow to fill in.

Buckeye, AZ
Dirt, aggregate, and rock are sorted and piled up
for landscaping and use in low-impact
xeriscaping.

Buckeye, AZ
Seen from the opposite side, earthen materials
are organized in piles.

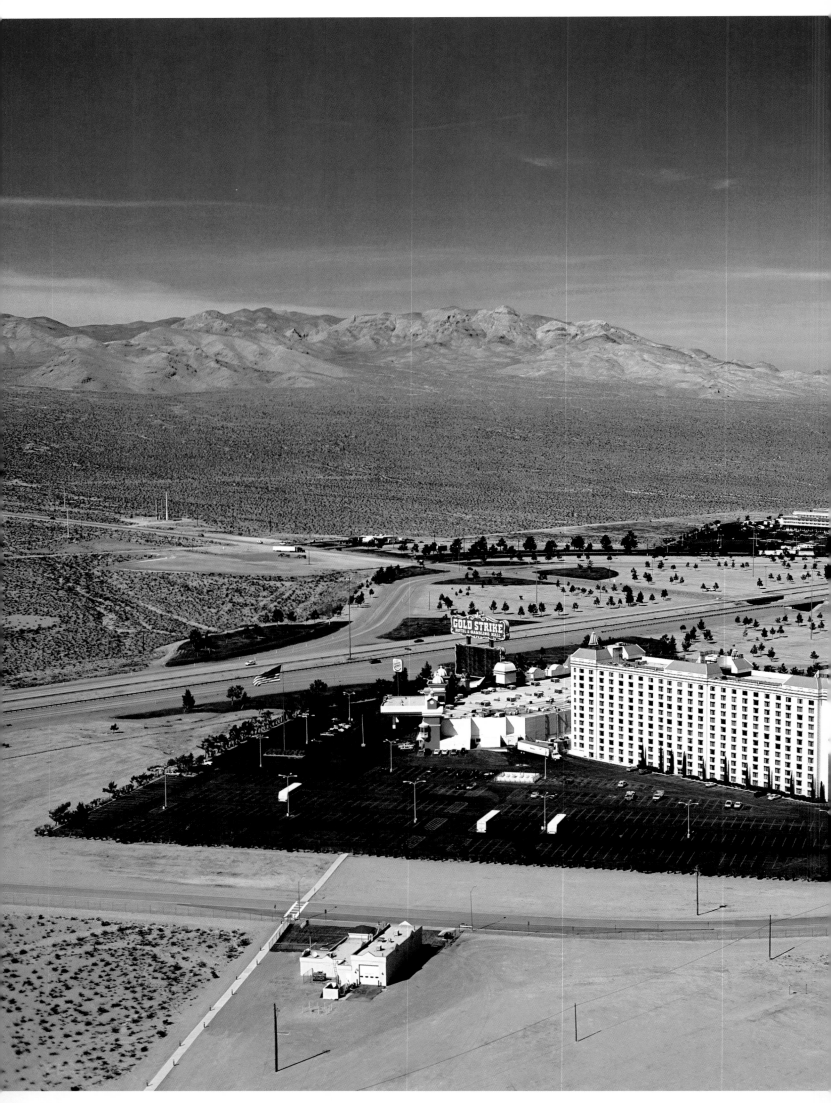

Jean, NV
Jean, a small desert community in Clark County, Nevada, is located along Interstate 15, about 12
miles over the California state line, to entice Californian gamblers on their way to nearby Las Vegas.

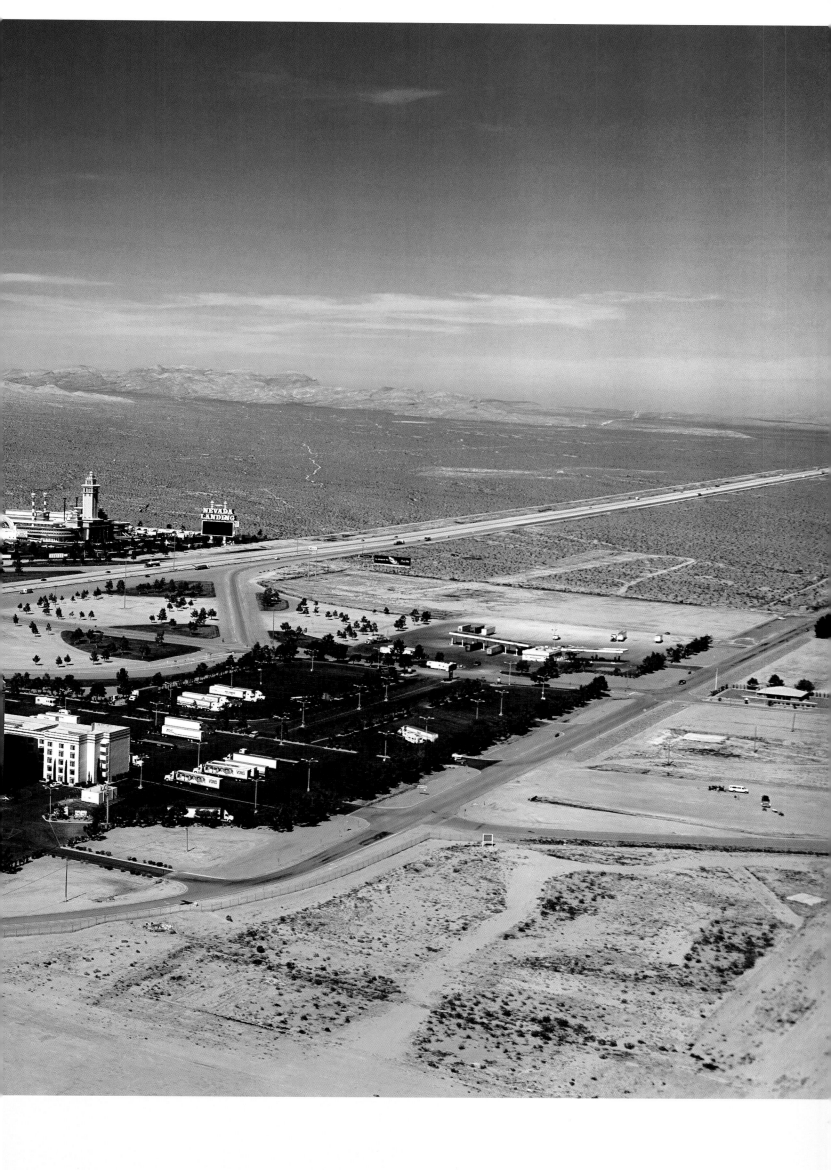

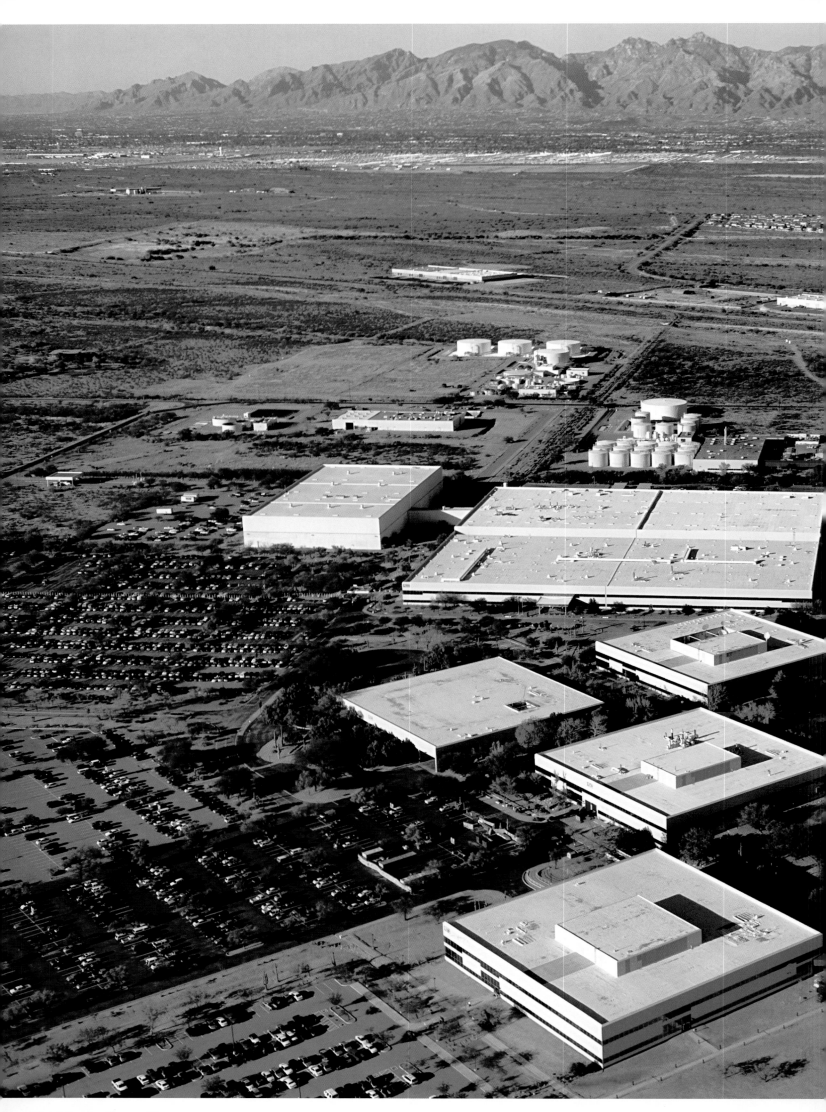

Tucson, AZ
The University of Arizona Technology Park houses 27 companies and employs more than 7,000
people on its 1,345 acres. It is a major incubator for the area's rapid growth 12 miles south of
downtown Tucson on the I-10 corridor. The full parking lots surrounding the facility are a sign of
added commuter traffic.

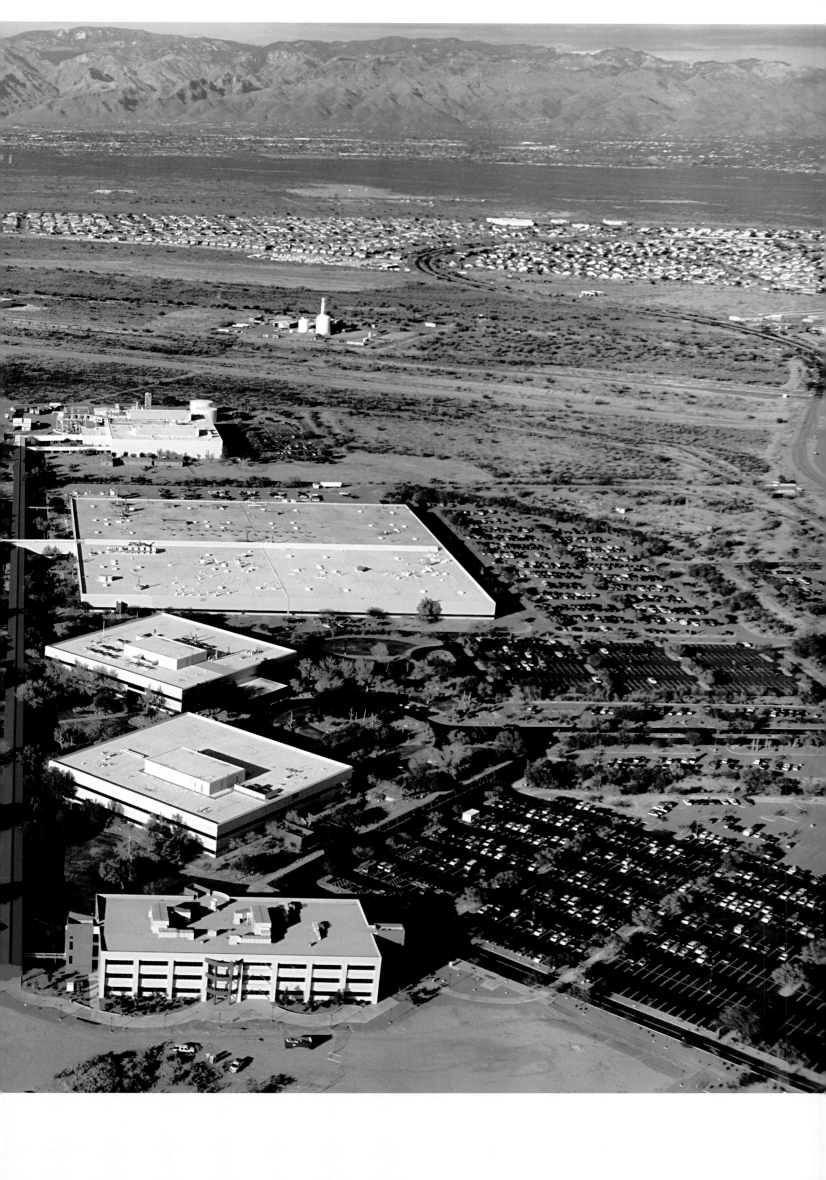

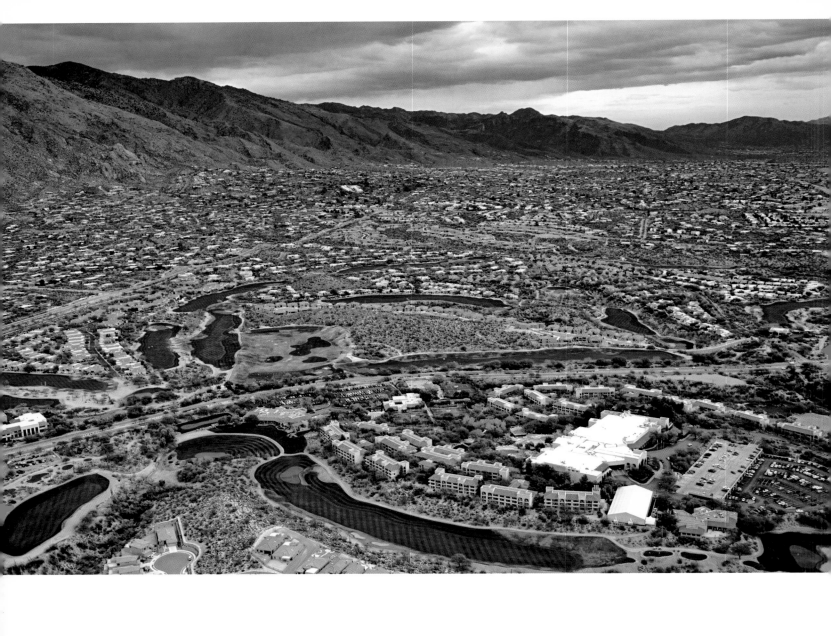

Tucson, AZ
An affluent community in southern Arizona, Catalina Hills was built on desert up to the mountains.

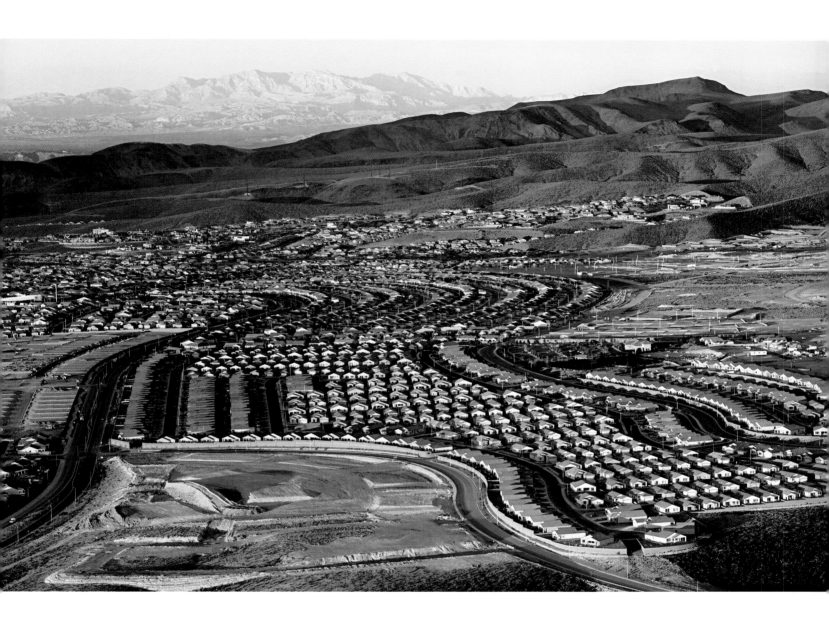

Henderson, NV
An explosion in population has fueled major housing development in the Las Vegas suburbs.

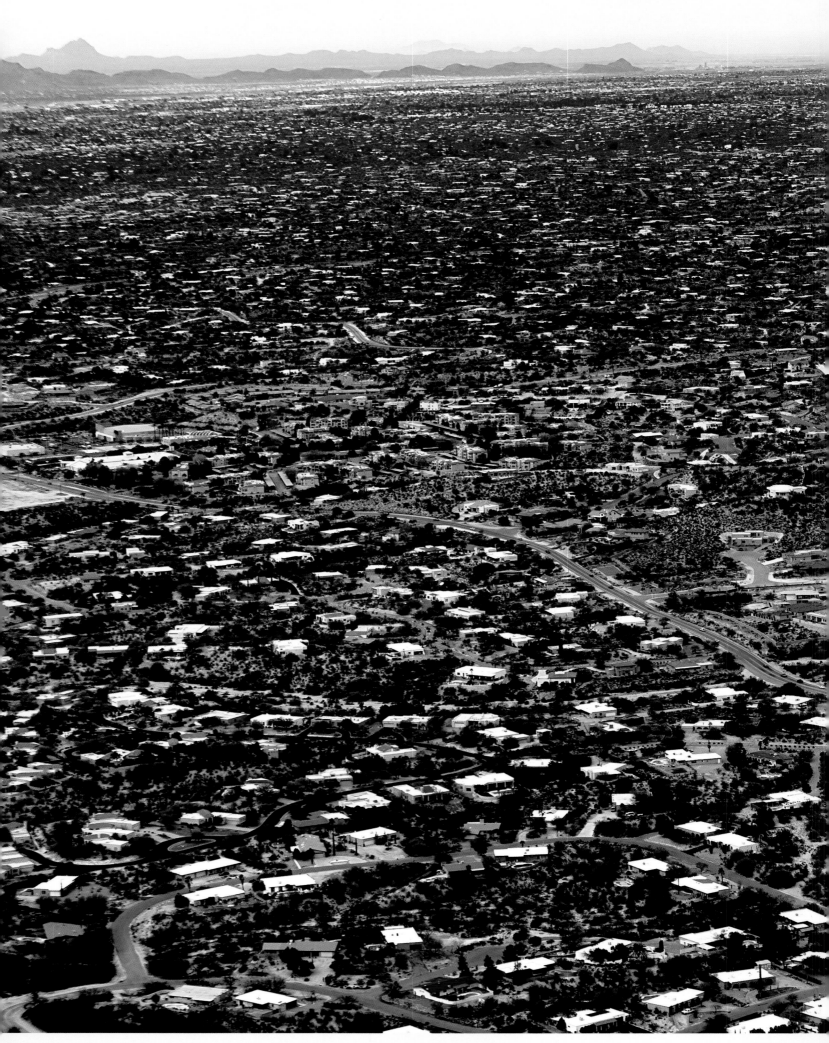

Tucson, AZ
North of Tucson, low-density housing in the Catalina foothills stretches to the horizon.

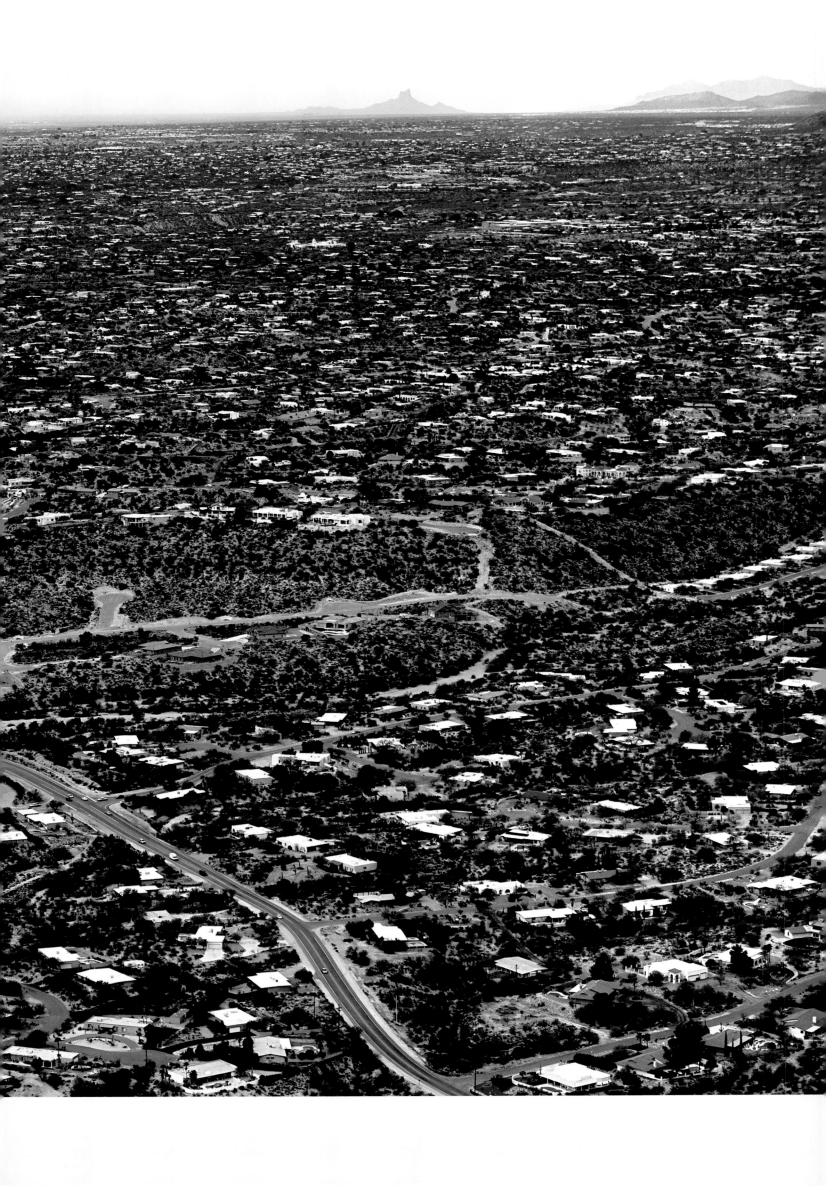

Lake Havasu City, AZ
Recreational trailers appear to spill out of the hills near Lake Havasu.

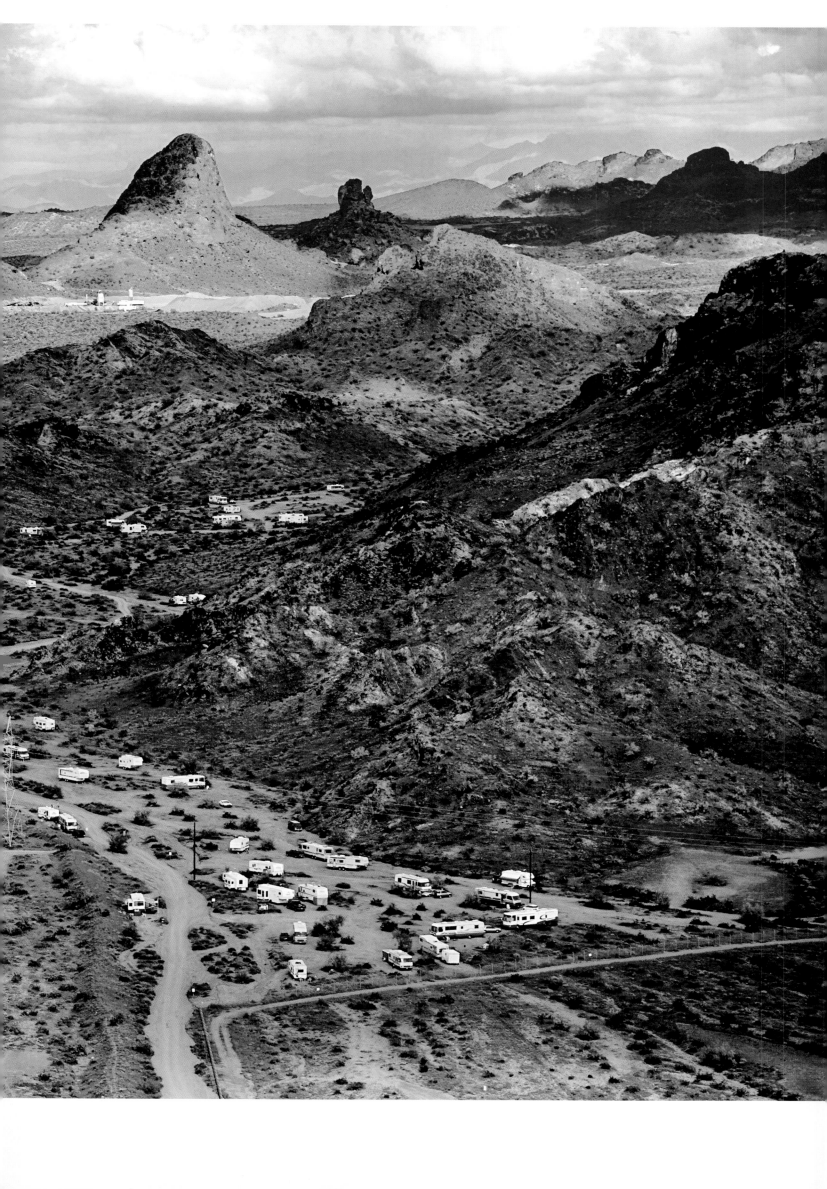

Water Use

Water in its natural setting is photographically striking when seen from the air. It is dynamic and mercurial in that it can reflect the sun's blinding light or completely absorb it so its surface appears black from overhead. In some cases it mirrors light, matching the colors of its surroundings; it can lie as a glassy flat surface or run and meander with ripples and texture, moving by gravity. Water has often left its fluvial tracks and markings on dry land, and it has been the force that has shaped many landforms.

From the plane, my perception of water can sometimes be limited and distorted. I would not have guessed that freshwater accounts for so little of the world's total water supply—just 2.6 percent—or that two-thirds of that freshwater is locked up in ice sheets, groundwater, and moisture in the atmosphere. What I see from above as surface water—lakes, rivers, ponds, swamps, and wetlands—accounts for only 0.3 percent of freshwater. Like all liquids, water is measured not by what we see on the surface but in volumes, such as cubic miles, acre-feet, and gallons; or in weight, such as tons. It is also measured over time, by rate of flow. Surface water only gives a rough idea of the quantity of water that is out there. Unseen, below the surface, lies 100 times more groundwater.

From the air, a better way to understand our water supply—and its use and consumption—is through looking at human habitation and settlement patterns. Most everything you see from overhead in the way of human settlement is shaped by the presence or absence of freshwater. Water is essential to the occupation of land, to industry, and to agriculture. Soil, topography, climate, and access determine land use; water is a key element that interacts with these four determinants. Historically, American settlement occurred on the coasts and then moved inland following the watercourses, and established economic centers alongside inland water bodies. Settlements farther away from surface water depended on either groundwater or water diversions for their survival.

From the air it is clear how the built environment has been engineered to accommodate and exploit water for our everyday habitation. Dams, reservoirs, and retention basins; the channelization of rivers and canals; irrigation ditches; and even everyday street culverts and gutters attest to this. Water's enormous value is plain to see wherever industry, agriculture, and recreation exist.

Water is directly linked to energy and to food. The largest water withdrawals are for cooling in thermoelectric power and irrigation. Water also has potential energy as it flows downstream; hydroelectric power accounts for 7 percent of electric power in the United States. Pumping groundwater up to the surface for municipal and agricultural use can be viewed as the opposite of making hydroelectric energy—it takes energy to bring it to the surface. As an example of the link between water and food, it takes 1,000 tons of water to grow one ton of wheat. Therefore, in arid regions where water is scarce, it is more energy and cost effective to ship wheat in from other parts of the world, rather than use 1,000 tons of precious water to grow that ton of wheat locally where water might be better used for municipal and domestic purposes.

All too often we put water to use locally with little regard for the larger environment. From an aerial view, the bigger picture emerges and these incongruities, such as green golf courses in the middle of the desert, make it apparent. Built interventions of water have led to natural disasters arising from the interruption of water's natural cycling process as it moves through the environment. This has been especially true of swamps, marshes, and wetlands, all considered worthless places for human activity until they could be filled in for commercial development. Our culture was slow to recognize the essentialness of wetlands to wildlife, water quality, and flood control. In their unaltered state, wetlands slow down water runoff to allow for natural water purification via biological processes, sedimentation, plant transpiration, and evaporation.

Climate change will have a major impact on the supply and distribution of freshwater resources. Increased rain and decreased snow at high elevations have already begun changing the hydrology of the western United States, and as a result the snowpack has been diminishing. The snowpack is an immense natural reservoir holding frozen water, which is released as meltwater during the drier months of summer for needed irrigation, hydropower, and restocking municipal water supplies.

With global warming, weather is proving, as predicted, to be more volatile. In some areas of the country the higher temperatures and evaporation rates are accentuating dry spells, while in other areas, heavy downpours—warmer air carries more moisture—are causing floods and

destruction. Likewise, warmer ocean surface temperatures are causing stronger coastal storms and hurricanes in the South Atlantic and the Gulf Coast.

In 2007 central Texas and the Midwest were hit with devastating floods from torrential rainstorms. Reservoirs' floodgates were opened to release water and prevent flooding along their banks upstream. Only 400 miles to the east, record heat and drought conditions caused widespread forest fires, forcing farmers to sell off their herds for lack of hay. In metropolitan Atlanta the same drought had brought the city's reservoirs to record low levels and left its 5 million residents with less than a 60-day water supply.

The growing economy and population are creating a demand for water that exceeds the supply of many watersheds. Couple this with the less predictable water supply that accompanies climate change, and it becomes clear that water is a finite commodity—which raises the question, is economic and population growth sustainable in these watersheds?

Southwest of Salt Lake City, UT
Climate change has altered the hydrology of America's western mountain regions. Higher temperatures, more rain, and less snow have diminished the snowpack on mountaintops, an immense natural reservoir holding water, which is released as meltwater during the drier months of summer for needed irrigation, hydropower, and restocking municipal water supplies.

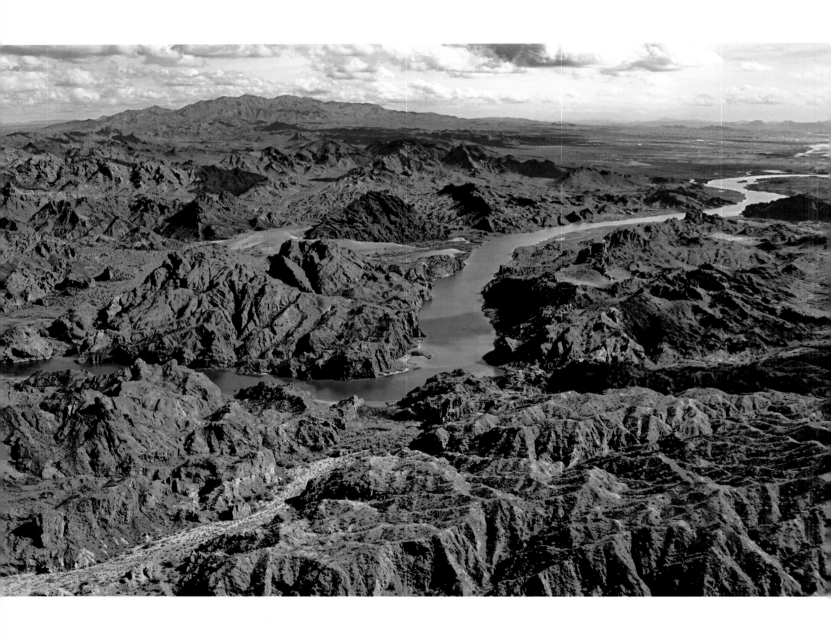

Needles, CA
The Colorado River marks the Arizona-California border. As the river flows south, it picks up salinity via water returns from wastewater treatment plants, irrigation, and evaporation from reservoirs. There are periods when water becomes so salty that it must, by treaty obligations, be run through a desalinization plant in Yuma before it crosses into Mexico.

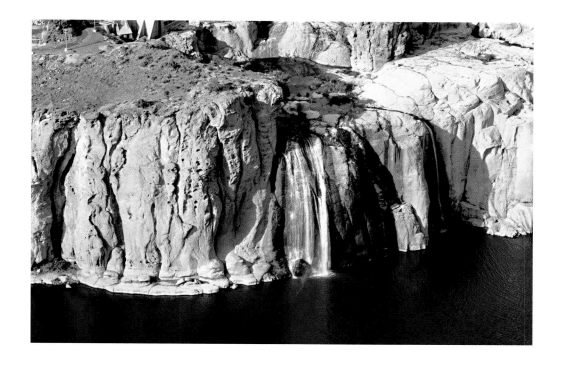

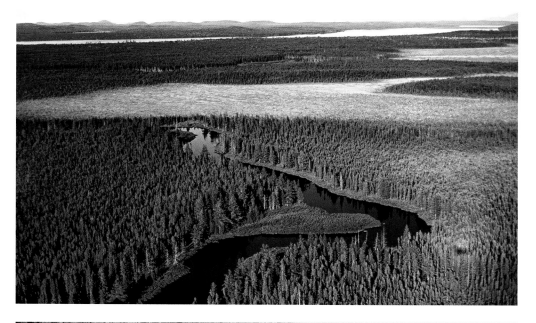

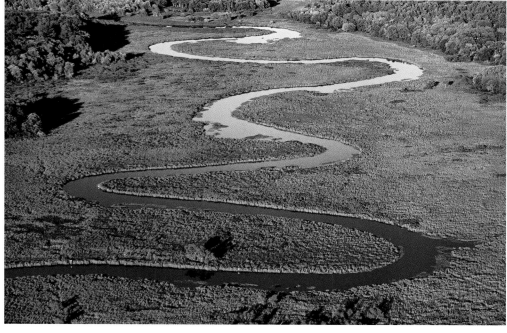

Five miles east of Twin Falls, ID
Shoshone Falls is known as the "Niagara of the West." In the summer, water levels are significantly depleted due to withdrawals from the Snake River for irrigation.

Northern ME
A river winds through low-lying pine forest and wetland.

Wayland, MA
The Sudbury River flows through wetlands in the Great Meadows National Wildlife Preserve.

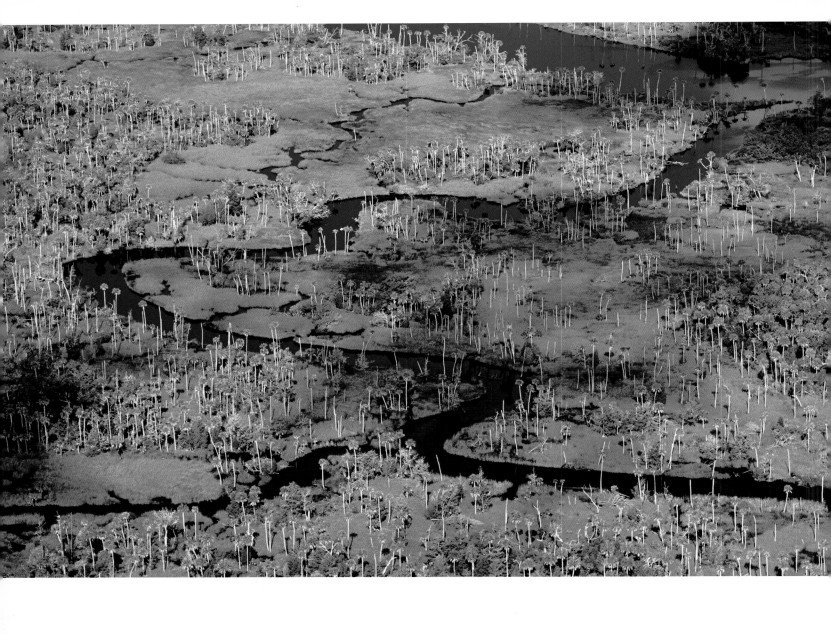

West of Cross City, FL
West of Cross City, Florida, on the Florida Gulf Coast, a freshwater stream meanders to the Gulf.
Wetlands typically slow water, allowing time for natural purification to occur through biological
processes, sedimentation, transpiration, and evaporation.

Sebring, FL
Lake Istokpoga is a shallow freshwater lake in central Florida. Bunches of grass and vegetation, called tussocks, float on top of the wetlands. Underneath these floating islands lies a rich biological habitat.

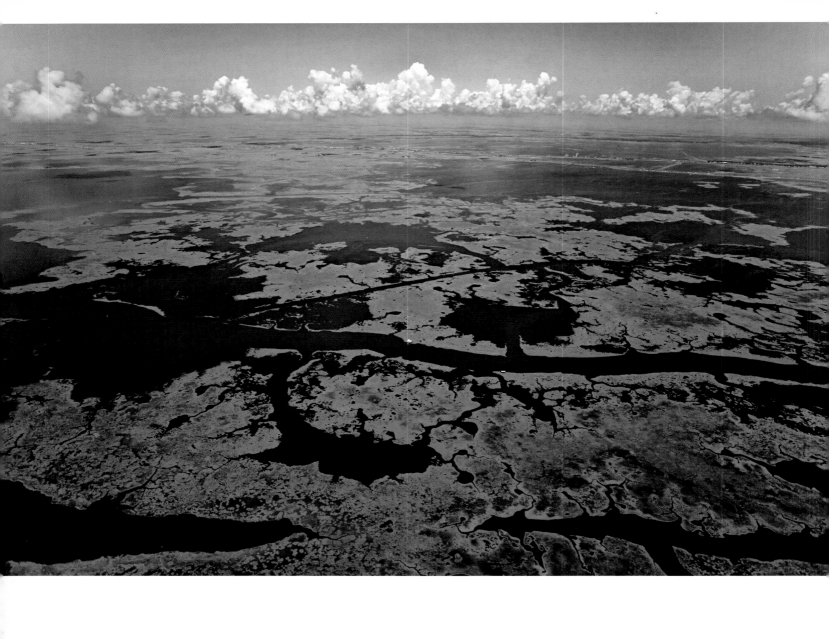

Lake Tambour, LA
Coastal marshes in Louisiana are experiencing what is known as "brown marsh phenomenon," a
dieback of smooth cord grass as a result of storms, sea-level rise, subsidence—land sinking in
relation to sea level—and the draining of wetlands for agriculture. The current rate of marshland
loss in Louisiana is approximately 25 to 35 square miles per year.

Port Sulphur, LA
Housing located at sea level cuts into coastal wetlands along the Mississippi River. This housing is situated along an access channel to utilize the resources of the Delta but, because of its coastal location, is unprotected from hurricanes and storm surges.

Maurepas, LA
Cypress trees once blanketed this area, but have since been harvested without regrowth. All that remains are the channels that were used to move the cut trees.

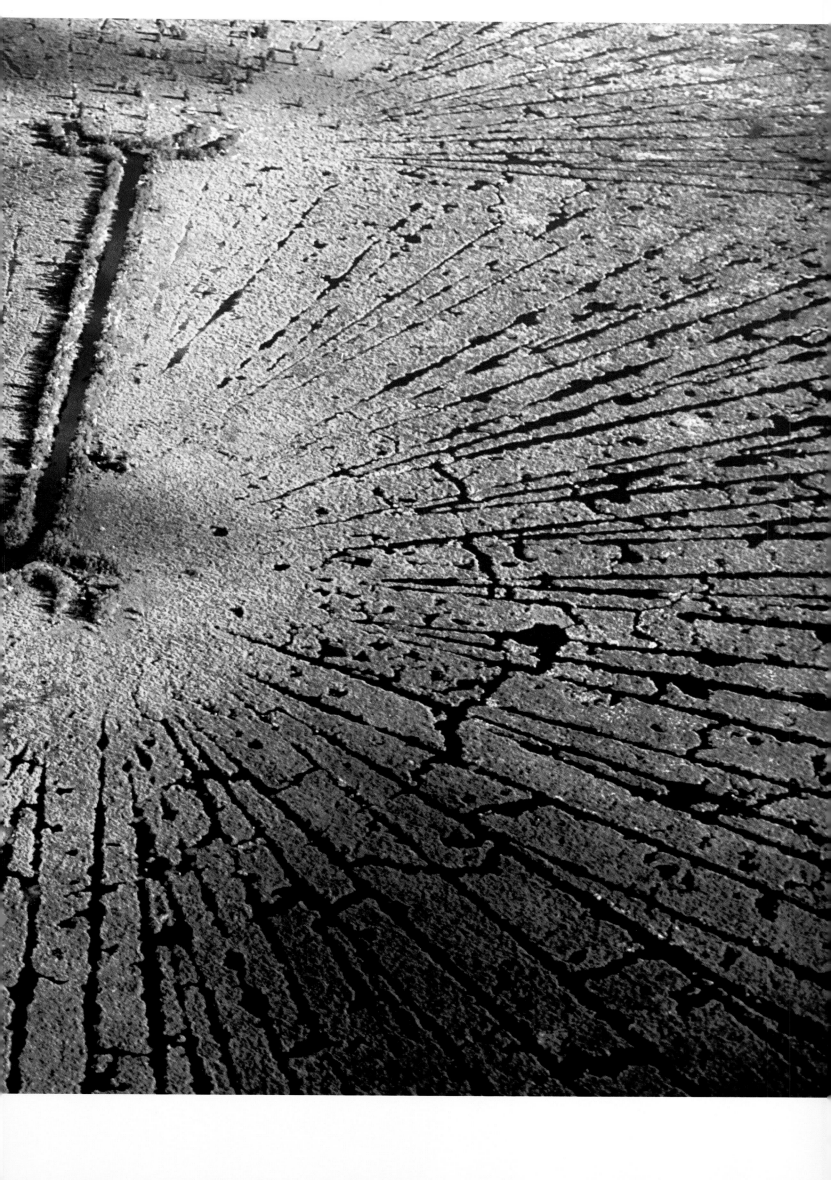

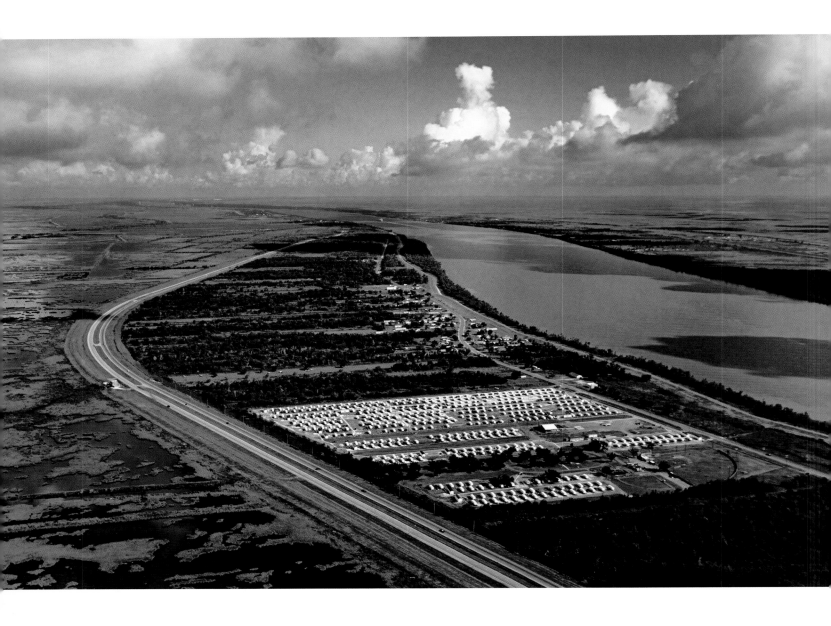

Port Sulphur, LA
The Mississippi River is the largest inland shipping waterway in the United States. Rows of Federal
Emergency Management Agency (FEMA) trailers form a small community on a natural embankment
of the Mississippi River. Situated between two levies, the FEMA trailers continue to provide shelter
for survivors nearly two years after Hurricane Katrina.

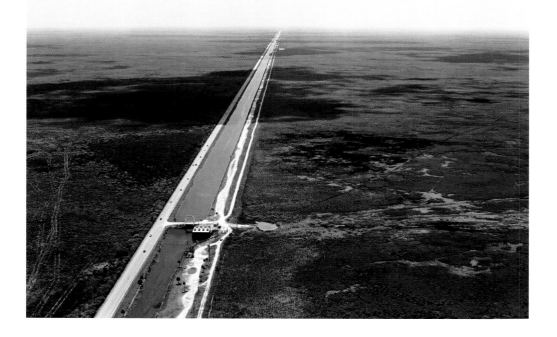

Belle Chasse, LA
An access channel cuts through wetlands to reach the edge of the Mississippi River. Lagoon keys have been cut into the wetlands for housing.

Crystal River, FL
A channel lined with cooling units collects water that was used to cool the thermoelectric power plant and moves it out toward the Gulf beyond coastal wetlands.

Homestead, FL
Aerojet's C-111 Canal passes just north of the Everglades National Park. It provides water supply and flood protection to 100 square miles of agricultural land in its surrounding basin.

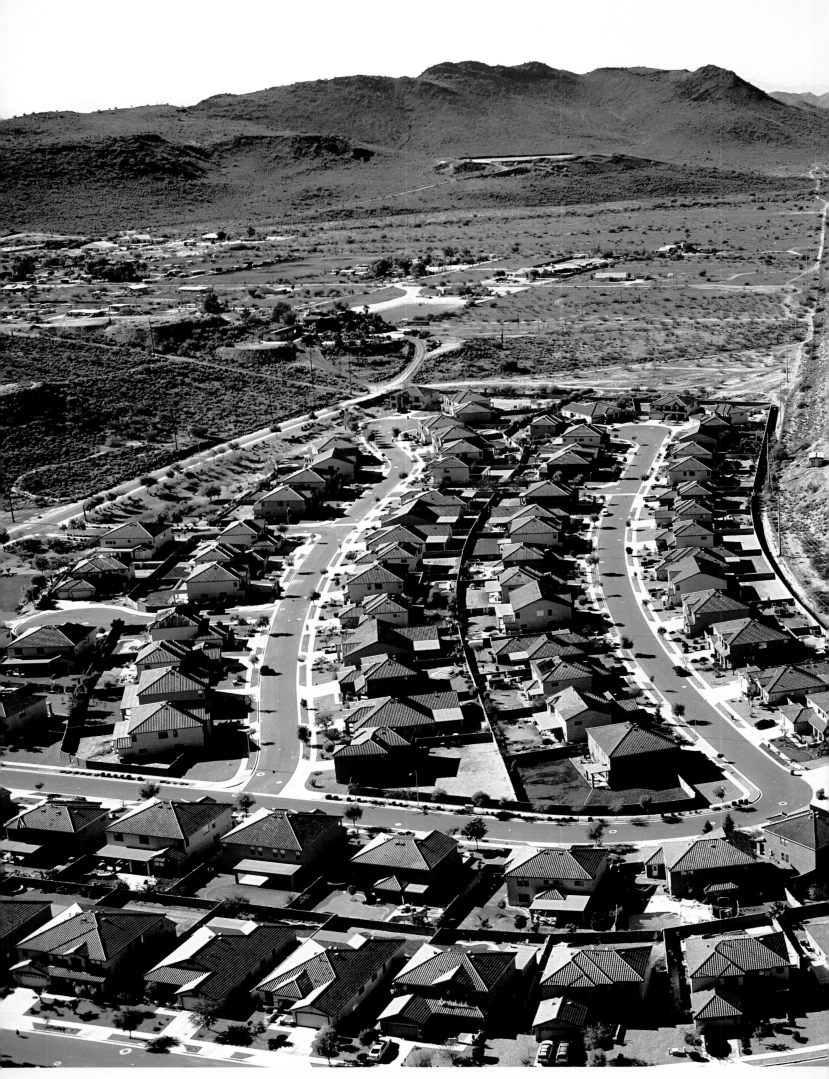

Phoenix, AZ

The Granite Reef Aqueduct, a man-made canal that has the carrying capacity of 1,800 cubic feet per second, diverts water from the Colorado River at Lake Havasu to central and southern Arizona. This aqueduct is part of the 4-million-dollar Central Arizona Project designed to bring water into arid municipalities including Phoenix and Tuscon, and irrigate farmland in central Arizona.

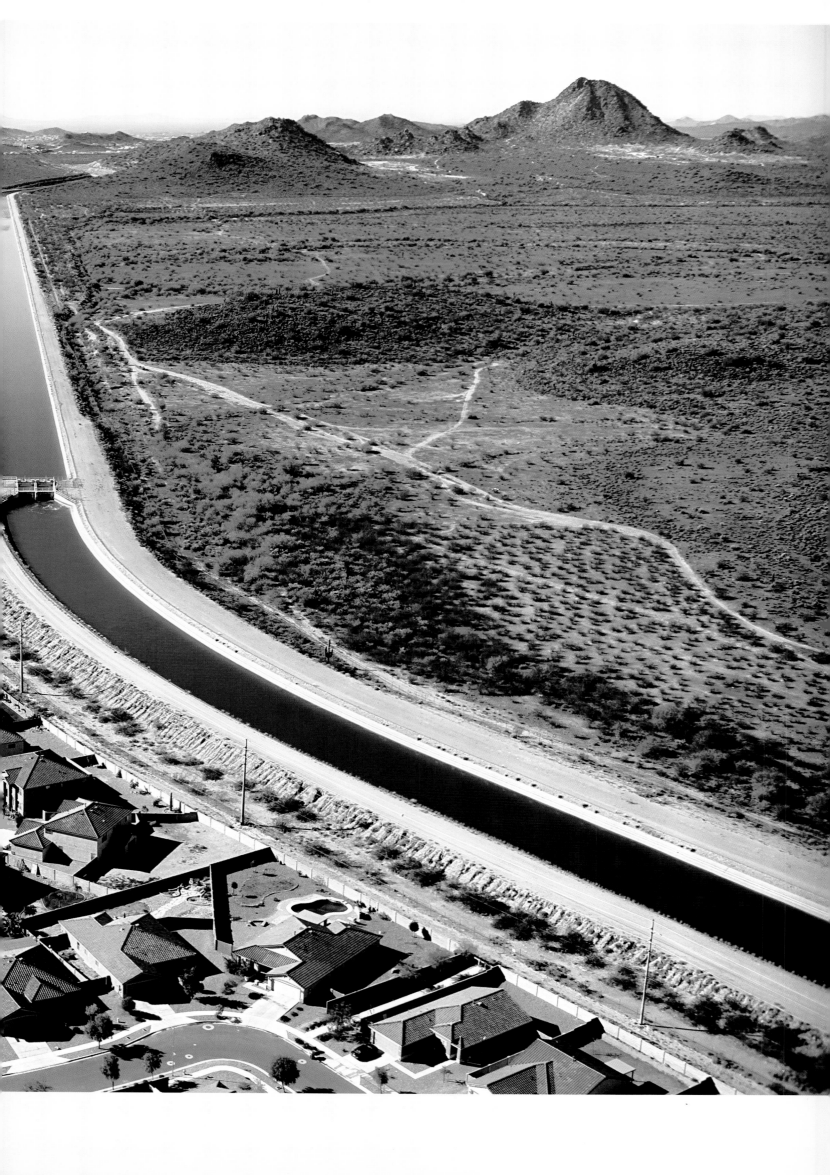

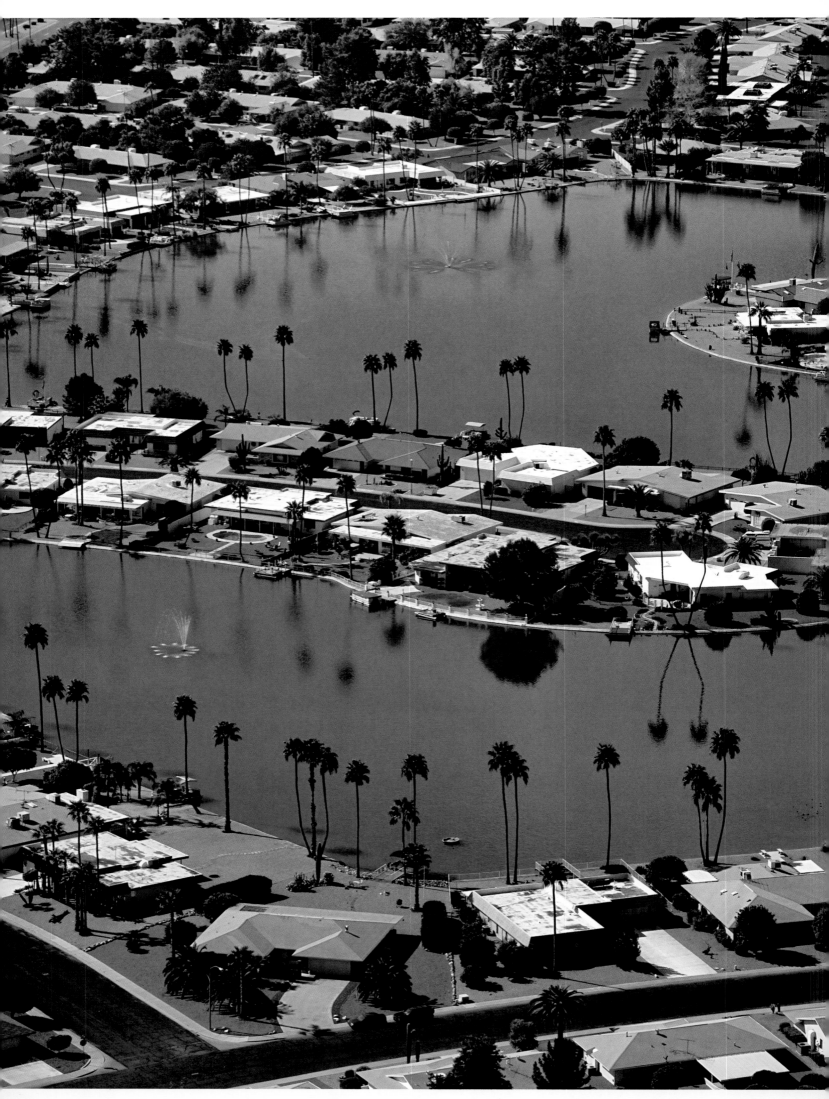

Sun City, AZ

Sun City, located a half hour northwest of downtown Phoenix, was built in the 1960s by Dell E. Webb Development Company, as a planned community for retirees. Arizona developers construct artificial lakes to capitalize on waterfront property values. The lakes are built with an impervious liner to store groundwater for irrigating nearby golf courses.

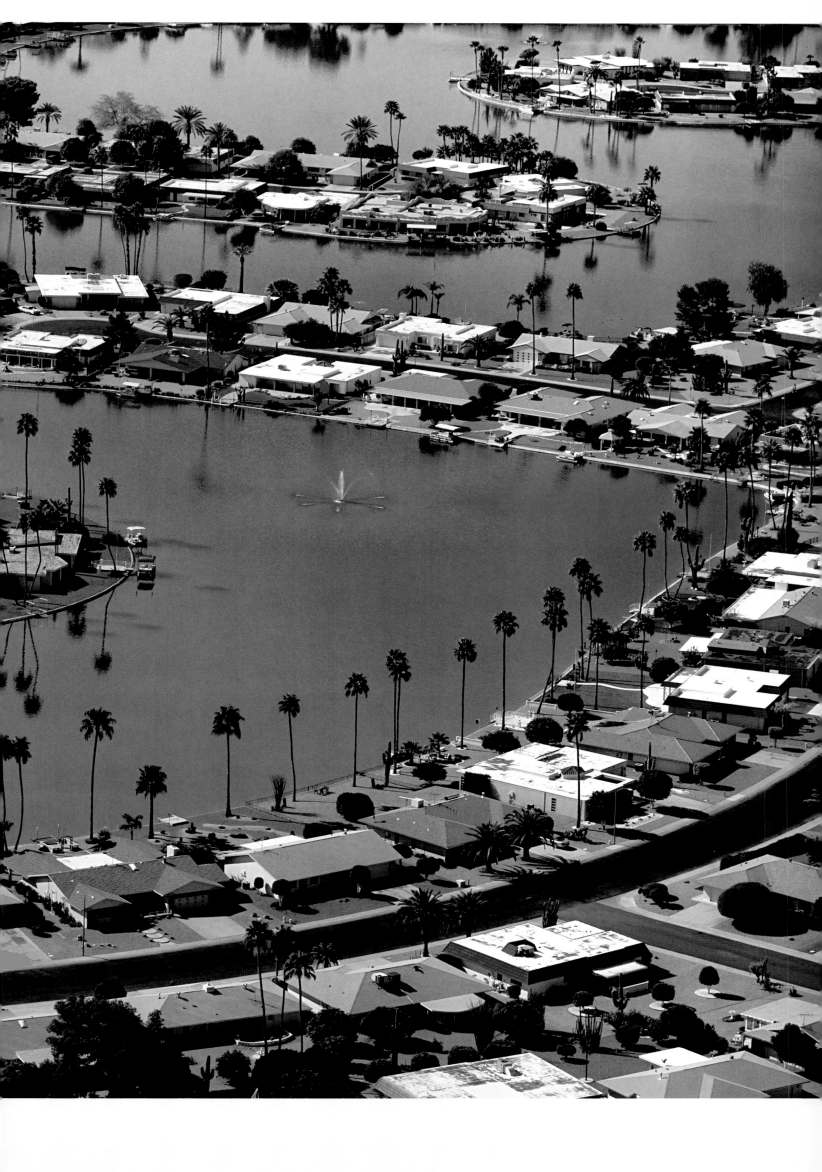

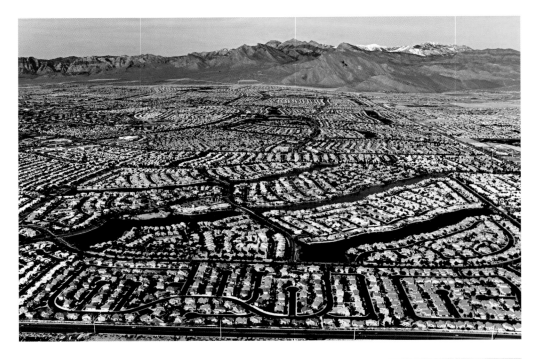

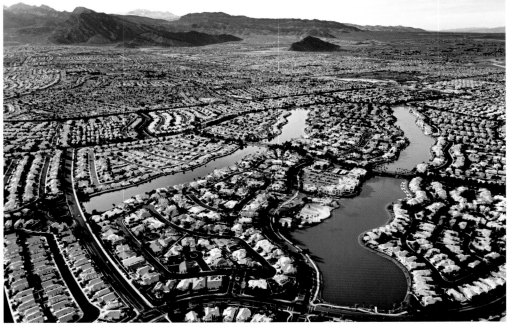

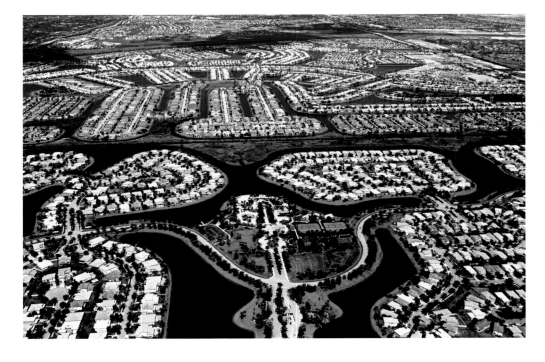

Las Vegas, NV
Desert Shores is a 3,068-unit planned community that includes 22 residential districts and four artificial lakes. The lakes are filled with potable municipal water.

Las Vegas, NV
A detail of two man-made lakes in Desert Shores.

Weston, FL
Weston is a planned community that obtains water from a complex drainage system, which then sends the runoff to the Everglades and nearby lakes.

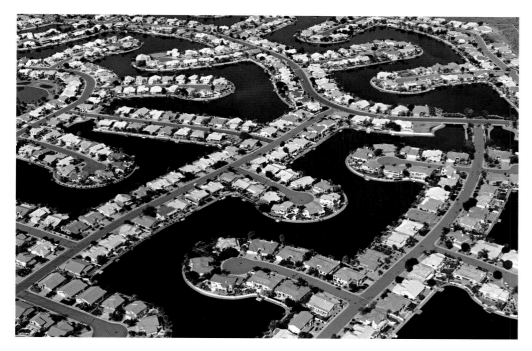

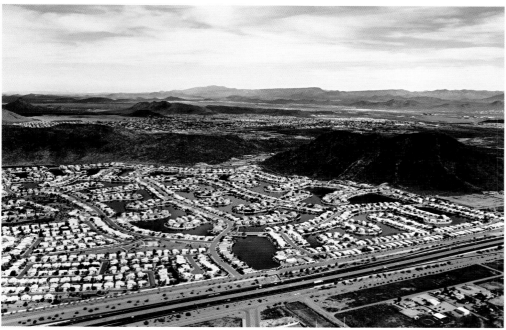

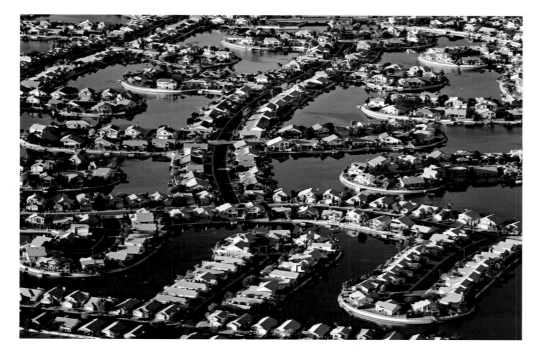

Glendale, AZ
A detail of Arrowhead community's desert waterfront homes.

Glendale, AZ
The lakes of the Arrowhead community use reclaimed wastewater systems, which store outside water in existing ground wells or aquifers.

Glendale, AZ
The Arrowhead community's lakes, filled with reclaimed water, are configured to maximize the potential for waterfront development.

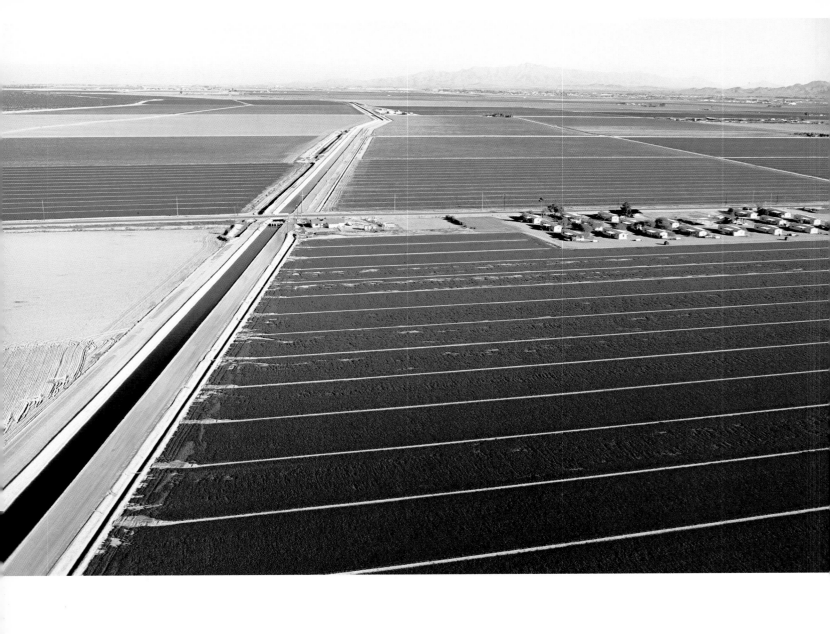

Buckeye, AZ
Lush, irrigated fields belie the arid climate of Buckeye, Arizona. Its agricultural fields are irrigated
with groundwater, as well as surface water that is transferred through the Buckeye and Roosevelt
Irrigation District canals.

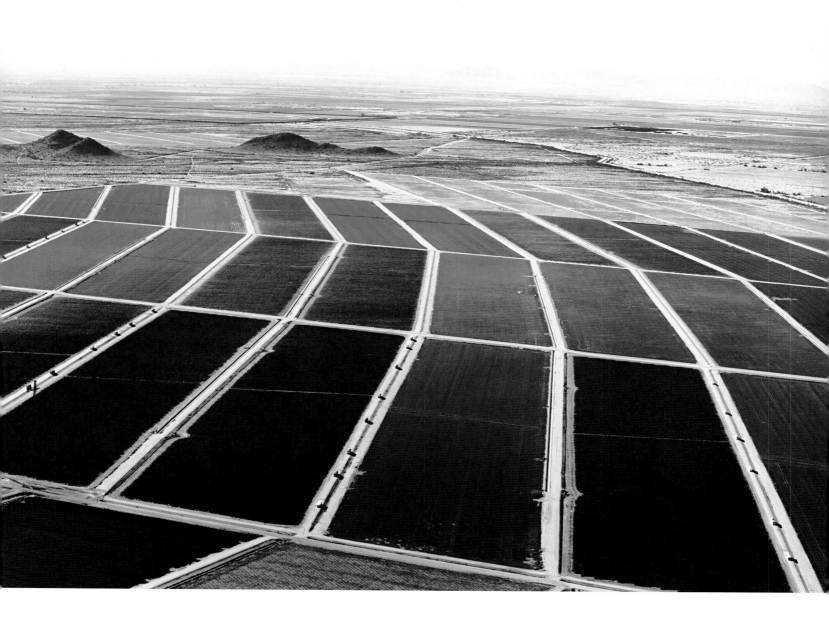

Florence, AZ
Farms use 68 percent of the 2.4 trillion gallons of water that Arizona uses every year. Agriculture is a $9.4 billion industry in the state.

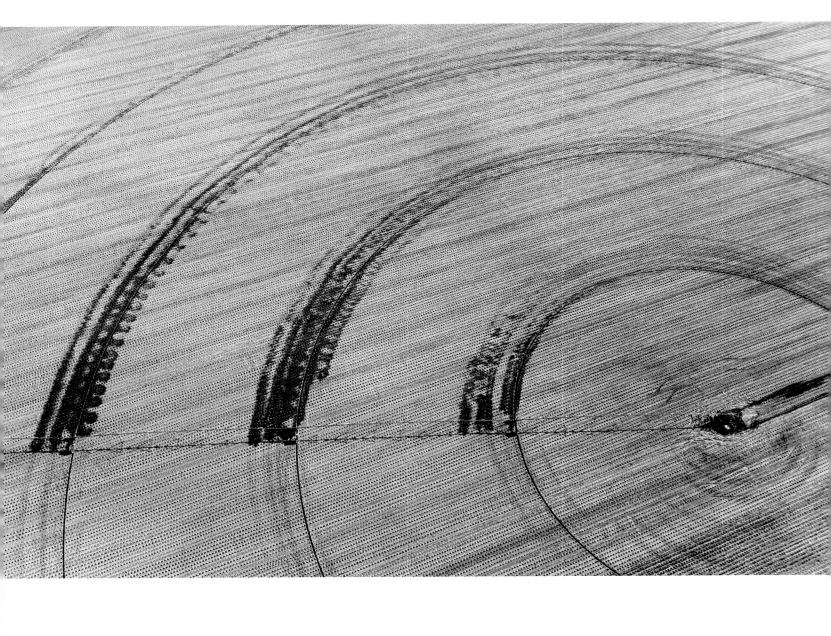

Twelve miles southeast of Twin Falls, ID
A pivot irrigator in start-up mode sprays fresh tracks of moisture on the dry soil. The state of Idaho
has over 4 million acres of irrigated farmland.

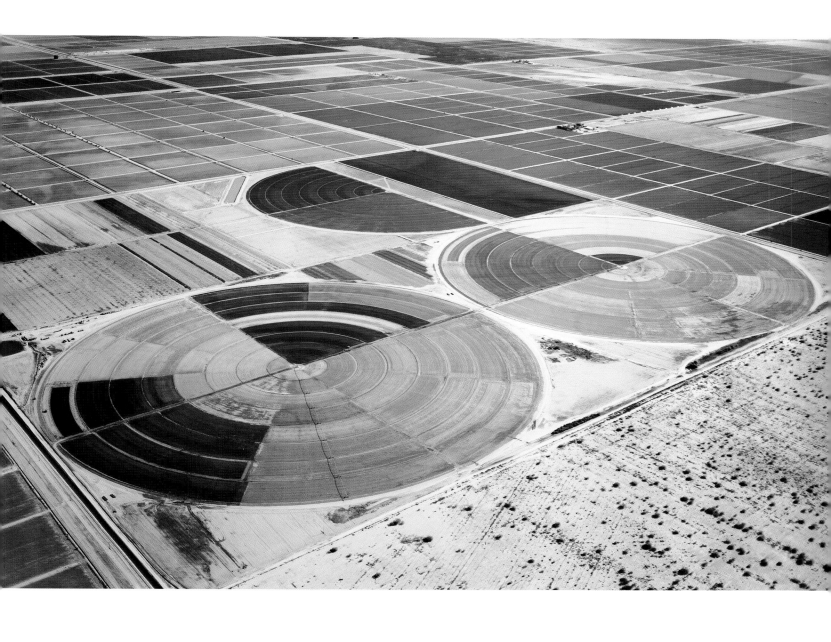

Eloy, AZ
Central pivot irrigation systems were developed in the United States in the 1950s. Since then, irrigated land in the U.S. has more than doubled. Central pivot irrigators are being put to heavy use in the Southwest, where their design is well-suited to the flat topography and large-scale agricultural plots.

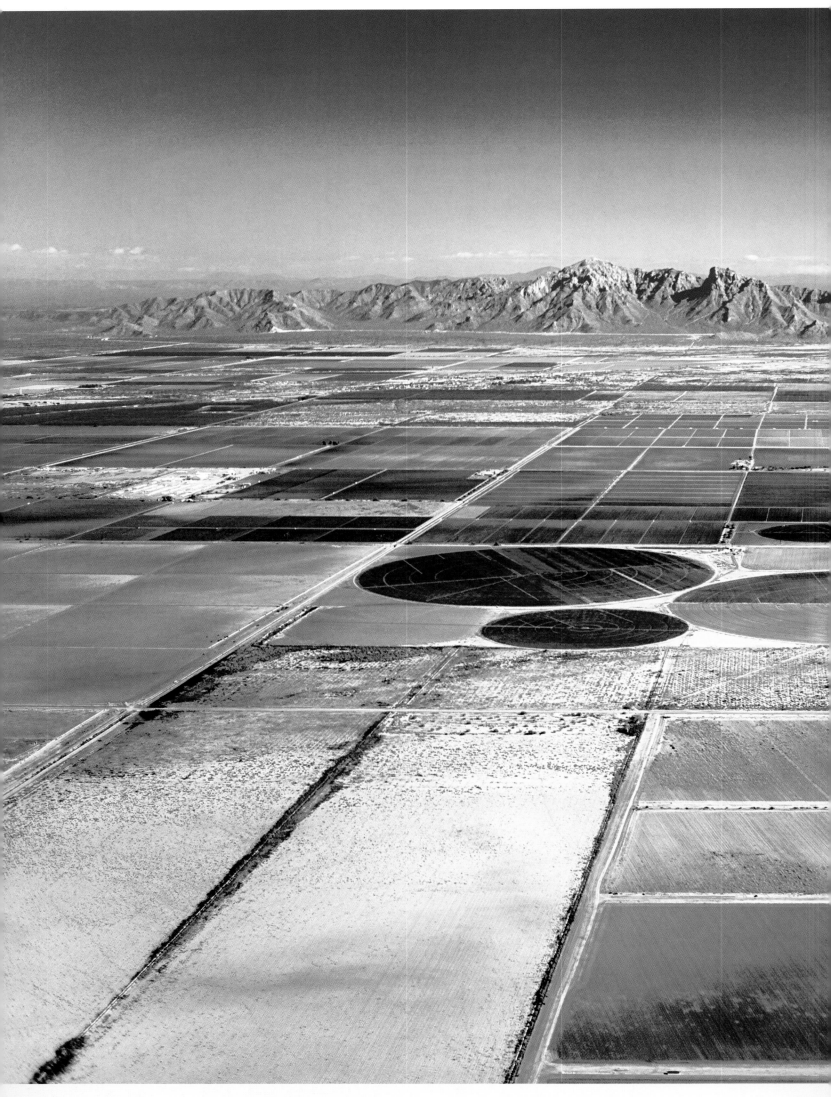

Eloy, AZ
In Pinal County, where Eloy is located, 256,000 bales of upland cotton are brought in each year.
Water for center-pivot crops is pumped up from ground wells.

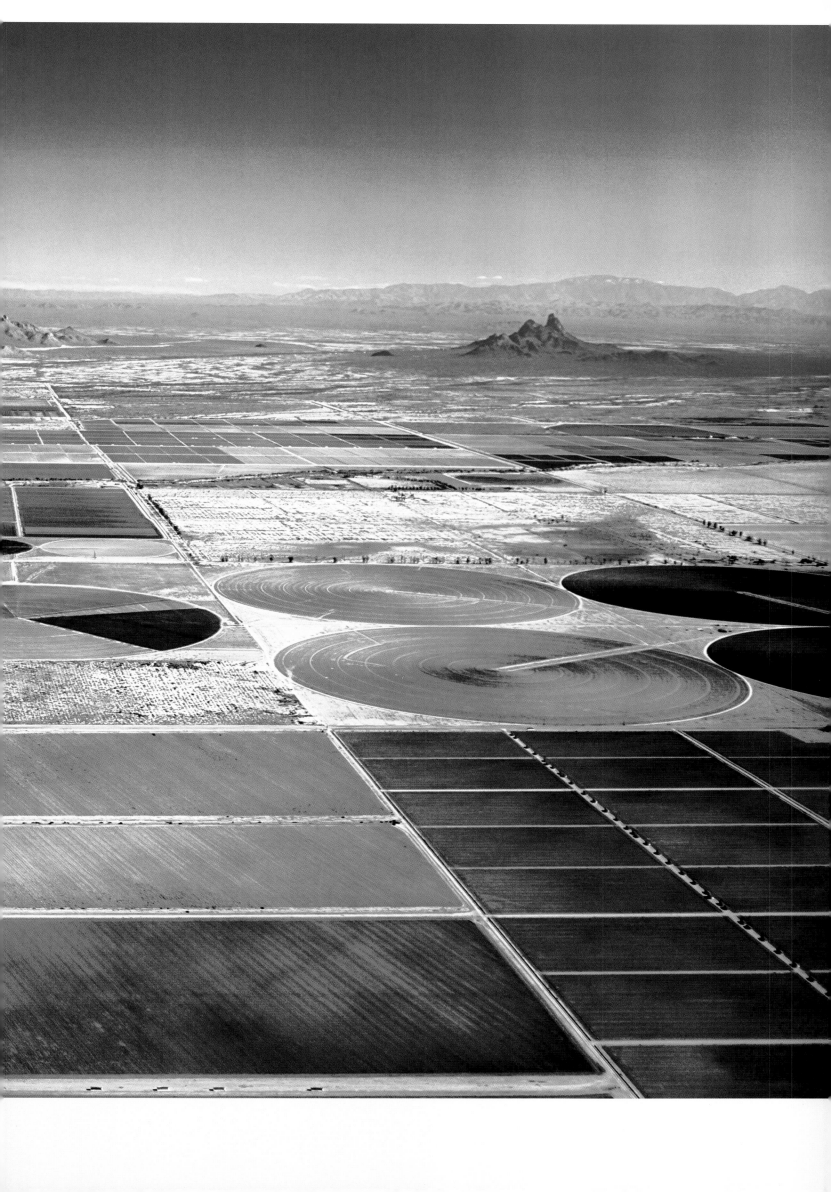

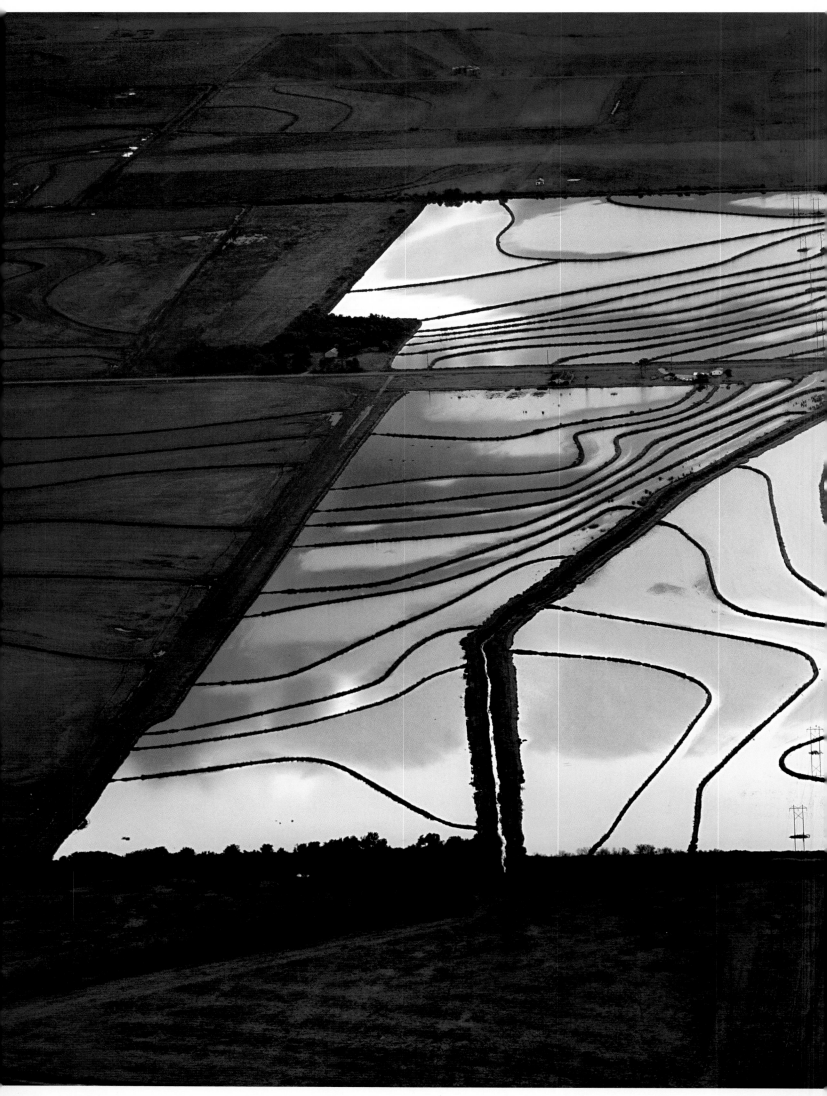

Welsh, LA
Before rice is planted, the earth is flooded with elevated groundwater. This process, known as wet seeding, is extremely water intensive, and pumping can become costly. The flooded land also serves as an ideal environment for methane production. Methane, a major greenhouse gas, is about 23 times more potent than carbon dioxide.

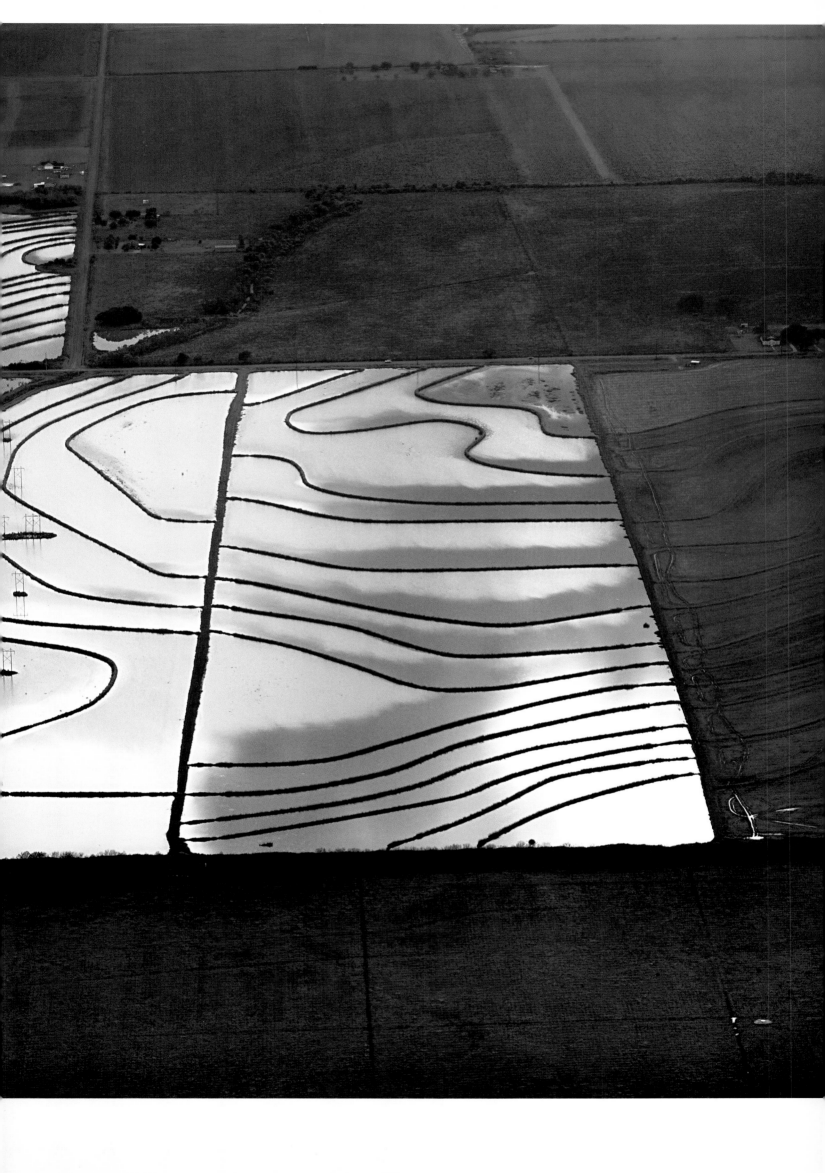

Twin Falls, ID
Blue Lakes Country Club is an 18-hole golf course along the Snake River Canyon. The course has a
buffer zone to keep the fertilizer from running off and polluting the waters of the Snake River. To
reduce the water required to maintain the greens, the course has a flow-control computer system,
which limits the time sprinklers are active and the amount of water they release.

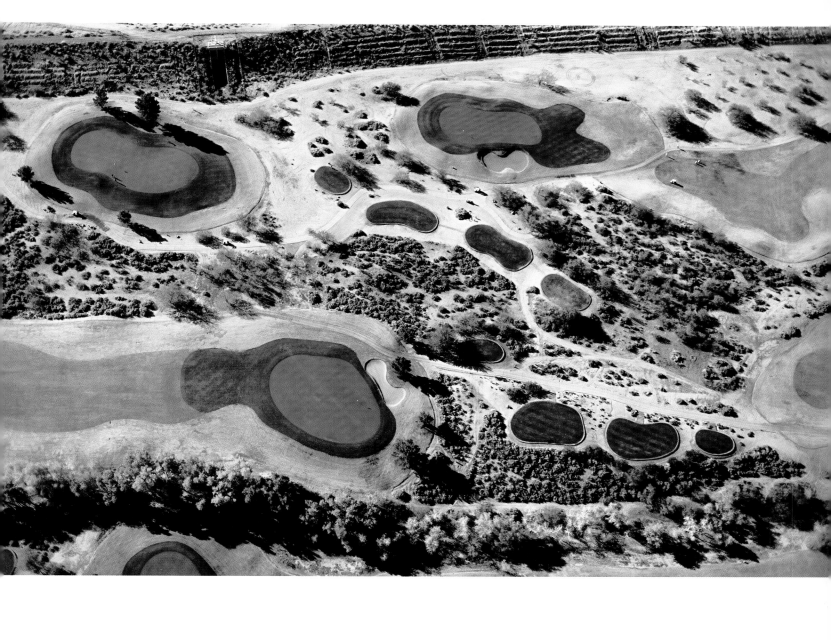

Scottsdale, AZ
Golf courses in Arizona, such as this one in Glendale, consume 4 to 5 percent of the state's total water supply. Many courses use two-loop irrigation systems, which water greens with potable water and fairways with reclaimed waste water.

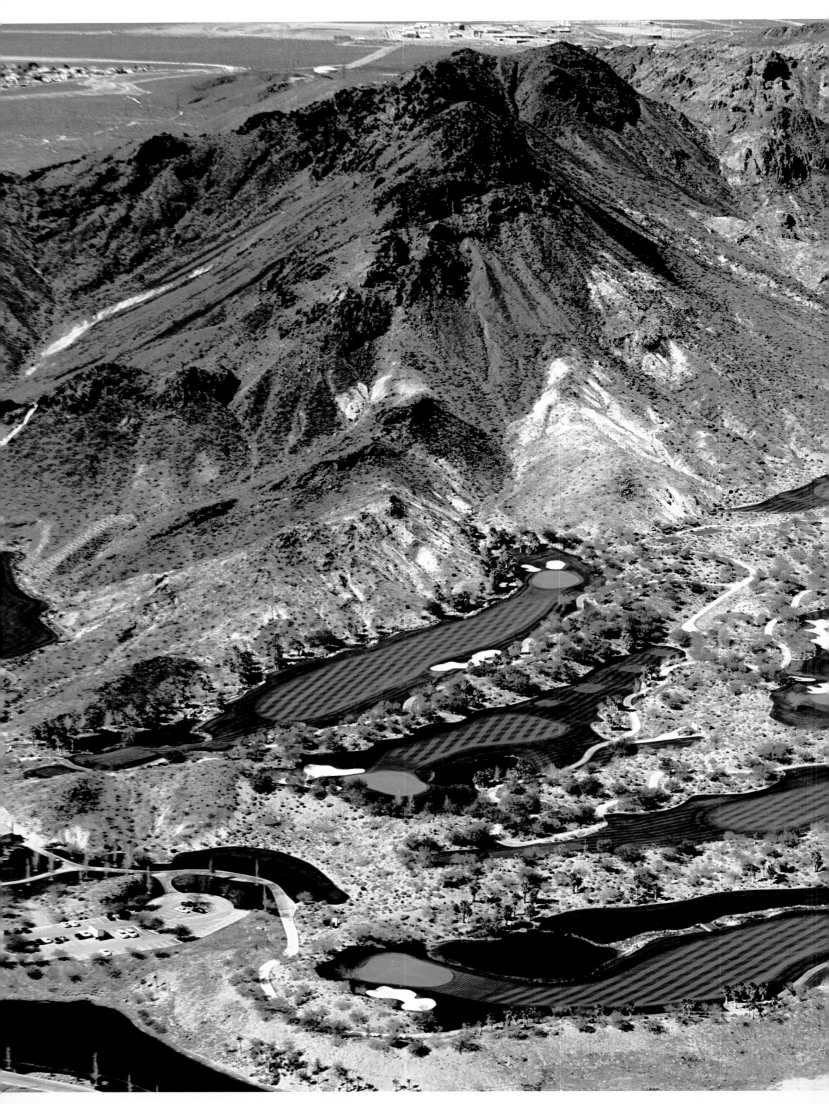

Boulder City, NV
Golf courses in the Las Vegas metropolitan area account for 5 percent of the region's water usage.
Pictured is a section of the 71-hole Cascata Golf Course, which has managed to conserve 60 million
gallons of water per year by increasing the aeration of the turf areas and replacing rye with
Bermuda grass (which requires less water) in some turf areas.

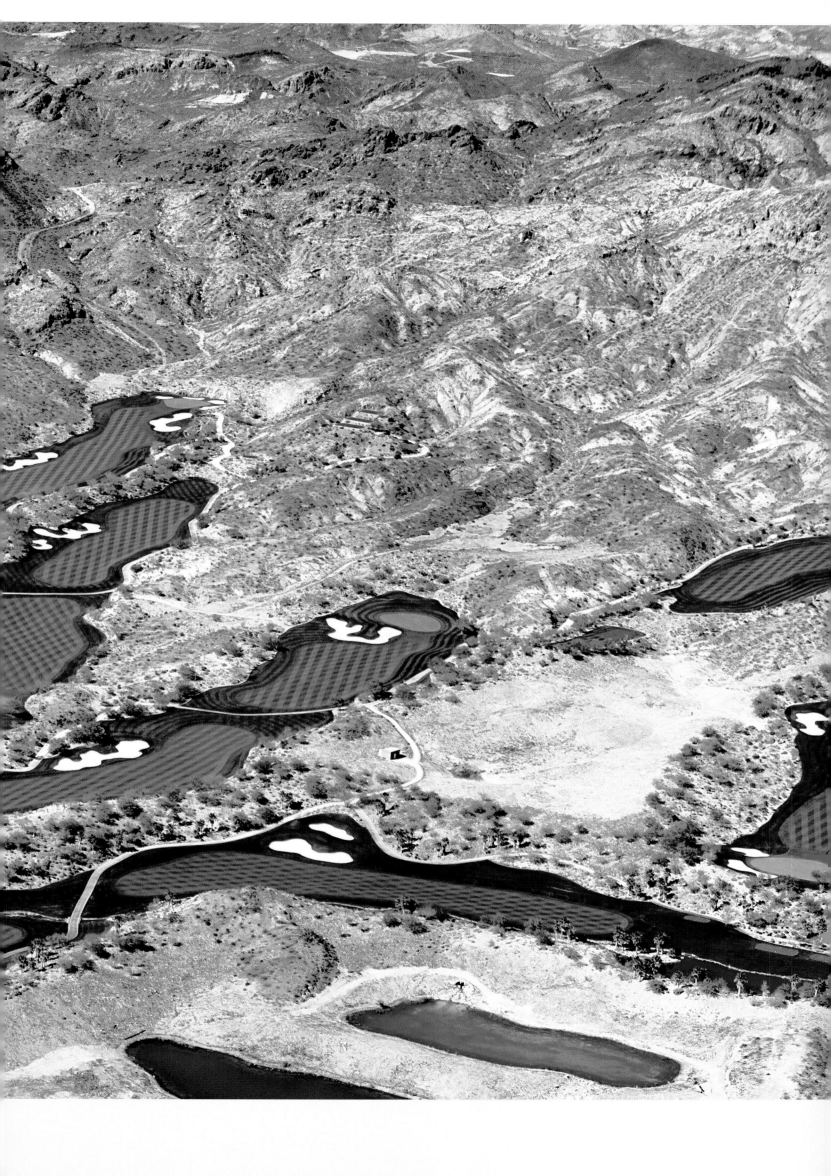

Needles, CA
A dried-out wash flows to the Colorado River. Hydrologists predict that in the coming decades the
Colorado's flow will sink considerably, and reservoirs could dry up as soon as 2021.

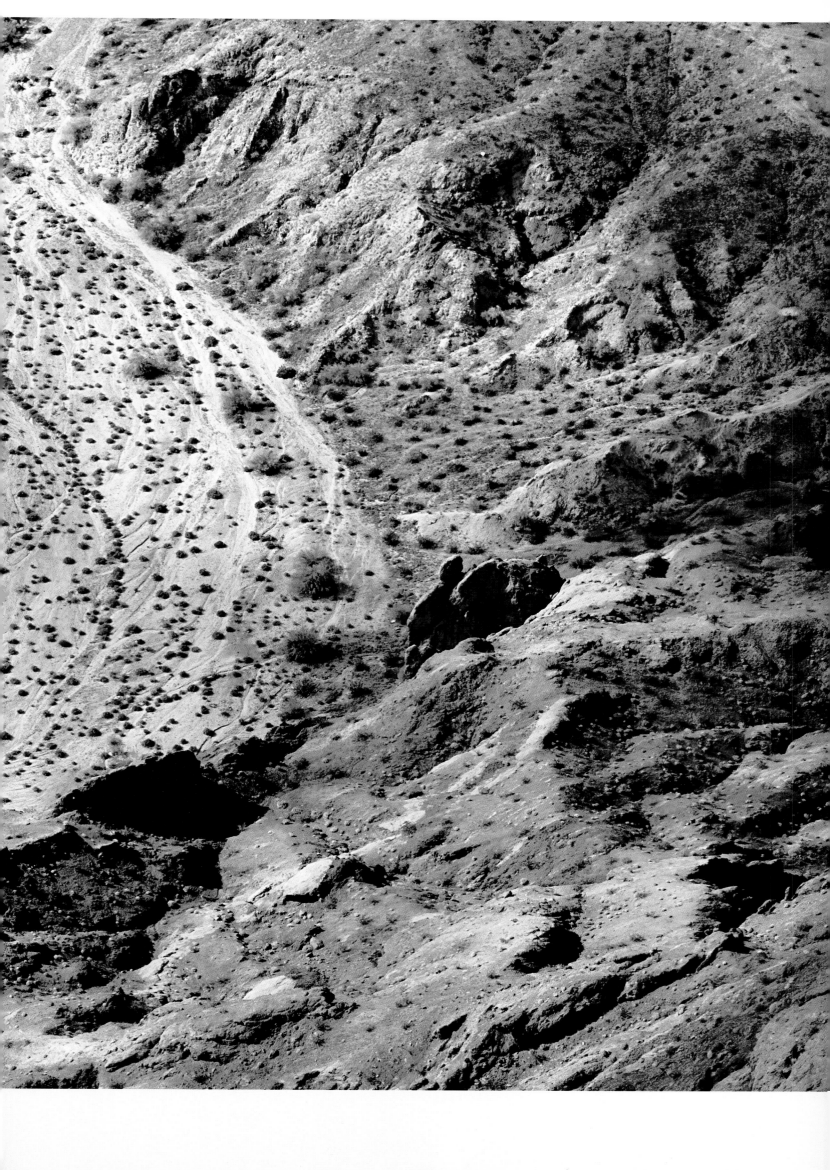

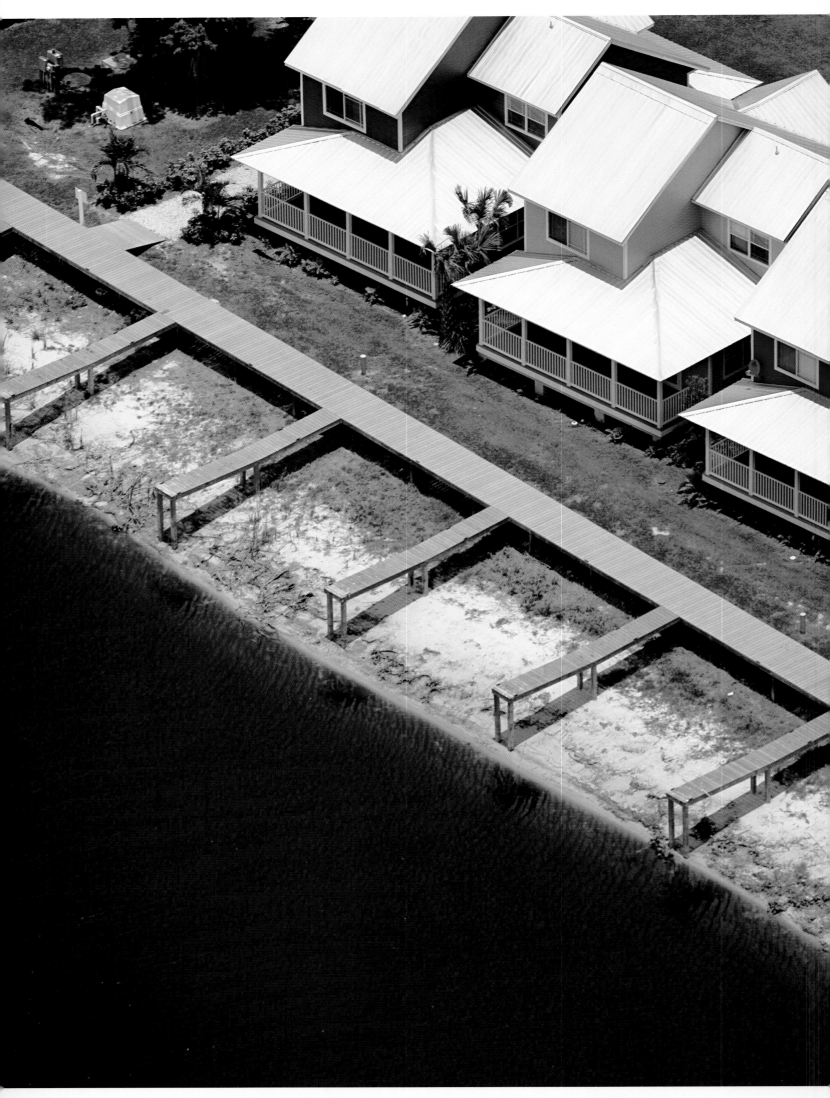

Lake Okeechobee, FL
Owing to drought, the private docks of these new homes are no longer usable. As a side effect of
water-level recession, the town of Okeechobee has also lost out on fishing tourism. In 2007, 1.9
million cubic yards of arsenic-laden mud was removed from the lake floor to reveal a more natural,
sandy bottom, which should improve water clarity and habitability for plant and animal species.

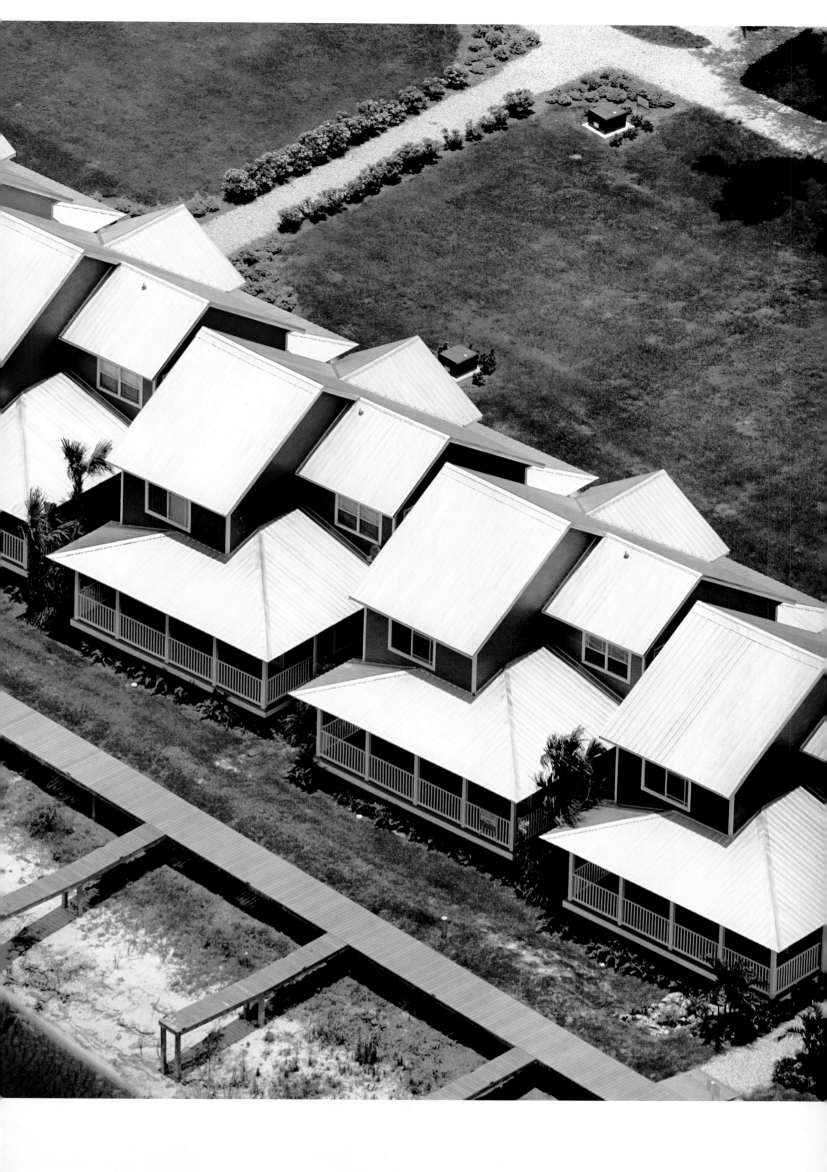

Sebring, FL
A private dock with multiple boat slips and a dock house sits high and dry on the shore of Lake Jackson. In the past decade, Lake Jackson has suffered severe drought and water levels have reached record lows. Tracks in the sand reveal the boat owner's now-abandoned effort to reach the receding shoreline.

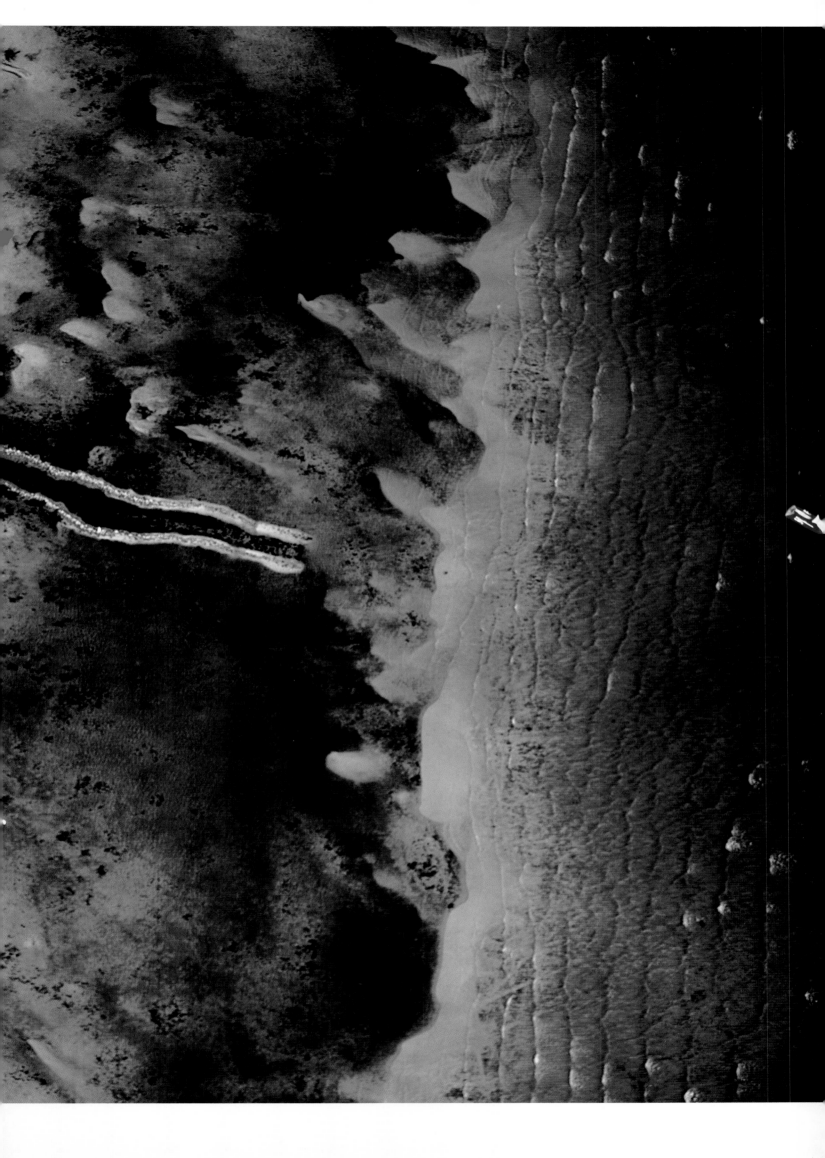

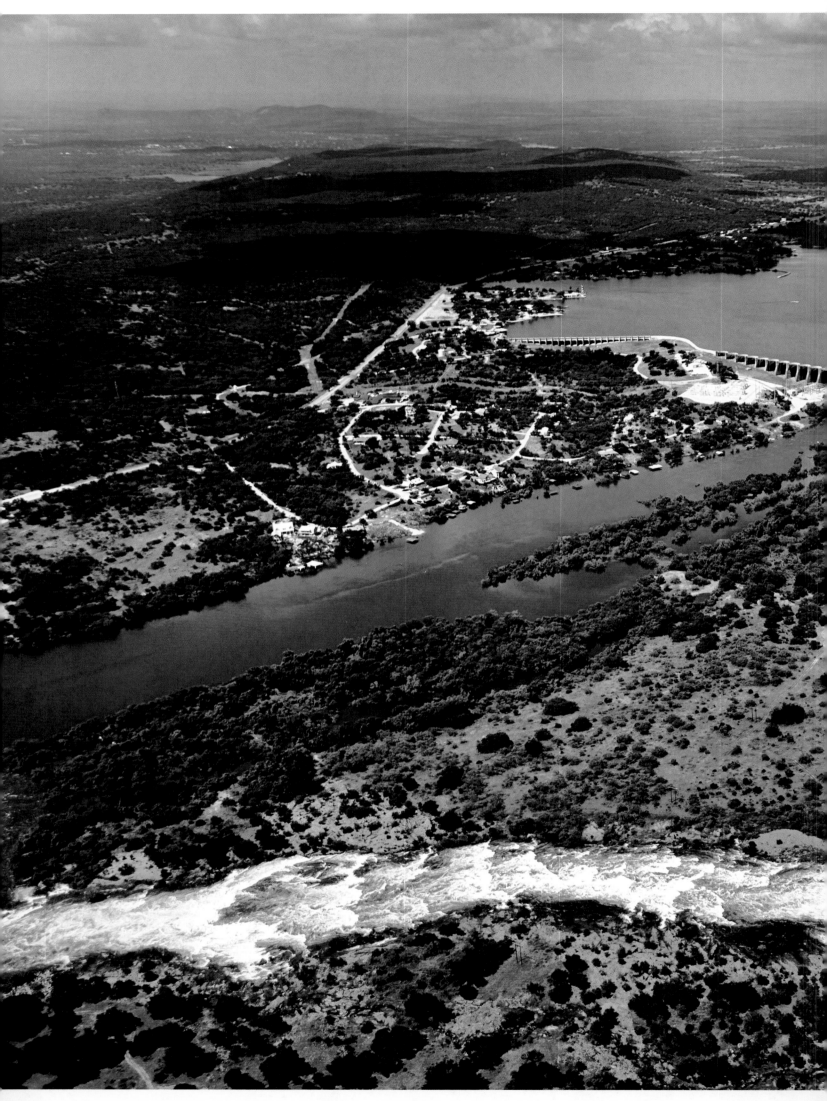

Horseshoe Bay, TX
After torrential rainstorms, Wirtz Dam lets water out of Lake Lyndon B. Johnson through its spillway,
to prevent flooding on the reservoir's shores. Controlled water release from reservoirs is usually
dictated by periods of peak energy use and water demands for irrigation and recreational use.

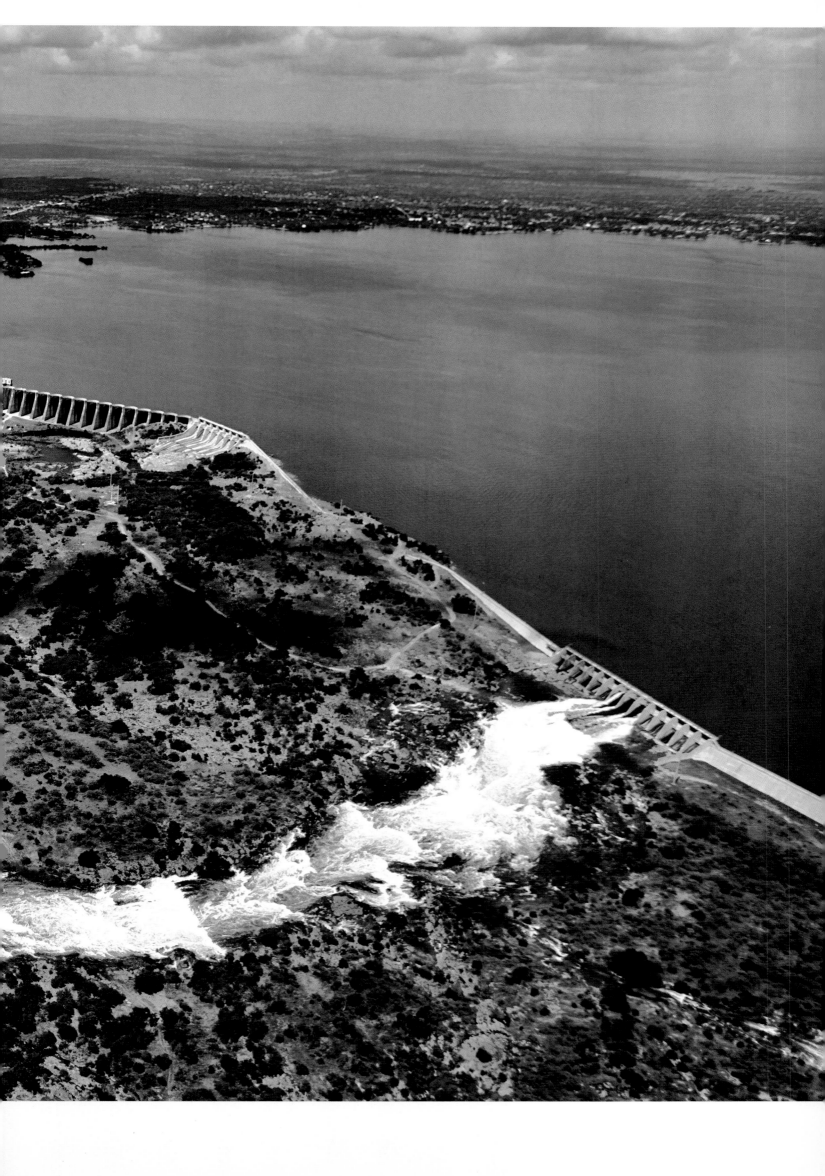

Sea-Level Rise

For me, one of the hardest things to fathom about climate change is the predicted rise in sea level. There are other dire predictions, such as megastorms, prolonged droughts, widespread forest fires, and beetle infestations, but these events have already happened, so I can envision them continuing to happen. However, the idea of the sea level rising gradually yet continuously, so much so that we will have to scramble to higher ground as shorelines move inland, does not viscerally seem possible in my lifetime. Instead, sea-level rise is supposed to happen in a geologic time frame, as it has actually happened in the past. While it seems logical that the oceans will rise from thermal expansion and as huge ground-based ice sheets in Greenland and Antarctica melt with global warming, the sheer magnitude and consequences of shrinking our land-based world is more an abstract idea than something I can internalize.

As a pilot, mean sea level (MSL) is the reference for my vertical world. The pressure altimeter and even the digital GPS in my plane refer to my altitude in feet above mean sea level. Does this suggest that as the ocean rises from climate change everything onshore will "drop"? Fifty years from now, might the given height of an airport or obstruction on my aeronautical chart be less than it is today? If sea level should rise 3 feet, would today's 1,000-foot antenna tower be registered on my chart as 997 feet MSL? While 3 feet does not sound like much of a loss for a 1,000-foot obstruction such as an antenna tower, for a gently sloping coast, a 3-foot vertical MSL gain could translate into thousands of square miles of lost shore land and property.

In the spring and early summer of 2007, I made a number of flights along the Florida coast and from there along the Gulf Coast to New Orleans. From New Orleans I flew down the Mississippi to the end of the Delta and on to Galveston Bay and Houston. There were moments when I felt I was flying through Armageddon. It was the beginning of a severe drought in the Southeast, and lake levels had dropped to record lows. There was thick smoke and haze drifting down from Georgia's uncontrollable forest fires; there were also massive fires in the Florida Everglades, and I had to deviate from my path to avoid no-fly zones established to accommodate firefighting aircraft. At the same time, there were devastating floods and tornadoes causing death and destruction in Texas and the Midwest.

But most unsettling of all was flying in beautiful, clear air from Biloxi to New Orleans and witnessing, for the first time, the devastation still in place from Hurricane Katrina two years earlier. I had understood the *intensity* of the destruction from all the media attention, and I had seen this type of destruction along the path of tornado tracks. What I had not fully comprehended was the *extent* of the destruction; by the time I reached New Orleans I was completely dazed. The amount of damage was staggering. Mile after mile for 80 miles, I flew over foundation slabs marking where buildings and homes had once stood, seeing mile-long bridges that crossed coastal bays knocked off their foundations, and the centers of towns and cities still decimated. FEMA trailers remained scattered everywhere, housing American refugees. (There were 42,000-plus trailers in Louisiana alone.) Much of this destruction along the coast was caused by the force of flooding from the storm surge.

The neighborhoods and suburbs around metropolitan New Orleans were still in ruins, marked by recently cleared lots and boarded-up houses, apartments, and commercial buildings. Many of the occupied dwellings had blue tarps on the roofs and FEMA trailers in front. There were abandoned strip malls and even big-box stores boarded up with plywood. I wondered how many of these neighborhoods would come back—and whether the ones below sea level *should* come back.

On my way west to Houston from New Orleans, I took a 90-mile detour to the southeast to fly down the Mississippi to the mouth of the river and view the coastal wetlands and barrier islands. I knew Louisiana was (it still is) losing 25 to 35 square miles of its coastal wetlands each year, for reasons that include saltwater infiltration, sea-level rise, and subsidence. Subsidence has the same effect as sea-level rise, in that it is land sinking into the ocean. It is difficult to recognize this loss without knowing what the land looked like originally, which is why before-and-after pictures of receding glaciers are so effective. In this case, I didn't have "before" pictures, but I had a flight sectional chart that depicted large marsh-grass areas; out my window, however, they were nowhere to be seen. Local pilots verified that the mapmakers had not kept up with recent wetland losses. One of the many important roles played by wetland marsh is protecting inland populations from storm surges coming in off the Gulf.

In flying this route all the way from Florida to Texas I could sense people's attitudes about developing property along and living by the ocean, and their belief in pending sea-level rise. It ranged from large-scale real estate development companies investing millions of dollars in high-rise towers less than a few hundred feet from the ocean and just a few feet above sea level to individual property owners investing small fortunes to build sand seawalls in front of their homes to stave off coastal erosion. I cannot remember seeing anything more futile than these desperate individual attempts to hold the ocean at bay; it speaks less of a realistic outlook and more of the deep attachment and love people develop for land and place.

When I arrived in Galveston Bay, I came across the ultimate construct in sea-level-rise denial: ongoing dredge-and-fill housing development built in the Bay's pristine wetlands. McMansions were being built on artificial lagoon keys just feet above sea level. The development featured views across the Bay to the city of Galveston, home of this country's deadliest natural disaster, the Galveston Hurricane of 1900—when sea level was eight inches lower than it is today.

As I fly along the country's coastlines, I find myself wondering what federal and local governments and even individual citizens are thinking when they build new housing and infrastructure so low and so close to the ocean. From what I can see, it is the beginning of an as yet unrecognized war at our coastal borders against the rising oceans. It is a war with no end, and it will continue to have horrific social and economic costs over time. Without a doubt, sea-level rise is difficult to comprehend and accept. If we did fully accept its existence, and its ties to climate change through human activity, then collectively we would be changing our activity and changing it fast.

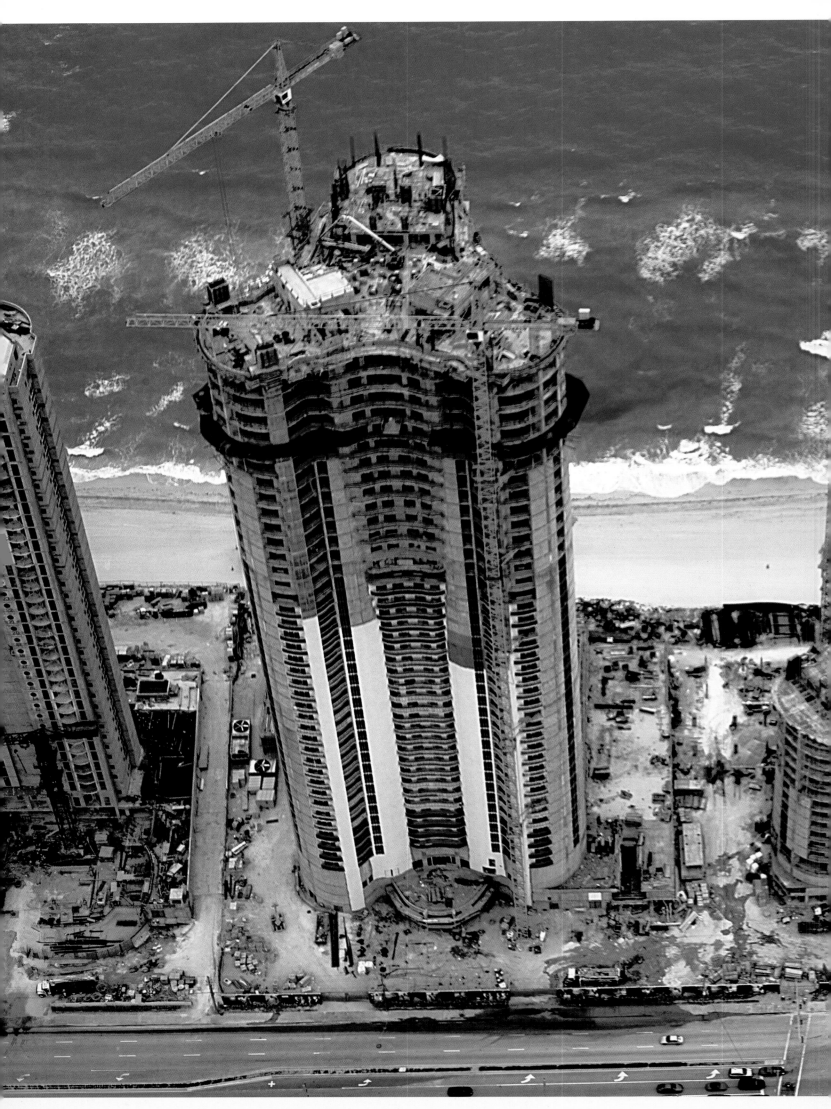

Sunny Isles, FL
Despite the destructive hurricanes and rising sea levels that have hit the Sunny Isles community, developers continue to build close to the shoreline. Trump Towers Miami is one of many high-rise structures going up on the coast between Fort Lauderdale and Miami.

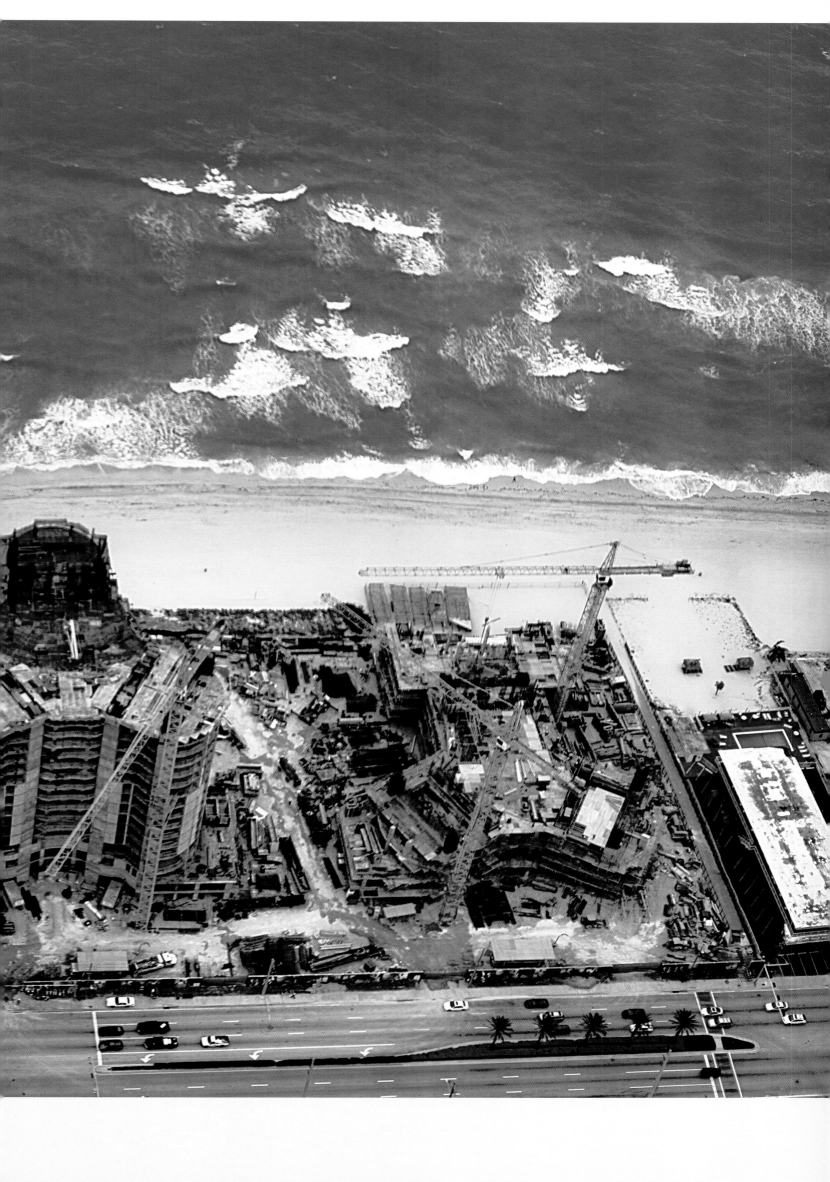

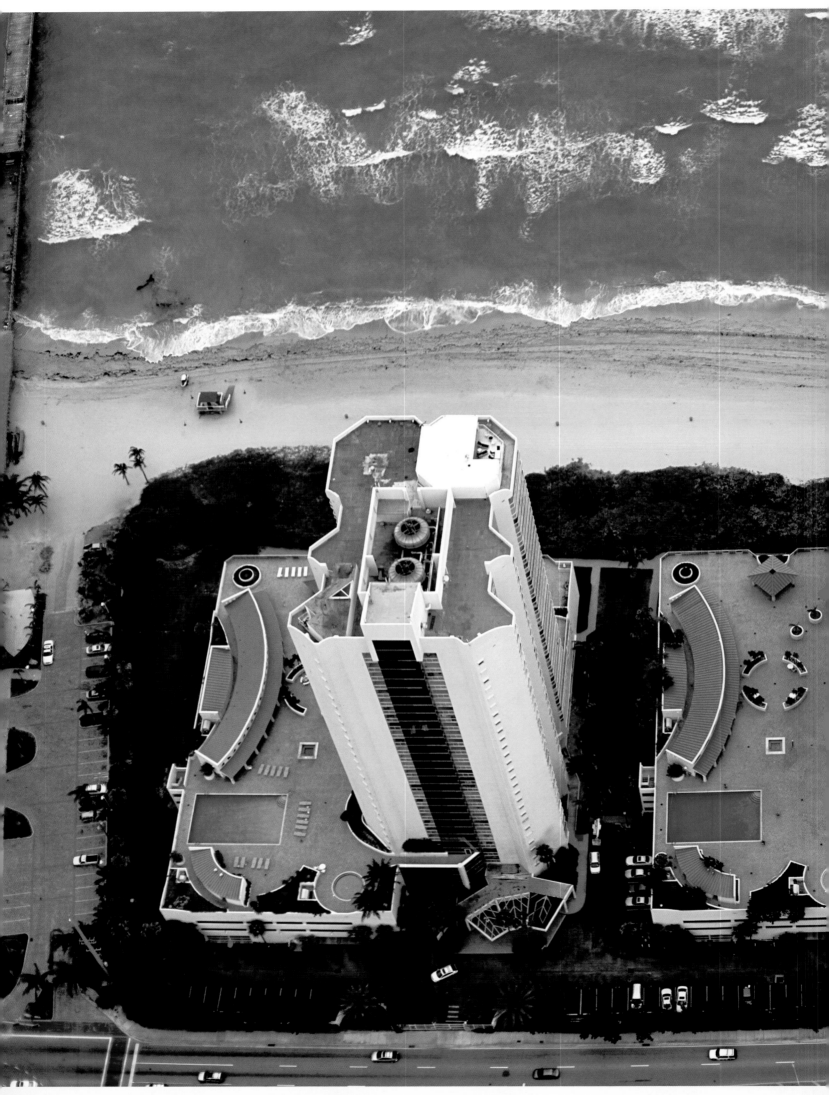

Sunny Isles, FL
The Oceania Property condo towers are located 8 feet above sea level and less than 200 feet from
the open waters of the Atlantic. The towers and grounds suffered millions of dollars in property
damage from Hurricane Wilma in 2005. Repairs and insurance settlements took more than two
years to complete.

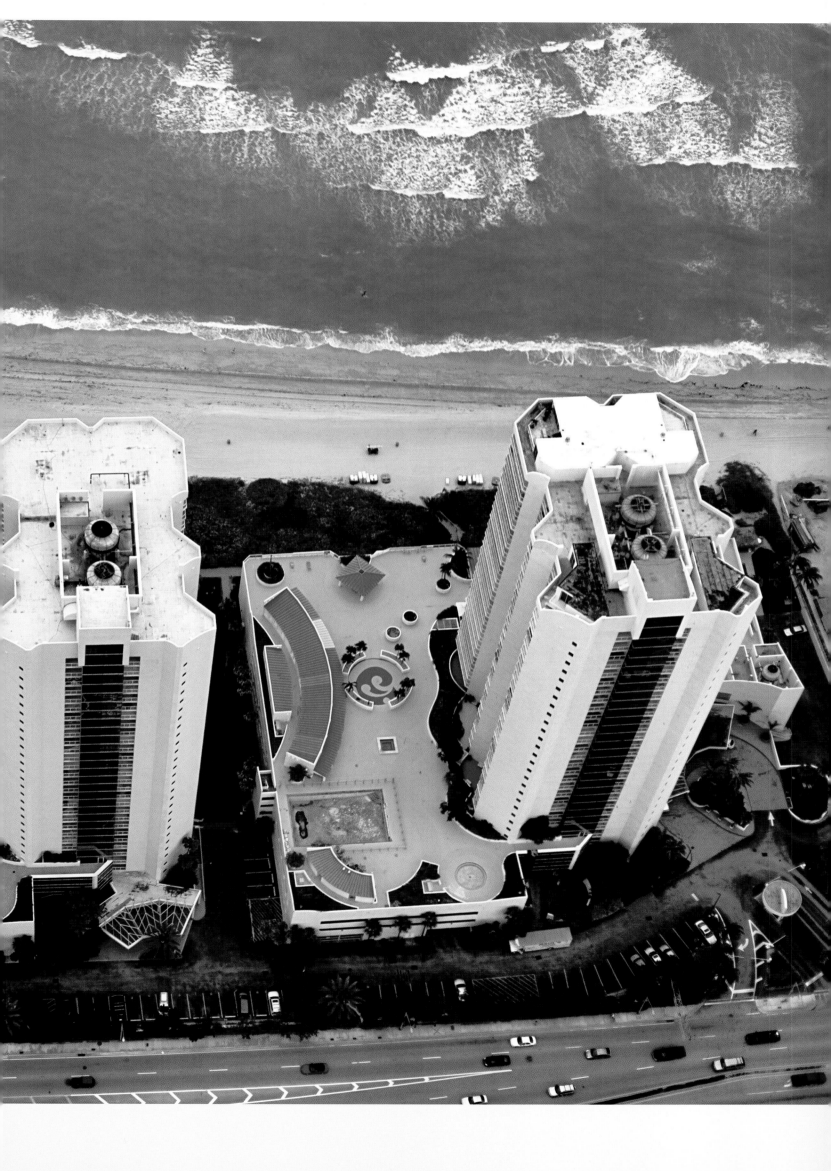

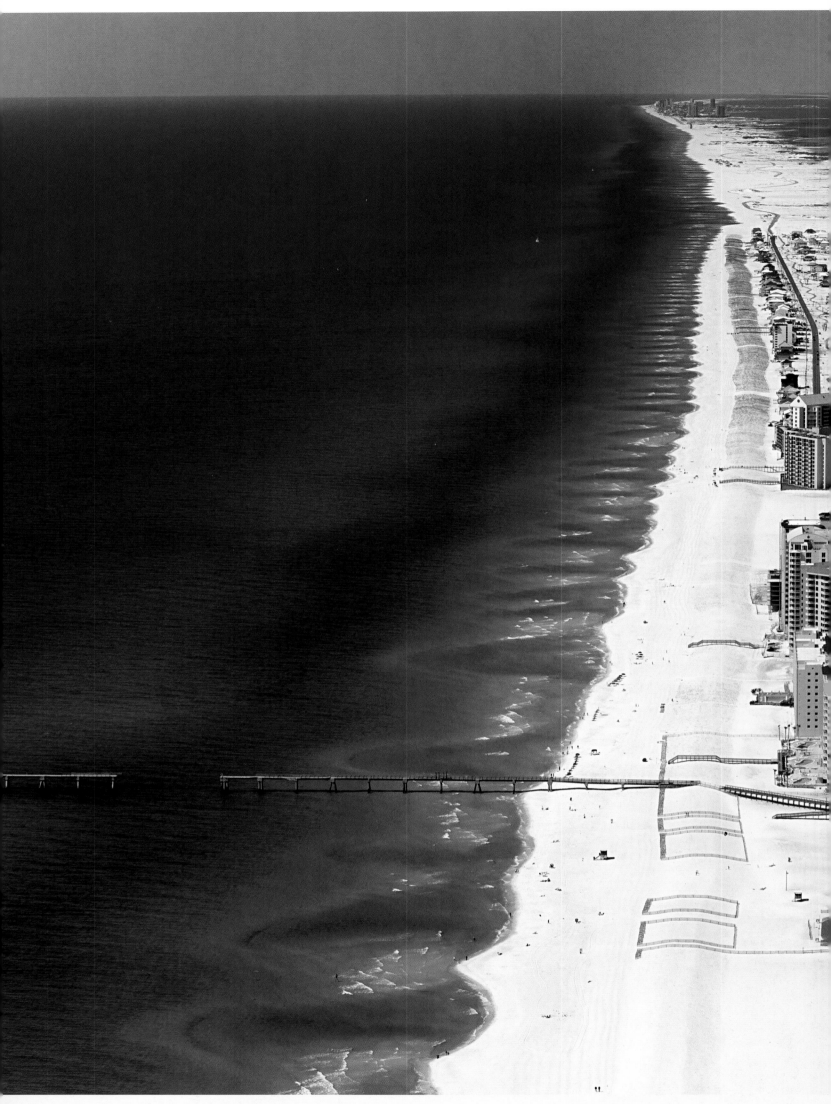

Santa Rosa Island, FL
Santa Rosa Island, a barrier island, was hit hard by hurricanes Ivan in 2004 and Dennis in 2005.
Rising sea levels erode the coast, yet the tourist industry continues to attract developers eager to
build. Between the beach and the buildings, sand is pumped from the bay to the shore, forming a
sand wall, similar to a natural barrier dune.

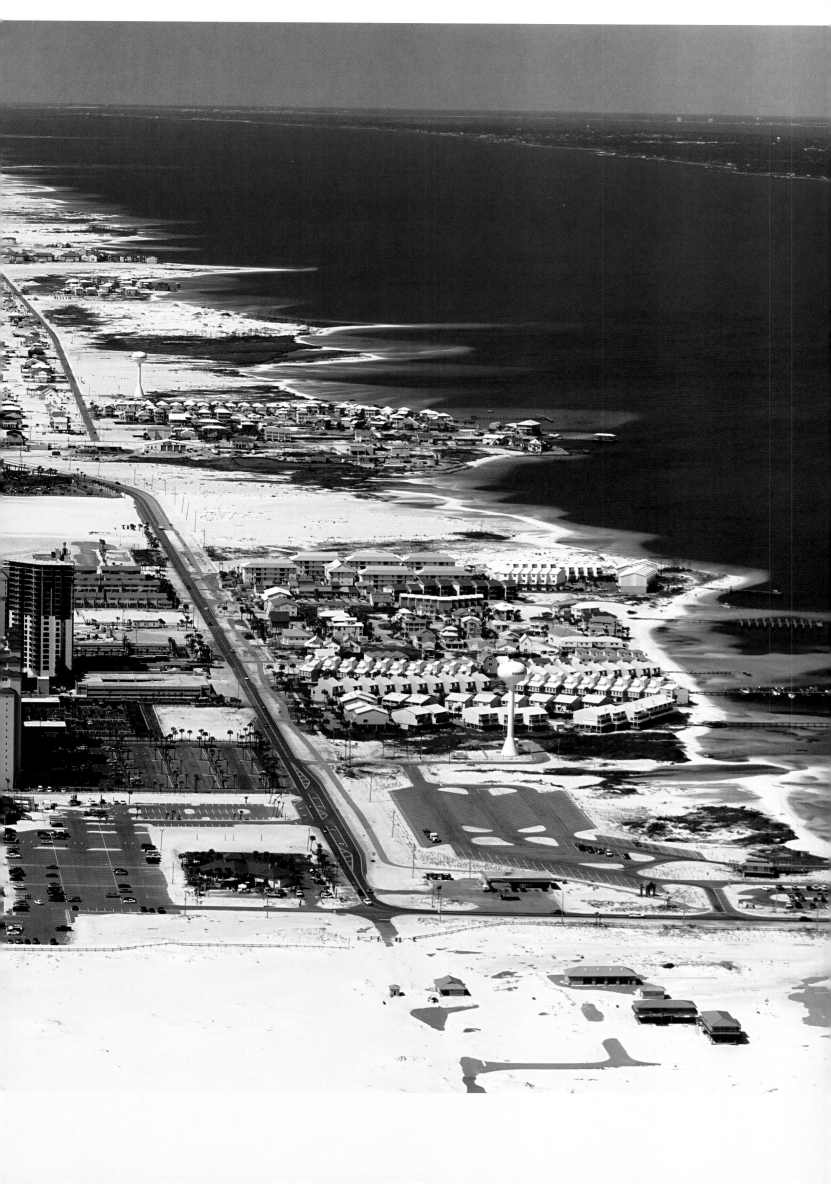

Downtown Miami, FL
High-rise buildings hug the coast along Burlingame Island at the mouth of the Miami River. Even
moderate sea-level rise puts many of Florida's coastal cities underwater.

New York, NY
At the tip of Manhattan Island, Battery Park and the Financial District lie just several feet above current mean sea level. New York City has more than 600 miles of coastline that will have to contend with flooding from rising sea levels and increasingly heavy storms caused by climate change.

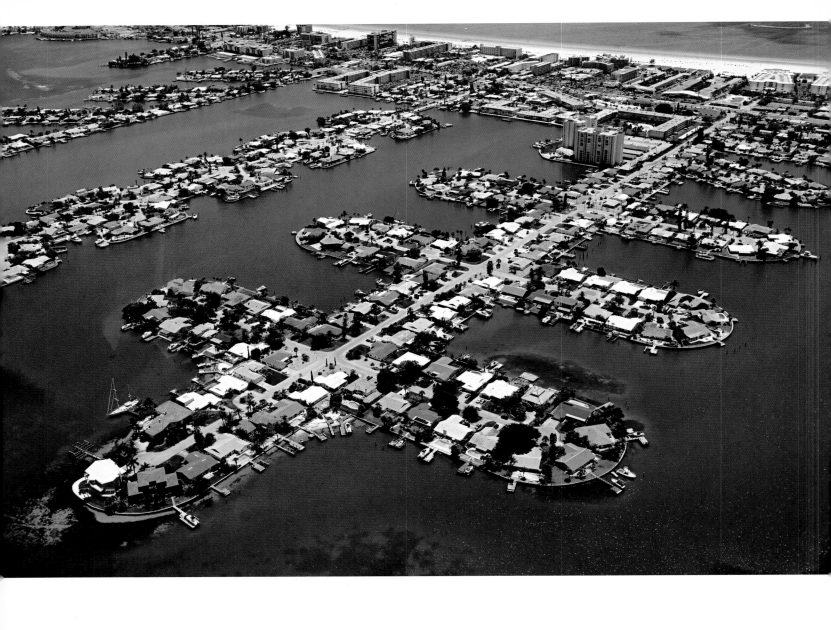

Treasure Island, FL
The construction of artificial dredge-and-fill peninsulas for housing behind barrier islands on the Gulf Coast is a common technique for creating waterfront property along much of the Florida coastline, all of which is vulnerable to flooding and storm surges.

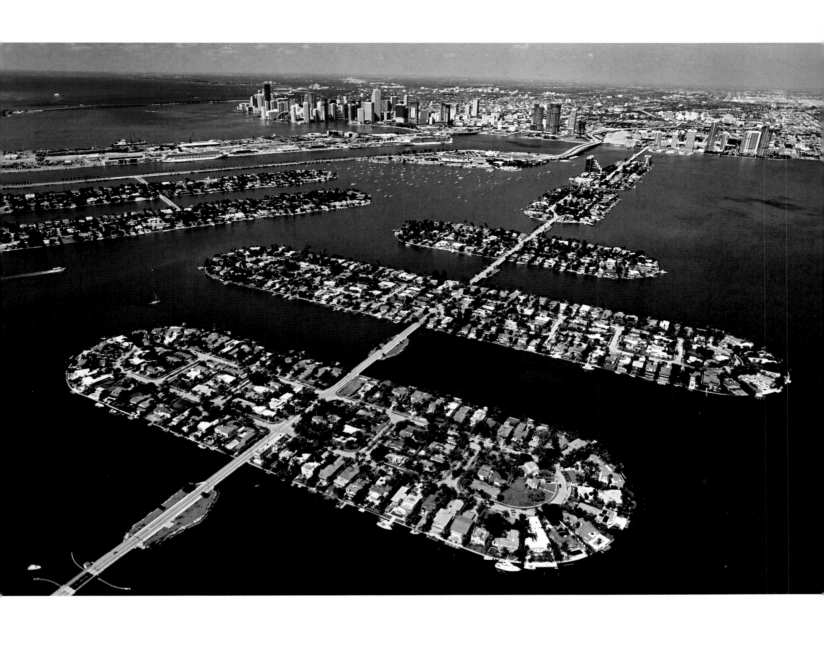

Miami Beach, FL
Built in the 1920s, long before sea-level rise was a global concern, the Venetian Islands are a set of
artificial islands made from dredging in Biscayne Bay.

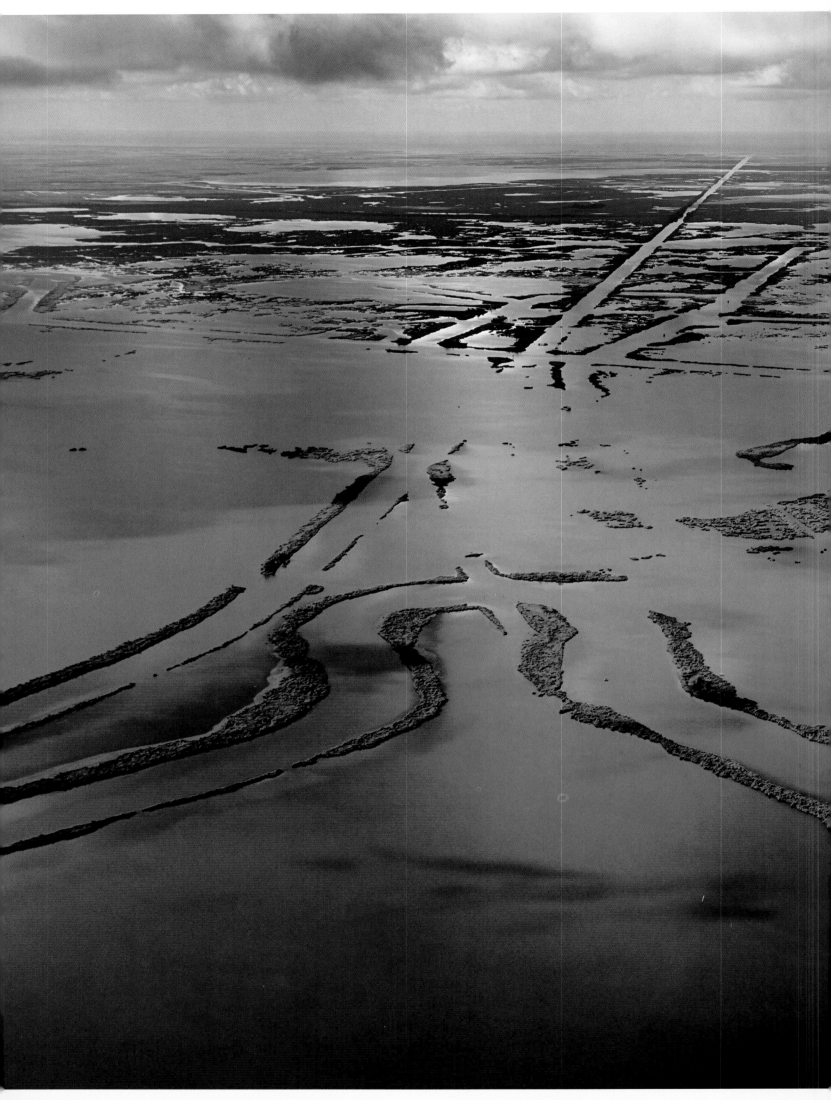

Plaquemine County, LA
The Mississippi Delta has over 10,000 miles of canals dug to tap oil and natural gas. The canals and drilling are blamed in part for the loss of more than 1,000 square miles of wetlands through the interruption of tidal flows, salt water infiltration, and subsidence.

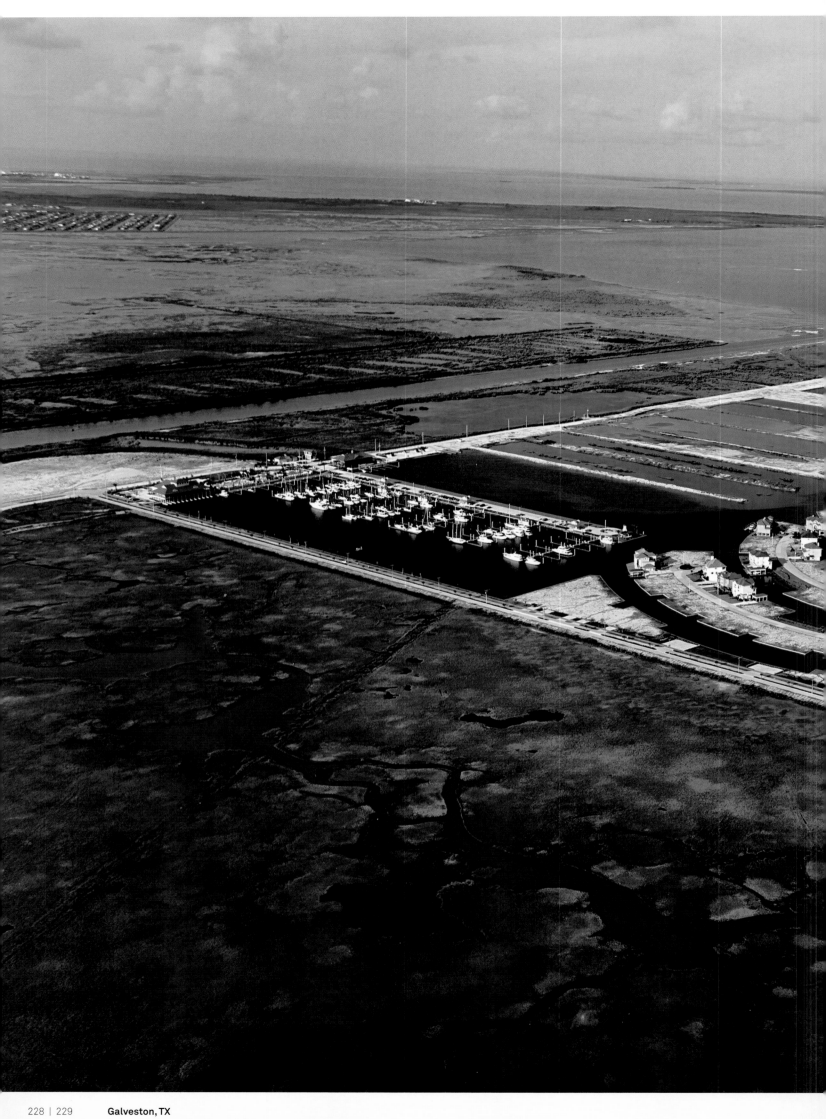

Galveston, TX
Galveston is experiencing subsidence caused by pumping out oil, gas, and water from underground.
In addition to changes in global climate that are increasing sea levels, human activities make this
already vulnerable area more disaster-prone.

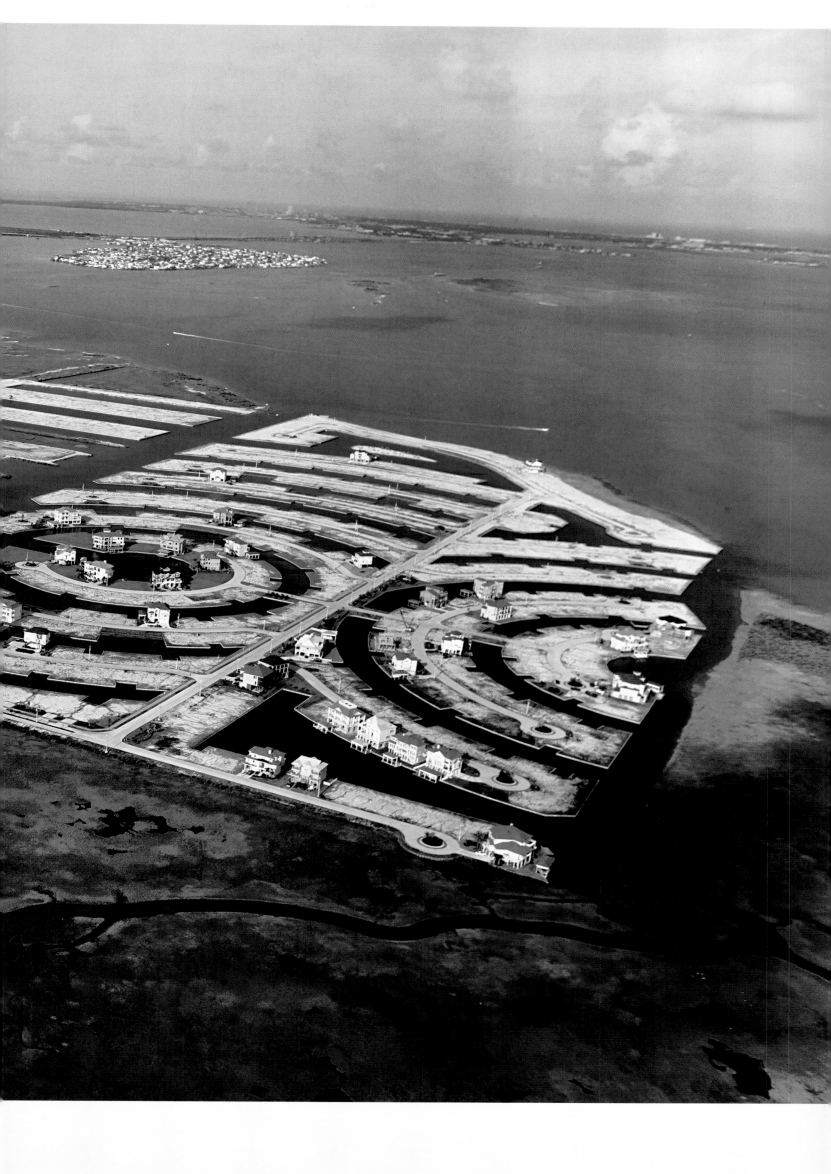

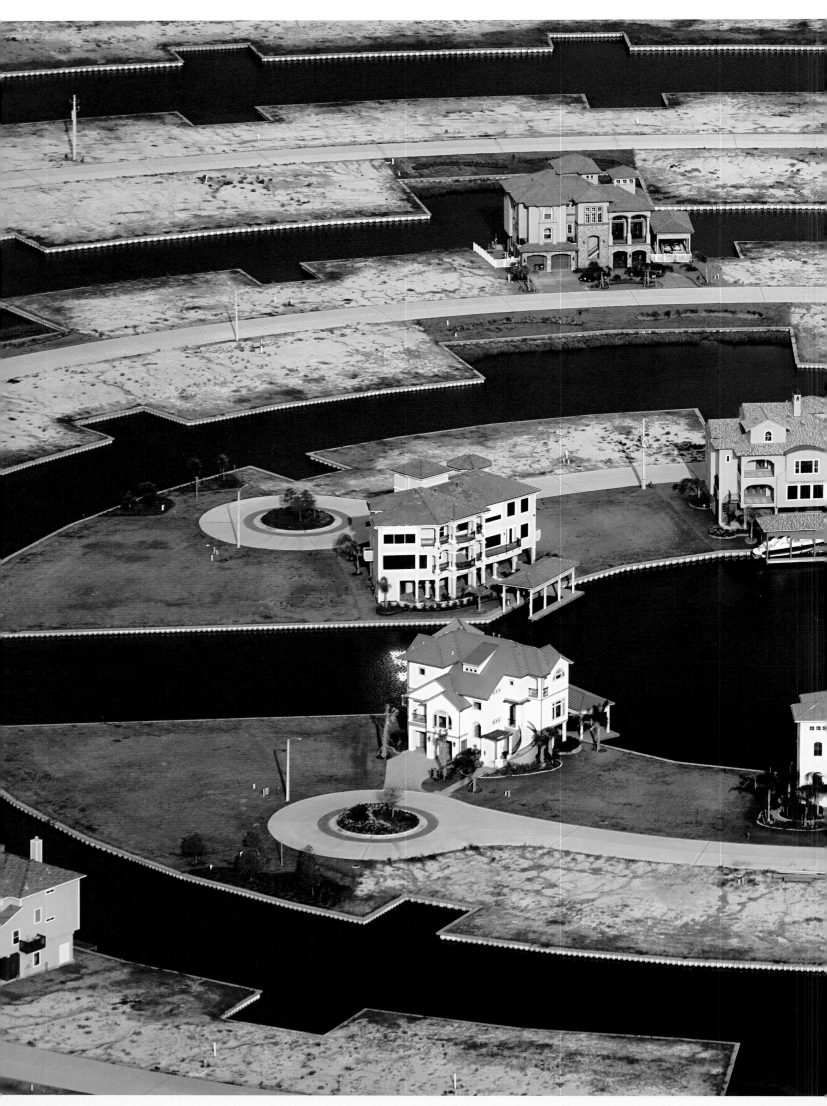

Galveston, TX
Harborwalk is a planned waterfront community built on wetlands on the western coast of
Galveston Bay. In the coming century this land will be some of the most vulnerable on the Texas
coast to sea-level rise, yet developers continue to construct low-lying homes to cash in on
waterfront property values.

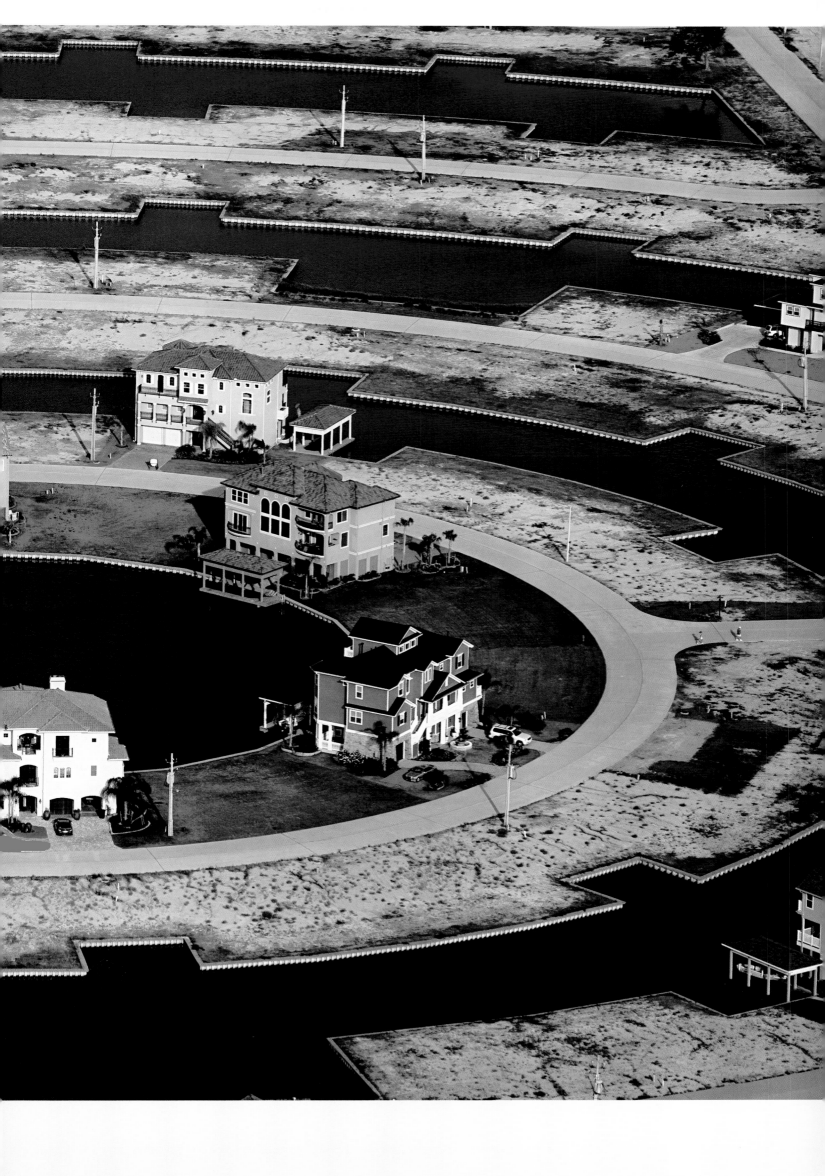

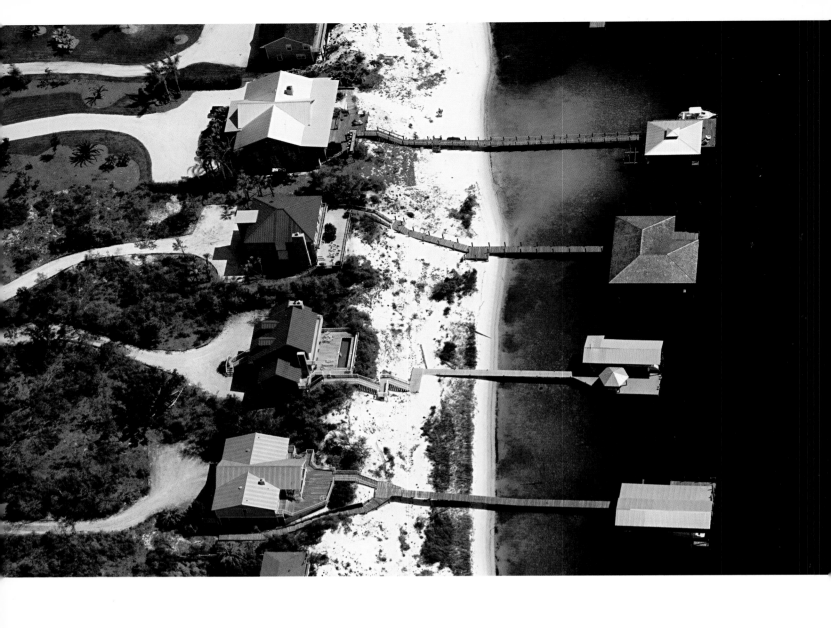

Ono Island, AL
Coastal vegetation helps maintain the shoreline while serving as a habitat for marine wildlife.
Marshland and coastal homes destroy this supportive vegetation, thereby increasing the shore's
vulnerability to erosion from strong hurricanes and rising sea levels.

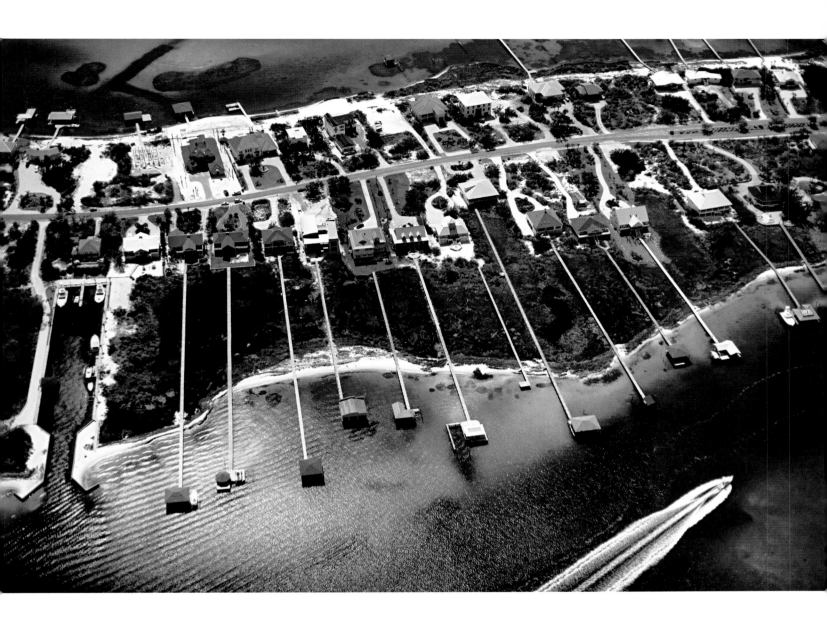

Ono Island, AL

Homeowners on this island all build long walkways over fragile wetland habitats to boathouses. An artificial harbor (left) slices into the already thin island.

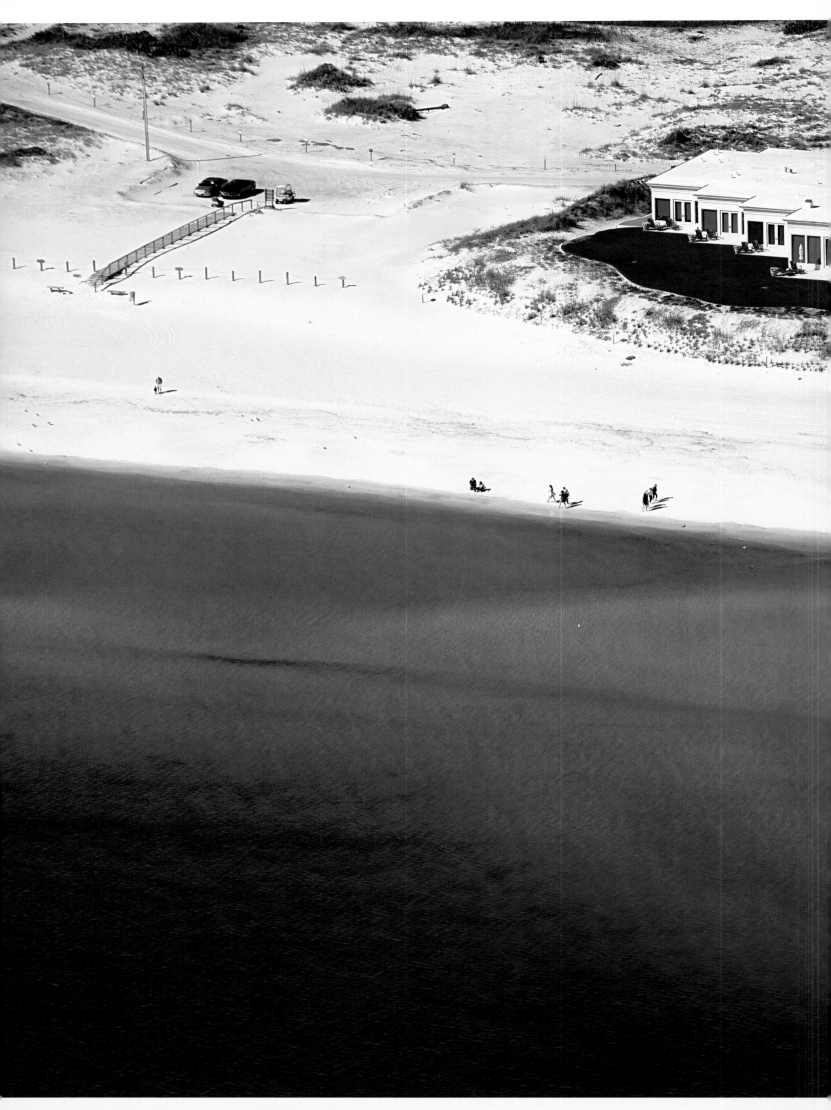

Miramar Beach, FL
An isolated beach mansion sits exposed to the open ocean. Barrier dunes protect the shoreline
from harsh storms and are a habitat for many seaside organisms. Houses are at great risk when
placed on the shoreline in front of protective dunes.

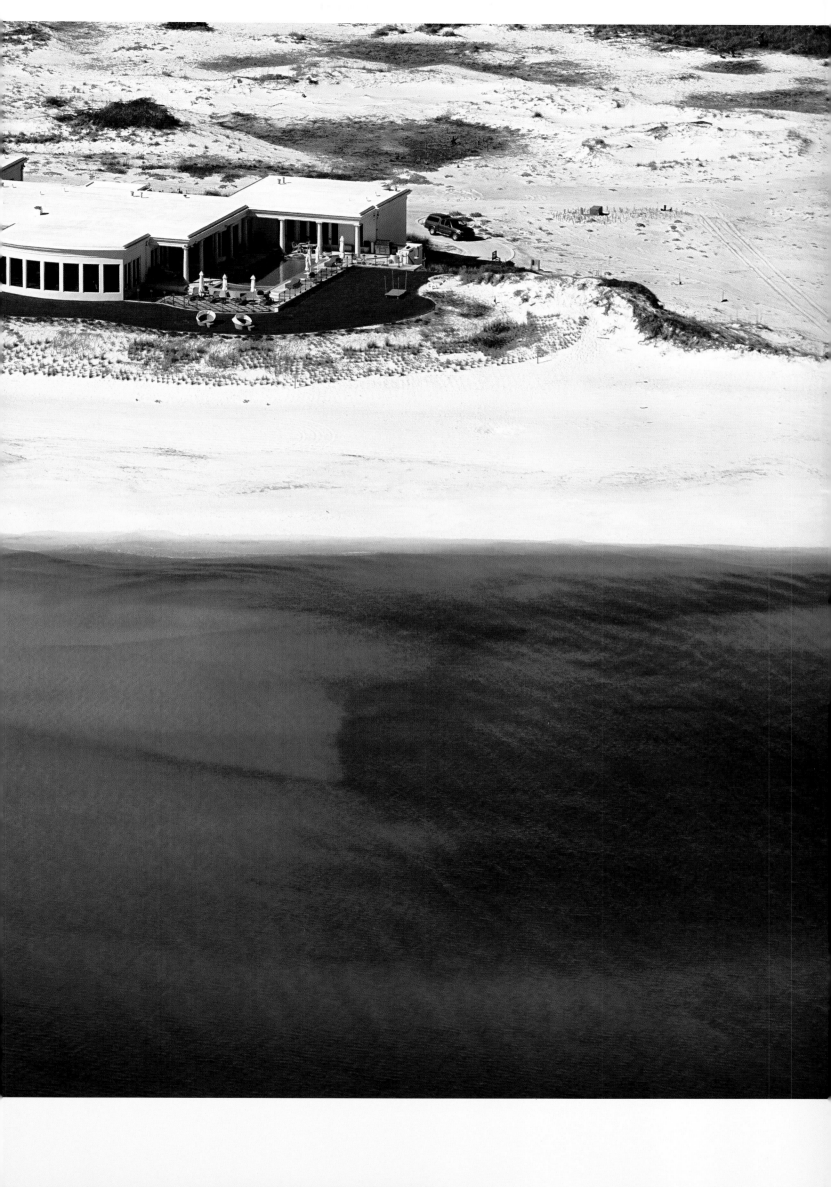

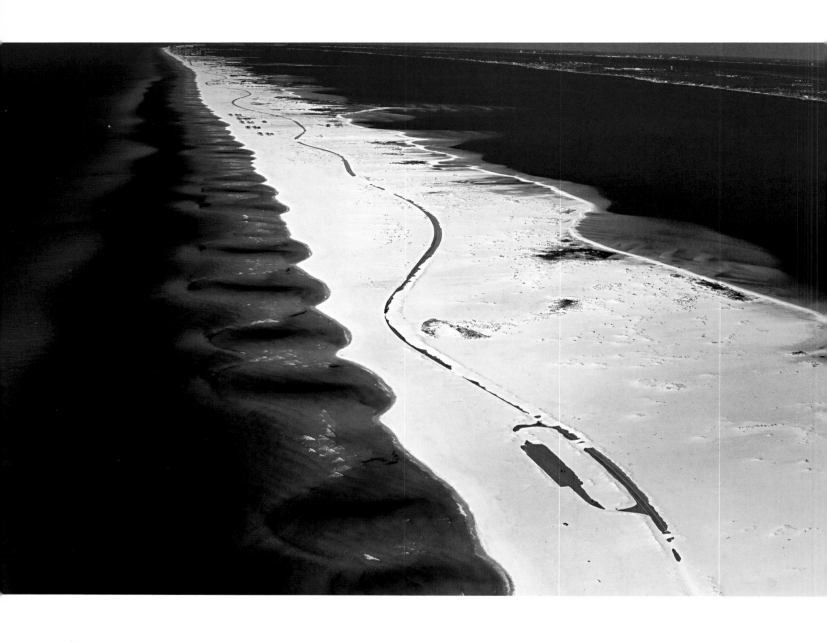

236 | 237 **Santa Rosa Island, FL**
Parking lots and roads are temporarily abandoned on this barrier island as a result of a succession
of tropical storms and hurricanes in 2004 and 2005.

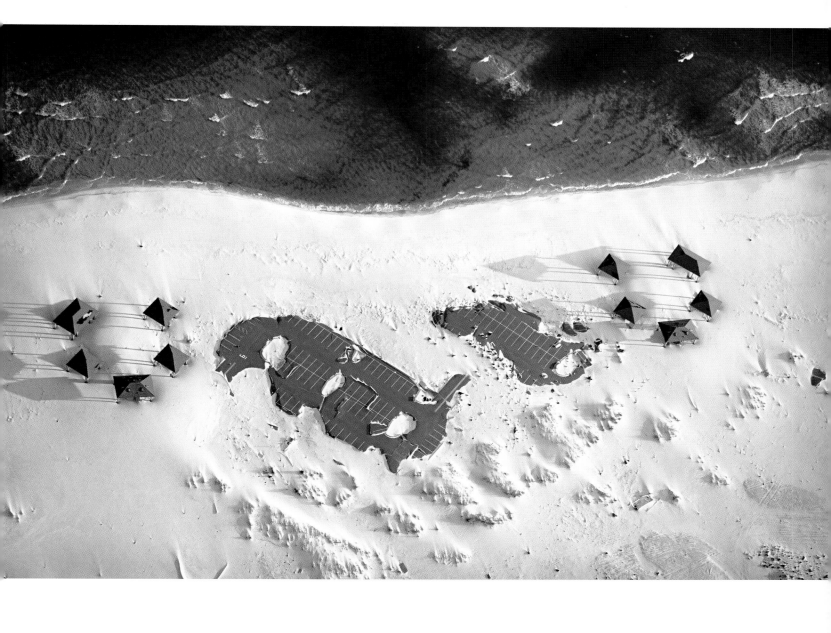

Santa Rosa Island, FL
Beach erosion has brought the ocean closer to a parking lot and picnic shelters that are partially covered by shifting sands.

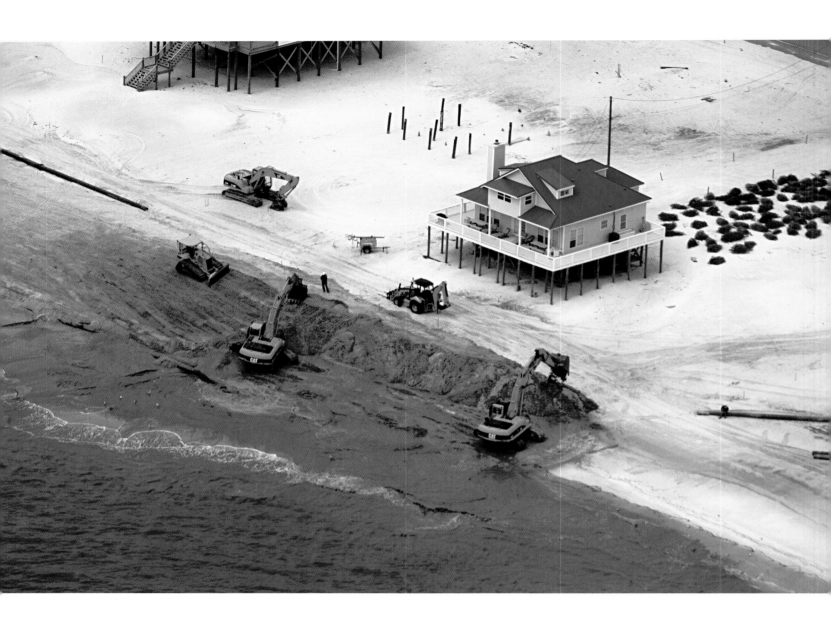

Dauphin Island, AL
Heavy equipment is brought in to fortify the shallow shoreline and threatened property against
rising seas and extreme weather. A pipe (upper left) feeds in sand that is pumped from the bay to
the equipment building up an artificial sand barrier.

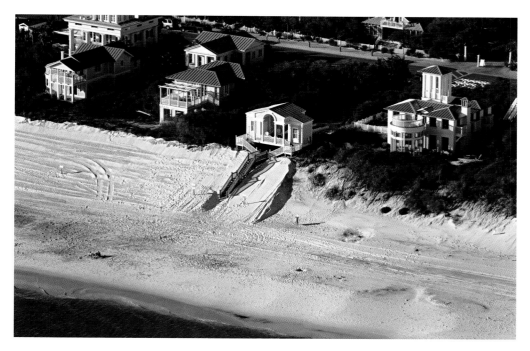

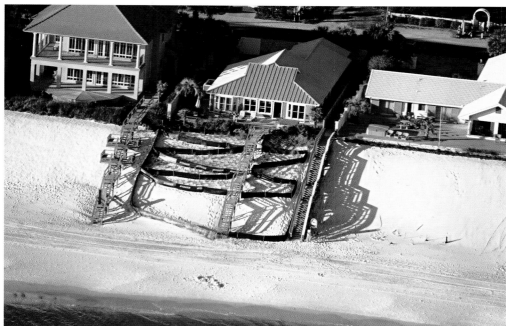

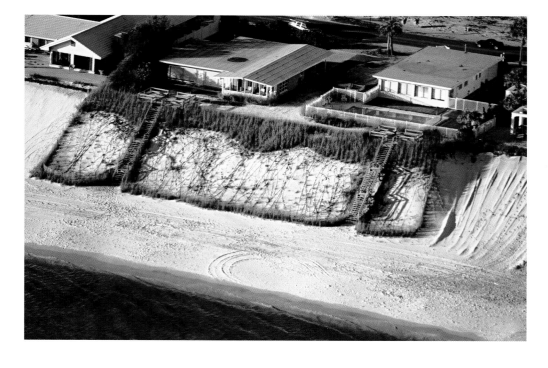

Seaside, FL
Erosion of barrier dunes threatens coastal homes. A walkover has been built across the dune for beach access that will protect dune vegetation.

Santa Rosa Beach, FL
Coastal homes destroy protective dunes and disrupt the coastal habitat. Sand nets and walkovers attempt to stabilize this barrier dune.

Santa Rosa Beach, FL
Homeowners band together to replant and reinforce barrier dunes from water and wind erosion.

Gulf Shores, AL
Beachgoers lounge in front of windbreaks, which stabilize sand from wind erosion.

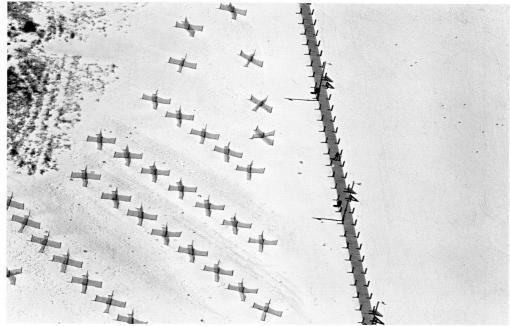

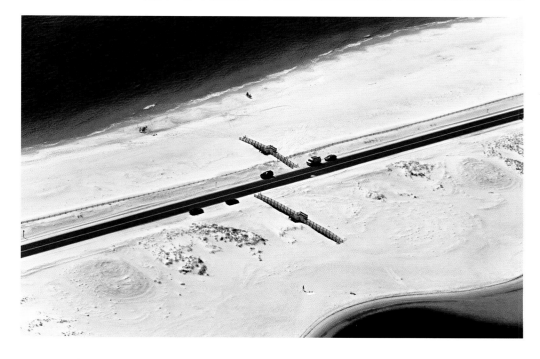

Gulf Shores, AL
Sand fences help build dunes by trapping windblown sand, while preventing damage to roads and property.

Gulf Shores, AL
Wooden walkways keep pedestrians from trampling vegetation, which is critical in stabilizing protective dunes.

Pensacola, FL
Walkovers provide access points to the beach and the bay on a barrier island and protect shore vegetation from being trampled.

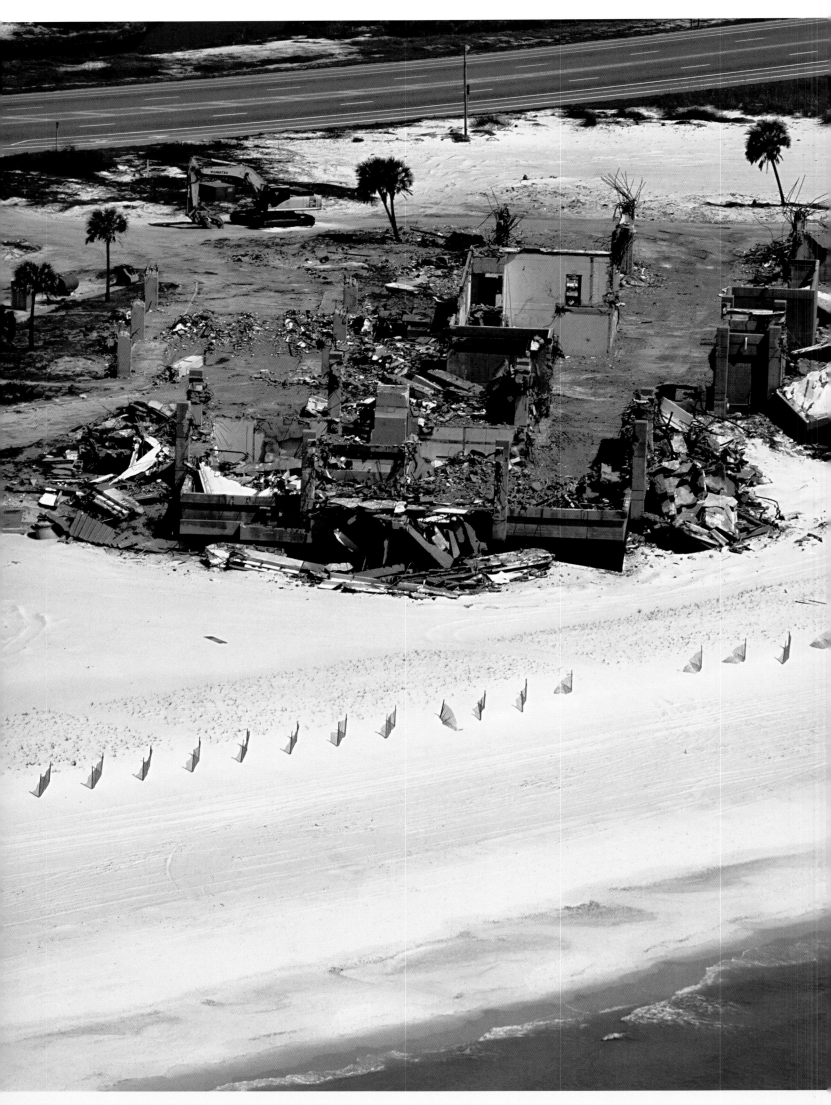

Orange Beach, FL
Coastal buildings lie in ruins behind a sand fence. Cleanup of destruction is still going on three
years after Hurricane Ivan hit in 2005.

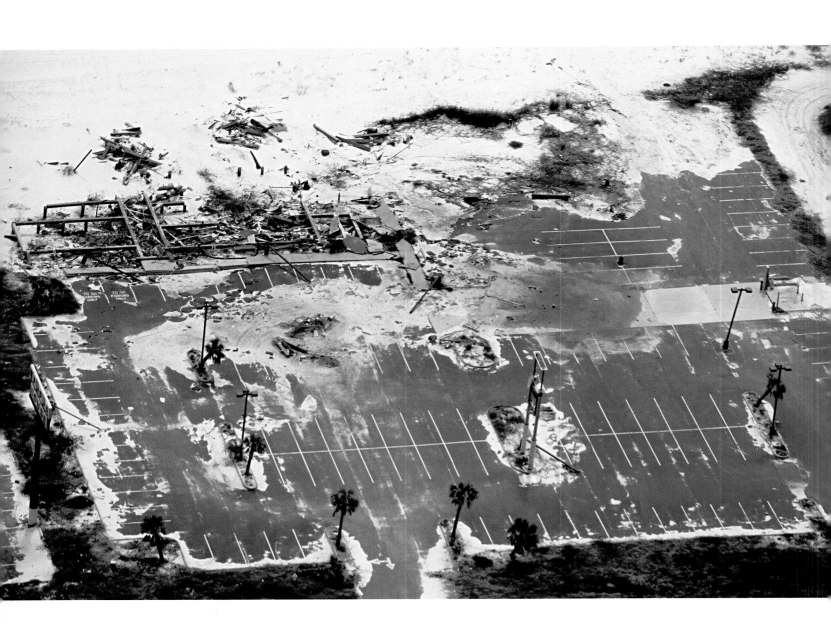

Gulfport, MS
The wreckage of a commercial center remains nearly two years after Hurricane Katrina.

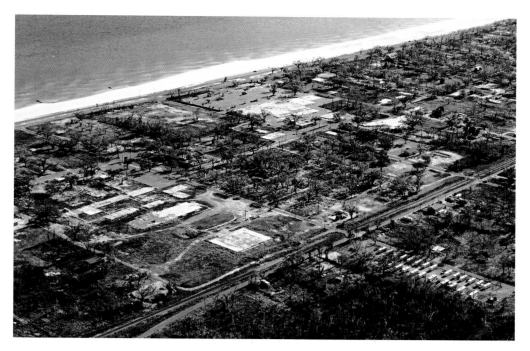

Gulfport, MS
Coastal damage similar to this extends over 100 miles along the coast from Biloxi, Mississippi, to New Orleans, Louisiana. Note FEMA trailers in the bottom corner.

Gulfport, MS
All that remains of an apartment complex after the cleanup from Katrina are the parking lots, slab foundations, and courtyard pool.

Gulfport, MS
This series of empty lots is marked by old foundation slabs and driveways. The house on stilts is the first to be rebuilt after Katrina.

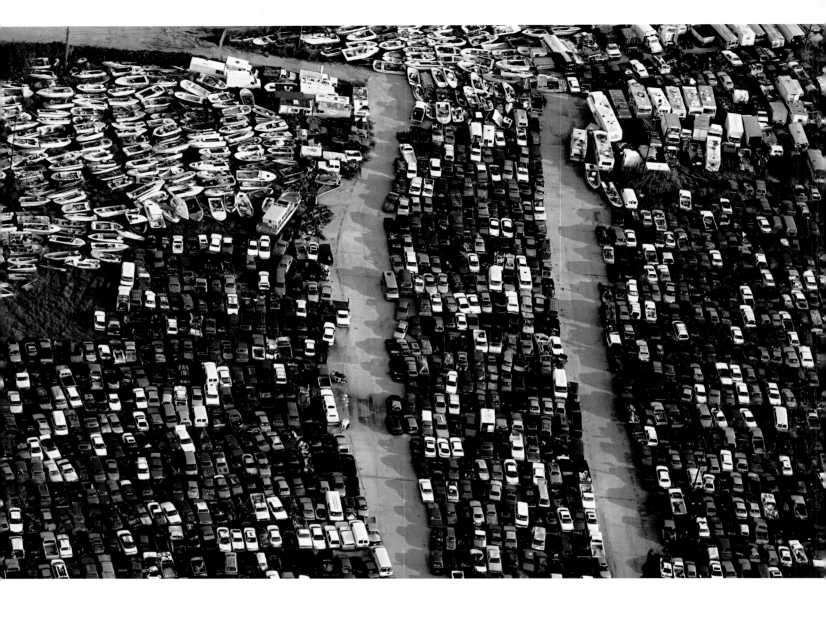

New Orleans, LA
A junkyard overflows with cars, boats, and mobile homes, all damaged by Hurricane Katrina.

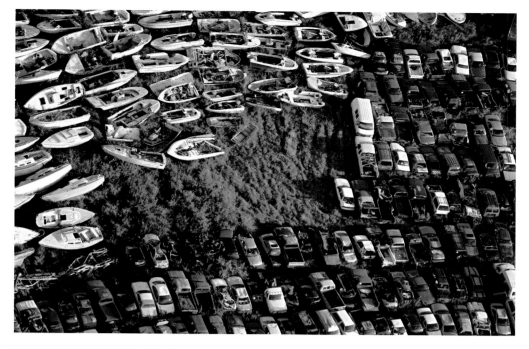

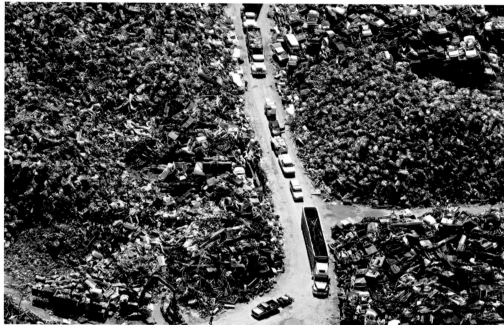

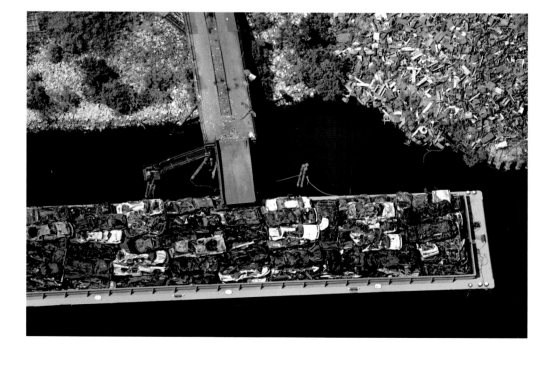

New Orleans, LA
A junkyard contains cars and boats (seen in detail) damaged by Hurricane Katrina.

Gulfport, MS
Trucks bring scrap from homes, cars, and other damaged items caused by Hurricane Katrina to a metal yard for recycling.

Gulfport, MS
A barge ships flattened cars to New Orleans for shredding and sorting.

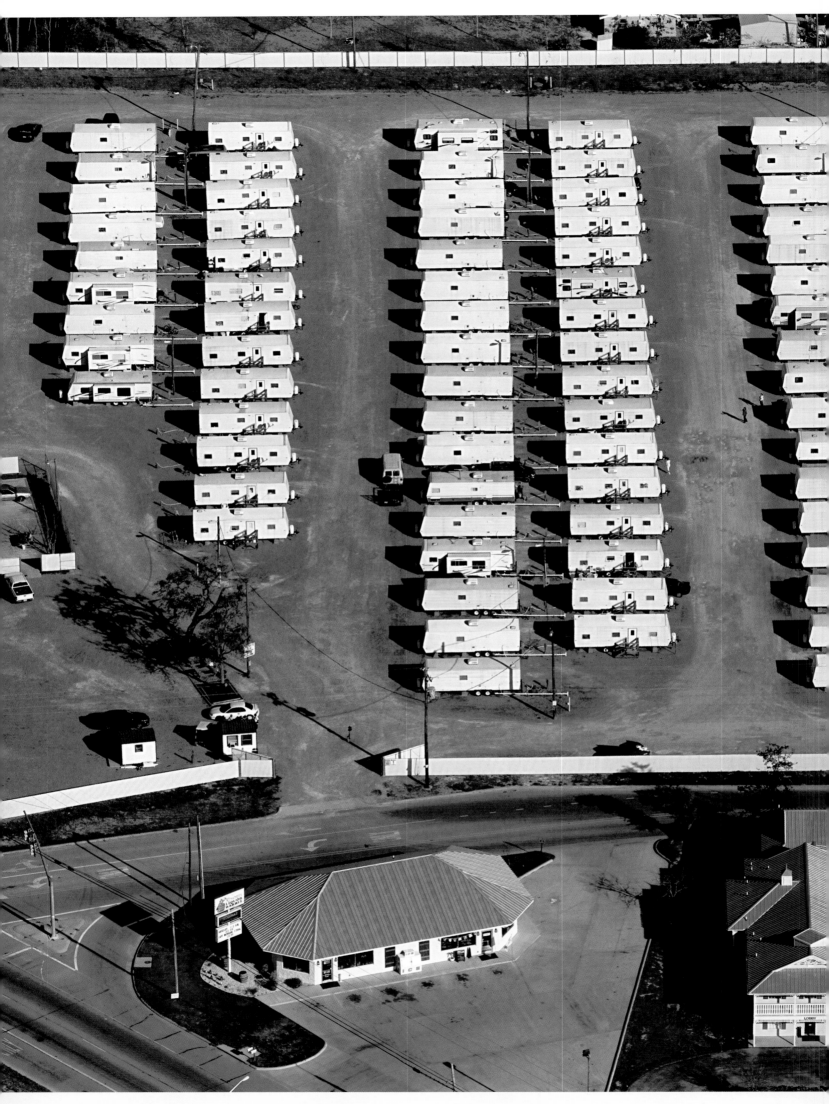

Bay St. Louis, MS
FEMA trailers next to a hotel form a small community of Katrina evacuees, which is only recently starting to disband. What was supposed to be temporary shelter turned into semipermanent housing for the community.

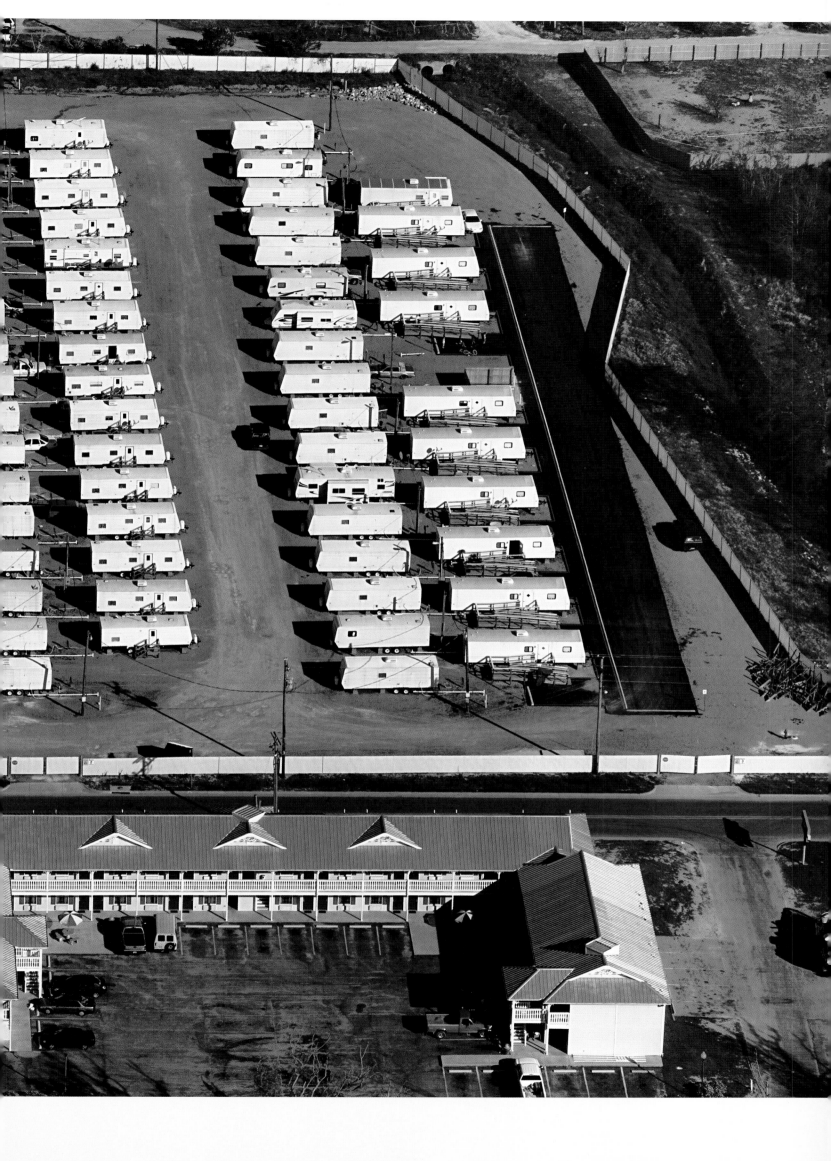

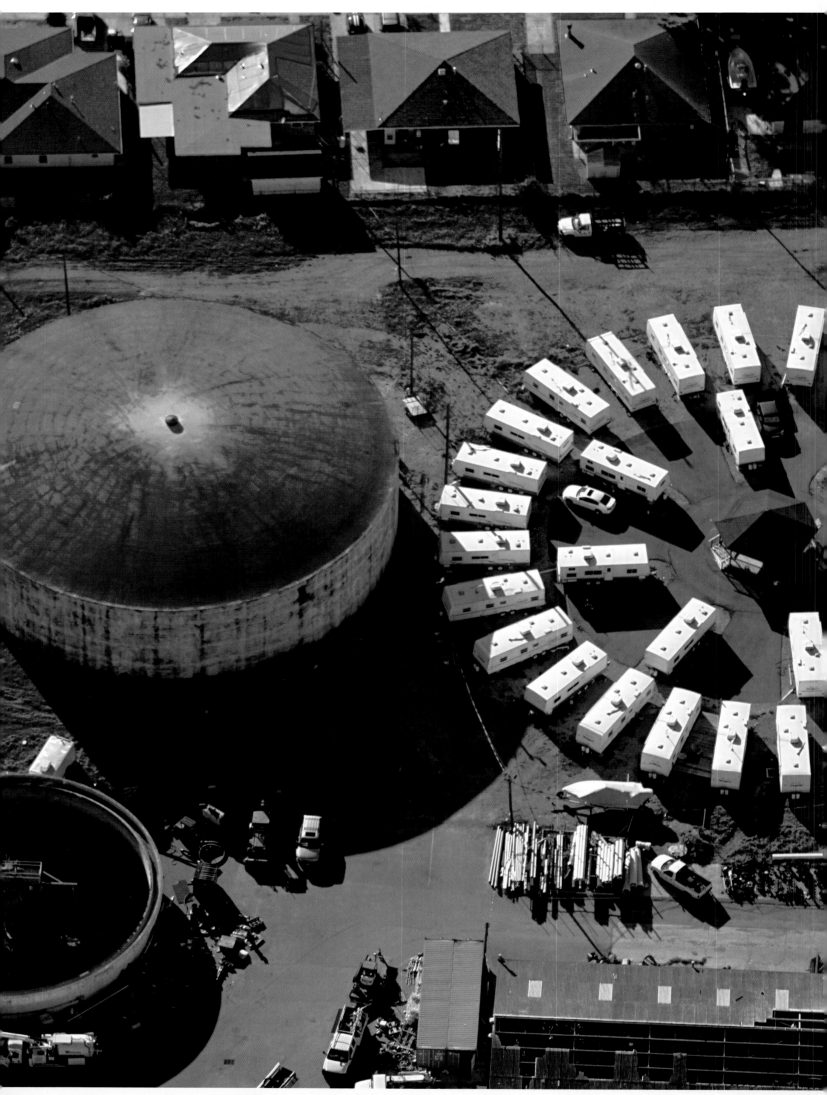

Chalmette, LA
FEMA trailers mimic the pattern of fuel-storage tanks. As of January 2008, two years after Hurricane Katrina, there were still more than 40,000 FEMA trailers being used as homes in Louisiana.

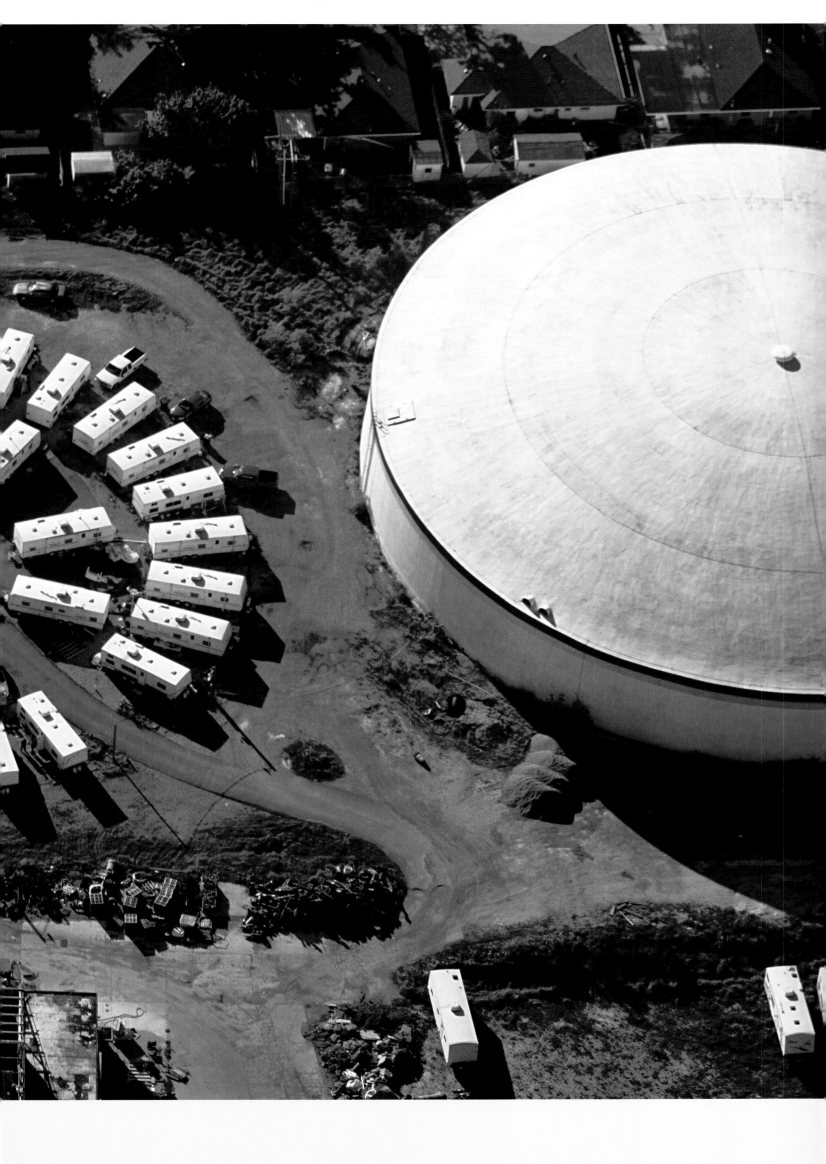

Waste and Recycling

Waste is nowhere to be seen when flying across expanses of land untouched by humans, such as the wilderness areas of the Adirondack Mountains or South Dakota's barren Badlands. Natural systems work in flows of inputs and outputs that are cycled again and again over time and remain in a state of equilibrium.

In July 1995 a microburst swept through the Adirondacks, blowing down tens of thousands of trees. Shortly after the storm had passed there were cries that these trees lying on the ground were going to waste and needed to be salvaged. There were many self-serving reasons to salvage the trees from the part of the park designated as "forever wild," which was meant to remain untouched by commercial interests. From the human perspective, the trees were going to waste, the definition of which is "objects or materials for which no use or reuse is intended." If nature had a perspective, these downed trees would be digested over the next 100 years, keeping the natural system in a steady state of equilibrium; in nature there is zero waste.

"Zero waste" is a concept that has historically not been part of American culture. However, interest in zero waste and recycling has grown with the realization that the earth's resources are finite, with the demands of a growing population, and with the need to reduce our carbon footprint because of climate change. Zero waste is a strategy where waste is viewed as a resource, a part of the production cycle. What is left for waste must be in some way recycled. It is a closed-loop system, which defines industrial ecology.

Waste is a substance that needs to be thought of in relation to time. A municipal sewage treatment plant will pass through 80 percent of its effluent in less than a day. Typically, these wastewater facilities do not have the capacity to hold the incoming volume of effluent on-site any longer than that. To compensate for the short time frame, the plant will use energy to run pumps, clarifiers, and aerators to break down solids, and chemicals to kill bacteria. Composting takes time and requires land to hold organic material for extended time periods; the quicker solution is to use energy and incinerate waste, reducing it to heat, smoke, and ash. The short-term solution seems more cost-effective. The long-term costs of handling (or ignoring) waste are external costs that are not usually figured into pricing goods and services in the market.

Pricing for nuclear-generated electricity does not always account for the external costs associated with disposing of radioactive waste and decommissioning a nuclear reactor, which can be equal to or more than its construction cost. The long-term external costs of waste include the energy used in making and disposing of the waste and the resulting impact on climate change.

Landfills, junkyards, and industrial retention basins are easy to spot from the air; they are all places where objects and materials considered waste have been collected. The other form of waste we see from the air is the land itself that has been wasted, with little chance of further use or reuse, such as contaminated industrial sites, strip-mined land, and farm fields left barren from erosion or salinization.

The challenge for waste management is to reduce waste before it materializes or needs to be recycled. Reduce, reuse, and—last—recycle. Many landfills have been converted to transfer stations, where so-called waste is taken away to be reused, recycled, or composted; the actual waste that remains is taken away to be incinerated in a trash-to-energy plant.

Metals have been one of the more successful items to be pulled from the waste stream and recycled. Two-thirds of all the steel in this country now comes from recycled metal, which is much less expensive to produce since it takes far less energy than making steel from raw ore and coke. Unlike paper and plastic, steel can be melted down and recast indefinitely. We now see large machines in junkyards that can shred cars and then sort their metal components by type and grade into piles of steel, copper, aluminum, and other materials. Scrap metal has become a commodity that is now traded globally. Container ships returning to China from the United States often carry loads of scrap metal; it has become one of our most valuable exports.

Landfills are literal representations of mountains of waste and a failure in recycling. The materials they contain have come to a dead end in the production loop. When filled to capacity, landfills themselves have also come to the end of their useful life, only existing to hold waste indefinitely as wasted land. Recently, however, landfills are themselves being recycled, by being mined for recyclable materials and tapped for their methane gas. After being capped over,

some of these wastelands have even found second lives as parks and golf courses.

Other uses of the land have also contributed to property being used up and left for waste. In urban areas there are old industrial sites, commonly known as brownfields, that have been abandoned for being obsolete, inefficient, and incompatible with the modern city. They are often contaminated and unsafe for public use barring extensive cleanup. Today, however, these sites, which are often located on older industrial waterfronts and adjacent to open space, are being converted and put to new use, and they frequently become prime property. Revitalizing and repurposing these properties is a success story for urban renewal; long a drag on neighborhoods, once recycled the sites become regional assets. In most cases these turnarounds take public investments and bring high returns both economically and in the quality of city life. Like many investments in infrastructure that deliver energy efficiency, these projects represent a sustainable form of economic growth.

The link that's been drawn between landscape and climate change has largely been focused on the climate's impact on landscape, via hurricanes, drought, flood, forest fires, and beetle blight, for example. But today we are beginning to see a new landscape, one that is being altered by human intervention in an attempt to avert and adapt to climate change. Prominent among these efforts are the windmill farms that have quickly appeared along ridgelines in the Northeast and in the plateaus of Texas; flying from Abilene to Midland, you see literally thousands of windmills, all constructed in a five-year time frame. On top of that, new energy-efficient buildings are being built from recycled steel, with solar panels, green roofs, and xeriscaping to reduce water consumption. All these measures reduce waste and produce sustainable energy. There is no doubt that the appearance of our built environment will need to continue to see rapid change in order to meet the many challenges of climate change.

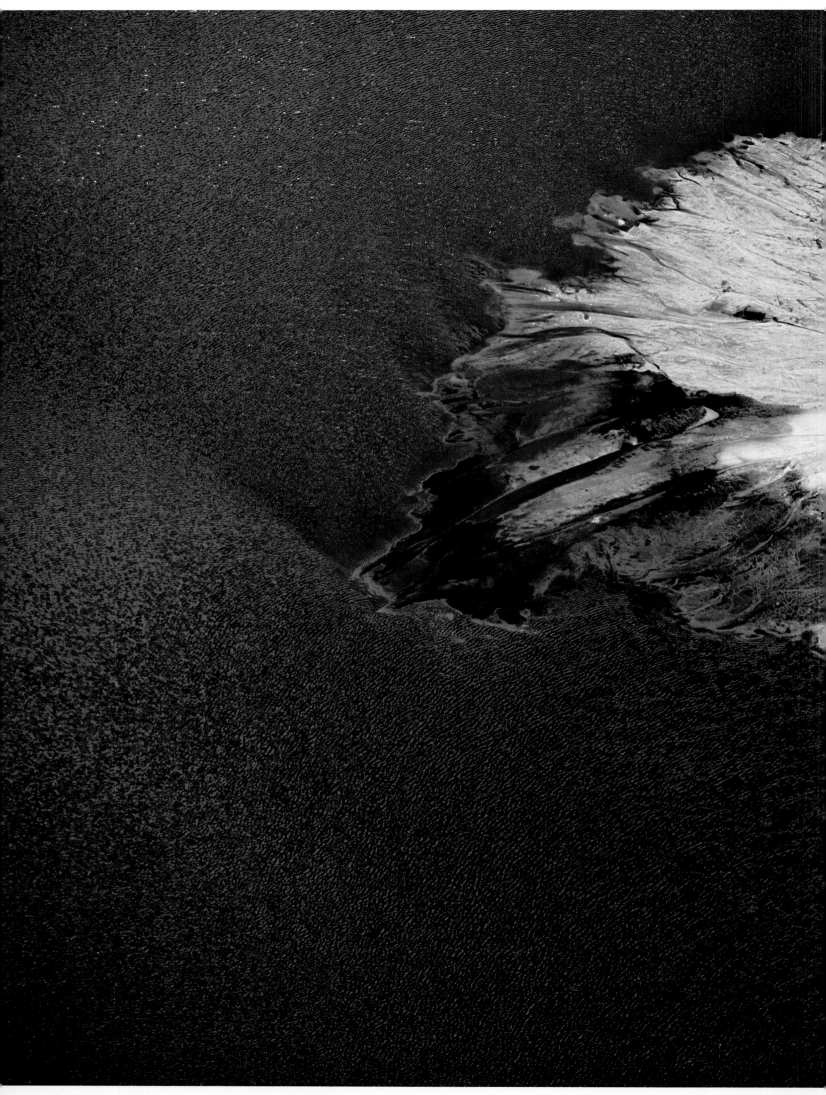

Mulberry, FL
Industrial waste from phosphate strip-mining spills out into a containment pond. Strip-mining
tears apart landscapes and rips vital nutrients out of the soil, rendering the land unusable long
after the mine is exhausted. The long-term external costs of waste created in this massive
undertaking are not factored into market costs.

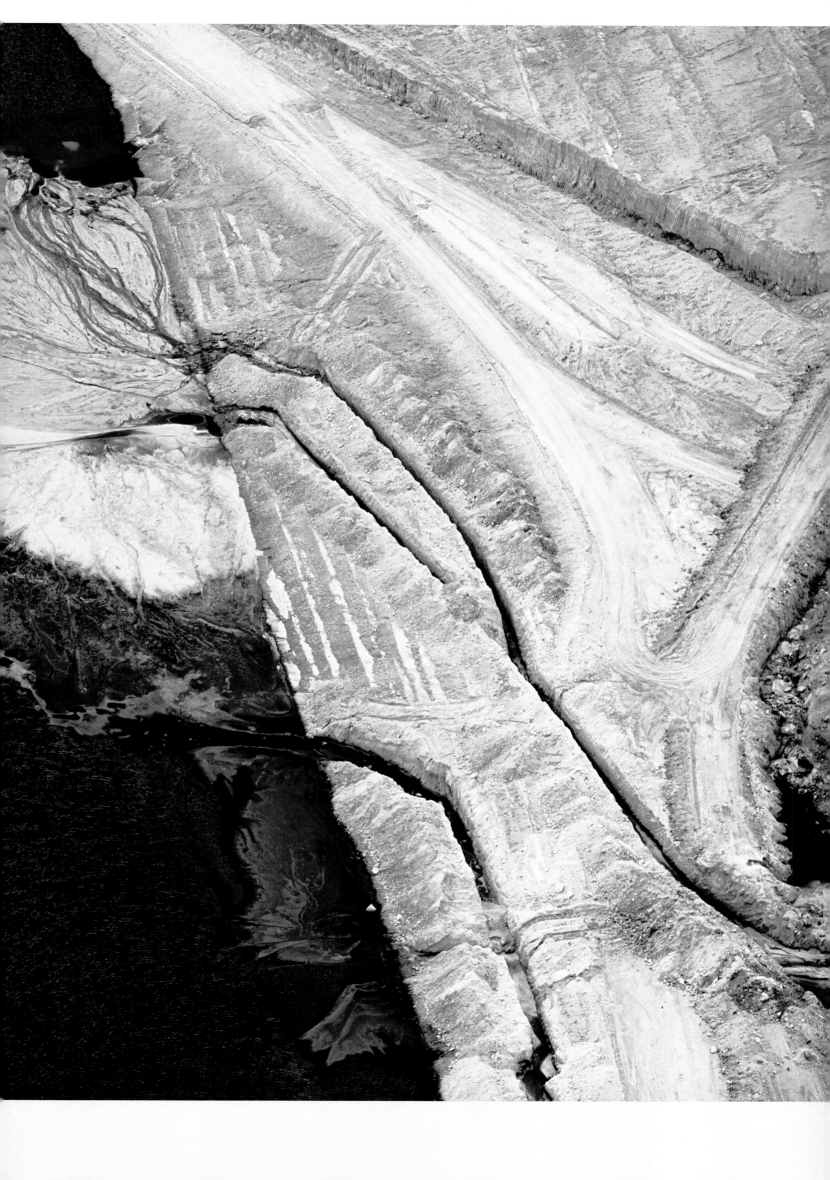

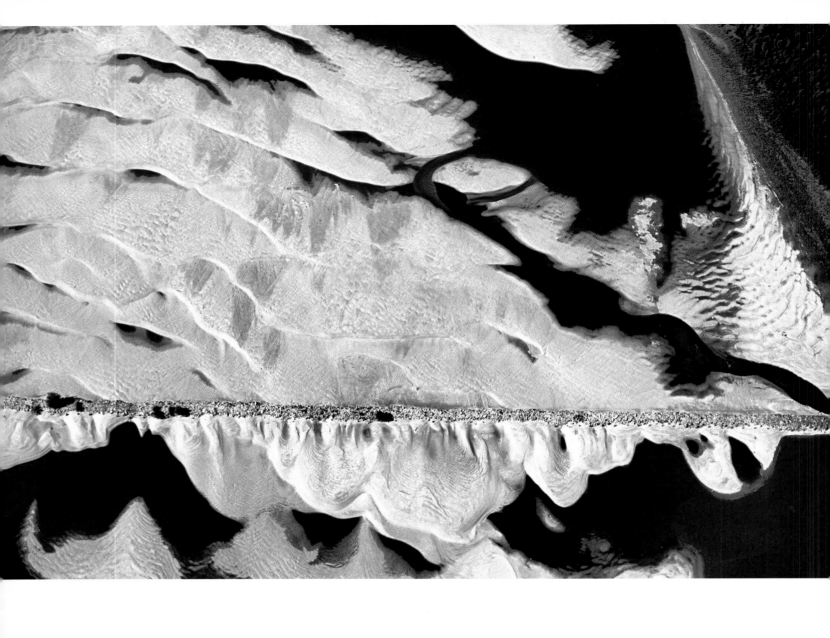

Memphis, TN
Sand forms sediment around a stone jetty on the Mississippi River. The river moves about 500 million tons of sediment into the Gulf of Mexico every year.

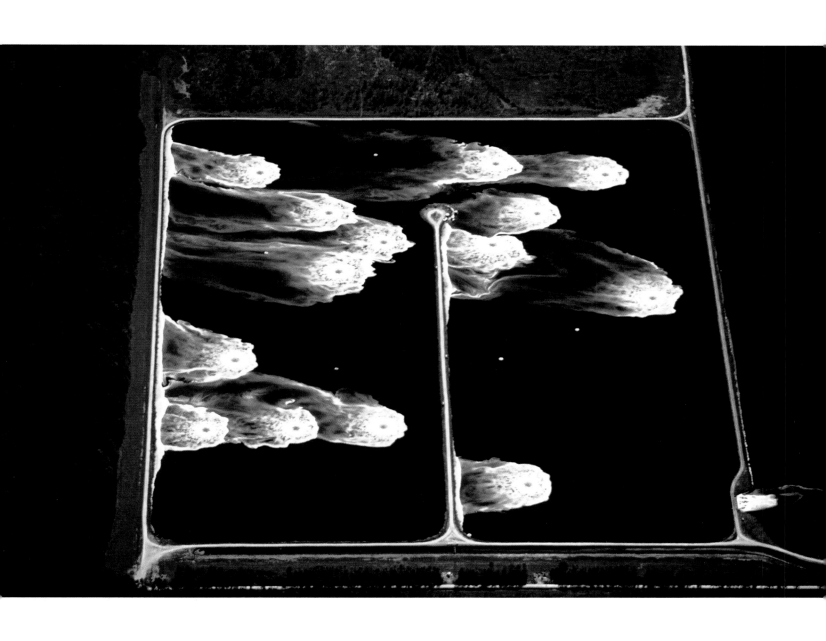

Northeast TX
Seen from one mile above, wastewater is aerated after use in the papermaking process. Paper mills use large amounts of freshwater to dilute chemical wastes.

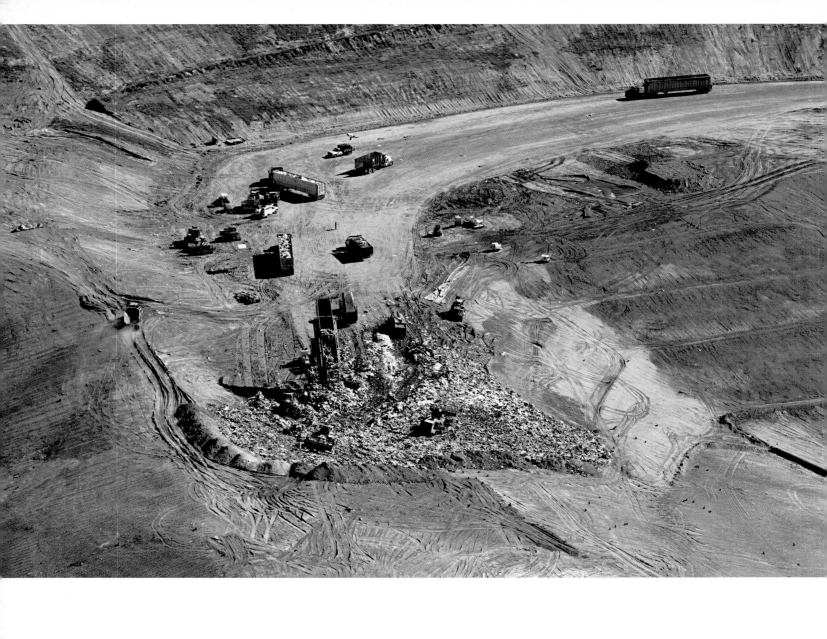

Atlanta, GA
Trucks cart in waste from the Atlanta area for burial. Piles of earth (front) are lined up to cover the incoming garbage.

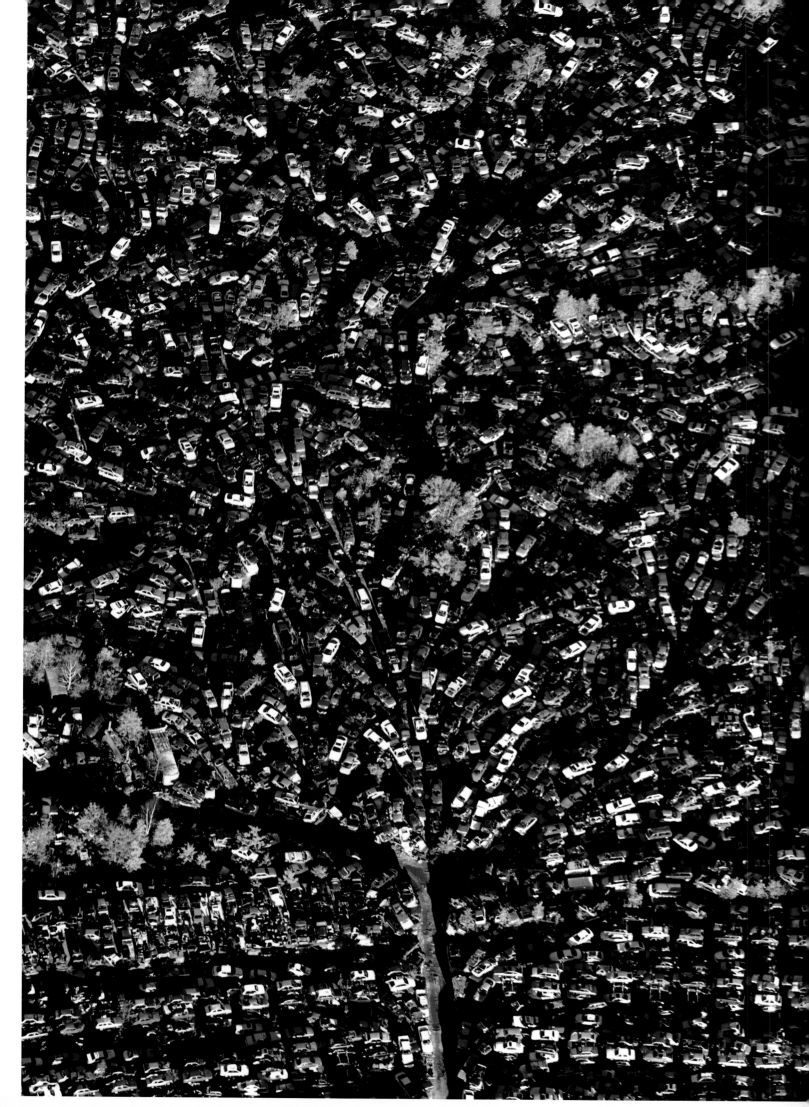

Ayer, MA
Cars pile up at a junkyard used for recycled auto parts. After the cars have been parted out they are
crushed and sent to Michigan for metal recycling.

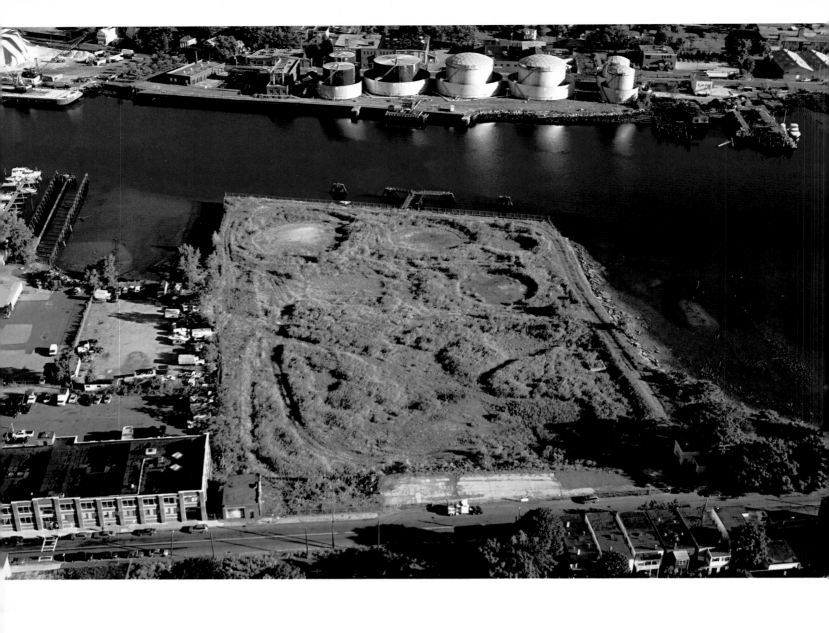

Boston, MA
Imprints of old fuel storage tanks leave their mark on an abandoned pier in East Boston. The pier is scheduled to be decontaminated and redeveloped for industrial and marine use.

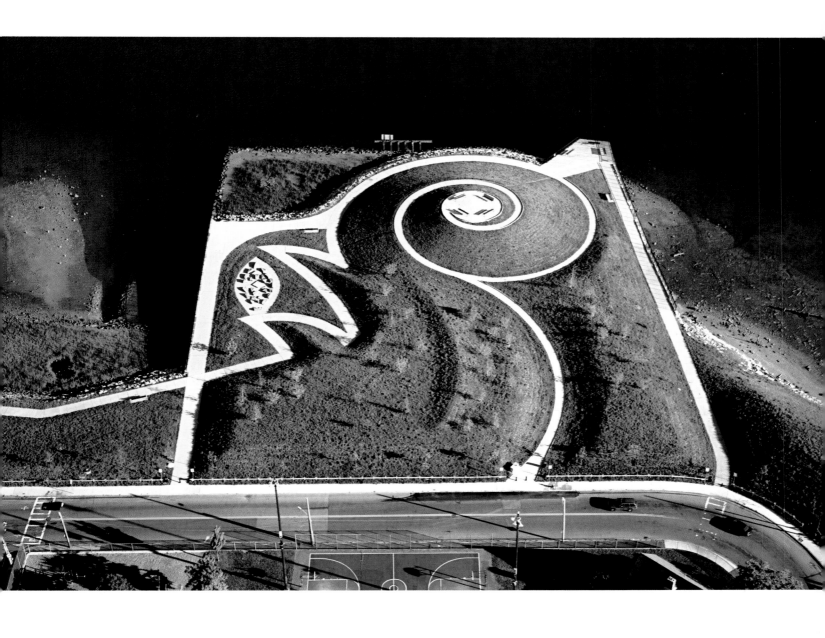

Boston, MA
Less than a quarter mile away, a similar pier has been converted into a park after being closed to the public for decades, marking a transition from a derelict industrial site to an active pedestrian park.

Seattle, WA
Gas Works Park was built in 1975 around the remnants of the Seattle Gas Light Works
gasification plant, which operated on the waterfront from 1906 to 1956. The old boilers were
recycled and adapted for use as landscaping elements, and serve as a reminder to area residents'
collective memory.

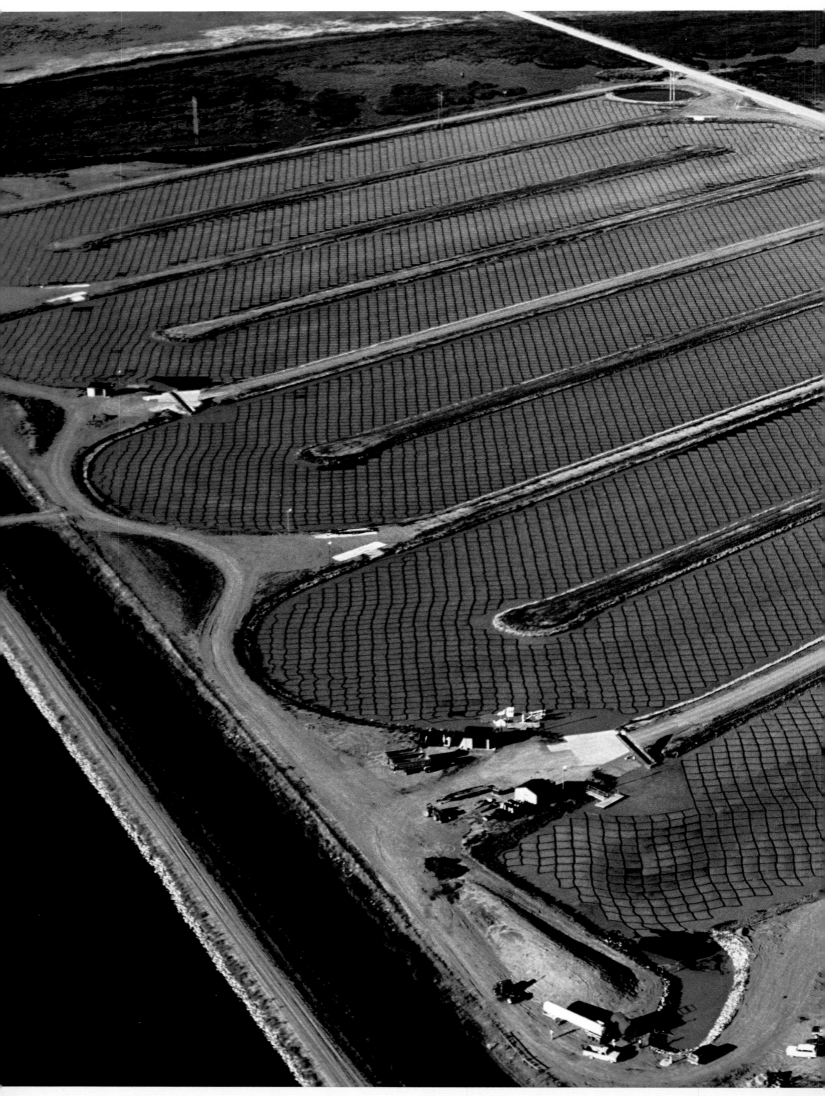

Devil's Lake, ND
Rubber lattice keeps duckweed evenly dispersed at this low-energy sewage-treatment facility, which employs entirely natural processes. Sewage first enters settlement ponds; wastewater is then pumped into wetland marshes, where plant and animal life absorbs nutrients. Next, the remaining water is transferred to this pond, where duckweed filters out residual impurities.

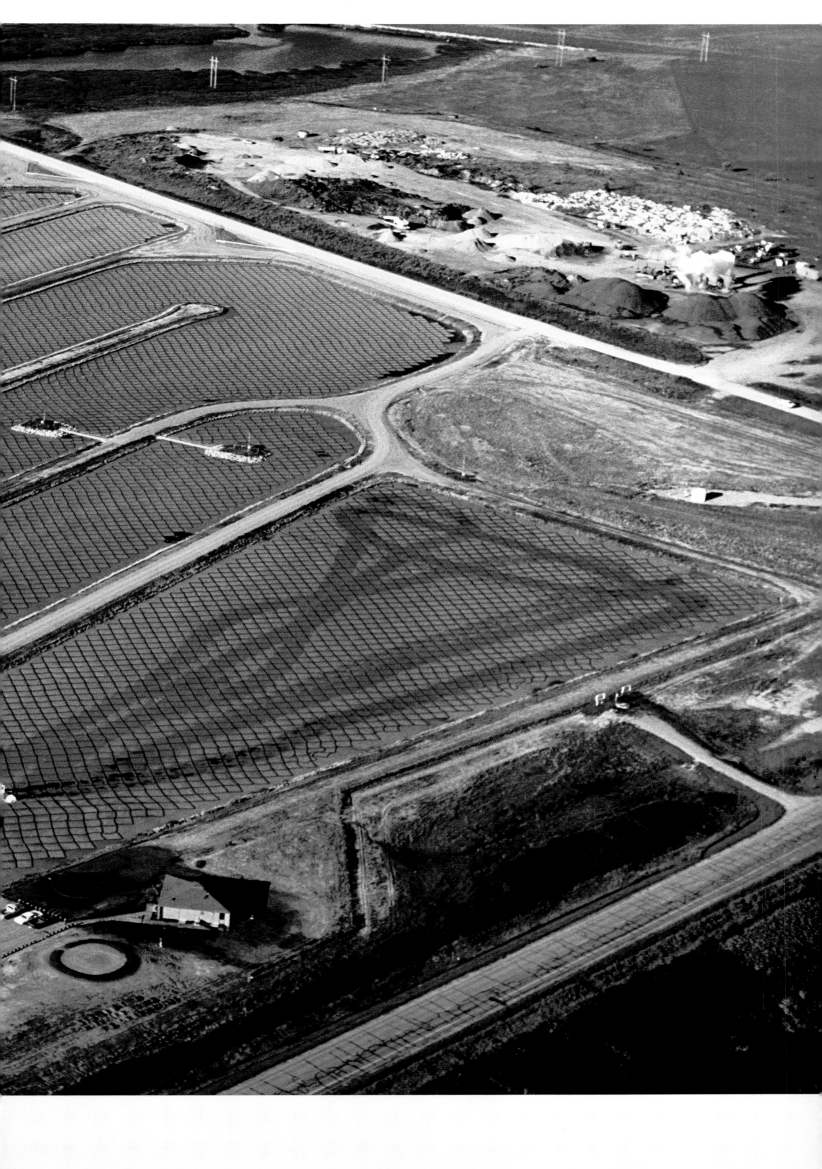

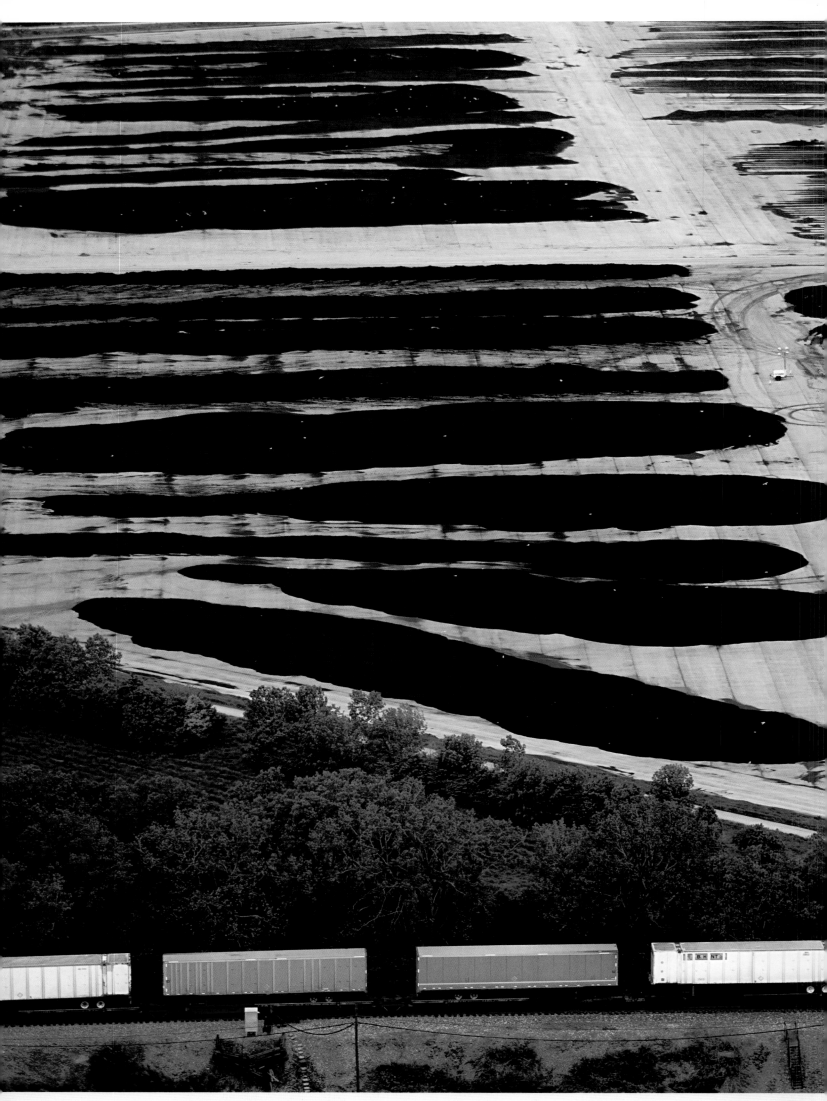

Chicago, IL
Rows of municipal compost at Harborview Landscape Waste Processing's facility in Chicago keep organic waste out of landfills. Compost is nutrient-rich soil that puts organic matter back into the food chain. Harborview primarily composts grass, leaves, and brush, which stay on site for six months and are then resold to the Department of Transportation and private landscapers.

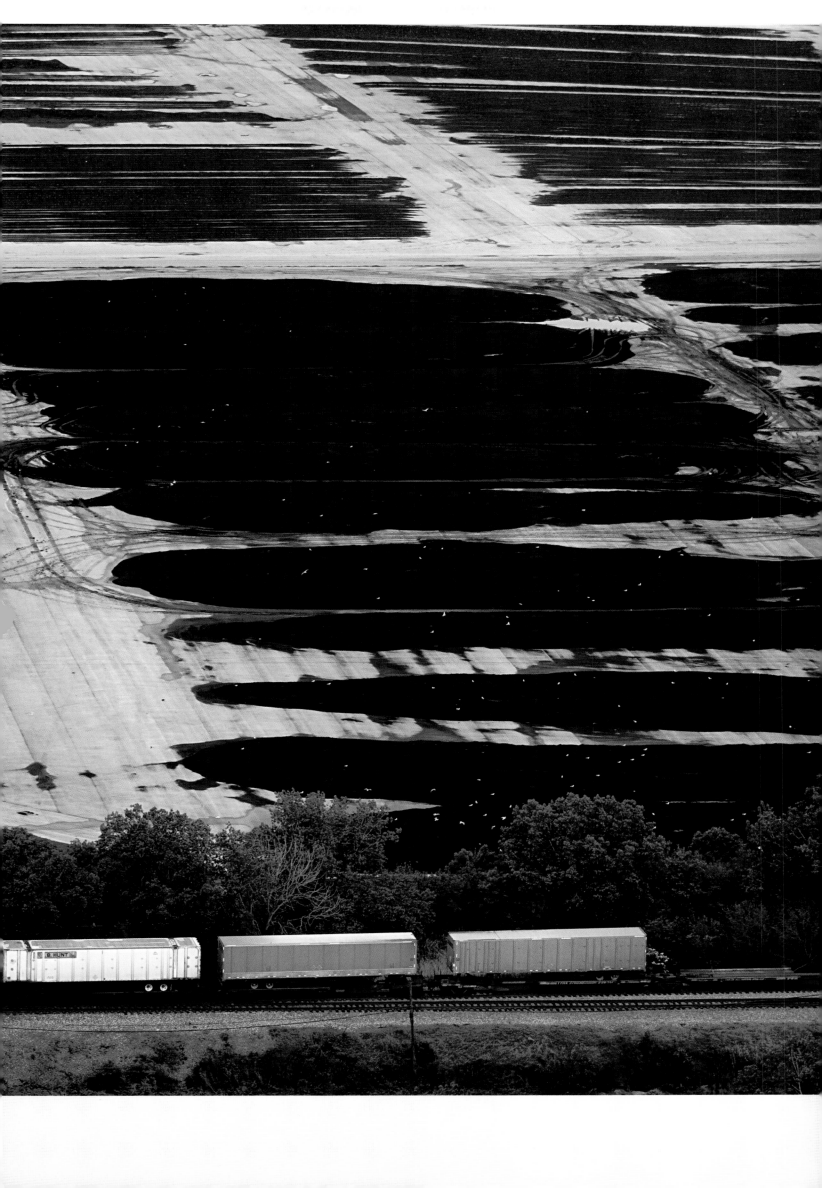

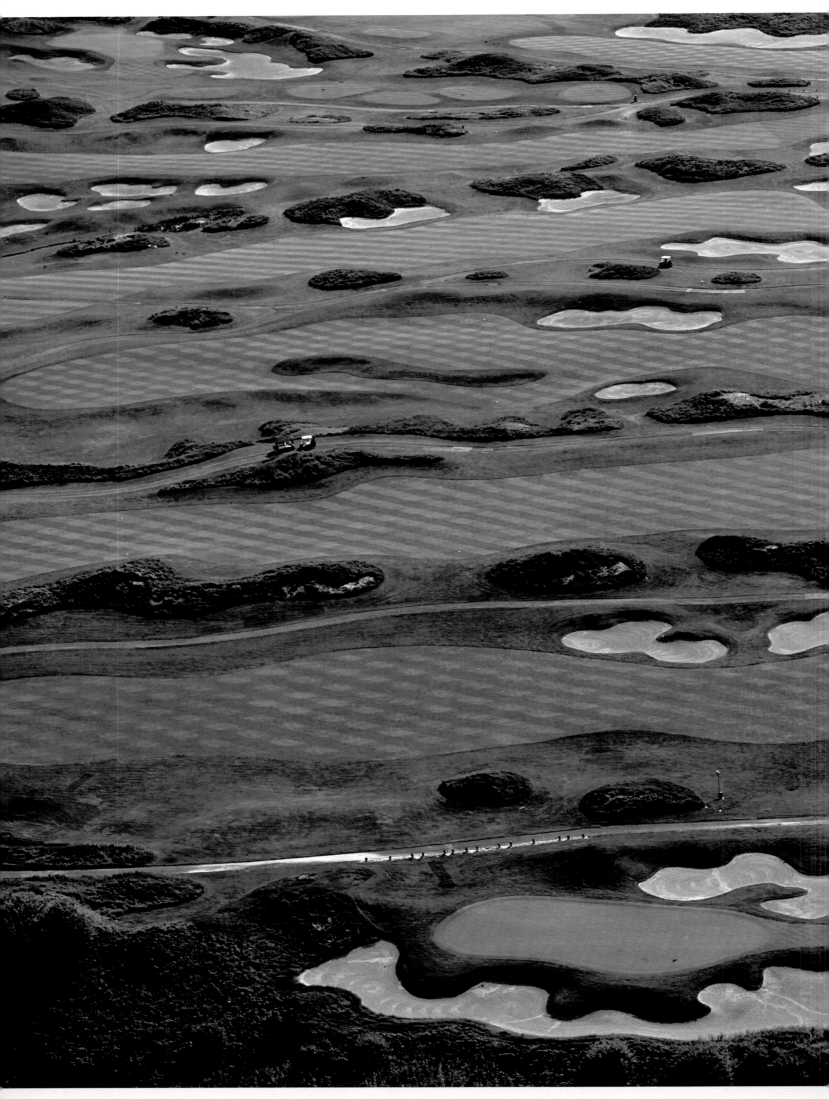

Chicago, IL
The Harborside International Golf Course is built on top of a former solid-waste landfill at Lake Calumet. As urban space becomes more limited, cities are finding new ways to repurpose unused and wasted land.

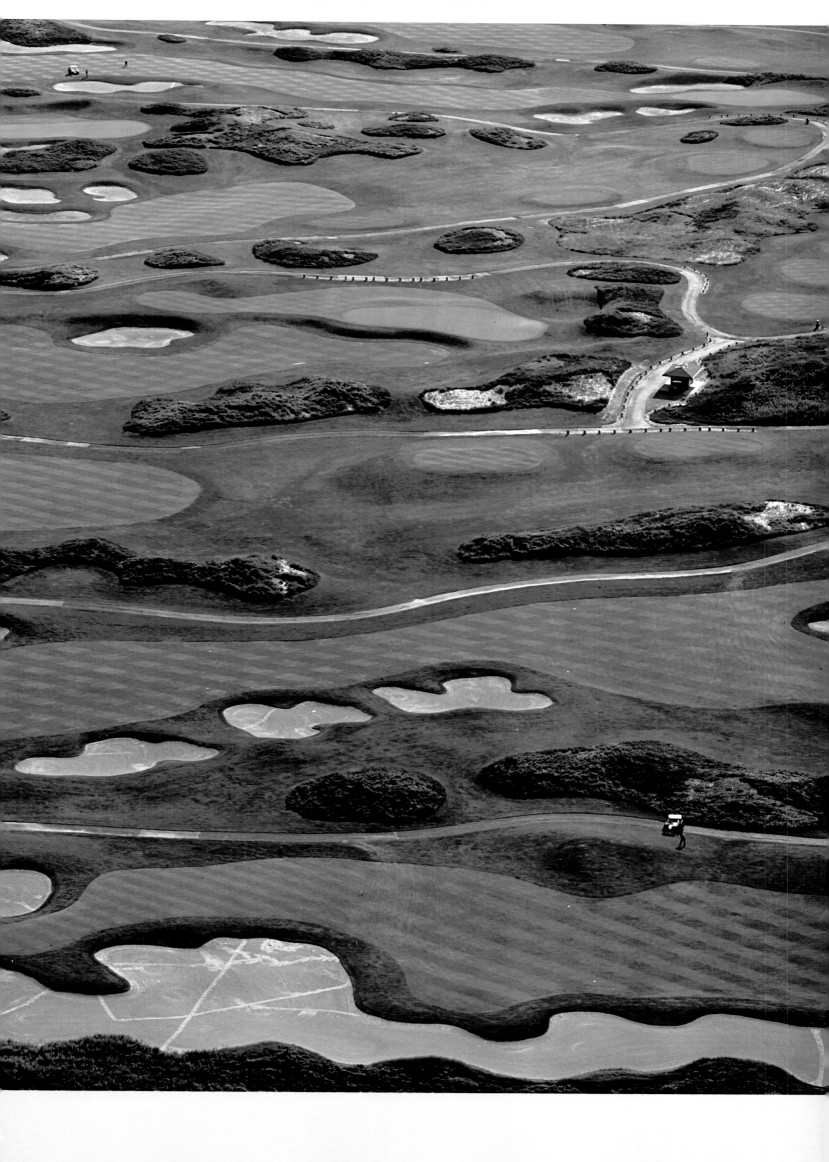

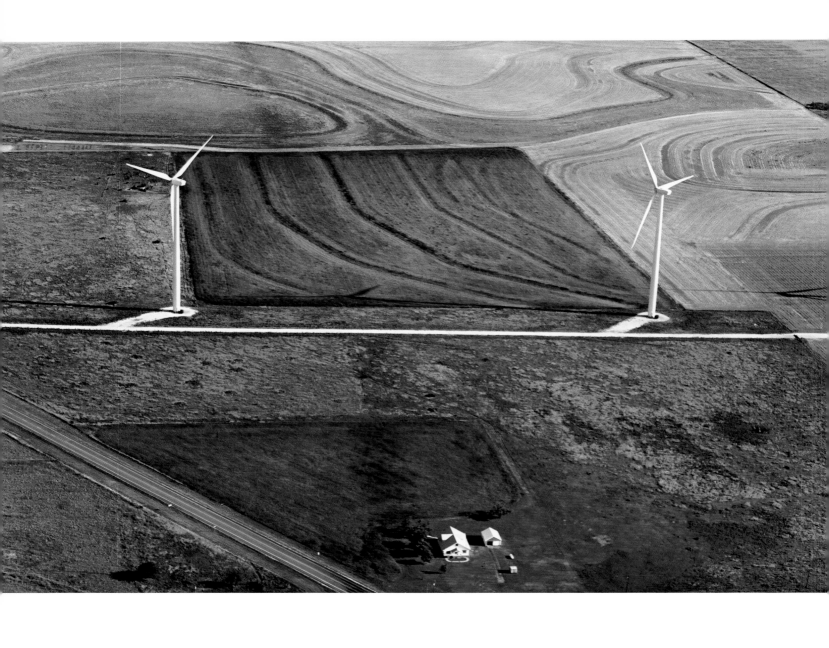

Abilene, TX
Two wind generators stand adjacent to a small farmhouse amid agricultural fields. U.S. farmers often lease land to wind developers and collect funds for each turbine built on their land or receive a small percentage of annual revenue from power generation.

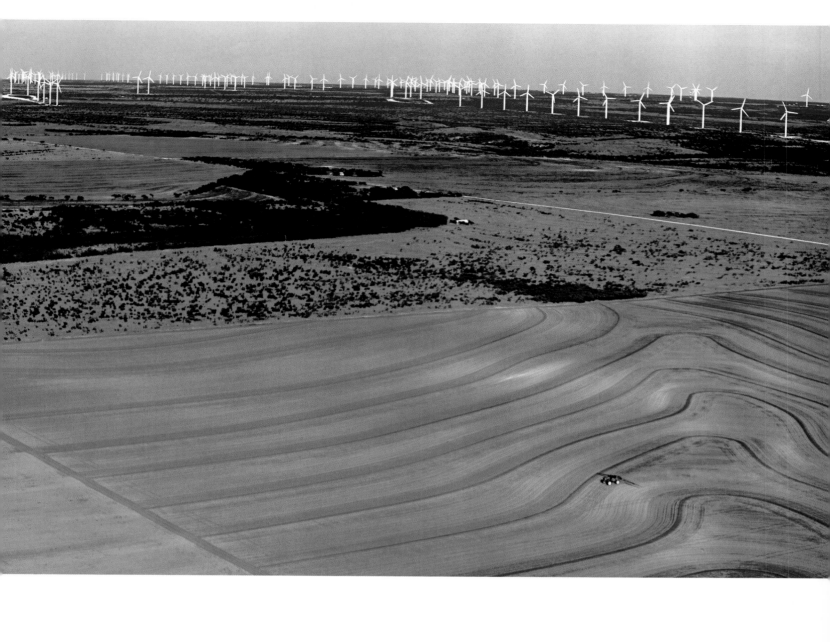

Sweetwater, TX
These clusters of wind turbines in Sweetwater are among the most productive in the country. The United States has more than 11,600 megawatts of wind power currently in service, enough to power 3 million average-size homes.

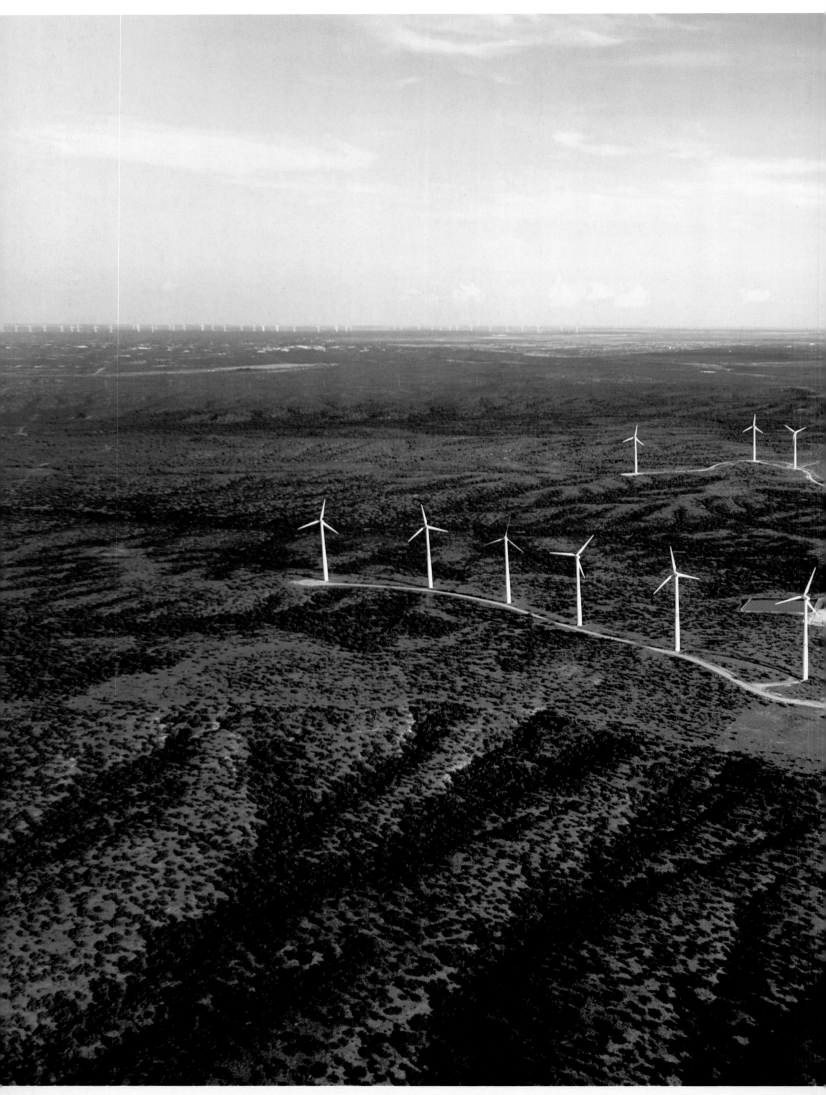

Midland, TX
Texas's geography lends the state great potential for wind power and, as a result, Texas produces
the most wind power of any U.S. state. Wind power is responsible for 3.3 percent of the energy used
in Texas, and much of its capacity is shipped out of state. Wind power is one of the largest-growing
areas of energy generation in the country.

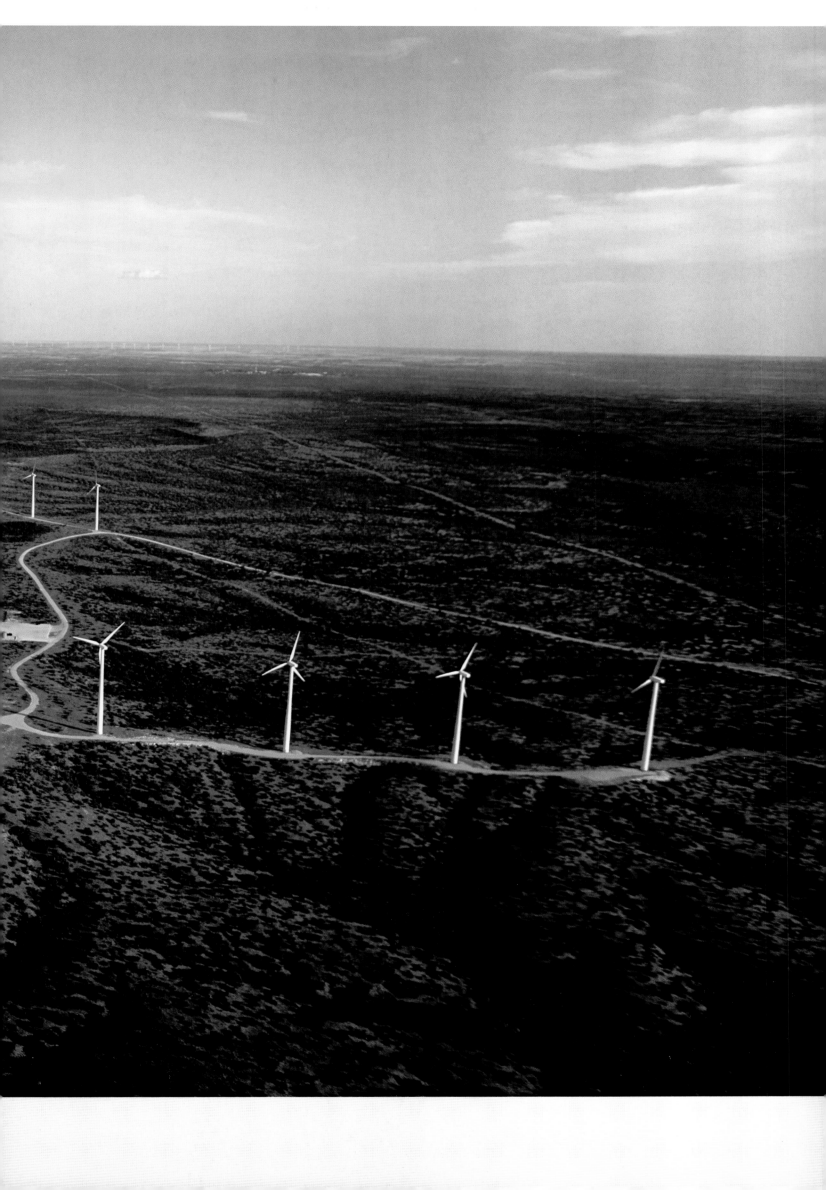

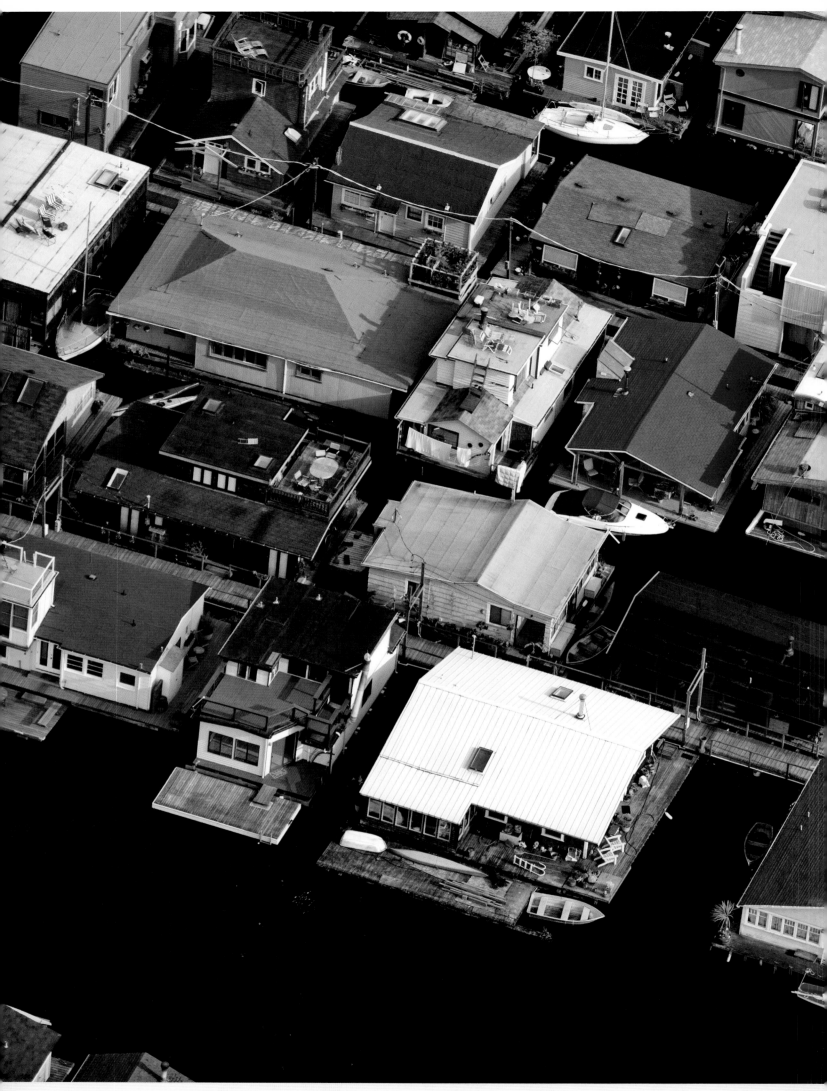

Seattle, WA
Tightly clustered houseboats on Lake Union have been bought up and rebuilt. Today, this neighborhood has a unique character that adds to the identity of the region. The real estate values of the houseboats are high, despite their small size and tight quarters.

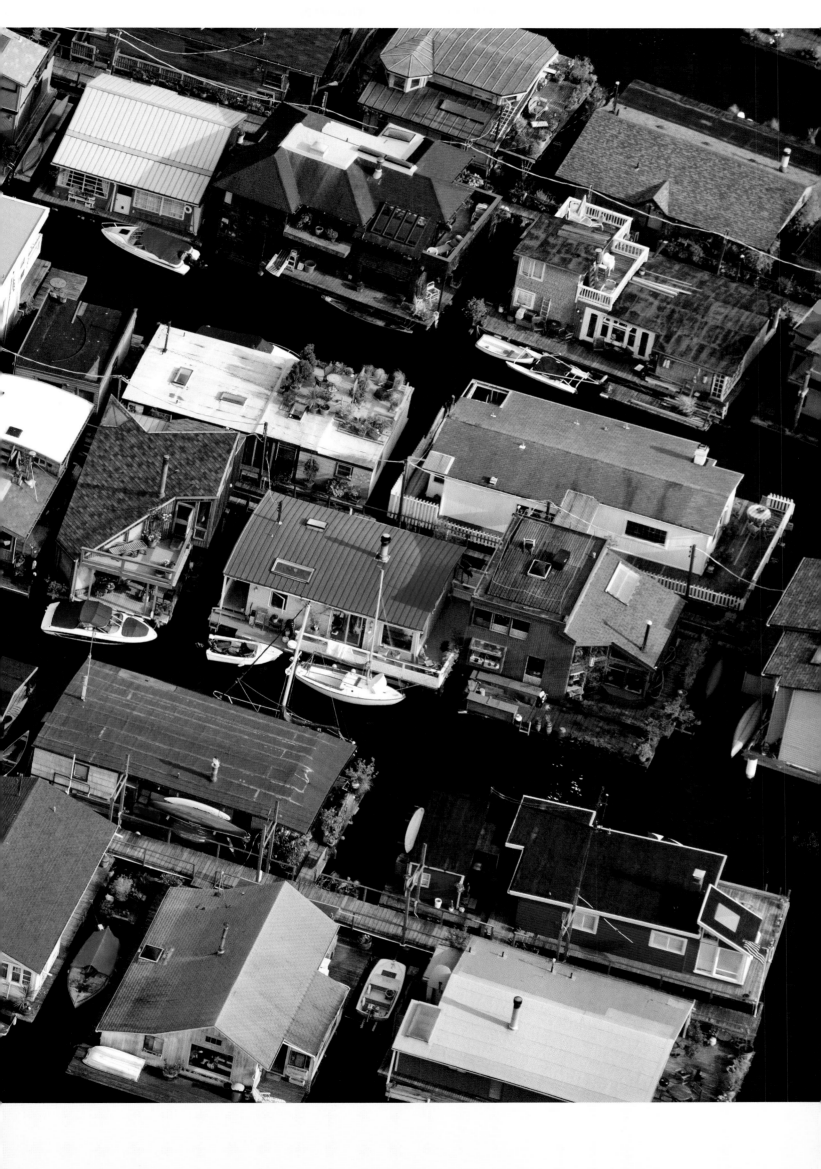

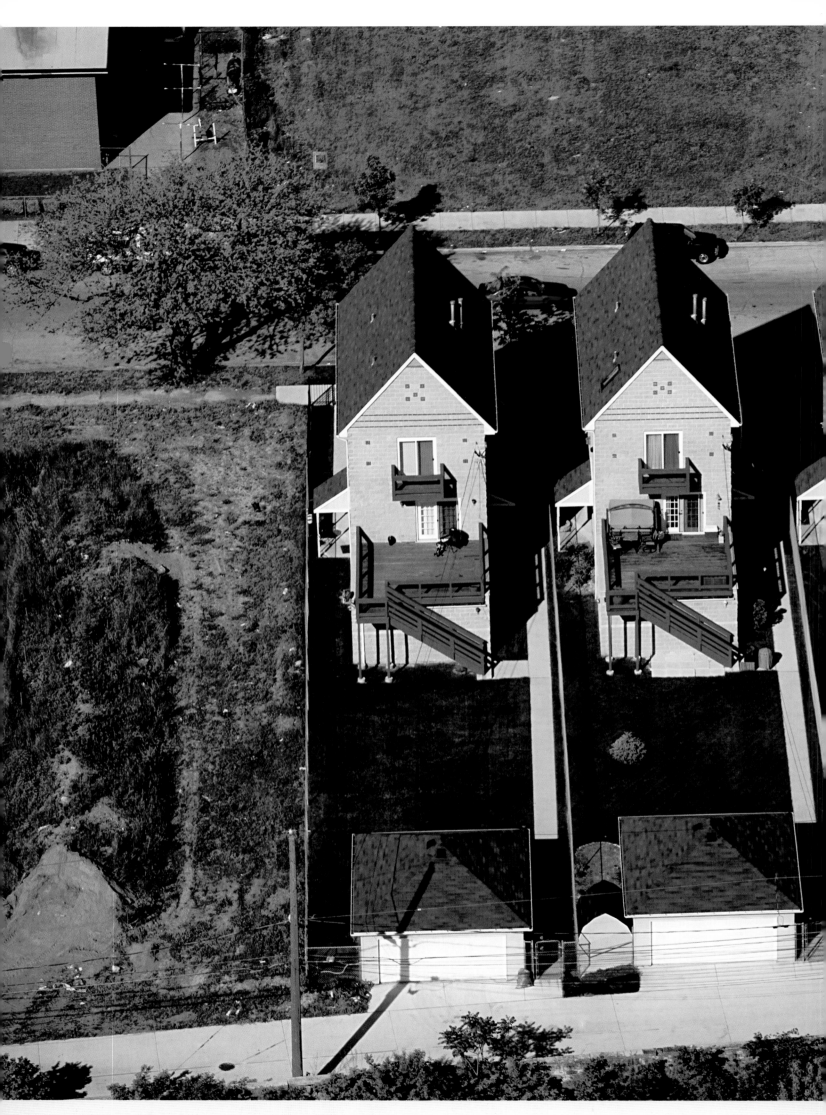

South Chicago, IL
In a blighted area of South Chicago, four new houses infill a vacant area as part of an effort to begin mending this neighborhood's decayed urban fabric.

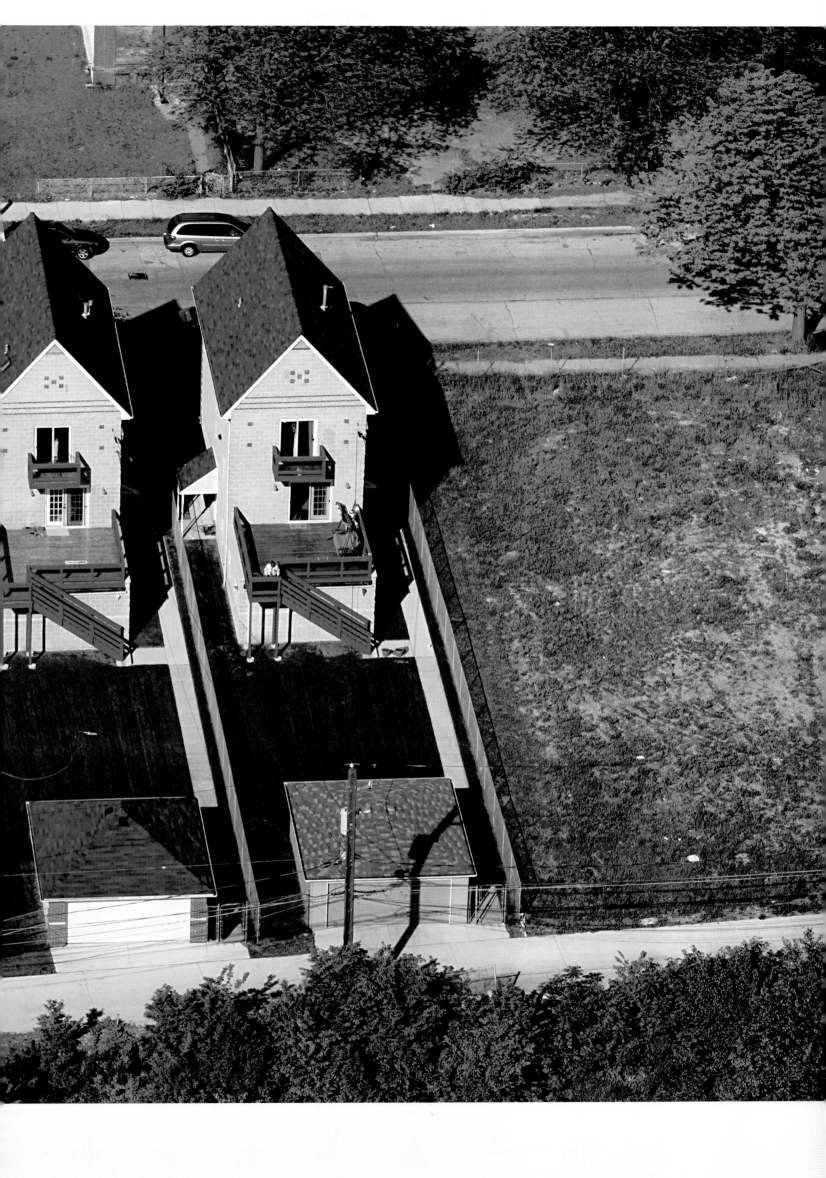

Anthem, AZ
Skylights project light through the roof of this new industrial building under construction. Day lighting saves energy by reducing electricity costs for lighting.

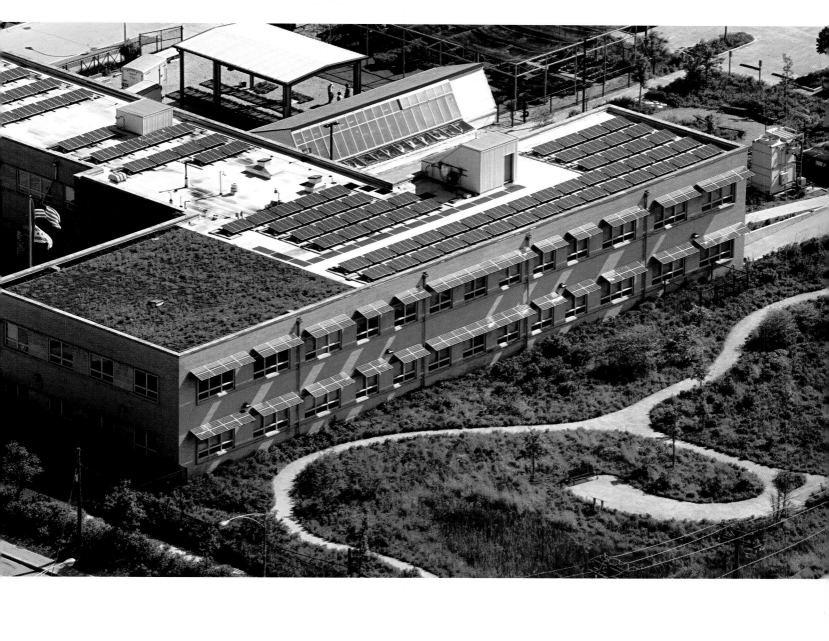

Chicago, IL
The Chicago Center for Green Technology has been retrofitted and redesigned with all-green elements and is Leadership in Energy and Environmental Design (LEED) platinum certified (the building industry's highest standard for green construction). The building's roof has solar panels and an earthen surface for water retention and insulation.

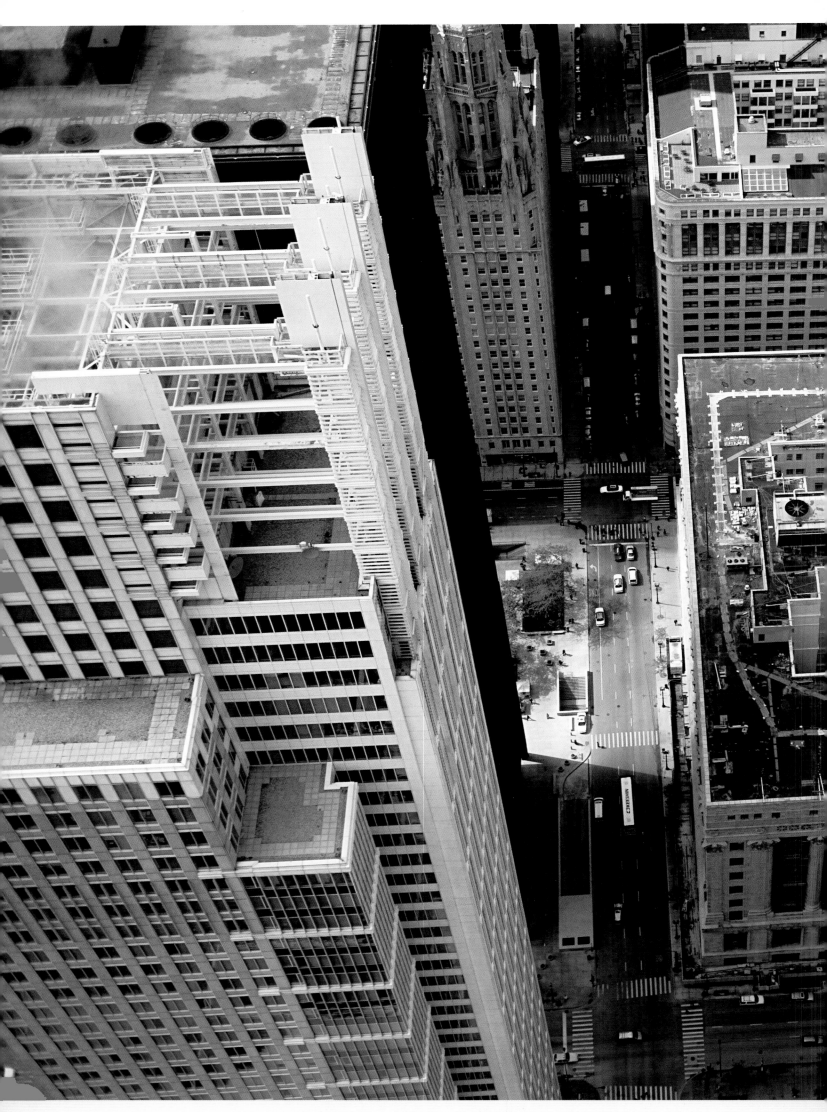

Chicago, IL
Chicago City Hall's rooftop garden was planted in 2000 as part of the city's Urban Heat Island Initiative, which tests the effects of green roofs on urban air quality and temperature. Rooftop plants reflect heat (unlike standard black-tar roofs), filter the air, absorb rainwater, provide shade, and cool the air around them by secreting tiny water droplets through pores in their leaves.

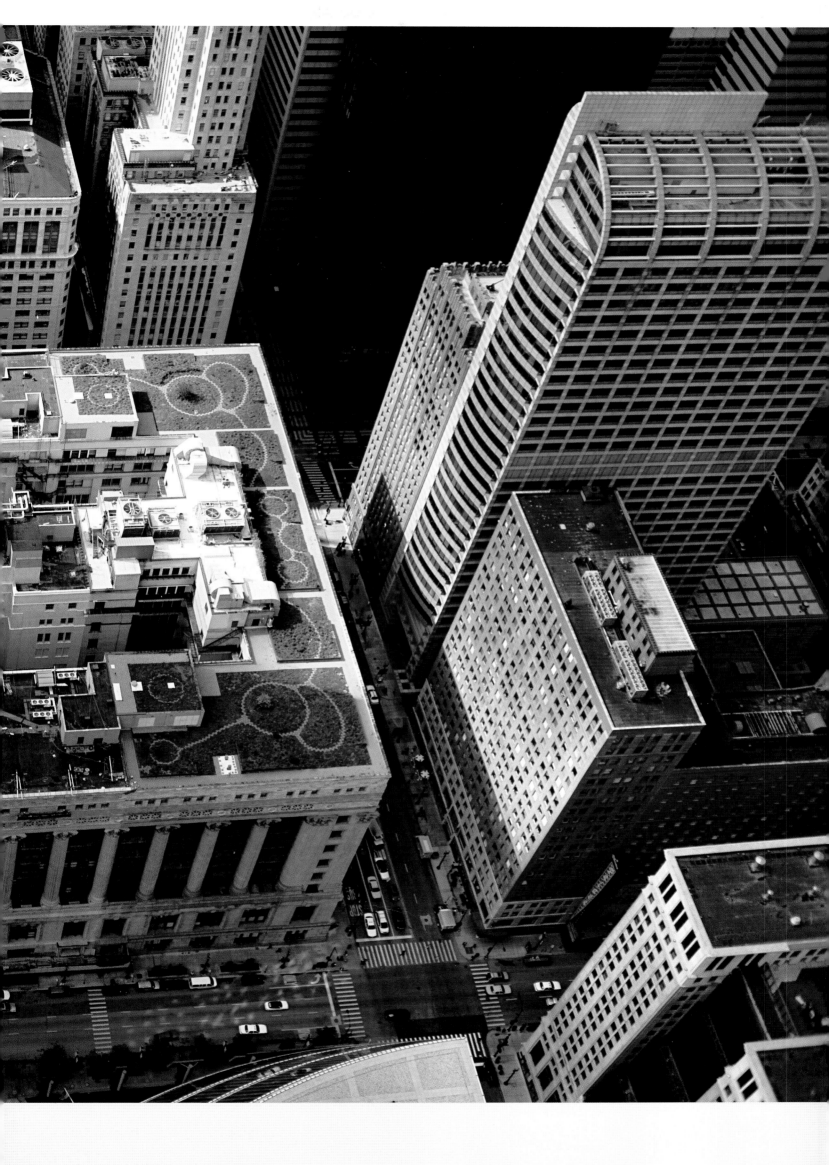

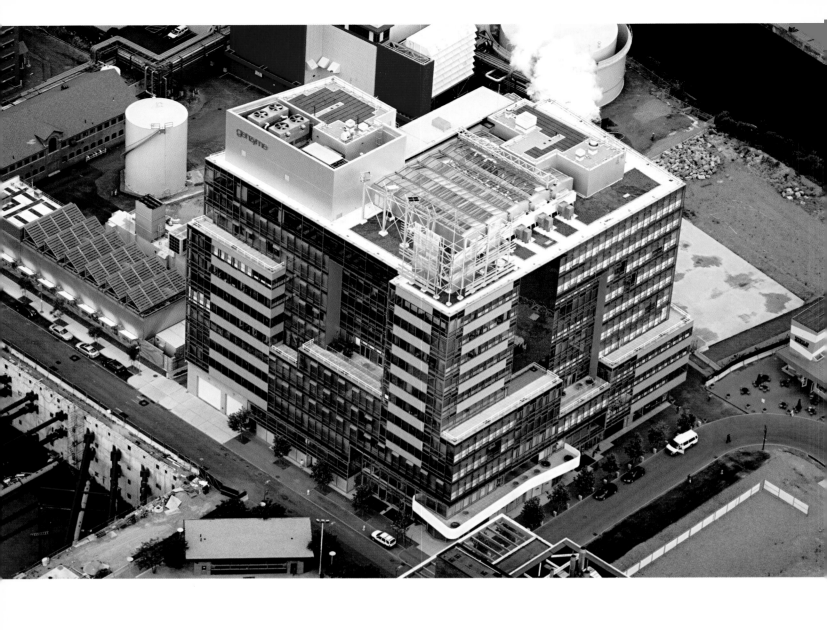

Cambridge, MA
Roof-mounted mirrors bring natural light into the GenZyme building, a LEED platinum-certified
structure in Cambridge, Massachusetts. The building's 12-story central atrium serves as both an air
duct and a light shaft, saving 42 percent on electricity costs.

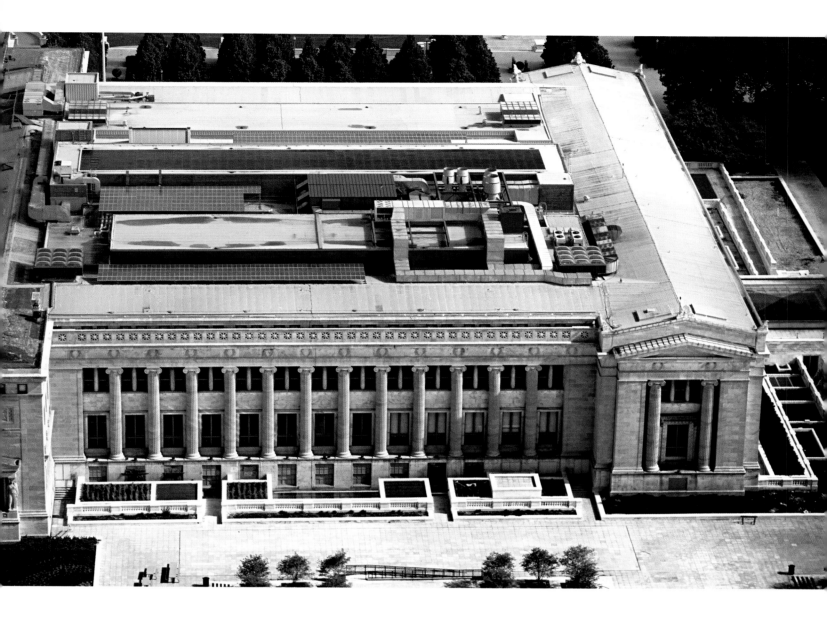

Chicago, IL
The solar electric system on top of the Field Museum of Natural History is the largest of its kind in Illinois and among the largest in the Midwest. The system is capable of producing 60,000 kilowatt hours annually, nearly enough power for 10 homes.

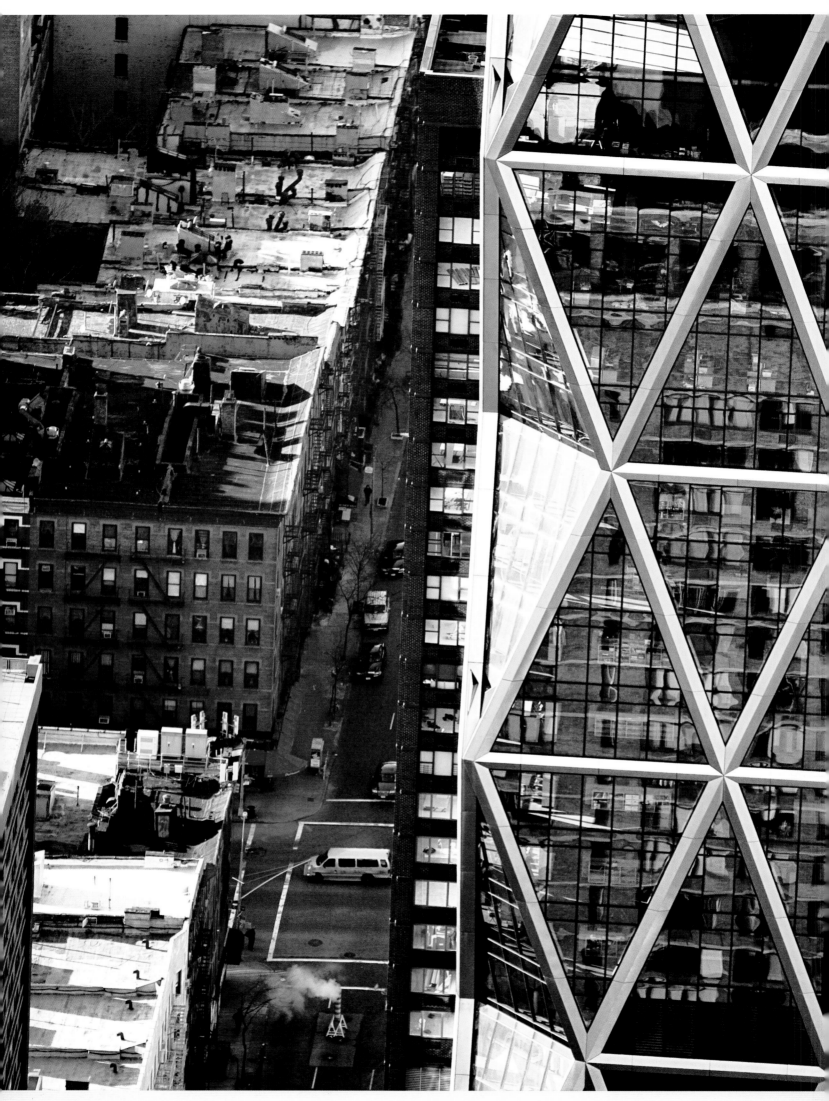

New York, NY
The Hearst Tower is New York's first green building and boasts LEED gold certification. Designed by Norman Foster, the tower's triangular framing uses 80 percent recycled steel—and 20 percent less steel than conventional construction. Rainwater collects on the roof and is used in the heating and cooling system and also to water the building's plants.

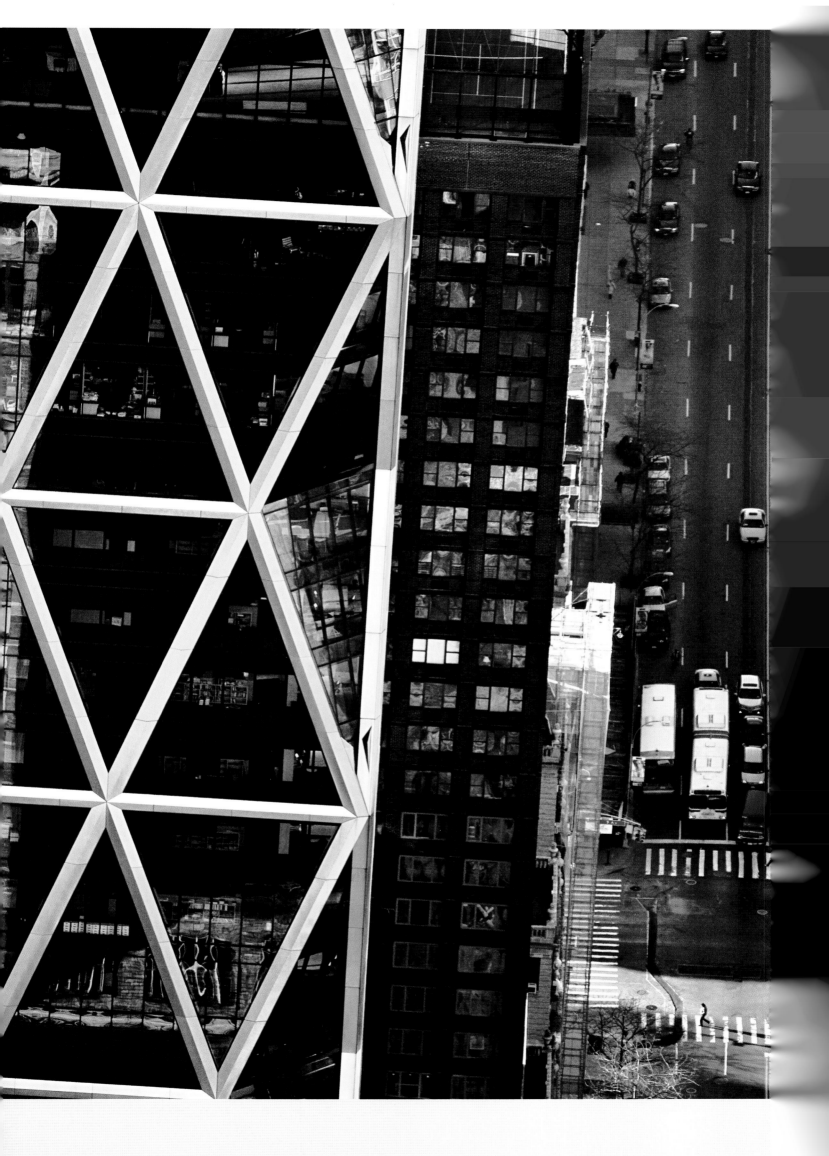

Urbanism

In 2006 the U.S. population reached 300 million. According to the U.S. Census Bureau, the country will grow by another 100 million people by 2040. To accommodate this 33 percent growth in population and to replace housing lost to natural disasters, fire, and demolition, we can expect to build an estimated 70 million new housing units. This represents just more than half of the 126 million housing units on the ground in 2006. And these figures do not include the build-out for industrial and commercial space. Seventy million new units of housing in less than 35 years is an incredible amount, especially when you try to imagine this from an aerial perspective. What will it look like? Where should it all go?

The colliding forces of climate change and population growth will necessitate new planning strategies to accommodate this expansion. One has to wonder how existing local regulations, such as zoning and building codes, can possibly change fast enough to make this onslaught of new housing more environmentally friendly than the housing built over the last 35 years.

Is steady population growth even sustainable? The answer is no. Since the earth and its atmosphere are finite, continued growth will eventually lead to overcrowding and shortages of resources, which will spur social and economic collapse. This is a daunting long-term prospect, yet our conversations about population growth and economic expansion rarely extend beyond their short-term benefits.

In the 35 years that I have been flying, I have witnessed a relentless and destructive pattern of low-density development that has consumed agricultural, forest, and recreational lands. At first I turned my eyes away, hoping the messiness of what I was seeing would not affect my interpretation of natural beauty. Over time, however, I turned the focus of my camera on these more degraded areas with a vengeance, hoping that others might see the destructive process at work.

Today, in the context of a changing climate, sprawling development patterns are more profoundly disturbing. Low-density development is extremely energy intensive, requiring excessive amounts of gasoline to deliver the mail, bus the kids, plow the streets, or simply to get home. Automobile use already makes up 21 percent of our carbon dioxide emissions; the expansion of a dispersed pattern

will only exacerbate the problem. Low-density communities also waste resources by extending infrastructure to rural areas and requiring more roads, pipes, wire, and poles to serve the distant homes.

We can create millions of new housing units and at the same time reduce our carbon footprint if we can free ourselves from automobile dependency. This would require building at a much higher density and placing homes closer together and within walking or biking distance of public transportation, stores, work, and schools. Higher densities allow transportation alternatives, and they enable us to reduce other energy costs. Multifamily homes (sharing a party wall) are 85 to 99 percent more efficient in cooling and heating than freestanding homes. For this reason, city dwellers, who often live in smaller homes and use mass transit frequently, are "greener" than their suburban counterparts. This is why New York City, on a per capita basis, is considered the greenest place to live in the United States.

In 2007, landscape architect and land planner Julie Campoli and I coauthored a book called *Visualizing Density*. The result of five years of research supported by the Lincoln Institute of Land Policy, the book examines the difference between measured and perceived housing densities. We were interested in the fact that while the nation's planners increasingly viewed density as an antidote to sprawl, the public remained wary of it. And while some Americans could recognize the benefits of someone else living at a higher density, they were themselves reluctant to embrace such a lifestyle. In the development review process, urban development projects are consistently denied or stalled on the grounds that they are "too dense" in units per acre. The problem is that density is usually evaluated in numerical terms, not by its form. In the book, we were interested in exposing the physical form of density.

When surveyed, despite varying perspectives, design professionals, developers, affordable housing advocates, and ordinary citizens in both large and small communities, and in different regions of the country, generally agreed on a common set of elements that distinguished the "good" density from the "bad." They also concluded that whether or not they liked a neighborhood had little to do with actual density numbers and everything to do with design.

Some of the common features that contributed to "bad" density were cookie-cutter designs; monotonous production housing with repetitive housing fronts; car-oriented layouts; overpaved and barren landscaping; and a marked feeling of isolation or disconnection from surrounding areas. Bad density was often thought of as transient in character and left viewers with a sense of disorientation.

It is not surprising that "good" density exhibited the opposite features. Good density had diversity in design and was rich in building details. It was described as pedestrian oriented and had open green spaces, which were integrated and connected to surrounding neighborhoods. There was a sense of orientation and local character due to its diversity and uniqueness. These would seem to be obvious characteristics that you would want built into your neighborhood regardless of the density, but they are often missing from dense developments, giving density a bad name. As Julie Campoli points out in her text, "What really matters is how the streets are laid out, how the land is subdivided, how the buildings are arranged and detailed, whether trees are planted, and where the sidewalks lead. These are all functions of design."

The positive attributes of truly good density are scalable; they work at both the block and the citywide level. Truly successful cities are not car oriented and overpaved with highways and surface parking; they are pedestrian friendly and have open green spaces. They have diversity in design, and neighborhoods that are well integrated. One has a sense of regional identity and orientation in these cities.

Ultimately, higher density will lead to greater urbanization and the creation of new cities from smaller towns and villages. This is exactly where we should be investing our money, not on 40-acre interchanges. There are common economic, political, and cultural forces shaping our communities. They are visible from the air, appearing as patterns in the landscape—evidence that urbanism can be determined, controlled, and shaped through urban design, planning, and good public policy.

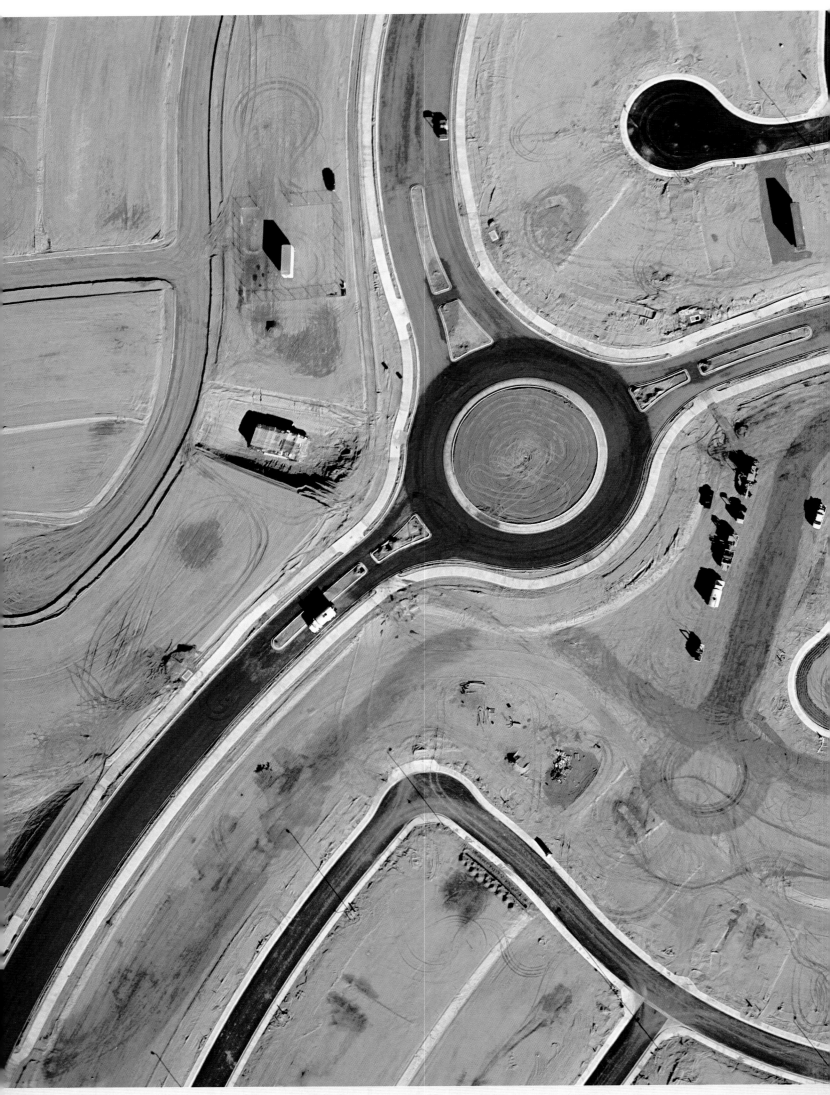

Buckeye, AZ
Concrete curbs line a road hierarchy in varying stages of completion for a future housing development.

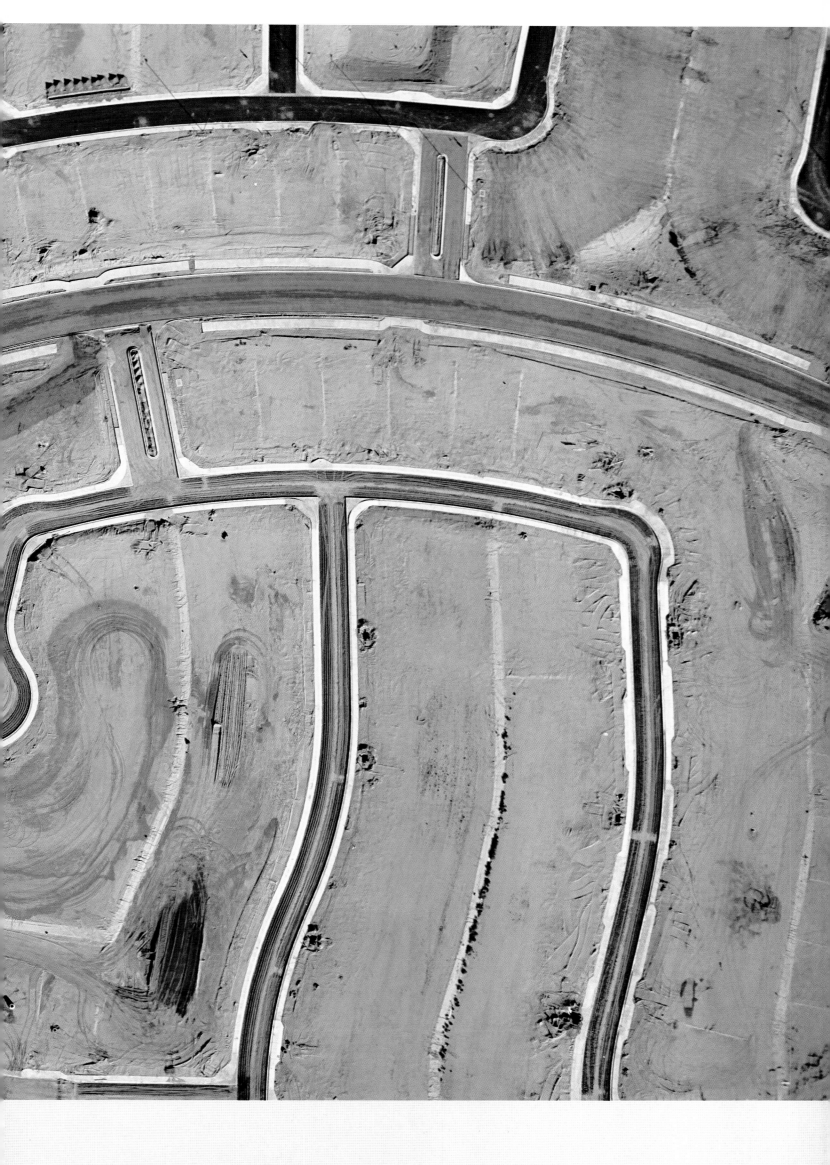

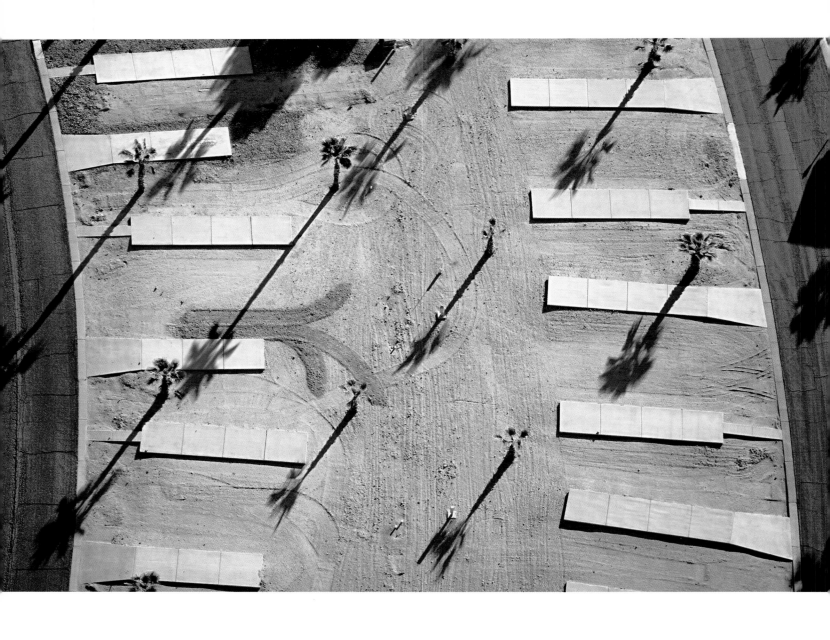

Buckeye, AZ
Empty driveways, pads, and palm trees await the placement of newly manufactured homes.

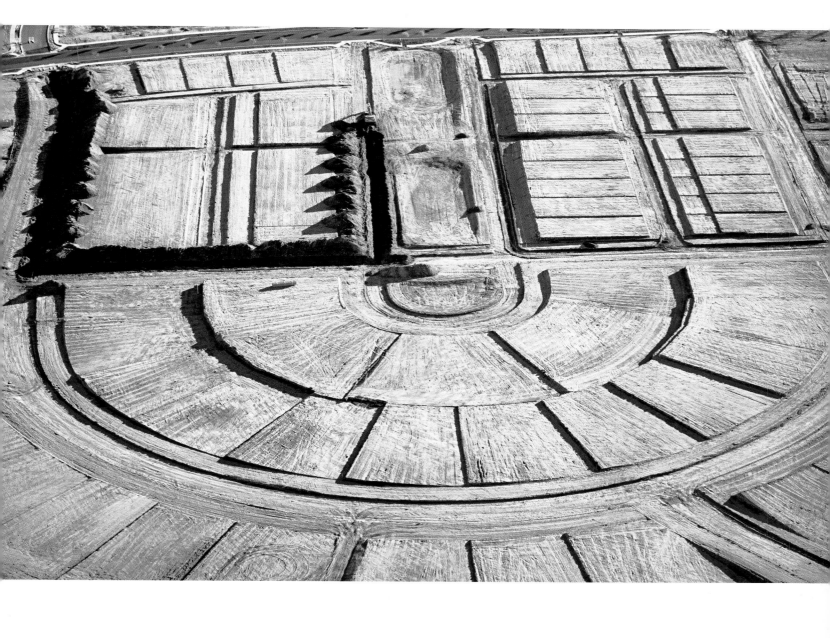

Buckeye, AZ
Grading lots and laying down underground infrastructure make up the early part of construction in the 11,000-home community of Verrado. The community is designed with many small neighborhoods, each with its own individual character.

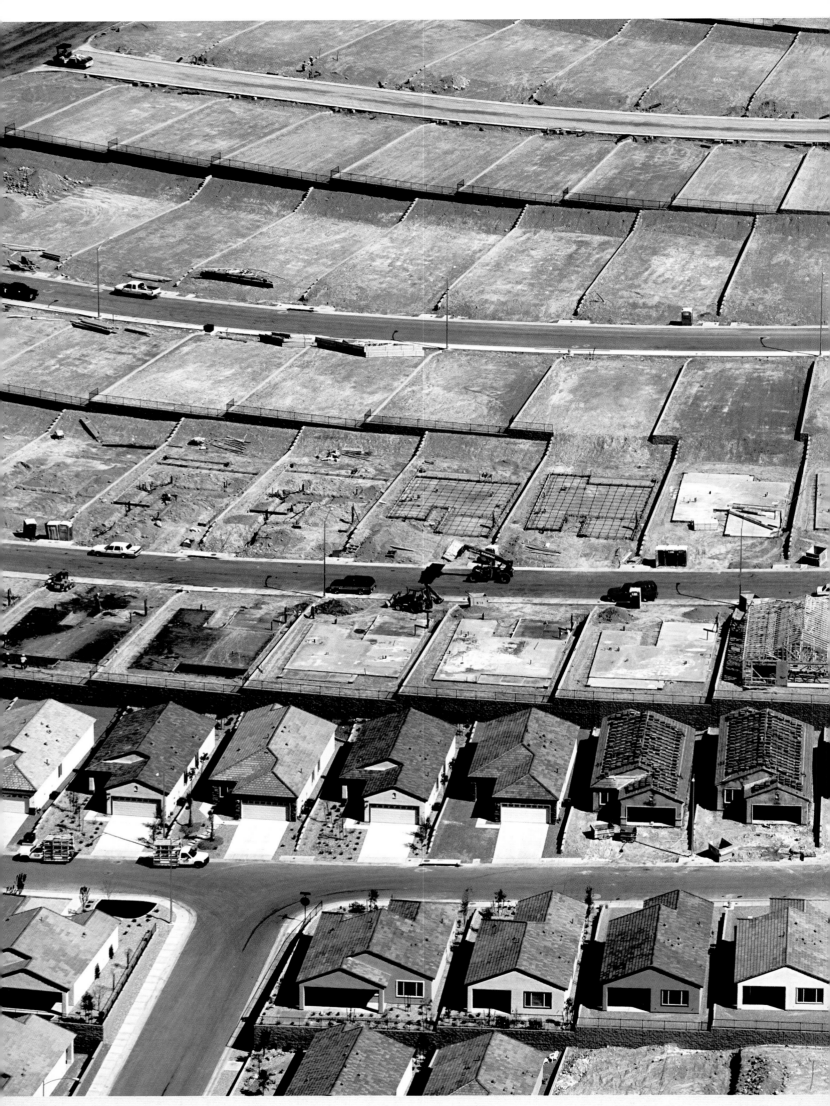

Henderson, Nevada
Henderson, a suburb located 15 miles outside of Las Vegas, is one of Nevada's fastest growing cities and is now Nevada's second largest city. To build homes quickly and cheaply, developers use assembly line-inspired design and construction methods.

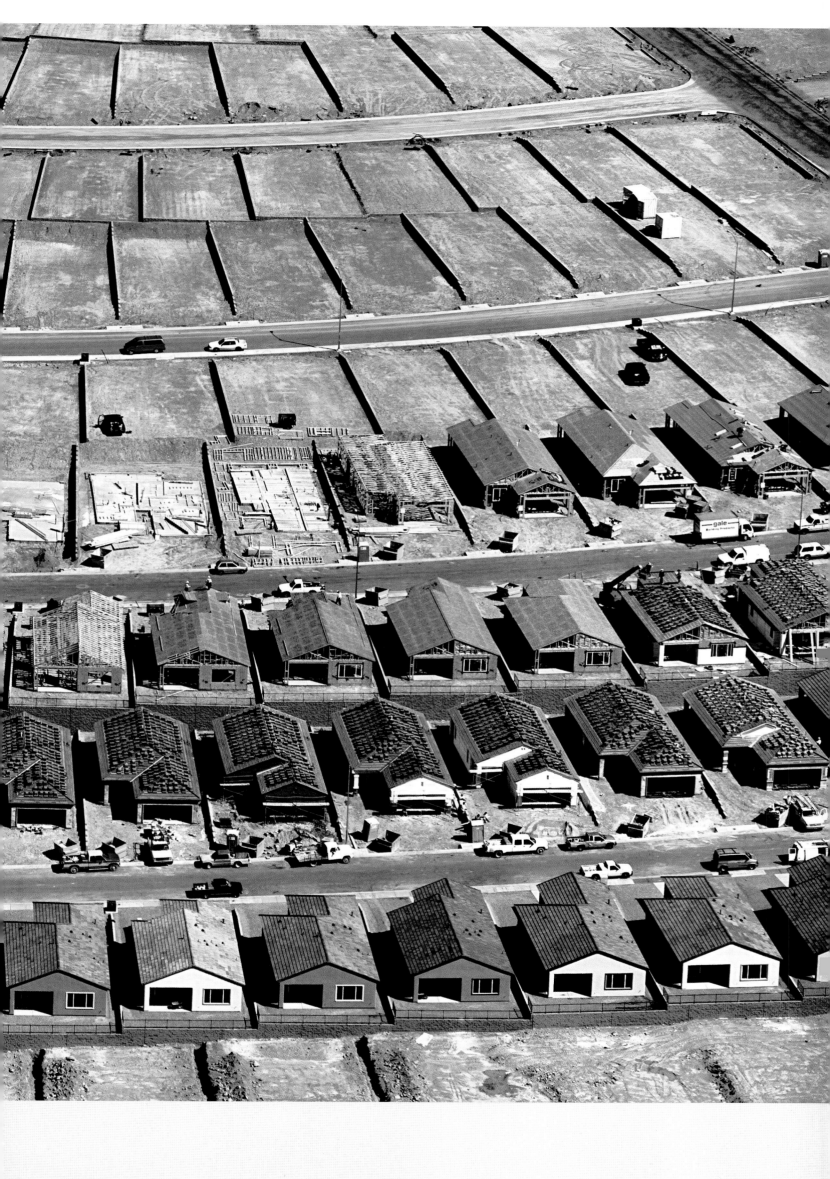

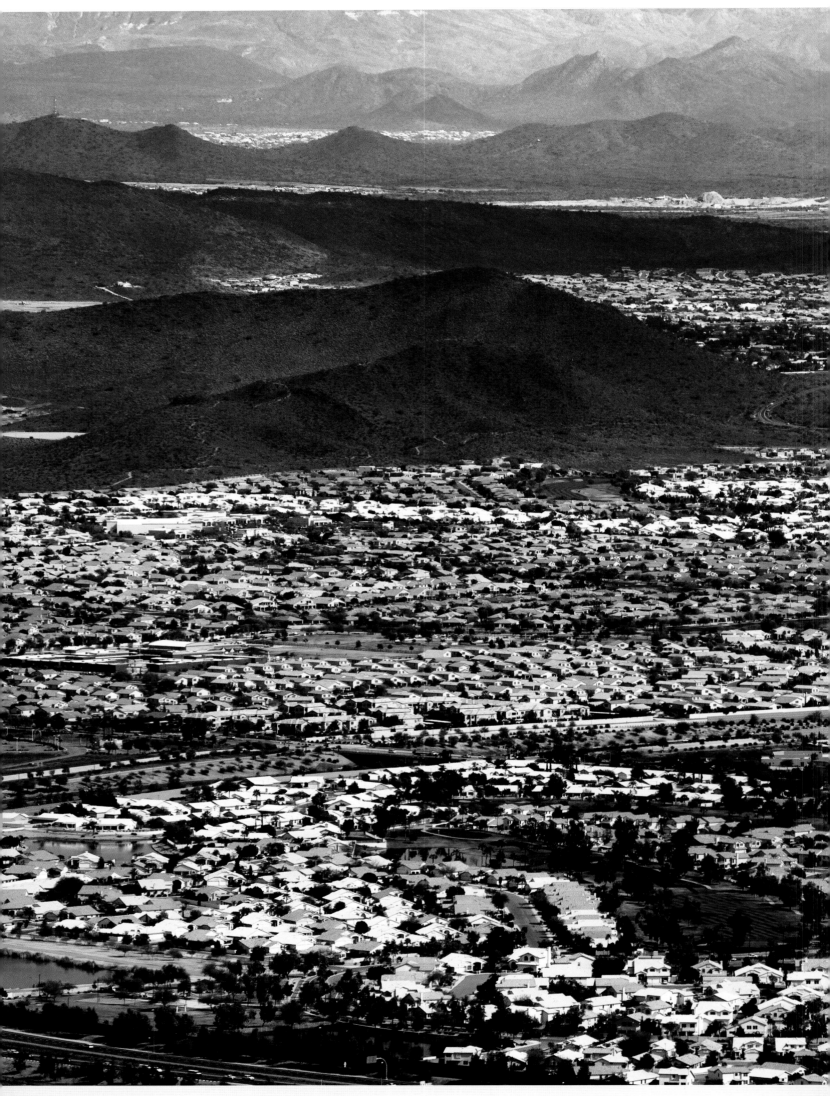

Glendale, AZ

Tract housing blankets the Phoenix suburbs and fills in the area's expansive valleys. Zoned single-use suburban landscapes virtually necessitate a car, and enclave neighborhoods and culs-de-sac make it difficult to navigate through the area.

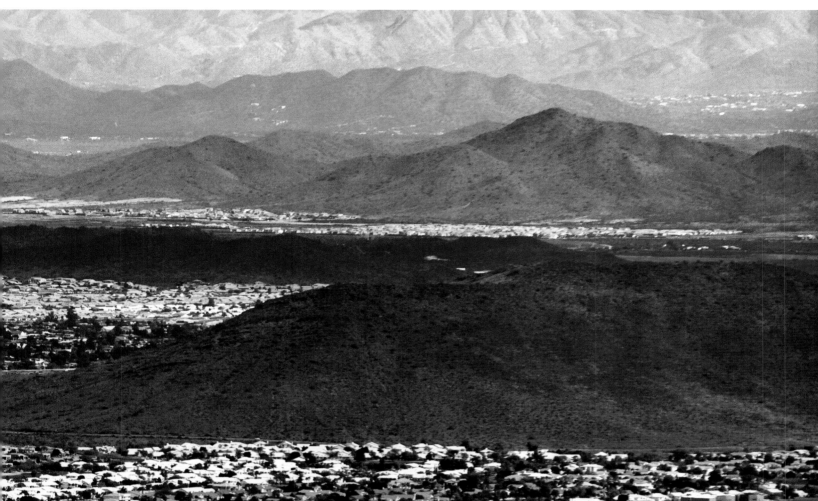

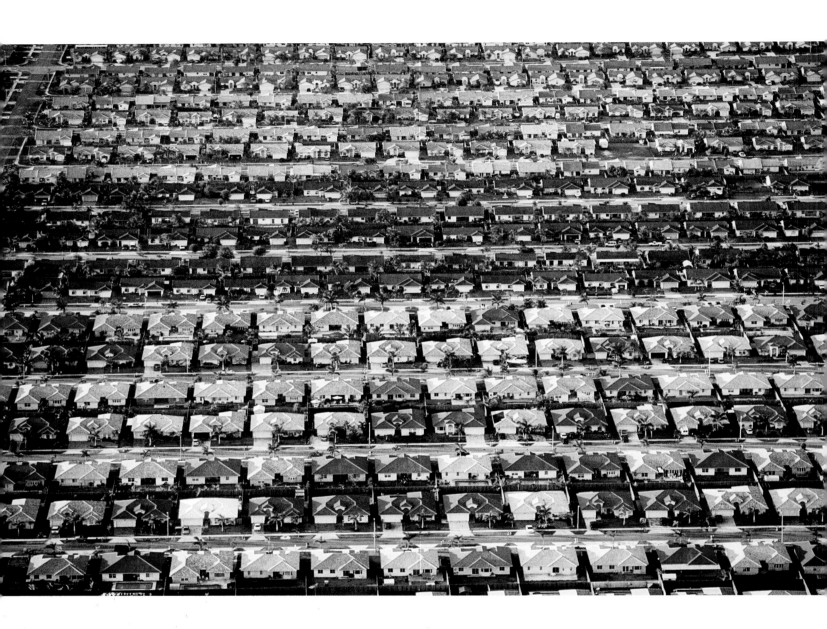

Miami, FL
In a southwest Miami neighborhood, houses boasting two-car garages have a gross density of 5.5 units per acre. Long, linear blocks prevent easy pedestrian access to neighbors on nearby streets.

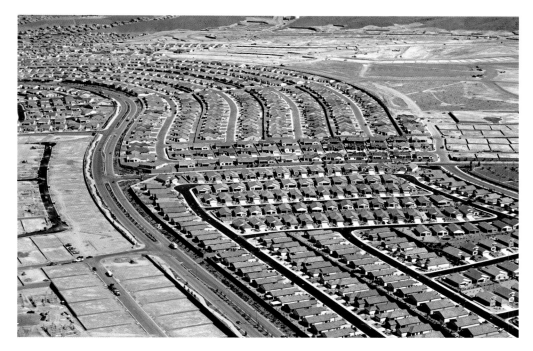

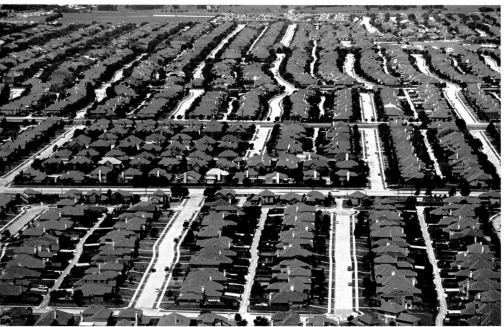

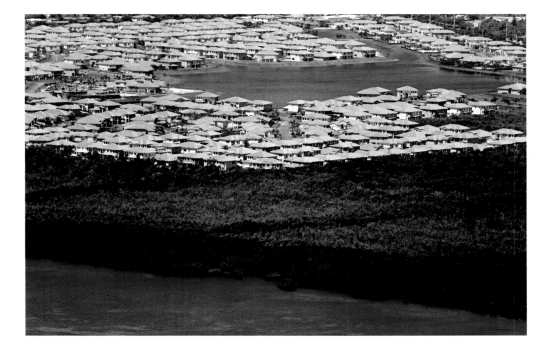

Henderson, NV
Henderson has averaged nearly 12,000 new residents per year since 1990. To keep up with this growth requires putting in an average of 400 additional units per month.

Plano, TX
In the 1980s many large corporations moved to Plano, a suburb of Dallas. Between 1990 and 2000, the city's population nearly doubled, growing from 128,000 to 222,000.

Cutler Bay, FL
Development edges wetlands in Cutler Bay, a municipality of Miami.

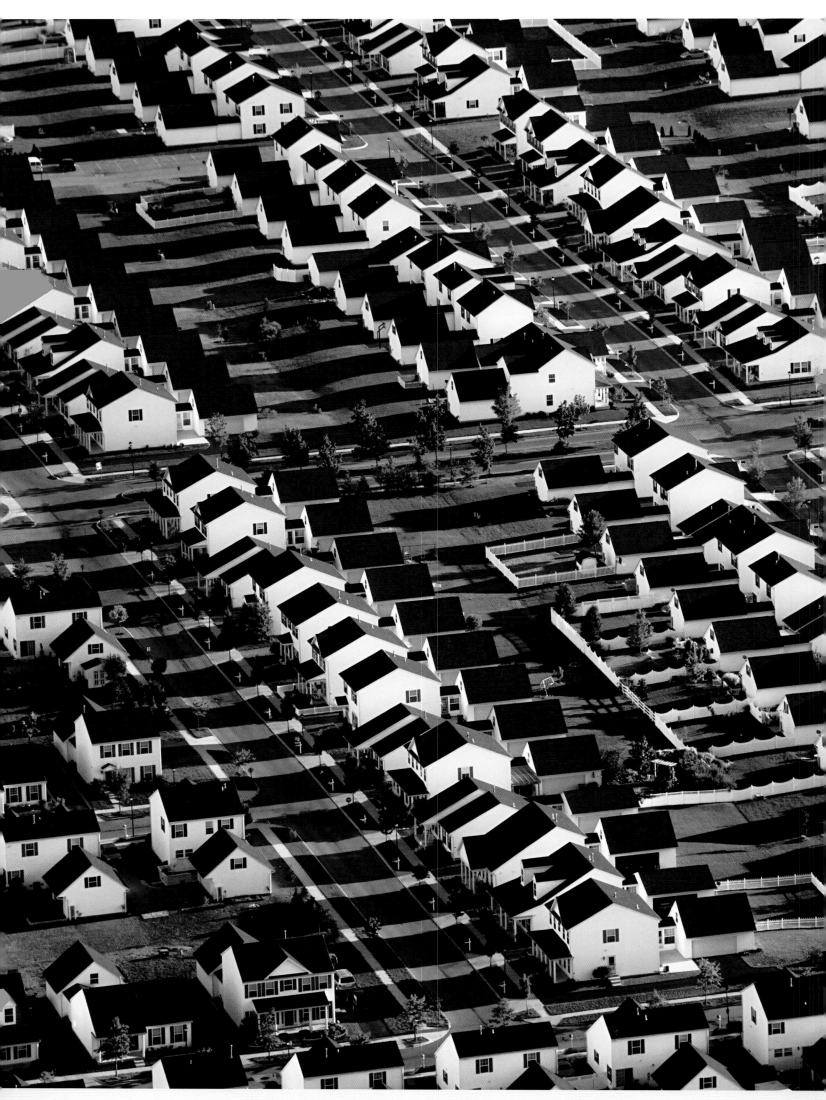

Columbus, OH
These repetitive single-family homes place the garages in the back and have small front yards and
street-front porches to create a less cluttered, less car-oriented neighborhood.

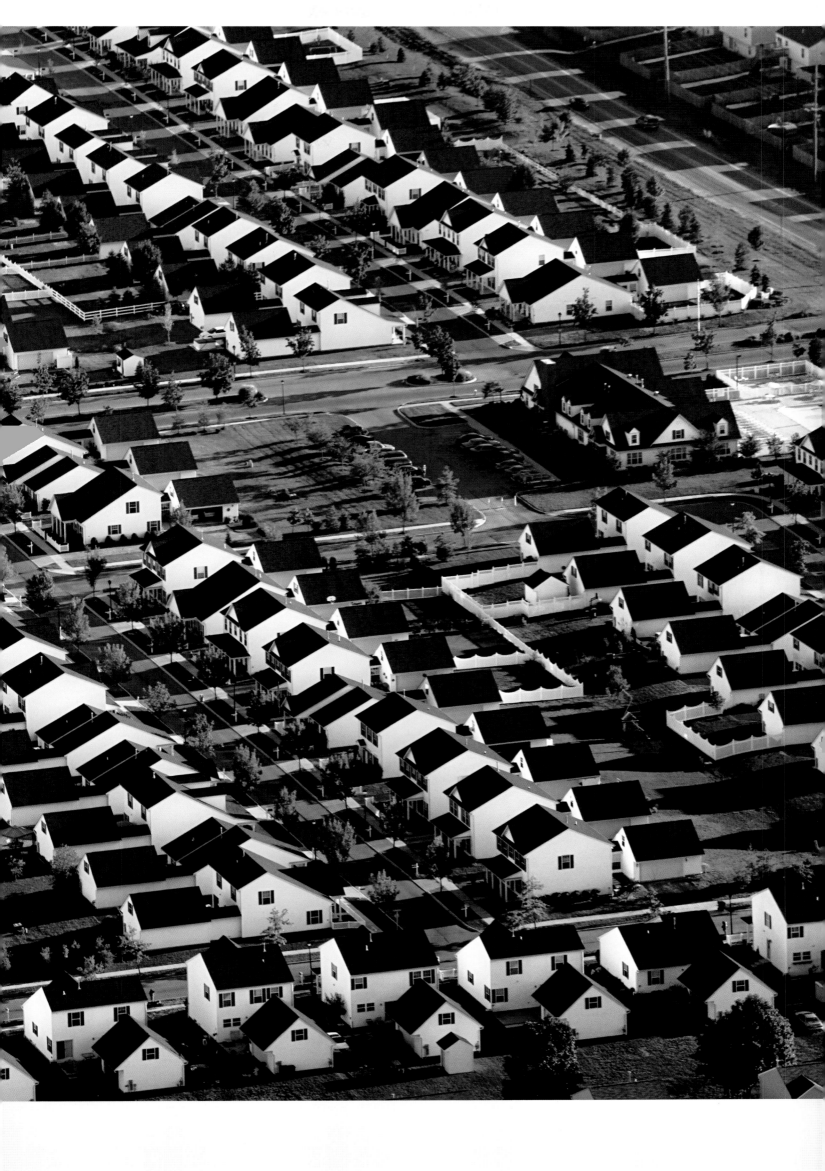

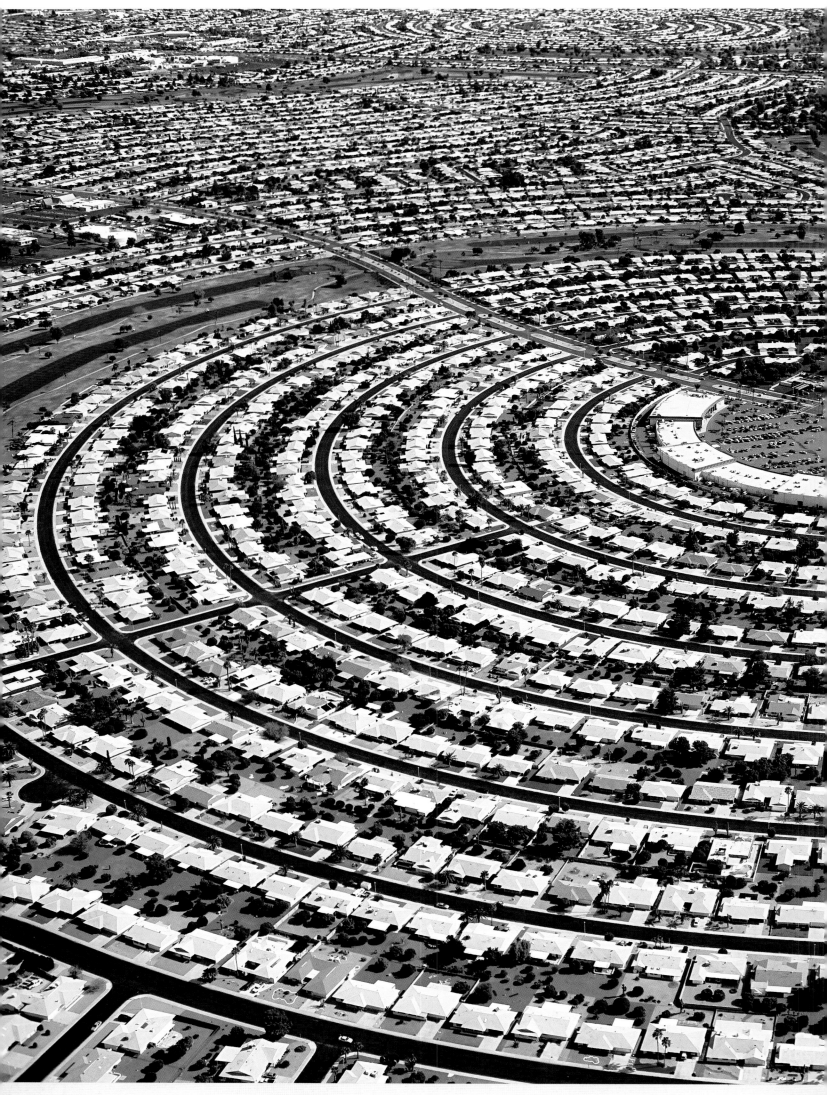

Sun City, AZ
Concentric roads surround a neighborhood commercial center. This road configuration does not
lend itself to pedestrian movement toward the center or toward the open space of the golf course
that encircles the community.

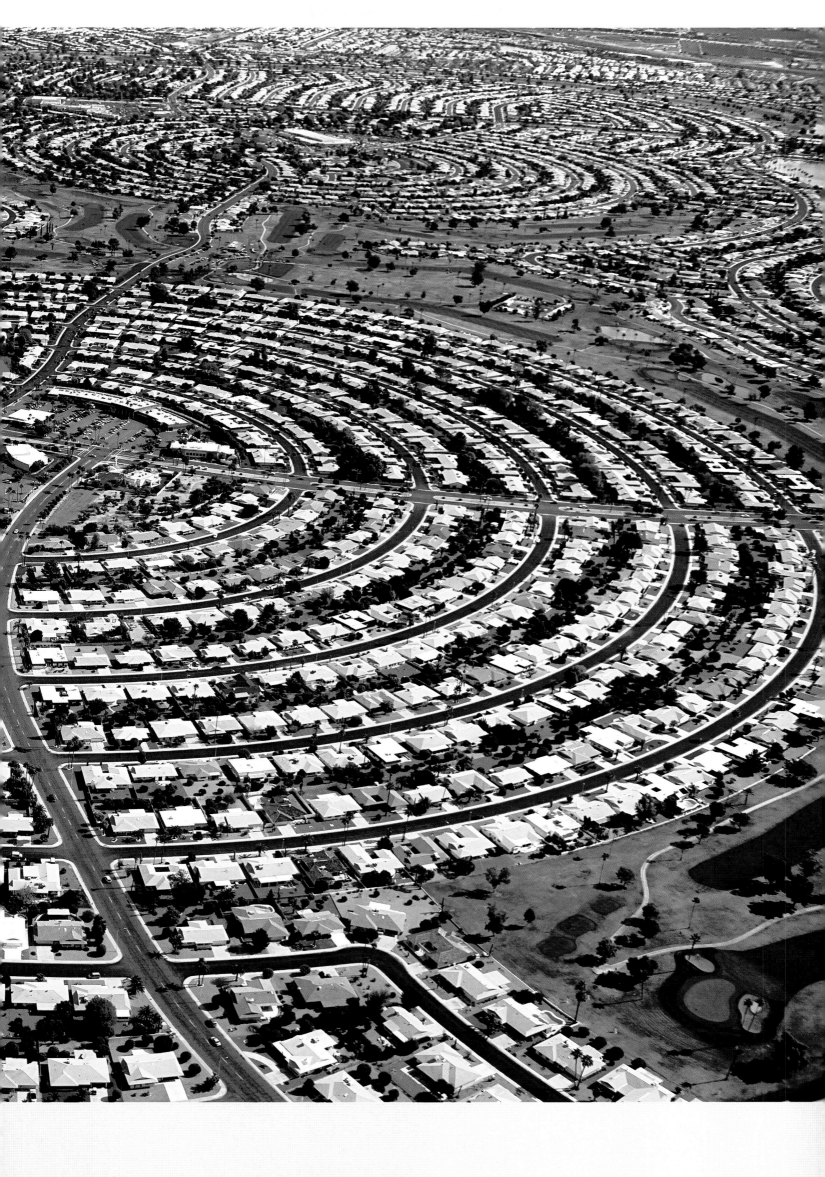

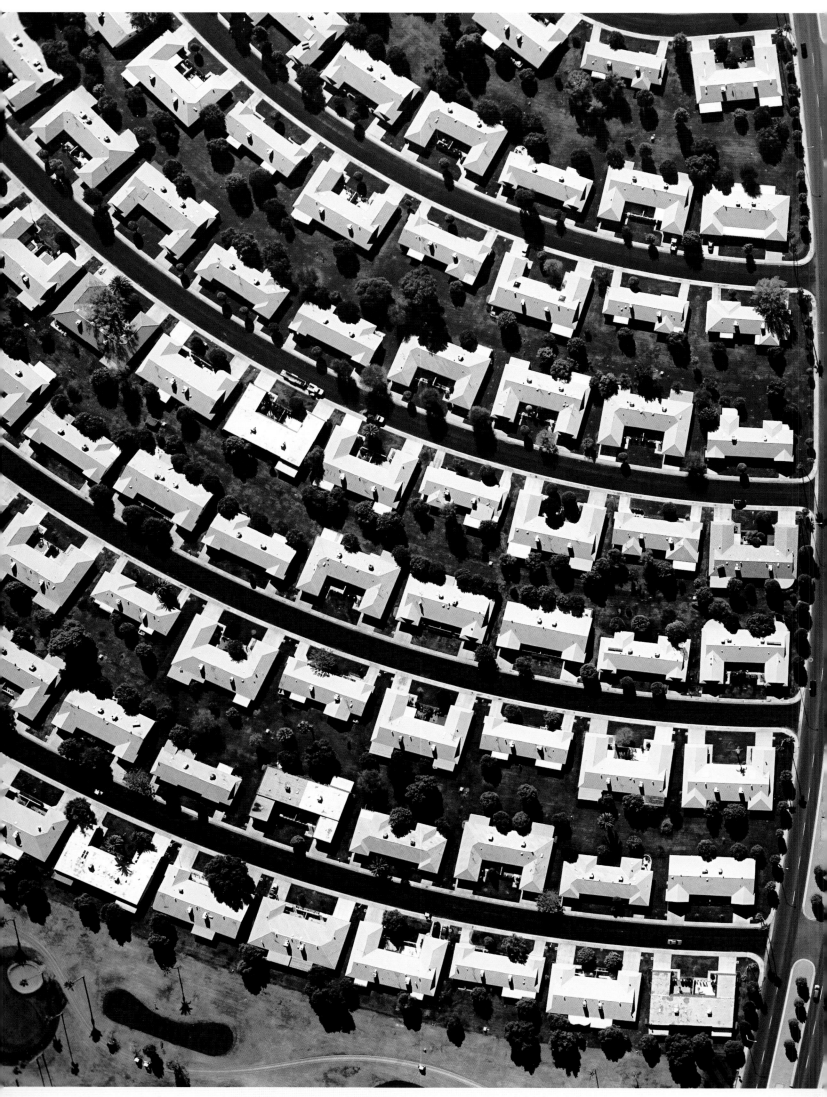

Sun City, AZ
A main arterial road divides single-family and multifamily neighborhoods. Note the difference between individual, xeriscaped lawns and communal backyards with green lawns. The multifamily backyards are not clearly defined as private or public, which is likely to discourage their use.

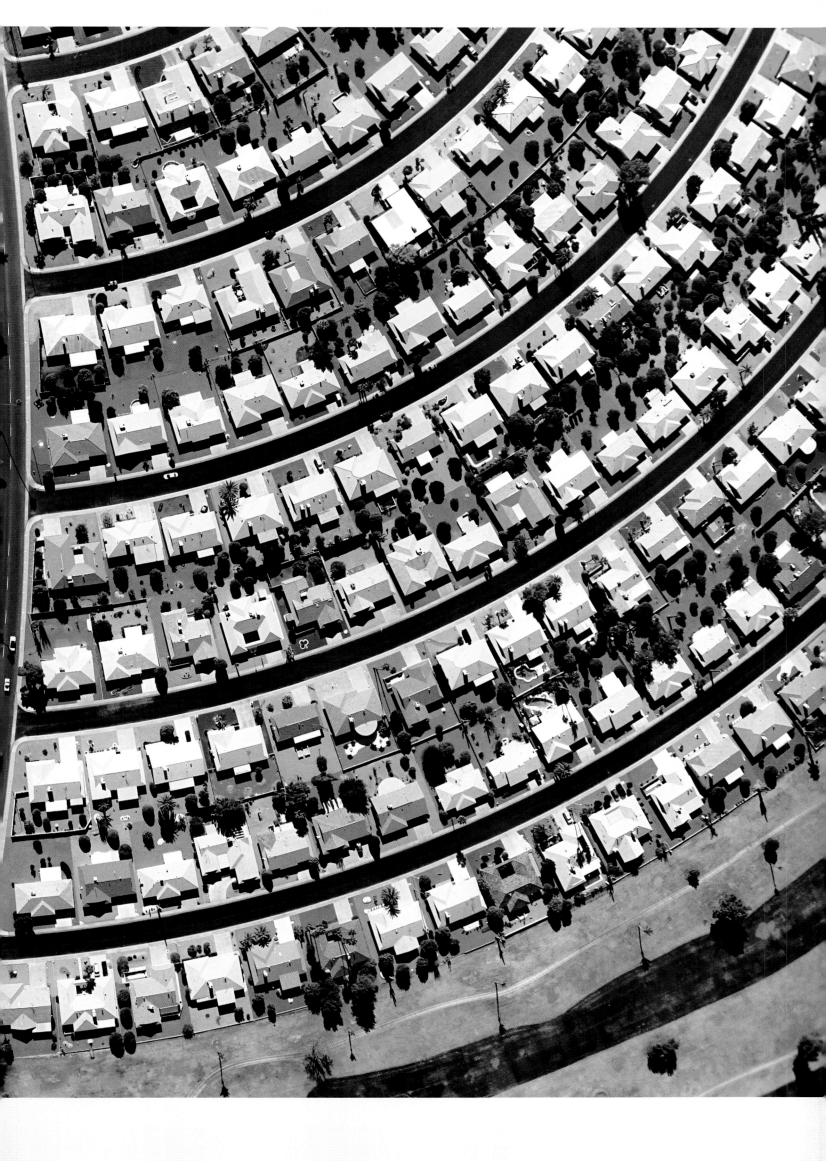

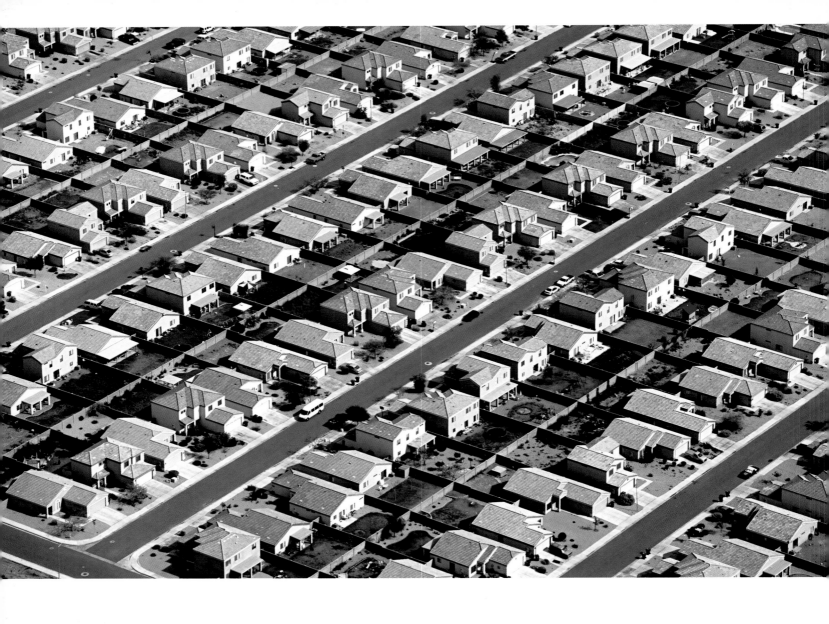

El Mirage, AZ
A detail and an overview of the same neighborhood illustrate how homogeneous and monotonous
housing developments can be, especially when made up of just two housing types. A sense of
community is further diminished by the lack of pedestrian linkage between streets and by these
"snout-nosed" houses, with their two-car garages, creating an uninviting blank wall on the street.

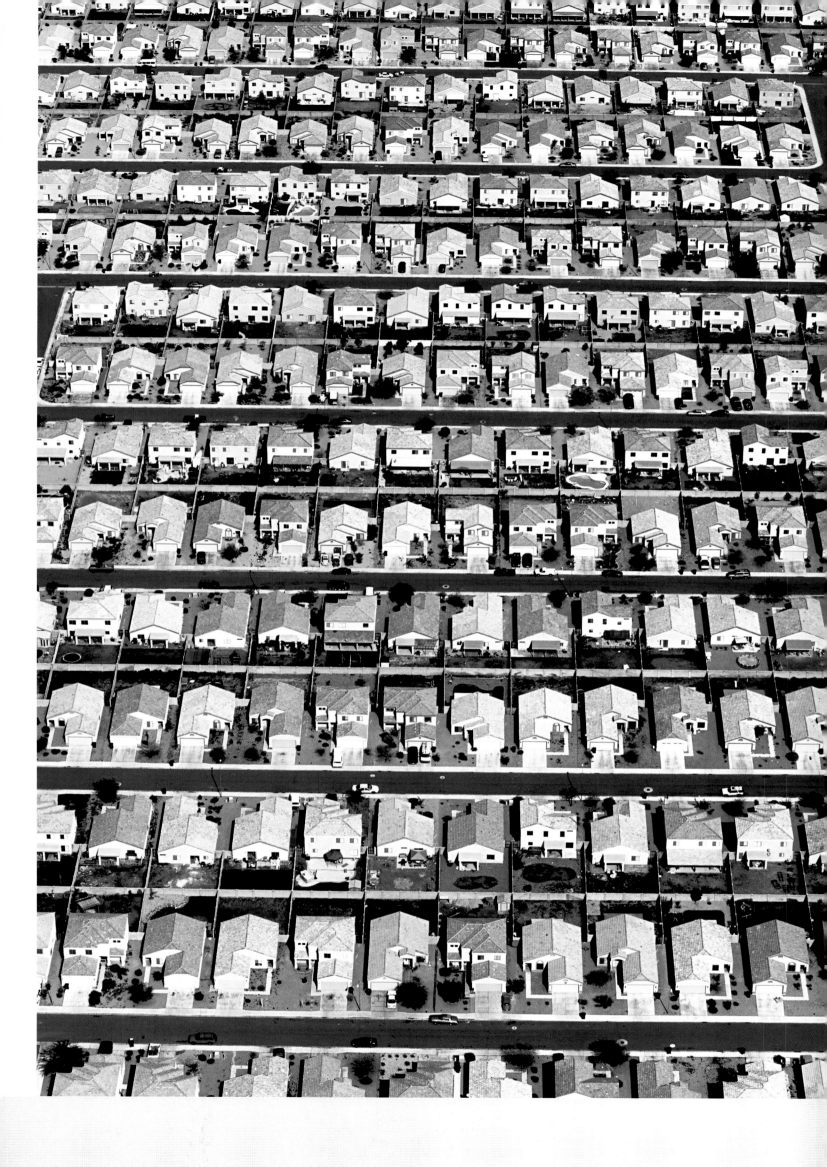

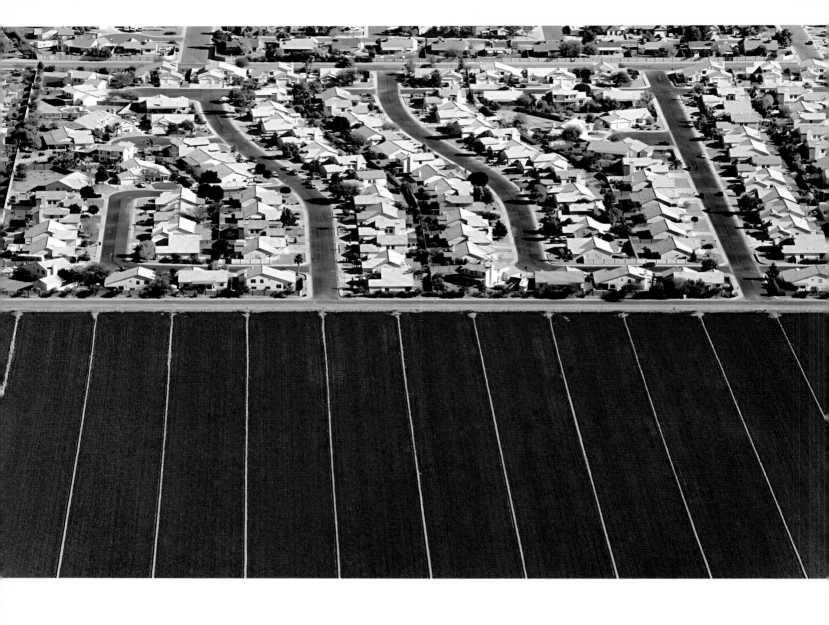

Glendale, AZ
Tract housing borders agricultural fields as development expands outward. The fields, zoned for
residential use, will soon be filled in with similar housing.

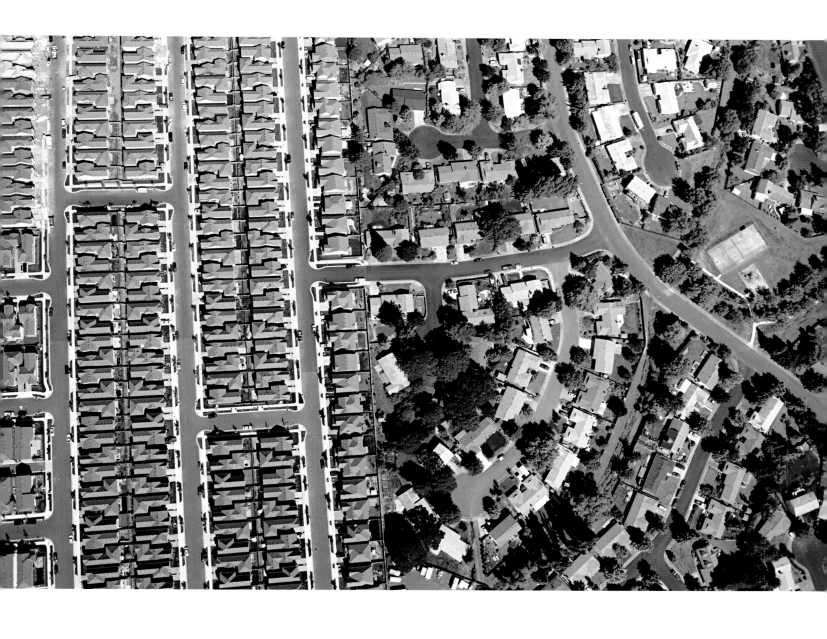

Aurora, OR
Recently constructed two-story tract homes (left) are built on long lots with minimal yard space and garages designed into the first floor. Older single-story houses (right) are built on more classic suburban subdivisions.

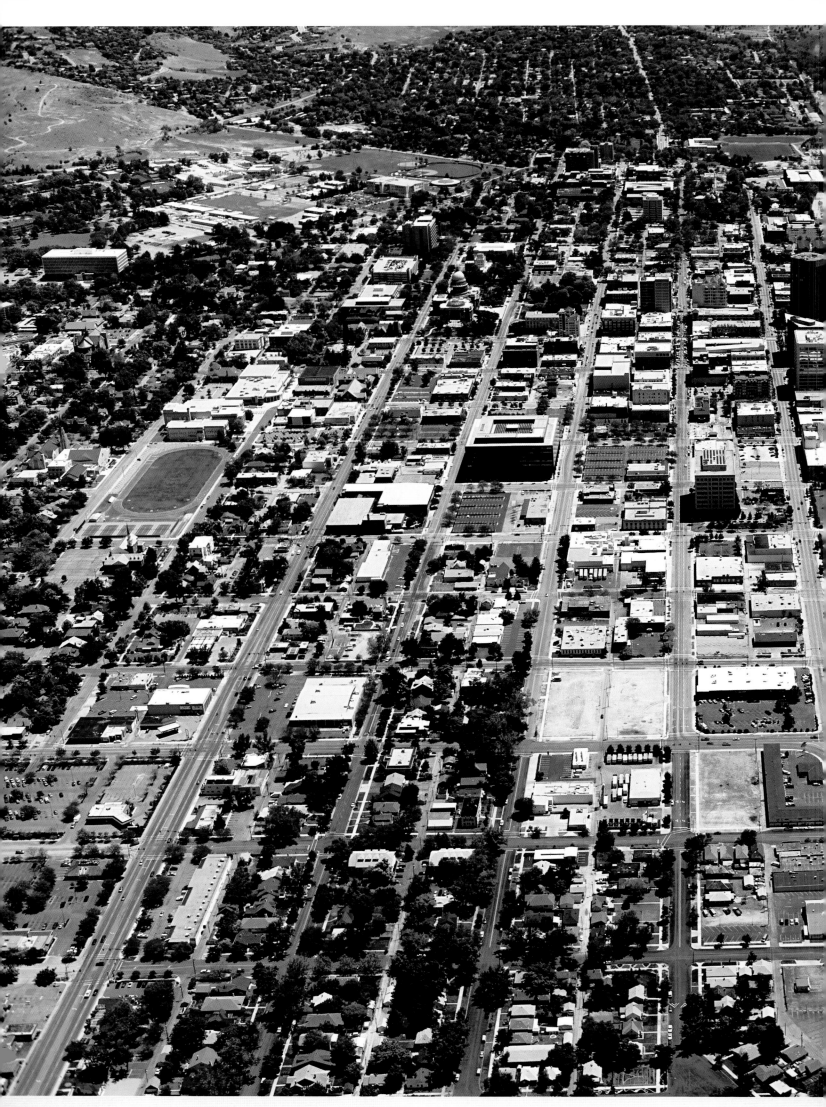

Boise, ID
Nicknamed the City of Trees, Boise boasts numerous forested patches and planted streets. Trees
are important for offsetting urban pollution, not only because they consume CO_2 and cool urban
heat islands, but also because they create shaded, pedestrian-friendly sidewalks and space for
public sanctuary.

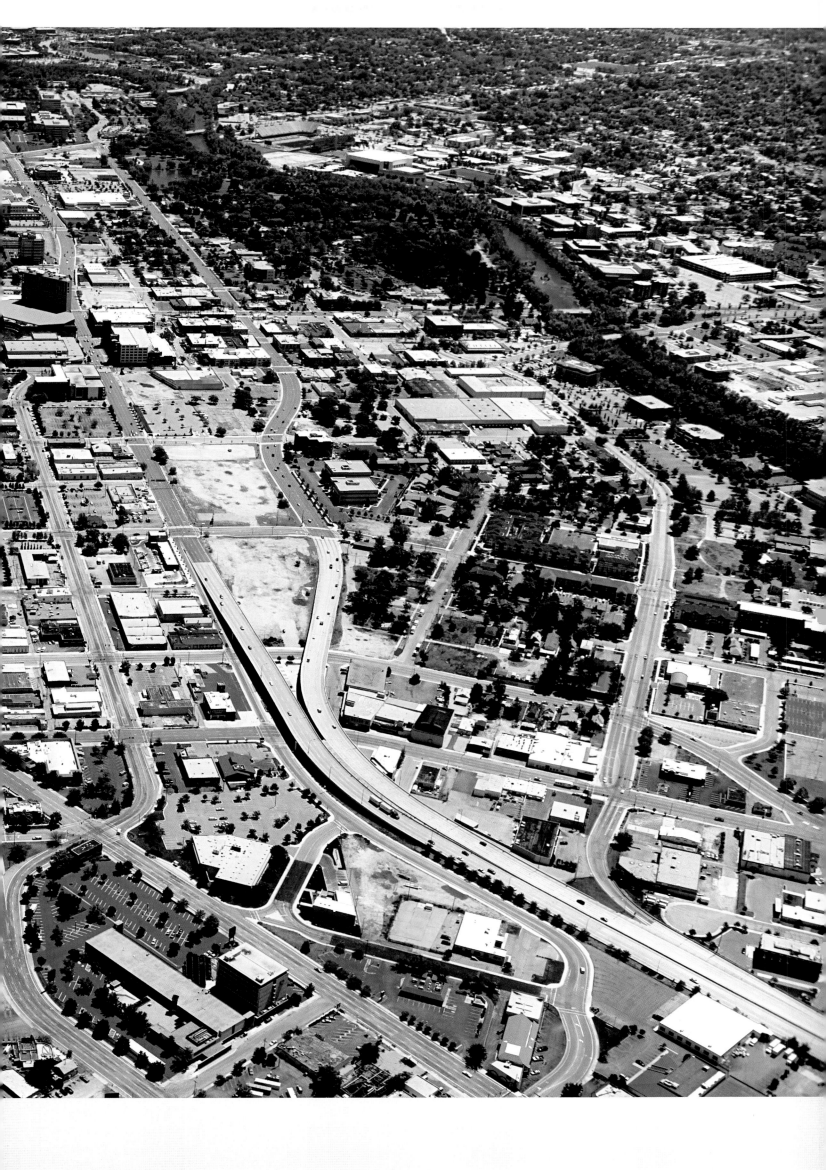

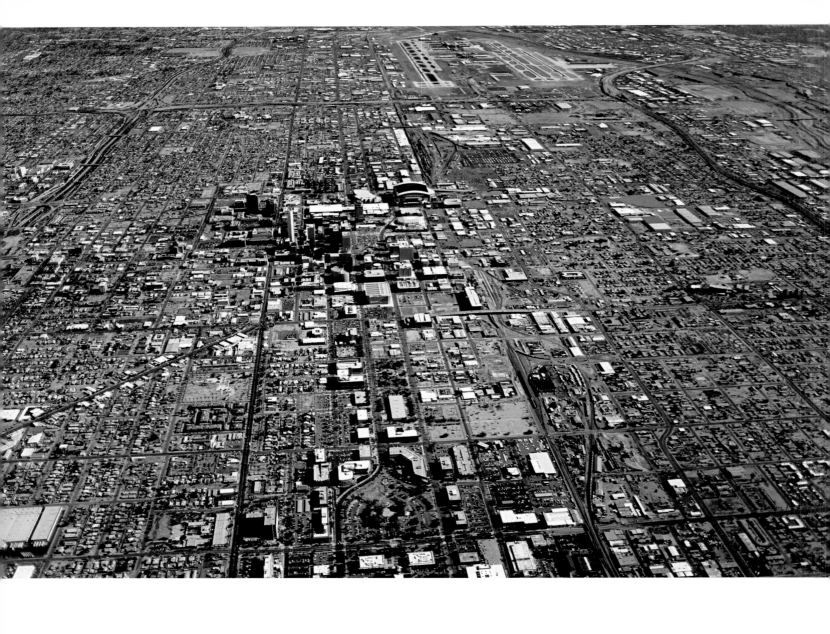

Phoenix, AZ

Phoenix mandates a large number of parking spaces downtown relative to jobs in the area, in part because access to the city center requires a car. Air and noise pollution from Skyharbor Airport's flyway (upper right) impacts development possibilities along the approach-and-departure path, which runs just south of downtown.

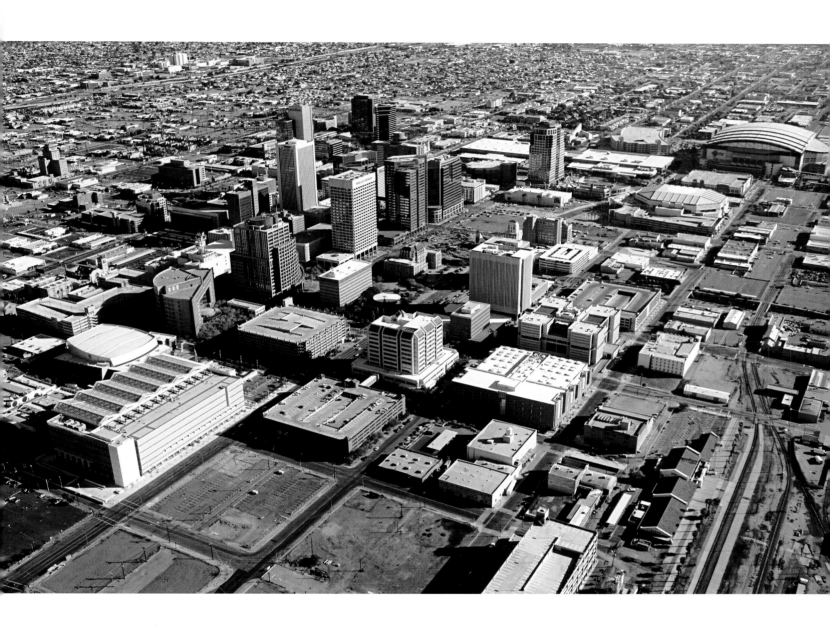

Phoenix, AZ
Lots for surface and structured parking create pedestrian dead space in Phoenix's central business district.

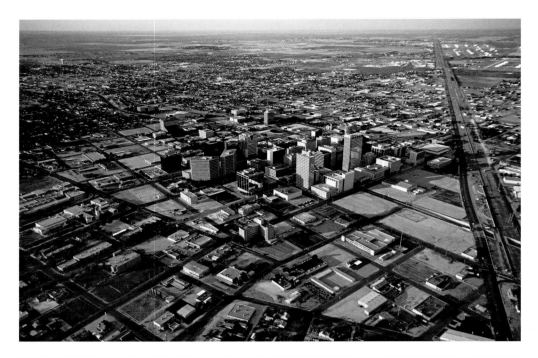

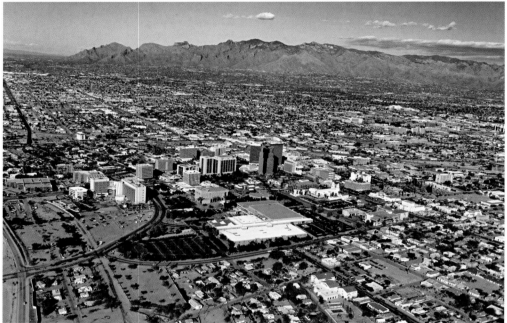

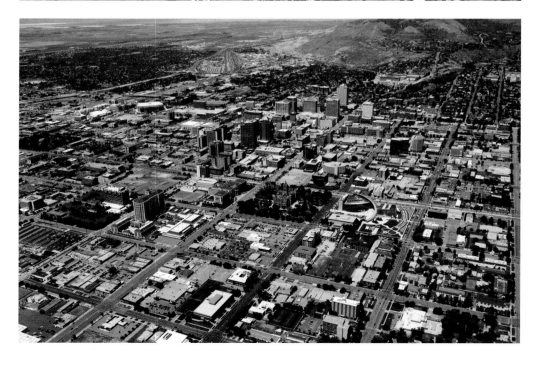

Midland, TX
Parking lots surround the city of Midland, whose fortune is virtually pegged to the price of oil. Midland's urban planners, however, claim the city still lacks adequate parking space.

Tucson, AZ
Oversize peak-demand parking lots flank Tucson's downtown area and convention center.

Salt Lake City, UT
Salt Lake City is built out on a square grid and is surrounded by a mix of low-density residential and commercial properties with surface parking.

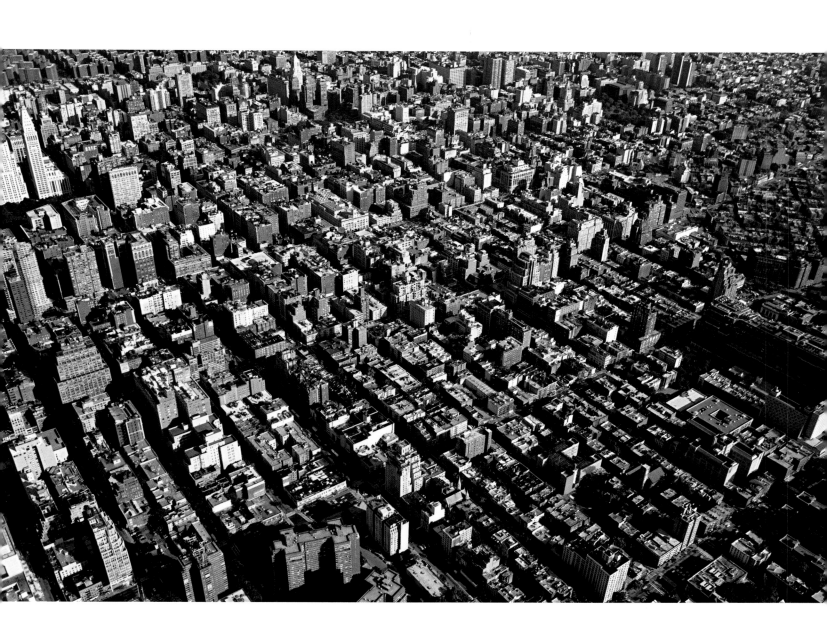

New York, NY
Despite the monotony of the grid layout, Lower Manhattan is culturally diverse with dense, mixed-use neighborhoods, rich with their own details.

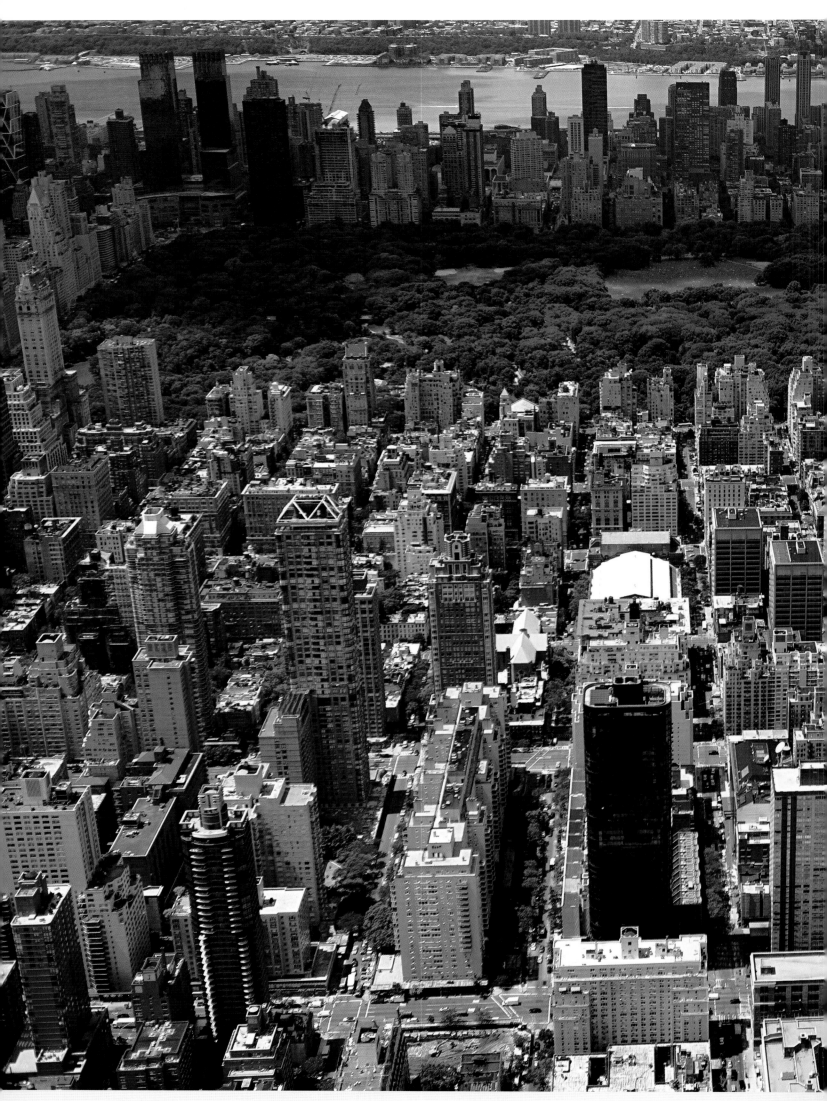

New York, NY

On a per-capita basis, New York is the greenest city in the country: Its residents own fewer cars, use public transportation, walk more, and inhabit smaller living spaces that share common walls. Looking from the East Side toward the Hudson River, Central Park offers an important refuge from the dense urban environment and fast pace of city life. The park has 25 million visitors each year.

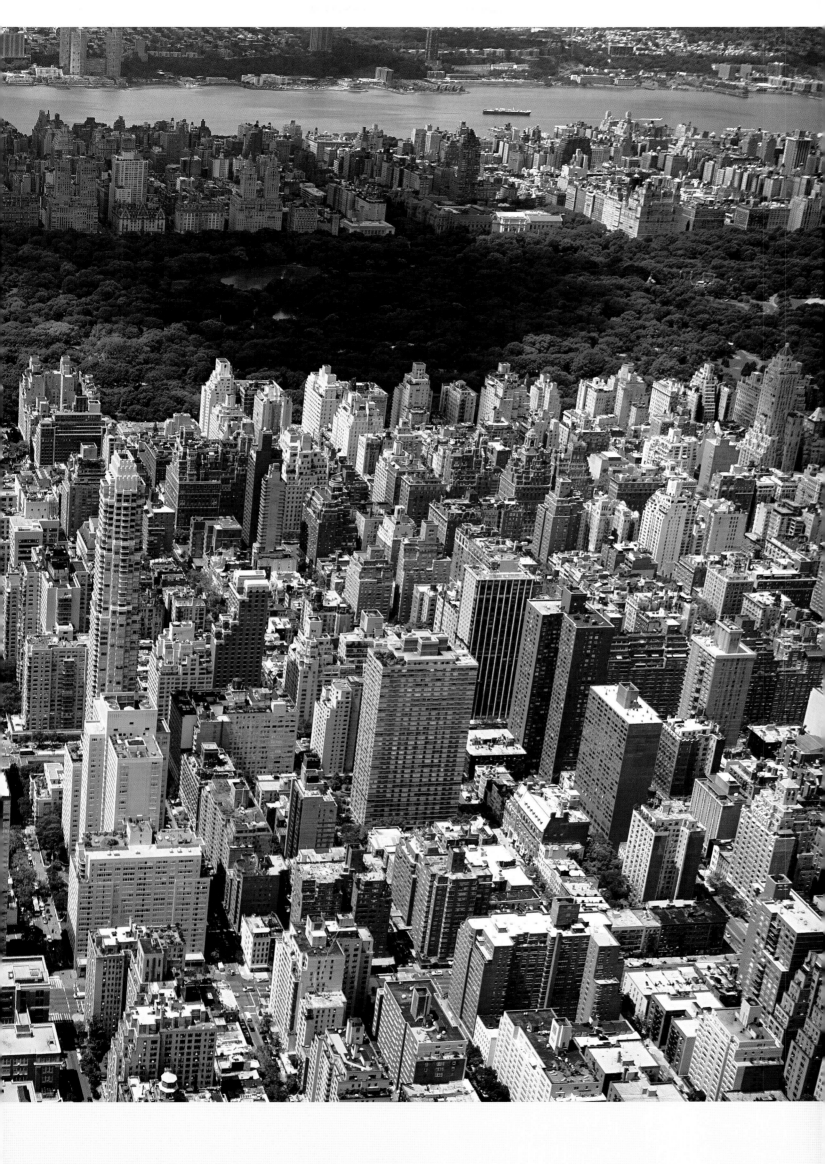

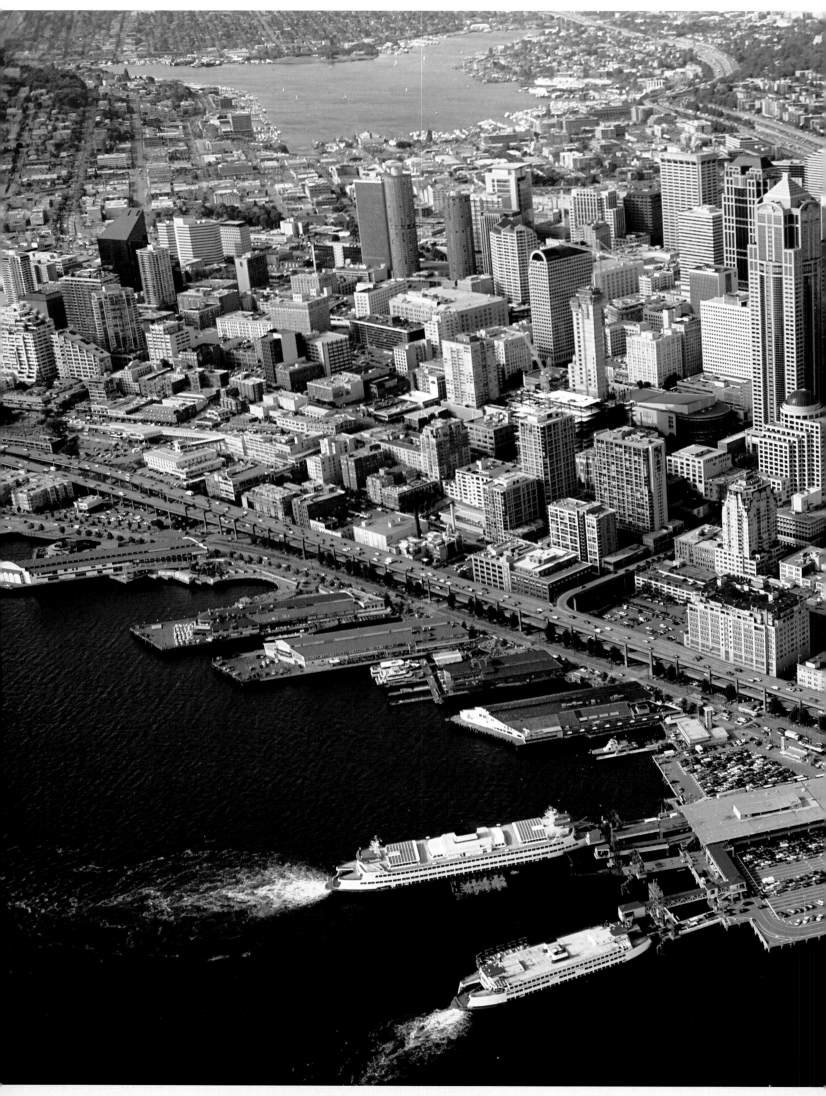

Seattle, WA
Seattle's waterfront is alive with boat activity, but the Alaskan Way Viaduct is a major impediment to waterfront access from downtown.

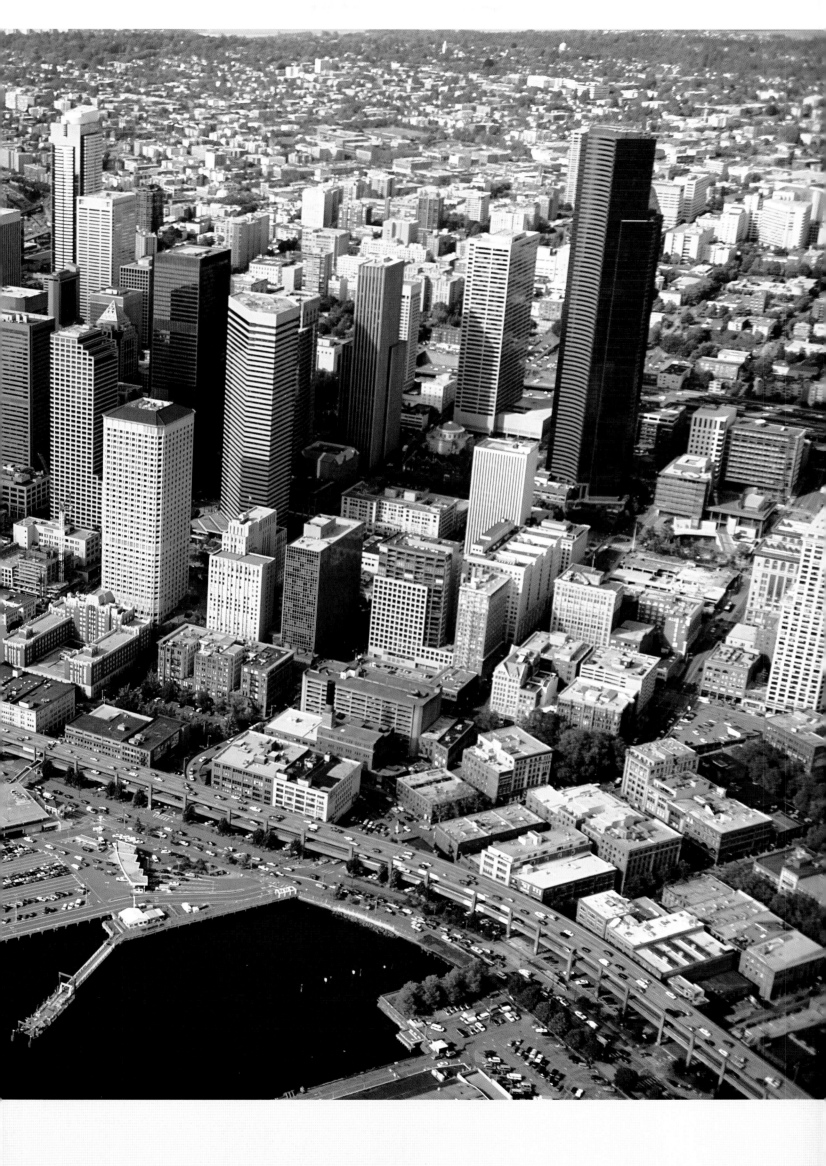

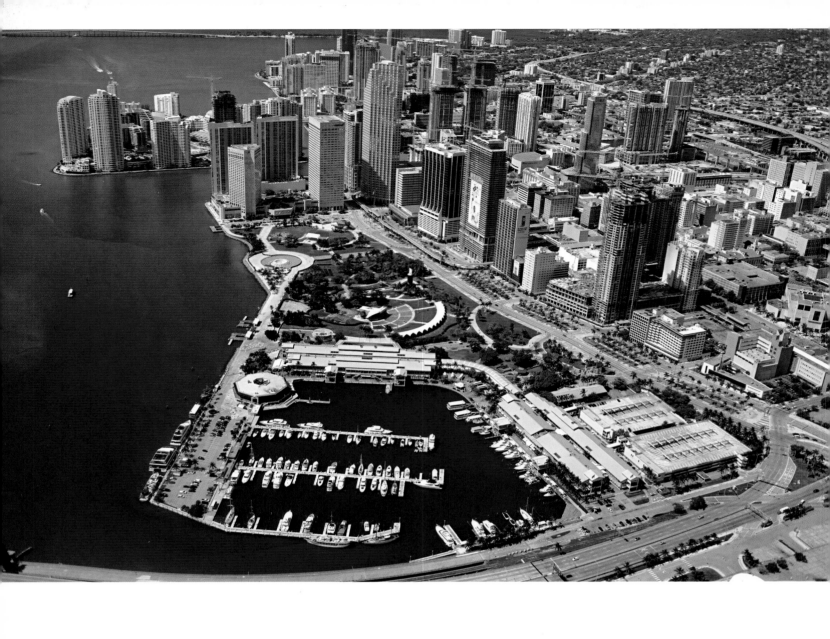

Miami, FL
Bayside Marketplace and Marina is a privately developed area adjacent to the city's public Bayside
Park (background), which is accessible by public transport, the Miami Metromover.

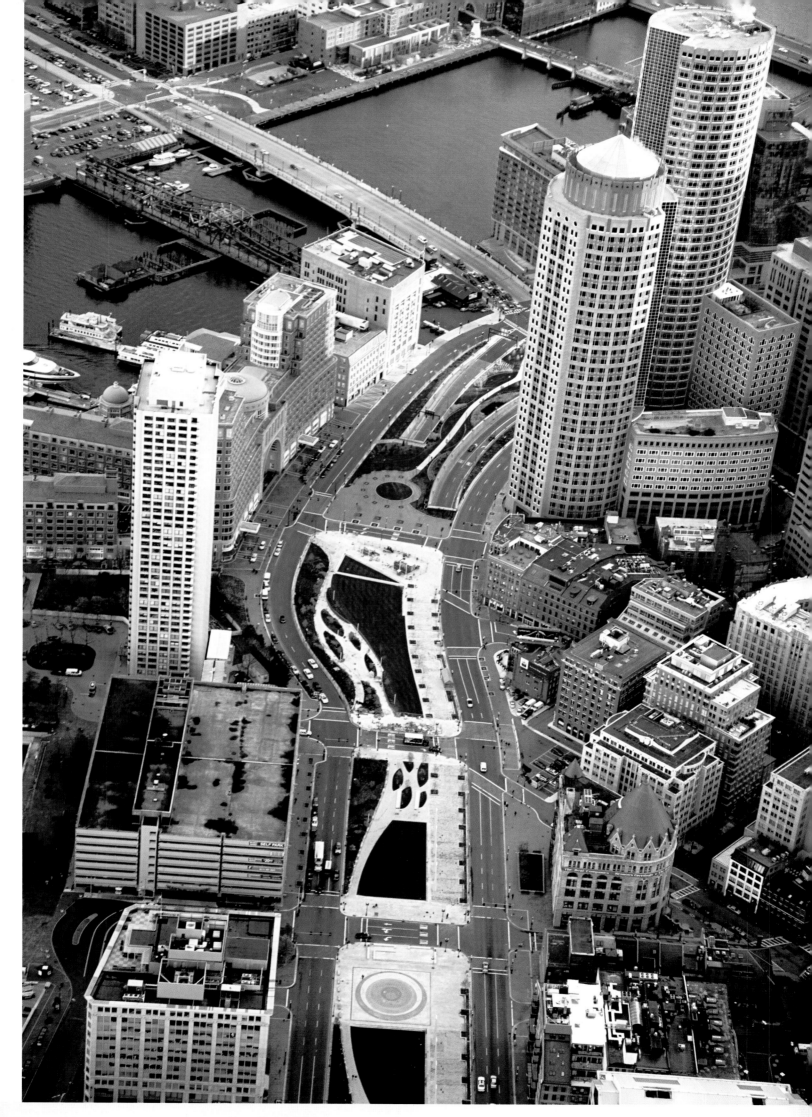

Boston, MA
Rose Kennedy Greenway runs from Chinatown to the North End, built over the same route as the old elevated central highway, which has been reconfigured to run underground. The Greenway serves as an important pedestrian link between the city and the waterfront.

Columbus, OH
North Bank Park is the first of several park projects along the Scioto River in downtown Columbus. Such riverside parks are designed to reconnect locals to regional landscapes.

Seattle, WA
New condominiums and Bell Harbor Marina, a dock for boats visiting Seattle, bring public life to the city's waterfront.

Salem, OR
Riverfront Park is a 23-acre commons that runs along the Willamette River at the foot of downtown Salem, making a good pedestrian connection.

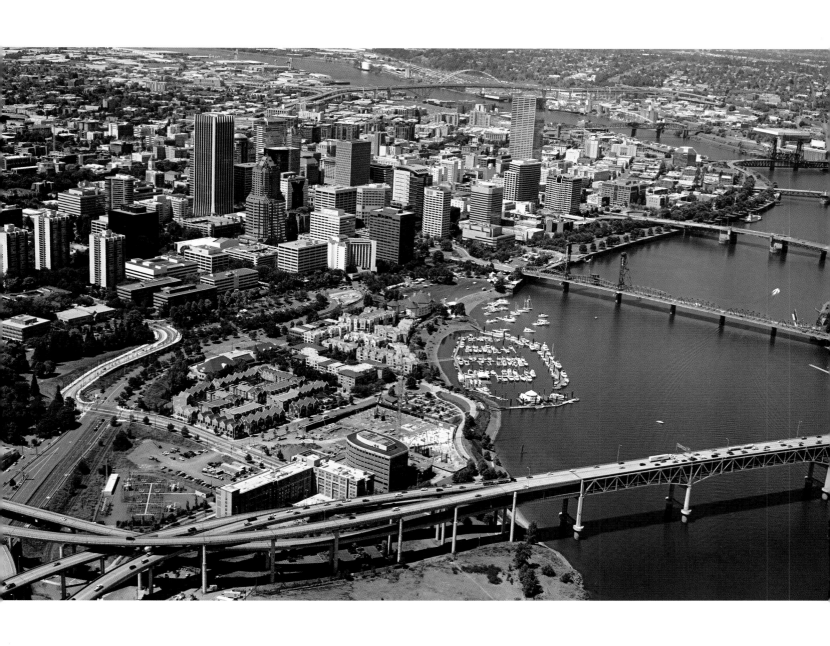

Portland, OR
Dedicated in the late 1970s, Governor Tom McCall Waterfront Park was designed to reconnect
Portland's citizens to the Willamette River. It was conceived of in the early 20th century when the
Olmstead brothers, landscape architects from Boston, visited the area. The brothers conveyed the
need for green space within cities and along riverbanks to provide an urban sanctuary.

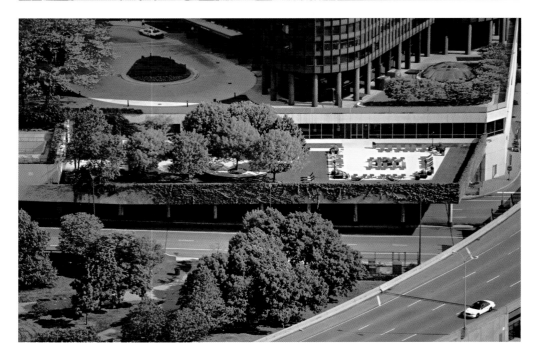

Columbus, OH
The High Street Cap, built over an eight-lane highway that runs through Columbus's downtown, was designed to be a seamless crossway for High Street, a pedestrian street.

Hartford, CT
A public plaza spans a major highway and rail line to make a new waterfront park on the Connecticut River accessible to pedestrians from downtown.

Chicago, IL
The right to build over a public roadway allows Harbor Point Tower to design outdoor green space for its residents in downtown Chicago.

Lowell, MA

Lowell was once a center of Massachusetts's textile production. As the industry went into recession in the mid-20th century, the town's factories were abandoned. In the late 1970s, they were restored and made into the first urban U.S. national historic park. Part of the city's rehabilitation included a pedestrian walk along the Merrimack River and a minor-league baseball park.

Chicago, IL

To the left of Daley Bicentennial Plaza sits the recently developed Millennium Park. Once a wasteland of train yards and surface parking lots, the area now provides Chicago residents with 93,000 square feet of new recreational space. The park uses high-tech solar panels that generate enough electricity to run its buildings.

Apocalypse Soon, Seen from Above: Interview with Jean Dethier,

former director of exhibitions about the built environment at the Centre Pompidou, Paris

Alex MacLean standing in front of his plane, a Flight Design CT
(Composite Technology) Light Sport, in Woodstock, Connecticut, 2008.

The images in this book are beautiful and dangerous. This is one of the paradoxes with which Alex MacLean's photographs confront us. They are aesthetically and intellectually seductive, but dangerous to use, because their aesthetics—while rigorous—can easily be usurped for the sake of "art" or media purposes. Namely by those whose collusion in the devastating waste and denaturing of the land and landscape for the sake of development and change is revealed in these photographs—at times to a caricatural extreme. Fortunately, Alex MacLean's talents are not limited to the mere production of these images; he decodes their meanings himself and deepens them with a necessary and appropriate critical discourse. This triple language—scientific, cultural, and critical—applied to the United States of America, is what constitutes MacLean's remarkable singularity in the world of photography. He sustains this creative trilogy with numerous publications, lectures, and courses.

When we began working on this book project together in 2005, we had to ask ourselves repeatedly about the relationship between this work and the observed climatic changes and supposedly inevitable "ecological revolution." Another question nagged us as well: Was the impact of the advanced industrial civilization shown in these images specific to the ambitions and dysfunctions of the United States, or was it useful as a warning to Europe and the rest of the world as well? Today, it is evident that the book's images do indeed expose a model that is becoming more and more universal—that is, the logic of an all-out overconsumption that devours our vital space. To shed light on this phenomenon as it pertains to MacLean's pictures, we interviewed the Belgian architect and urbanist Jean Dethier. Since 1975, he has initiated outstanding exhibitions at the Centre Pompidou in Paris that have demonstrated—in critical terms and for a wide audience—the issues and transformations surrounding our built environment.

Dominique Carré, Publisher
Dominique Carré Editions

DOMINIQUE CARRÉ (D.C.): Although devoid of human presence, Alex MacLean's work is an expression of photographic humanism; it is steeped in humanity. How do you explain this paradox?

JEAN DETHIER (J.D.): This paradox only seems to exist. While aerial photography is generally ill suited to provide a direct testimony to the human presence within a vast landscape, MacLean's talent lies in rendering this presence visible—indirectly, and in a spectacular and memorable way. Namely, he accomplishes this by showing the marks that society leaves on the landscape with its urban and rural developments. He bears witness with unprecedented eloquence to the changes that humankind has wrought on its environment. In so doing, he joins a long list of precursors in Europe and America. As with all great creators, MacLean has to be considered within the context of the lineage of other pioneers who used aerial photography with an eye to meaningful social concerns— in order to better understand and highlight the particular features of the landscape and territories that have been inhabited or developed by humankind.

D.C.: How did these trends evolve in the course of the 20th century?

J.D.: A new discipline called human geography gave voice to the trend at the beginning of the 20th century in France. Its first public manifesto appeared in 1925 in a book bearing the same title by the geographer and humanist Jean Brunhes. He was a charismatic leader who attracted supporters from other disciplines: anthropologists, philosophers, reformers, and so on. They all used aerial photography as a tool to investigate the extraordinary diversity of natural, agricultural, and urban landscapes throughout the world, not to mention the great sociocultural diversity of the traces left by human beings through the ages, from antiquity to the present. This intellectual movement offered an alternative to passive and academic geography and helped forge the basic idea of cultural diversity, which was only recognized much later; although crucial, this idea was not adopted by the United Nations until 2006 (thanks to a joint initiative at UNESCO led by France, Belgium, and Canada). The only government that expressed hostility to this measure—calling it "highly suspect"—was the one presided over by George W. Bush— who was just as hostile to the Kyoto Protocol's efforts to combat the greenhouse effect.

These images are from *Flying Solo*, a 52-minute film made in 2002 by Odile Fillion. The aerial footage was shot aboard MacLean's Cessna Skylane 182 during a trip between Kansas City and Boston. In other sequences in the film, Fillion shot MacLean in conversation with architects, landscape architects, and also urbanism students attending lectures MacLean gave about his photographs. © Odile Fillion / Mirage illimité.

D.C.: But what do these facts have to do with Alex MacLean's work in the U.S.?

J.D.: Although the movement originated in Europe, it was in the U.S. that certain methodological and critical issues specific to human geography began to take on a new character—one of protest—in the 1940s and '50s. This happened thanks to the strong personality of a landscape architect based at Harvard University: John B. Jackson. With the help of solid intellectual and militant allies— especially the highly regarded and combative Lewis Mumford, a very progressive urban historian—Jackson became one of the main proponents of what came to be called the "regional revolution." As a result, he became a leading figure in the American counterculture and the institutional protest movement, at the heart of one of the most highly regarded and influential universities in the world. MacLean himself has spoken of the seminal impact Jackson's teaching had on him while he was studying architecture. This probably exerted a decisive influence on his career, his method, and his work.

D.C.: How does the aerial view specifically contribute to our understanding of the landscape?

J.D.: The great fascination with the bird's-eye view trained on the world can prove problematic when the purpose is to communicate something useful and meaningful; specifically, the photographs have to have more than a mere aesthetic or anecdotal character. When you fly, your eye is pulled in all directions by a sort of "total spectacle" of such breadth and strangeness, of such beauty and mobility that it becomes very difficult to execute three necessary, simultaneous, and complementary tasks in addition to flying the aircraft: one, evaluating the pertinence of what is seen all around; two, selecting from the vastness of the moving and panoramic landscape the best photographic composition; and three, taking into account the precise geographic information (position, orientation, etc.) necessary to place the selected "detail" into the larger scientific context of the landscape being represented. Alex MacLean's accomplishment is all the more remarkable in that he is alone in the plane, piloting while executing all three of these delicate tasks. This requires a rare level of skill. He must be able to coordinate at each instant his technical mastery of the aircraft with the photographic logistics, and his intellectual mastery of that particular flight's methodological objectives with the

artistic mastery to compose his pictures at a fast clip. All of this in the midst of a constantly changing, and so very ephemeral, landscape below. Each of these photographs is therefore the result of an astonishing array of constraints and requirements, all being addressed on the spur of the moment.

D.C.: What would you say is the specificity of MacLean's work?

J.D.: Let's compare his professional practice with that of some other major proponents of the genre. In Europe, the Swiss Georg Gerster and the French Yann Arthus-Bertrand practice the same profession as MacLean does. All three are highly talented, but each has a very different approach. Gerster has devoted a significant part of his long career as a photographer to superbly photographing archaeological sites and the cultural heritage landmarks of humankind. Arthus-Bertrand brilliantly focuses his work on the many facets of the physical and human geography of our planet, more recently to underscore his commitment to environmental issues. Both Gerster and Arthus-Bertrand have adopted a kind of cumulative—and occasionally comparative—approach that encompasses a wide range of sites. This basically implies a scattered exploration extending all over the planet that, by its very nature, might remain superficial due to the huge number of sites and countries they cover. This is meant as an observation, not as a criticism. MacLean, on the other hand, works like a farmer, untiringly "cultivating his field." He limits his exploration to his own country in order to capture it in great detail, in all its diversity and contradictions. For the last three decades, he has probed ever deeper, monitoring the gradual changes that have been effected. He articulates his work along two axes: space (aerial) and time (duration). Focusing his remarkable mission solely on the territory of the United States—which is vast enough, to be sure, but politically and geographically one—is not something MacLean does because he has geopolitical cold feet, but due to his methodological rigor. He thus avoids a superficial accumulation of images and yields instead a rational, virtually encyclopedic body of work describing the variety of American landscapes: urban, suburban, industrial, and agricultural. His is a durable examination and analysis of the typological and morphological characteristics of these territories.

D.C.: Would you say, then, that MacLean's work involves the practice of a geographer?

J.D.: Above all, it's the work of an architect—one who has been sensitized to the issues of urbanism and habitat, to all the forms of construction and deconstruction, as well as to the logic of landscaping and of the material and human development of the land. But it is also the work of a citizen acting on the major issues of sustainable development, ecology, and the environment. And then it is an approach that pursues the work of the pioneers and activists of human geography. In compiling his iconographic encyclopedia of the American land, it seems to me that MacLean is inventing a new kind of geography that we could call civic geography. Indeed, his visual and intellectual work helps inform the citizens of the 21st century about the transformations—often irreversible, but not necessarily perceptible by the lay public—that gravely menace the environment and our common future. All the more so if, in the name of an all-out neoliberal politicoeconomic laissez-faire, we leave it up to the market forces to modify the land for the sake of short-term interests—that is, without taking into account the overriding, and indivisible, interests of local, regional, national, and global communities.

D.C.: According to your analysis, is MacLean the pioneer of a new discipline, of an innovative approach within society?

J.D.: MacLean has become the American pioneer of a new iconographic art with a civic mission. In this new genre, informational content responds to a dual expectation of society: one, to render visible and intelligible the various components and typologies of the national landscape (especially those affected by human activity); and two, to communicate the nature of the changes effected by humankind on the environment. The end result is to permit the emergence of a vision that is at once analytical and synthetic. This vision should nourish in turn a critical approach to the development of our urban and rural territories. In Europe, the civic demand for this kind of approach became obvious at the end of the 20th century. In the United States, however, this public awareness remains merely potential, owing to the stalling tactics of the Bush administration, which persists in being strategically "blind" to the extent and gravity of national and global environmental issues. MacLean's aerial photographs constitute a specific kind of protest against

the violent changes wrought by society on its environment. As a result, the accomplishments, mistakes, and aberrations that they expose might foster a gradual and salutary coming to consciousness among citizens and certain decision makers or university professors, the latter of whom have a decisive pedagogical role to play.

D.C.: In terms of urbanism, habitat, agriculture, and so on, could this approach in the university that you mentioned lead to innovations of a reformatory, or even revolutionary, nature?

J.D.: If the future elite are encouraged at the university level to adopt a critical reading of MacLean's visual messages and to propose alternative, responsible policies for the development of our landscape, then this should lead to certain unwholesome practices in development being called into question and to a search for suitable solutions. This process might also spark a much-needed revolution in our way of viewing, developing, and managing the land. For now, we are wasting land through the frenzy of a collectively irresponsible hyperconsumer society, which is propelled by the daunting environmental crisis—itself brought on by the notorious excesses of industrial society.

D.C.: What is Alex MacLean's contribution to the slew of signals and information on the environmental crisis and warming of the global climate?

J.D.: MacLean's images do not reveal the effects of global warming—or only very slightly—but rather some of its causes. He leaves us with a solemn warning, expressed in terms of photographic sequences: The social model according to which North America is pursuing its unbridled development is at odds with the climatic balance worldwide and the strategic and ecological requirements of sustainable development. He opens our eyes critically and mobilizes our intelligence for the sake of a necessary change—society will have to develop its land according to radically different ethical and material precepts.

D.C.: If you had to compare MacLean's present or potential influence with that of another great American figure, who would it be?

J.D.: I'd have to say Thoreau, because of his intellectual positions about nature in the 19th century. I also think

of Mumford again, who warned us as early as the 1950s about the danger of cities decomposing into segregated communities and eventually expanding into far-flung suburbs—dismal, inhuman, and perverse American suburbia. He proclaimed the fatal dehumanization that is suburbia was being developed for the sole profit of the oil and automobile lobbies and speculative real estate and construction businesses. But I'd also have to say, predominantly, Francis Ford Coppola and his film *Apocalypse Now*, which dramatized so memorably the decay of American military might in Vietnam, which most American citizens refused even to consider at the time. I think that the "aerial staging" of the U.S. that MacLean has created—this time at the very heart of America—could be called a sort of "Apocalypse Soon, Seen from Above." Like all great artists, MacLean is endowed with a perception of things that is well ahead of society's perception at large. And so, his work proclaims the imminent collapse of the American model of urbanization and habitat, especially the ubiquity of suburbia. This constitutes a major portion of the American way of life that is no longer "sustainable," even by the superpower that is America.

D.C.: What perspectives do MacLean's photographs lend the viewer?

J.D.: Given this damning evidence of the immeasurable damage inflicted upon our natural and inhabited environment, what is urgently required is a new collective dream—that of the ecological city as a reasonable medium for community life. This can only be achieved through a concomitant restructuring of the agricultural and industrial sectors. To this end, a knowledge of the antecedents of human geography will prove very useful in reminding us of the common sense that has invariably led to a renewed harmonious balance between humankind and the environment; between the city, its inhabitants, and other territories. We have to modernize and update certain ideas that have already proved useful, but that our often-amnesiac society has too rashly disposed of on the trash heap of history—though we must do so without nostalgia. We need a very dense, compact, and diversified city; an inhabited environment that is well equipped with efficient and ecological public and private transportation; agribusinesses converted to organic mixed farms and geared to the real needs of the regional population; and so on. These and so many commonsense ideas concerning civic life, planning, and the environment, and their radical

foundations are revealed, ironically enough, through an objective reading of the photographs—correspondingly prophetic—of citizen Alex MacLean.

Index of Places

Further Reading

Other books from Alex S. MacLean

Campoli, Julie, Beth Humstone, and Alex S. MacLean. *Above and Beyond: Visualizing Change in Small Towns and Rural Areas*. Chicago, IL: American Planning Association, 2002.

Campoli, Julie, and Alex S. MacLean. *Visualizing Density*. Cambridge, MA: Lincoln Institute of Land Policy, 2007.

Corner, James, and Alex S. MacLean. *Taking Measures Across the American Landscape*. New Haven, CT: Yale University Press, 1996.

MacLean, Alex S. *Designs on the Land: Exploring America from the Air*. New York: Thames & Hudson, 2003.

_____. *Look at the Land: Aerial Reflections on America*. New York: Rizzoli, 1993.

_____. *The Playbook*. London: Thames & Hudson, 2006.

Other books from Bill McKibben

McKibben, Bill. *The Age of Missing Information*. New York: Random House, 1992.

_____. *American Earth: Environmental Writing Since Thoreau*. New York: Library of America, 2008.

_____. *The Bill McKibben Reader: Pieces from an Active Life*. New York: Henry Holt and Company, 2008.

_____. *Deep Economy: The Wealth of Communities and the Durable Future*. New York: Times Books, 2007.

_____. *The End of Nature*. New York: Random House, 1989.

_____. *Enough: Staying Human in an Engineered Age*. New York: Times Books, 2003.

_____. *Fight Global Warming Now: The Handbook for Taking Action in Your Community*. New York: Henry Holt and Company, 2007.

_____. *Hope, Human and Wild: True Stories of Living Lightly on the Earth*. New York: Little, Brown and Company, 1995.

_____. *Hundred Dollar Holiday: The Case for a More Joyful Christmas*. New York: Simon & Schuster, 1998.

_____. *Long Distance: Testing the Limits of Body and Spirit in a Year of Living Strenuously*. New York: Simon & Schuster, 2000.

_____. *Maybe One: A Personal and Environmental Argument for Single-Child Families*. New York: Simon & Schuster, 1998.

_____. *Wandering Home: A Long Walk Across America's Most Hopeful Landscape: Vermont's Champlain Valley and New York's Adirondacks*. New York: Crown Journeys, 2005.

Acknowledgments

It is an incredible privilege to fly so freely around our beautiful country and photograph with minimal restrictions. And I have been equally privileged to work with so many interesting, talented, and supportive people from different disciplines who have all helped in making this book.

I am grateful to Dominique Carré of Carré Editions, who has become a good friend in the process of publishing and editing two books of my photographs. I am indebted to him for his creativity, his image selections as an editor, and his unique European perspective on the workings of the American landscape that helped shape the concepts of this book. Anaïs Lancrenon, who works with Carré Editions, was instrumental in visualizing and producing the layout of the book with its many subtleties.

Deborah Aaronson, Editorial Director at Harry N. Abrams, Inc., made the English version of this book a reality. Also at Abrams, my thanks to Laura Tam and Esther de Hollander for keeping the moving parts organized, Carrie Hornbeck for her expert copyediting, and Sarah Gifford and Darilyn Carnes for the typesetting and design of this edition.

I was honored that Bill McKibben was able to contribute his insightful introduction to this book. He has been a great leader, heightening awareness worldwide about climate change, and has empowered people individually and collectively into taking meaningful action. I am thankful to Jean Dethier, architect, urbanist, and influential critic for his thoughts and opinions that appear in this book.

At the office of Landslides Aerial Photography, I am lucky to have Danielle McCarthy, my studio manager, for her steadfast encouragement, business acumen, artistic sensibility, and good spirits; Zach Vitale, for his knowledge and skill working with the digital pictures, his aesthetic sense, and his hard work throughout the production of the book; Mai Lombardi for her hours of research and interest in the subject; Aaron Stein-Chester, who was an invaluable source of fact checking and caption editing; and Drew Katz, my former studio manager, and now my colleague and confidant, for always offering his opinion over lunch.

Thanks to Jonathan Wilson, who volunteered his time doing research to find relevant locations to photograph during the initial phases of this book, and who contributed ideas, content, and edits to the text. Joe Kristl was brilliant in helping automate the process of connecting GPS spatial data with digital image files. Throughout the project my niece, Natalie MacLean, and my brother, Paul MacLean, were generous with their time and contributed important edits and encouragement, along with David and James MacLean, and Alison Cassidy.

To my friends in planning and design, I would particularly like to thank Armando Carbonell, Chair, Department of Planning and Urban Form at the Lincoln Institute of Land Policy, whose longtime support has allowed me to use my aerial photography to explore and convey ideas about urban form and climate change. Landscape architect and planner Julie Campoli, my good friend, and coauthor of *Visualizing Density* and other books, is a constant source of intelligent advice and interesting ideas. I am grateful to Ann Whinston-Spirn, teacher, landscape architect, and photographer for so freely sharing her knowledge.

Thanks to those in the aviation community, including Tom Peghiny from Flight Design USA, for moving me into a sophisticated composite technology plane with a cantilevered wing. Bose Corporation was generous in supplying their light and comfortable noise-canceling headsets. I can always count on Mike Dupont of American Aero Services, friend, aviation technician, and advisor to be there when I'm in a pinch, along with the people at Executive Flyers Aviation in Bedford, Massachusetts. Thanks to the many flight controllers who have guided me through controlled airspace and looked after my safety and the safety of others.

I am grateful to Remi Babinet, Betsy Berne, Richard Berne, Eric Bland, Russ Breiner, Chris Brown, Marilyn Cadenbach, Daniela Cangiano, Isabelle Chevillon, Mark Cumming, Mark Doyle, Francesca Fabiani, Odile Fillion, Skip Freeman, Luca Galofaro, Andrea Hammer, Henry Horenstein, Francis LaCloche, Peter LaSalle, Luca and Andrea Leonardi, Stefania Manna, Chris Miller, Pierre Novel, Robyn Nuzzulo, Alex Quennell, John Seabrook, St. John Smith, Palo De Stefano, Steve Stone, Giles Tiberghien, Remi Thornton, Andrea Volpe, Elizabeth Werby, and James Wolff.

Above all I thank my wife, Kate, for her artistic direction, ideas, and her patience with my trips away from home, and my wonderful daughters, Eliza and Avery, who make life even more fun.

Designed by Pierre Bernard and Anaïs Lancrenon, Atelier de création graphique, Paris
English-language edition typeset by Darilyn Lowe Carnes

Library of Congress Cataloging-in-Publication Data

MacLean, Alex S.
 Over : the American landscape at the tipping point / by Alex MacLean ;
introduction by Bill McKibben.
 p. cm.
 ISBN 978-0-8109-7145-5
 1. United States—Aerial photographs. 2. City and town life—United
States—Pictorial works. 3. Human ecology—United States. I. Title.

 E169.Z83M28 2008
 304.20973—dc22
 2008017513

Printed and bound in Singapore
10 9 8 7 6 5 4 3 2 1

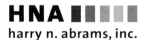

HNA ▊▊▊▊▊
harry n. abrams, inc.
a subsidiary of La Martinière Groupe

115 West 18th Street
New York, NY 10011
www.hnabooks.com

Case: Cars pile up at a junkyard used
for auto parts, Ayer, Massachusetts.